Wisdom With Understanding is Better Than Rubies

Lurine Karon Greenberg
Fine Arts Collection

Roberto Longhi

Three Studies

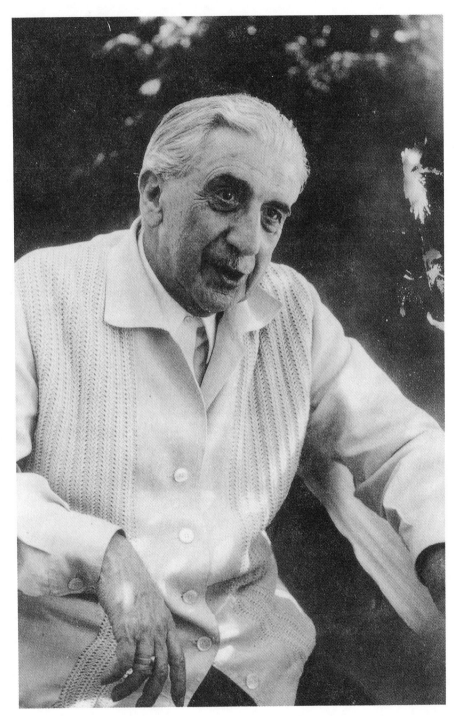

R. Longhi

Roberto Longhi
Three Studies

Masolino and Masaccio

•

Caravaggio and His Forerunners

•

Carlo Braccesco

STANLEY MOSS – SHEEP MEADOW BOOK
RIVERDALE-ON-HUDSON, NEW YORK

Published by Stanley Moss-Sheep Meadow Press.
Italian rights Sansoni, Firenze.

All inquiries and permission requests should be addressed to:
The Sheep Meadow Press, Post Office Box 1345,
Riverdale-on-Hudson, New York 10471.

Printed on acid-free paper in the United States by McNaughton & Gunn. Typeset in
AGaramond. This book meets the guidelines for permanence and durability of the
Committee on Production Guidelines for Book Longevity of the Council on Library
Resources.

Library of Congress Cataloging-in-Publication Data

Longhi, Roberto, 1890–1970.
 Three Studies / Roberto Longhi.
 p. cm.
 "Stanley Moss book."
 Includes bibliographical references and index.
 Contents: Masolino and Masaccio—Caravaggio and his forerunners
 —Carlo Braccesco.
 ISBN 1-878818-51-1 (hardcover)
 1. Painting, Renaissance—Italy. 2. Painting, Italian.
 3. Masolino, da Panicale, 1383–1440?—Criticism and interpretation
 4. Masaccio, 1401–1428?—Criticism and interpretation
 5. Caravaggio, Michelangelo Merisi da, 1573–1610—Criticism and
 interpretation. 6. Braccesco, Carlo, 15th cent.—Criticism and
 interpretation. I. Title.
 ND615.L676 1996
 759.5'09'024—dc20 96–16974
 CIP

Acknowledgements

Bringing Longhi across the Atlantic was thought by many to be a fool-hardy voyage, much of the cargo bound to be washed overboard. Special thanks to those who banged the compass from time to time when it seemed to malfunction: Mina Gregori, José Milicua, Allen Mandelbaum, Sir John Pope-Hennessy, Walter Cassola, and thanks to Federico Zeri for support and fire.

S.M.

Passages of the introduction *The Eloquent Eye* by David Tabbat were originally published in *Differentia* in 1991.

All attributions are by Roberto Longhi.

Contents

INTRODUCTION

The Eloquent Eye: Roberto Longhi and the Historical Criticism of Art

Bernard Berenson once observed that Vasari's greatest strength as a writer was that sure instinct for narrative and characterization which made him a worthy heir of Boccaccio. Lest his readers misconstrue this appreciation of Vasari's "novelistic tendency" as a denigration of his work when judged by purely art-historical criteria, Berenson added that the author of the *Lives* "is still the unrivaled critic of Italian art," in part because "he always describes a picture or a statue with the vividness of a man who saw the thing while he wrote about it."[1]

To a remarkable degree, these same observations may aptly introduce the work of Roberto Longhi (1890-1970),[2] who is often regarded by the Italians themselves (whether specialists or interested laymen) as the most important connoisseur, critic, and art historian their country has produced in our century.[3] Like Vasari, Longhi had the storyteller's sense of incident and character; like him, too, Longhi had an extraordinary capacity to perceive a work of art keenly and to convey his perceptions in words.

Throughout the whole of his long career, Longhi never published anything that was not intended, on the face of it, as a meticulously scholarly contribution to connoisseurship and art historical understanding. And yet, in reading his works, one may at times be assailed by doubts as to whether Longhi the dazzling stylist is really the loyal ally of Longhi the scrupulous connoisseur, or whether he is not—perhaps—subversively pursuing some independent end. However many traits Longhi may have in common with Vasari, there is a point at which any analogy ends abruptly; as a writer, Longhi has none of his predecessor's naive spontaneity. On the contrary, he has, as we shall see, all the modern literary artist's self-awareness, self-consciousness even, complete with a fully articulated theoretical justification for his own writing.

In any discussion of the "novelistic tendency" in Longhi, the *locus classicus* must be his essay entitled "Fatti di Masolino e di Masaccio."[4] Published in 1940 (and translated in the present volume), this seminal study represents a milestone in the history of connoisseurship, clarifying convinc-

ingly for the first time the division of hands in the *Madonna and Child with St. Anne* now in the Uffizi, and also (with astonishing results) in the Brancacci Chapel fresco of the *Tribute Money*.[5] While the essay offers food for critical thought on such varied topics as Masolino's later career and Fra Angelico's surprisingly *avant-garde* beginnings, the most startling thing about it may be the form in which parts of it are cast, a form practically unprecedented in a serious scholarly article. Rather than setting forth long stretches of formal exposition in order to explore how Masolino and Masaccio might have set about trying to reconcile their wildly divergent visions and methods, and how this interaction was reflected in the actual progress of work on the chapel, Longhi, at crucial points in his argument, puts passages of dialogue into the mouths of the two painters.[6] Thus we can read (and most entertainingly, too) how Masaccio went about browbeating his hapless and flustered elder associate with newfangled, radical ideas about Brunelleschian perspective, and about much else besides. It is obvious that Longhi cannot have transcribed the very words spoken in the church of the Carmine back in the 1420s; but the point is that, looking at the frescoes in the light of Longhi's text, one comes to the conclusion that the process by which they were brought into being may well have been very close to the one he reconstructs in his delicious dialogues: dialogues one willingly accepts as "history," because they are so perfectly mirrored in the mute "dialogue" between the two artists on the walls. As Longhi himself observes, demurely and a little maliciously, in commenting on his own essay, "a little imagination isn't a bad thing in an historian."[7]

Although Longhi's works contain innumerable other instances of his remarkable—positively "novelistic"—capacity to bring a historical setting to life,[8] his apparently paradoxical ability to give his literary imagination free play while adhering scrupulously to the matter and manner of his subject is nowhere more in evidence than in his close readings of individual works of art. Here is his characterization of the Virgin in the
Pl. 13
Louvre's wonderful *Annunciation* by Carlo Braccesco, a late-fifteenth-century Lombard-Ligurian master whose *œuvre* Longhi was the first to reconstruct:

> Chi sarà intanto questa Signora della Loggia? La "pucelle" dello stile cavalleresco, suggerita dai miniatori francesi del Duecento ma trovata soltanto da Simone? O non più che un ricordo di essa, già divenuta castellana un po' greve

di riviera ligure e magari della Costa Azzurra? Ancora alquanto "bas bleu" ma, ormai, non senza sospetto di "bas de laine". Quello aperto sul leggio tutto d'oro, non c'è dubbio, è il "livre d'heures", ma, più in basso, nello scaffaletto dove ridono le legature di prezzo, è forse anche il *Roman de la Rose* e il taccuino orlato di platino delle spese segrete.

O, ad attentarsi in una domanda anche più elementare: bella o brutta questa signora della loggia, non so chi sarà da tanto da rispondere. Chi ne saprà mai nulla di questo viso quasi albino, pienotto e minuto, i capelli platinati a bandelle sotto l'antico maforion bizantino, ciglia spelate, orecchie da rosicante, pelle tesa come un guscio d'ovo, con un sospetto d'efelidi e d'acari nel tessuto un po' grasso? E il segreto di quello sguardo accorto e smarrito, di quell'ombra sorniona accoccata agli angoli della bocca, di quell'aria di castellana saputa, di parrocchiana del primo banco che non si lascerebbe, per nulla al mondo, sorprendere alla sprovveduta, me lo vorrete spiegare?

Perché arriva ronzando, sul suo piatto dorato in prospettiva, questo calabrone violetto, la tunica smartellinata dal vento, la tracolla di nastro che brandisce, i piedi impigliati nelle ultime trinelle di nube, il serto ridotto a tre sole roselline stiacciate e all'"aigrette" che struscia sul cielo caldo? Ah! una distrazione finalmente nella filza di questi pomeriggi così grevi....[9]

First of all, just who is this Lady of the Loggia? The "damsel" of the chivalric style, hinted at by French thirteenth-century miniaturists but found only by Simone [Martini]? Or nothing but a memory of her, already become a slightly coarse châtelaine of the Ligurian Riviera or perhaps the Côte d'Azur? Still rather a bluestocking but not, by now, without a hint that her stockings are of good bourgeois wool. The book open on the golden lectern is, no doubt about it, the *Book of Hours*, but a bit lower down, on the shelf where the costly bindings make so fine a show, there are also, perhaps, the *Roman de la Rose* and the platinum-edged notebook for secret expenditures.

Or, to take a stab at an even more elementary question, that of whether this Lady of the Loggia be beautiful or plain, I have no idea who might be able to answer it. Who will ever know anything about that nearly albino, round and tiny face, or about the platinum-dyed hair parted in *bandeaux* beneath the old Byzantine *maforion*, the plucked eyebrows, rodent ears, skin drawn tight as an eggshell, with a hint of freckles and mites in the slightly oily tissue? And the secret of that shrewd and dreamy gaze, that mischievous shadow at the corners of the mouth, that air of the smug châtelaine, of the front-row churchgoer who would never, for anything in the world, allow herself to be caught unawares—can you explain it to me?

What's he coming buzzing around here for on his gilded perspective plate—this violet hornet, his tunic buffeted by the wind, his shoulder-ribbon waving, his feet entangled in the last snippets of cloud, his garland reduced to just three flat little rosebuds and his plume brushing against the hot sky? Ah!—a distraction at last, in this long string of afternoons, so wearisome....

That a first-class wit is at work here scarcely needs to be emphasized. But does not a passage like the above, so far from being gratuitous in its ironic playfulness, perfectly define the half-courtly, half-bourgeois, and entirely worldly spirit of the picture itself?

This same painting had already called forth from Longhi in 1920—many years before he solved the problem of its attribution—the following gorgeous evocation of its stylistic qualities:

> Apparizione d'oro e di avana, azzurro e grigio. Le carni lievemente aduste; quasi un sospetto di meticciato. Sui visi più chiari le ombre ardesia. Le babbucce di Sant'Alberto come olive nere. Toni caldi e toni freddi (che cosa importa?) da non distinguersi. Ori, ori: non però appiattiti sulla luce, anzi che smagliano nella luce, bruciati dalla penna nera dell'ombra. Sentimento degli ori. Coltivazione degli ori. Civiltà degli ori lombardi (Monza, Treviglio, Lodi). Intelligenza della forma da screditare più d'un fiorentino, però, non fiorentina; confidenziale, accostante, non insolente e saputa. La città nel pomeriggio torpido: una Pavia immaginaria, di ricordo? E l'angelo che sembra smartellinato da uno scultore della Certosa. Viola come nel Bergognone. Gli azzurri, invece, di lago, intatti, come in Fouquet e Charonton. Del resto, anche la Madonna, "fermière". Elezione della spalliera di rose come in un antico "lai" provenzale; i garofani che tremano nell'afa entro il vaso, ahi, "rinascimento." Ironico, però, anche nel frammento di girale troppo bello, impeccabile. Tutto scritto e tutto dipinto; largo e minuto. Un miniatore di genio. Un gran pittore di minimi. Il più alto colloquio tra nord e sud, tra Van Eyck e Piero. L'apice della pittura lombarda del Quattrocento.[10]

> Apparition of gold and yellow-brown, azure and gray. The flesh-tones slightly dusky; almost a suspicion of mixed blood. On the brighter faces, slate-gray shadows. Saint Albert's Oriental slippers like black olives. Warm tones and cool tones (what does it matter?) that cannot be told apart. Gold, gold: but not flattened out by the light; instead, dazzling in the light, and burnt by the black feather of shadow. Feeling for gold. Cultivation of gold. Culture of Lombard gold (Monza, Treviglio, Lodi). Astute handling of form, such as would put many a Florentine to shame, yet not Florentine: confidential, intimate, not insolent and smug. The city in the torpid afternoon: an imaginary Pavia, a memory? And the angel, seemingly hammered out by some sculptor of the Charterhouse [of Pavia]. Violet as in Bergognone. The azures, on the other hand, are like a lake, pristine, as in Fouquet and Charonton. As for the rest, even the Madonna: "rustic." The choice of the rose-trellis setting, as in an old Provençal lay: the carnations trembling in the sultry heat within the vase, which is—alas!— "Renaissance". Ironically so, however, as is the too-beautiful, impeccable fragment of acanthus-leaf decoration. Everything written

and everything painted; large and minute. A miniaturist of genius. A great painter of small things. The most elevated dialogue between North and South, between van Eyck and Piero [della Francesca]. The pinnacle of fifteenth-century Lombard painting.

The above passage may serve well as one example of Longhi's verbal transcriptions of works of art. The particular insistence in this instance upon the recording of color, as well as the somewhat stenographic, hermetic quality, may perhaps reflect the fact of the page's originally having been written as a promemoria for Longhi's own use; in any event, Longhi did eventually publish it, convinced that it did successfully illuminate the painting's aesthetic impact. It is worth calling attention to the numerous references to the work's "correspondences" with other artistic styles, an instance of a recurrent Longhian technique that here serves in a first attempt to "place" the work, as well as providing a shorthand summary of formal traits.

In the example quoted below, different in approach but equally characteristic, Longhi is concerned exclusively with the meticulous and methodical description of an individual painting in and of itself, in this case Antonello da Messina's *Annunciate Virgin* in the Museum in Palermo: Pl. 59

> È il gesto architettonico della Vergine che compie il miracolo stirando con la sinistra il manto ad includersi in una piramide assoluta, la quale rotea sopra un perno cristallino, motore immobile, fino ad assestare di fronte a noi l'asse ideale che, scavato nella piega sulla fronte, sfila per lo spigolo facciale, discende oltre l'angolo chiuso del panneggio fino alla prominenza dell'inginocchiatoio. Ma la mano destra s'avanza inclinata a tentare cautamente il limite possibile del volume; trovandolo s'arresta, mentre, contrapposto, il libro alza sull'aria il fendente affilato del suo foglio candido. Nella cavità interiore sulla colonna del collo si depone lentamente l'ovoide incluso del viso su cui virano come sovra un pianeta larghi diagrammi d'ombre regolari. [11]

> It is the architectonic gesture of the Virgin which accomplishes the miracle, as she pulls at her mantle with her left hand so as to enclose herself in an absolute pyramid which turns, an unmoved mover, on a crystalline pivot, until it establishes before us the ideal axis which, etched in the fold on the forehead, runs down the protruding part of the face and descends past the closed edge of the drapery as far as the jutting corner of the *prie-Dieu*. But the right hand advances at an angle, to test cautiously the possible boundary of the pictorial space; having found it, it halts; while, counterbalancing it, the book slices the air with the sharp blade of its bright page. In the hollow within the column of the

neck, there slowly settles the enclosed ovoid of the face, over which turn, as over a planet, broad diagrams of regular shadows.

Even if we may wonder a bit at the "crystalline pivot" and the "slowly settling" head, the formal function of the right hand's gesture is magnificently observed and communicated, the construction of the painting is painstakingly described, and the tone is measured and precise, admirably reflecting the poised geometry of Antonello's forms.

The rhetorical elaboration of passages such as these inevitably raises a question as to their fundamental nature. Are we in the presence of formal analyses such as might have been written by any art historian, save that they happen to be the work of one gifted with unusual eloquence? Or does that very eloquence imply that the text itself aspires to the status of art, thus taking on a quasi-independent existence which tends in some way to vitiate its credibility as critical commentary on the painting under discussion? To put the problem differently: is the aesthetic pleasure we feel upon reading such a passage due to a heightened perception of the work of art itself, or is it, instead, a response to Longhi's verbal creation? (Or, should it partake of both elements at once, what does that imply about the relationship between the work of art and Longhi's description of it?)

Longhi himself noted, as early as 1920, that he had on occasion been accused "of frequently substituting for the figurative artwork a literary artwork whose relationship to the object that brings it about is often accidental."[12] He answered the charge as follows:

> Poiché si tratta di stabilire esattamente le qualità formali di opere figurative, noi pensiamo che...sia possibile ed utile stabilire e rendere la particolare orditura formale dell'opera con parole conte ed acconce, con una specie di trasferimento verbale che potrà avere valore letterario *ma sempre e solo...in quanto mantenga un rapporto costante con l'opera che tende a rappresentare.* Ci pare che sia possibile creare certe equivalenze verbali di certe visioni; equivalenze che procedano quasi geneticamente, a seconda cioè del modo con che l'opera venne gradualmente creata ed espressa. Non sappiamo se ciò sia tradurre... ma da quando un fatto personale è inevitabile per chiunque imprenda fare storia, crediamo che questo nostro modo possa ancora aver luogo in *un buon metodo di critica storica delle arti figurative,* e ce ne pare riprova il fatto che quelle nostre "trascritture di opere d'arte" non avrebbero più alcuna efficacia una volta astratte dal *rapporto essenziale e continuo che mantengono e vogliono mantenere con l'opera....*[13]

> Since it is a matter of establishing exactly the formal qualities of figurative works, we think that ... it is possible and useful to establish and represent, with clear and appropriate words, the particular formal structure of the work with a sort of verbal transposition which may have literary value, but always and only ... to the extent that it maintains a constant relationship with the work it aims to represent. It seems to us that it is possible to create certain verbal equivalents of certain visions; equivalents which proceed almost genetically; that is, according to the manner in which the work was gradually created and expressed. We do not know whether this is translation ...but since a personal factor is inevitable for anyone who undertakes to practice history, we believe that this approach of ours can have a place in a good method of historical criticism of the figurative arts; and we think this is proved by the fact that our "transcriptions of works of art" would no longer make any effect if they were removed from the essential and continuous relationship which they maintain and are meant to maintain with the work....

Now, it is perfectly true that Longhi's "verbal equivalents," so far from being self-referential, only make sense insofar as they depend upon the work of figurative art under discussion. Longhi is also undoubtedly justified in arguing that *all* historical writing, no matter how it may be cast, inevitably partakes of the subjective experience and outlook of the writer, so that there is no good reason why his own work should be singled out for attack merely because its subjective nature is more readily apparent than is generally the case. At the same time, however, this very element of subjectivity is precisely what leads one to doubt whether a text by Longhi (or by anyone else, for that matter) can ever constitute a genuine "verbal equivalent" of a figurative work.

Other writers before Longhi have postulated the idea that the critical text may constitute an "equivalent" for the work of visual art, aiming to reproduce the latter's aesthetic impact rather than merely describing or explaining such impact at a suitable critical remove. Here, for example, is the English critic William Hazlitt (1778-1830): "...the critic, in place of analysis and an inquiry into the causes, undertakes to formulate a verbal equivalent for the aesthetic effects of the work under consideration."[14]

Addressing himself (at least ostensibly) to this very text, Mario Praz, in a lecture entitled "Time Unveils Truth,"[15] has argued cogently that, save perhaps in the case of texts created more or less contemporaneously with the works they aim to represent, "verbal equivalents" will always reveal themselves, with the passage of time, as artifacts of their own period, and thus as something other than true equivalents. He compares them in this

regard to skillfully executed fakes, suggesting that, in both cases, changes in taste will bring to light "period" stylistic traits and preoccupations that went unnoticed at the time that the text or fake was created, simply because they were at that moment practically universal.[16]

While Praz's point is well taken, it is also true that all historical and critical works tend to date, from whatever angle they are written; the problem is scarcely unique to those involving the attempt to create a verbal equivalent for a work created in another medium. Furthermore, there probably exists a fundamental difference in kind between visual·and verbal experience, such as to limit significantly the degree to which two works created in such differing media as words and paint can evoke identical sensations or convey identical messages.[17]

Although, for the reasons adduced above, Longhi's descriptions cannot be true "verbal equivalents," we may nonetheless conclude—even if we sometimes feel disinclined to accept his disavowal of any autonomous artistic ambitions[18]—that these texts constitute a legitimate form of critical commentary, an eloquent vehicle for the transmission of Longhi's close observation of visual art. Even if they seem at times to forget their station and head for the empyrean—what of it? As Lytton Strachey once said: "That the question has ever been not only asked but seriously debated, whether History was an art, is certainly one of the curiosities of human ineptitude. What else can it possibly be?"[19]

And that Roberto Longhi was an artist there can be no doubt. His quick imagination, his sense of the metaphor, his mastery of prose rhythm, his verve, above all that instantly recognizable tone of voice—lyrical, ironic, hortatory—make of him, to put it as simply as possible, a great writer.[20]

* * *

Was he also, judged by more conventional standards, a great art historian? To put the question in epistemological terms: what do his writings communicate which is knowable in a form other than the specific verbalization he gave to it?[21]

Longhi arrived early at his conception of the nature of the art-historical discipline, from which he was never, in the essentials, to deviate. He defines it in the *Breve ma veridica storia della pittura italiana,* written in

1914:

> Porre la relazione fra ... due opere è anche porre il concetto della Storia dell'Arte, come almeno l'intendo io, e cioè null'altro che la storia dello svolgimento degli stili figurativi....[22]

> To set forth the relationship between two works is also to set forth the concept of Art History, at least as I understand it; and that is, nothing else than the history of the development of figurative styles....

This conception, concerned as it is primarily with tracing the development of visual style, risks excluding, as extrinsic to the work of art considered *qua* art, whole areas which have been most fruitfully cultivated by other art historians. And in fact we shall search in vain through all of Longhi's works for any real illuminations regarding iconography, for instance, or the relationships between economic life, technology, and the visual arts; at bottom, such matters simply did not interest him.[23]

What *did* interest him was the interplay between tradition, influences, and the individual artistic personality. Throughout his career, he strove to demonstrate how even the most innovative visual language is always to be understood as an outcome of previous artistic idioms, without which it would be inconceivable; and to show how a new style may in turn contribute to what will come after.[24]

Longhi viewed the analysis of stylistic development not as an occasion for the formulation of neat abstractions, but rather as a methodology for use in the study of concrete historical cases. He writes of his

> ...studi storici singoli, condotti sempre con quel "puro" metodo figurativo, sempre cioè per via di un rilievo esatto di tutti gli elementi formali che, esaminati con acutezza nei rapporti tra opera e opera, si dispongono inevitabilmente in serie di sviluppo storico....[25]

> ...single historical studies, always carried out using that "pure" figurative method, that is to say, always by means of a precise stress upon all the formal elements which, observantly examined in the relationships between one work and another, inevitably dispose themselves in an historically developing series....

A good example of this approach is the first major article of Longhi's maturity, "Piero dei Franceschi e lo sviluppo della pittura veneziana,"[26]

where he argues, on purely stylistic grounds, that the art of Piero della Francesca, although it may have found no worthy continuators in the artist's native Central Italy, nonetheless constitutes the *sine qua non* for the work done elsewhere by Antonello da Messina and Giovanni Bellini.

In this early essay, Longhi was laying the groundwork for a method which was later to bear magnificent fruit in—to cite but a single instance—his series of studies of the sources of Caravaggio's style (represented in the present volume by "Caravaggio and His Forerunners"). Rather than throwing up his hands before the mystery of this painter's shattering originality, Longhi set patiently to work in order to demonstrate, in numerous articles and other publications over the years,[27] how Caravaggio might have found much of what he needed for the formation of his own style in the then-recent example of such "luminists" and "forerunners of naturalism" as the Lombards Moretto, Moroni, Savoldo, and the Venetian Lotto, all of whom were active in the artist's native Lombardy, in the area around Brescia and Bergamo, not far from the town of Caravaggio. He further established "the tortuous procedure whereby the works of Antonio Campi [a Cremonese painter of the generation before Caravaggio's] might have been useful to Caravaggio."[28] And he was especially pleased when, after he had hypothesized a relationship between Caravaggio and the Milanese Mannerist painter Peterzano—a connection which most observers, on the strength of the visual evidence, might find less than immediately obvious—documentation subsequently turned up confirming that Peterzano had in fact been Caravaggio's first teacher.[29]

More than any other art-historical method one can think of, one based (at least in theory and intention) solely upon the analysis of stylistic factors requires an extraordinary verbal virtuosity on the part of its practitioner if insights are to be communicated with the necessary subtlety and completeness; and this may be one reason Longhi developed such a highly "literary" style.

More than any other method, too, a purely formal one will tend, in its relentless concentration upon the work of art's stylistic aspects[30] (which is to say, ultimately, its aesthetic qualities), to approach the condition of art criticism. Longhi recognized as much when he defined his field of activity as "historical criticism of the figurative arts."[31] He elaborates upon the idea:

Nel far critica figurativa abbiamo sempre inteso di fare storia, ed abbiamo anzi fin dagli inizi del nostro lavoro esplicitamente dichiarato di esserci accorti che "la critica coincideva con la storia."[32]

In practicing figurative criticism we have always understood ourselves to be practicing history; and ever since beginning work, we have in fact explicitly declared our realization that "criticism coincides with history."

Criticism, of course, ultimately implies the expression of subjective aesthetic opinions; and Longhi never shrank from formulating a value judgment.[33] In his *Viatico per cinque secoli di pittura veneziana*,[34] for example, he retraces the history of Venetian painting from the Gothic period down to the time of Tiepolo (or, as he would have preferred to say, of Pietro Longhi and Rosalba); and at every step of the way, he take sides passionately "for" or "against" certain artists and the tendencies they represent. One need not accept all his (often unorthodox) verdicts in order to find them stimulating; what is significant is that here the frontier between historiography and overtly subjective criticism has been very nearly erased.

He was instinctively drawn to artists he perceived as rebels, outsiders, "eccentrics," or even as simply not having received their due from their contemporaries or from posterity.[35] Along with his lifelong fascination with Caravaggio, he had, for example, a particular sympathy—shared, as it happens, with Berenson—for that unsettled genius Lorenzo Lotto (as will be readily apparent to readers of "Caravaggio and His Forerunners").

Longhi's passionately subjective advocacy of many artists generally considered minor had consequences which must be regarded as contributions to purely historical—in the sense of factual—knowledge. Along with his studies of such towering figures as Piero della Francesca or Masaccio, he devoted much attention to such varied artists as Lelio Orsi, Amico Aspertini, Orazio Borgianni, Gaspare Traversi and countless others. Longhi clarified the corpus of their works and elucidated their styles; he also, to a greater extent, perhaps, than his theoretical premises would seem to admit, addressed questions of biographical detail, especially where these served his interest in stylistic development.[36]

His capacity for radical re-evaluation often extended to the work of entire schools or geographical areas. He helped create an interest in the Renaissance painting of such Lombard centers as Brescia and Bergamo as something more than an earthbound and provincial imitation of Venetian

models;[37] he delineated the importance of Bologna as an independent artistic center in the fourteenth and fifteenth centuries;[38] he was among the first to explore seriously certain aspects of the artistic history of such relatively out-of-the-way areas, art-historically speaking, as Sicily, the Marches, and Piedmont.[39] It is entirely characteristic that one of his very few full-dress monographs should have been devoted to the painters of a school which, while not precisely unknown, had been regarded as of secondary importance: that of Ferrara.[40]

It is, in any case, difficult to envisage a more concrete, if potentially narrow, contribution to scholarship than a correct attribution: if acceptable and accepted, it becomes a *fact*. In this sense Longhi, with his constant activity as a connoisseur, undoubtedly made a major contribution to our knowledge of the history of Italian art.

Paradoxically, it is the narrowness as well as the breadth of Longhi's interests which makes it hard to define the essence of his contribution. The narrowness because, of all insights, those into purely stylistic matters are among the most resistant to proof or easy reformulation. The breadth, precisely because so many different works by so many different artists engaged his attention, and he resisted coordinating his observations about them—scattered in profusion through the fourteen thick volumes of mostly short articles which comprise his collected works[41]—into any kind of grand system, feeling that any schematic reading of art history involved oversimplification and hence falsification.[42] (Longhi's unflagging attention to the infinitely varied particularity of the past, in all its disorderliness, sets him at the antipodes from a system-building historian like Wölfflin, who in 1898 was able to write, without a trace of irony: "It goes without saying that only masterpieces are mentioned."[43])

The difficulty of defining Longhi's place in the development of the art-historical discipline is increased by the fact that his work was, by its very nature, somewhat unprecedented. If such earlier connoisseurs of Italian painting as Cavalcaselle or Morelli had been without serious "literary" pretensions,[44] such great stylists as Ruskin, Pater, even Fromentin, had in no sense of the word been genuine connoisseurs or art historians.[45] The co-existence (and even, at times, the absolute identity) in Longhi of the gifted imaginative writer and prose stylist with the conscientious connoisseur and art historian, committed to the meticulous annotation of his observations regarding pre-existing works of art, may perhaps have

led him to postulate, as we have seen, theoretical premises of problemat-
ical validity for his methodology as a writer; but even if we think this is
so, it needn't necessarily compromise the enduring value of the keen
insights so brilliantly set forth in the actual writings.

* * *

English-speaking readers encountering for the first time the imaginative
power, the capacity to illuminate, the sheer authority of the essays included
in this volume may find themselves wondering: how come we didn't know
about Longhi from the start? After all, those of us with an interest in art
usually have at least some awareness of the contributions made in this
century by such art historians and connoisseurs as Panofsky, Gombrich,
Schapiro, Chastel, Berenson, and Pope-Hennessy. So why have we not been
more Longhi-conscious?

Put that way, of course, the question makes an implicit claim: that
Roberto Longhi does ultimately belong in the exalted company of the
greatest writers on the art of the past. As we have seen, it's a view many
would take for granted in Italy; his influence in certain other countries,
such as France and Spain, has likewise been significant.[46] So why have
his writings been so relatively invisible to the English-speaking world
(even, to some extent, among academics and other art professionals?)

It may seem tautological to begin our hunt for an explanation—a hunt
which will, perhaps, also shed some light on the reasons Longhi's work is
likely to be of special interest today—by observing that little of his vast
corpus has been translated, and that what has hitherto been made avail-
able does not include his most significant writings. After all, one might
think, if there had been a real need and demand, the task would have
been accomplished long since.

A first response might be, very simply, that most of Longhi's best work
is hair-raisingly difficult to translate. Never mind (but of course, one *must*
mind) about the challenge of capturing every inflection of that idiosyn-
cratic and mercurial voice. It is no easy task just to ferry the structure
and literal meaning of many of his sentences, ecstastic Proust-like labyrinths
of dependent clauses, into English, a language offering few of those gram-
matical signposts (agreement of noun and adjective by number and gender,
agreement of verb ending with subject) that help the reader thread his

way through the Italian original without feeling the strain.

This isn't just a mechanical problem, either; it raises an issue of epistemology. When a scholarly essay is intensely dependent upon high literary style, we modern English-language readers get suspicious. Remembering how earlier generations were swept out of their armchairs by the Victorian rhetoric of Ruskin and Pater, we tend to ask what, precisely, it is that such elaborately self-conscious, non-neutral, seemingly belletristic writing leaves us with in terms of real solid "content." (After all, our own literature has long since recovered from its "aesthetic" phase.) Our reigning academic prose style is, in its sobriety, at a double remove—temporal and national—from the context in which Longhi wrote.[47]

The disjunction between Longhi's style and that of most modern Anglo-American scholars betokens, of course, a deeper difference in interests; as we have seen, Longhi devoted little attention to many of the issues with which art history has most consistently concerned itself over the past several decades. Furthermore, several of Longhi's underlying ideological assumptions—about the isolability of style, the practically Darwinian processes by which the latter evolves, the artist as social outsider—tend to mark him as one whose mental categories were formed in a belated nineteenth-century climate of aestheticism, positivism, and Romanticism.[48]

Along with the challenge posed by his exceptionally elaborate prose, these are, perhaps, the principal reasons Longhi's work has remained at the periphery of public and academic awareness in the English-speaking countries. Paradoxically, though, it is just his distance from our current assumptions and concerns which may now make Longhi's work especially useful to us.

After all, contemporary academic values and practices often entail a danger of seeing every work as, first and foremost, a symptom of something else: social and economic tensions, religious impulses, dynastic ambitions, technological developments, or what have you. This tendency can, and all too frequently does, lead to a certain diffidence about addressing the work of art as, first and foremost, a unique aesthetic object capable of provoking a specific and very intense experience.[49] One might even suggest that our enhanced understanding of earlier works' original contexts and purposes has only increased our awareness of the gulf separating us from the art itself. Recognizing that we do not feel and think just as people did "back then," and that we are using their creations for pur-

poses of our own, which often correspond only marginally to those of the artist and his intended audience, we no longer tend to assume that we can perceive the art they made in the same terms they did. There is a sense in which we may come to distrust our own inescapable subjectivity.

With his unsurpassed powers of observation and description, of sheer concentration on the object, and with his conviction that "criticism coincides with history," Longhi urgently recalls us to a more immediate, spontaneous, and specific engagement with the works as they actually present themselves to the eye, with the unique experience each painting makes possible in the here and now. He shows us, as vividly as any writer ever has, the extent to which heightened, sharp-edged visual perceptions can constitute, in and of themselves, a real form of intimate historical knowledge. Such triumphs of connoisseurship as his reconstruction of Braccesco's personality, or his intuition of Caravaggio's "Peterzano connection," born simply of intense looking, remind us of the extent to which such knowledge indeed can be concrete, demonstrable, anything but illusory.

While most readers—even, perhaps, most art professionals—are unlikely to aspire to such feats as these, Longhi's genius for seeing, and for putting what he sees into words, may well help many among us to arrive at a new, more flexible scale of values having little to do with the eternal Tuscan-Venetian polarity. "Caravaggio and His Forerunners, " for instance, opens the door to an enhanced appreciation of such Lombard Renaissance painters as Bergognone and Foppa on terms having as little to do with Brunelleschian perspective as with any sort of classicizing idealism.

In all probability, Longhi's indifference to the received canon is yet another reason his work has never achieved an international prestige comparable to its fame in Italy. After all, practical considerations have always made it simplest for students of Italian art in Vienna or London or New York to look at slides of works everybody agrees to consider "important," and then to board the express train running straight from (let us say) Giotto through Masaccio to Michelangelo, with occasional glances out the window at the scenery closely contiguous to the tracks. Longhi, on the other hand, who was out there studying the thousands of works to be found in every way station in Italy, and who had a fresh eye for much (although not all) of what he encountered there, also had to decide what he was going to do with artists like Gaudenzio Ferrari or Amico Aspertini, and what their work might have had to do with that of other artists and schools gener-

ally considered "mainstream."

This sort of messy reality can be alarming. At best, it disturbs our reassuringly schematic preconceptions, complicating our ideas about what matters, who influenced whom, what we're supposed to be looking at. At worst, it makes us realize that there's a great deal of significant stuff out there we haven't a clue about, and that we will probably never have the means to catch up on all of it. Longhi is inconvenient. In an age like ours, given to the radical reassessment of hierarchies, this is, of course, just one more excellent reason for reading him.

If additional ones are needed, we need look no farther than the sheer delight his writing can occasion as literature. His imaginary dialogues between Masaccio and Masolino, for example, are, among other things, a brilliant comedy of character. His close reading of the *Annunciation* from Braccesco's Louvre poliptych is at once careful stylistic analysis, witty social commentary, and a vividly evocative prose poem. And when all is said and done, it's hard to deny that, having read such passages, one really is likely to *see* the paintings as never before.

David Tabbat

NOTES

1. B. Berenson, "Vasari in the Light of Recent Publications," in BER, pp. 1-12. The personal relationship between Berenson and Longhi, incidentally, comprises one of the more colorful stories in the by-no-means peaceful annals of artistic historiography. The young Longhi, an enthusiastic admirer of Berenson's, proposed to translate the latter's *Italian Painters of the Renaissance* into Italian, and his offer was initially accepted. Later, irritated by Longhi's delays in sending him a text and assailed by growing doubts about Longhi's linguistic equipment and flamboyant prose style, and by what he took to be a certain tendency on the latter's part to slant the translations to reflect his own aesthetic convictions, Berenson withdrew his authorization. The ensuing rupture was aggravated in following years by the two men's competition for hegemony as the supreme arbiter of attributions in the field of Italian painting; Longhi's attack on the elder connoisseur's entrenched position culminated in the publication in 1934 of Longhi's *Officina ferrarese*, which contained, along with much else calculated to offend Berenson, a caustic allusion to his celebrated "lists" (giving Berenson's attributions of many Italian paintings) as "that new timetable of the Italian artistic railways which many people, out of mental cowardice, take as Gospel" (OF, p. 9). (E. K. Waterhouse, reviewing Longhi's book in the *Burlington Magazine*, LXVIII, 1936, pp. 150-51, felt moved to write: "His two principal aims appear to be to establish as rigorous a chronology as possible, and to be as rude to Mr. Berenson as the large vocabulary of the Italian language allows.") The rift between the two critic-connoisseurs was not healed until 1956, when Longhi delivered a glowing eulogy on Berenson (published in BG, p. 259) upon the occasion of the latter's being awarded an honorary degree by the University of Florence. Their correspondance has been published as B. Berenson and R. Longhi, *Lettere e scartafacci* 1912-1957, C. Garboli, ed., Milan, 1993. See also F. Bellini, "Una passione giovanile di Roberto Longhi: Bernard Berenson," and G. Previtali, "Roberto Longhi, profilo biografico," both PRE, pp. 9-26 and pp. 141-70 respectively; also the entry for 1916 in the "Cronologia" in CON, p. LXXXV.

2. A brief biographical sketch is here in order. The son of a schoolteacher, Longhi was born in 1890 at Alba in Piedmont. In 1911 he took his degree in art history at the University of Turin, where he studied under Pietro Toesca; he wrote his thesis on Caravaggio, who was to remain a particular interest through out his career. Following a period as a teacher of art history in the *licei* (high schools) of Rome, he was "taken up," around 1920, by the great collector Alessandro Contini-Bonacossi, who gave him the opportunity to travel throughout Europe and helped launch him upon his career as a connoisseur. In 1924 he married the writer Lucia Lopresti, who was herself to have a distinguished career under the pen-name of "Anna Banti." Longhi was appointed in 1934 to the chair of art history at the University of Bologna, and in 1949 to an analogous post at the University of Florence. Throughout his career, he was involved with a series of art-historical and critical journals; following publication of several articles (dealing with contemporary as well as with earlier art) in periodicals such as *La Voce* and *L'Arte*, he briefly co-edited the magazines *Vita Artistica* (1927), *Pinacotheca* (1928-29), and *La Critica d'Arte* (starting

1938); in 1943 he founded *Proporzioni*, which appeared only four times, the last in 1963; in 1950 he founded the monthly *Paragone*, which was to remain one of his interests practically to the end of his career. Longhi died in Florence in 1970. See the chronological tables in PRE, pp. 258-63, and G. Previtali, "Roberto Longhi, profilo biografico," in PRE, pp, 141-70; for his work in magazines "Le riviste di Roberto Longhi," in CON, pp. 1122-1123.

3. It sometimes seems that one cannot open a book by an art historian currently active in Italy without encountering some reference to Longhi's brilliance as a connoisseur, the keenness of his insights into the history of artistic styles, and the stimulus provided by his example. See for instance A. Conti, ed., *Sul restauro*, Turin, 1988, "Introduzione," pp. 80-81; and F. Zeri, *Dietro l'immagine*, Milan, 1987, pp. 146-50 and 167-70. And Longhi is still probably the art historian whose name appears most frequently in Italian newspapers and general interest magazines.

4. R. Longhi, "Fatti di Masolino e di Masaccio," *La Critica d'Arte*, vol. XXVXXXVl (July-December 1940), pp. 145-91; reprinted in FM, pp. 3-65.

5. It should be noted, however, that Longhi's conclusions regarding the division of hands in the Uffizi panel and the Brancacci Chapel have not been universally accepted. (Dissenters from his views on the Chapel include the restorers who recently worked on it.)

6. *Ibid.*, p. 15, pp. 18-19 in FM. Longhi builds up to his effect with the sure instinct of an accomplished literary artist; the pages of dramatic dialogue are preceded, a few pages earlier, by a passage of paraphrased conversation which sets the scene and predisposes the reader to absorb the shock when it comes.

7. *Ibid.*, p. 15.

8. An important example is the evocation of life in Squarcione's studio contained in the "Lettera pittorica a Giuseppe Fiocco," *Vita Artistica*, 1926, pp. 127-36 (reprinted in SR, pp. 77-98, where the relevant passage appears on pp. 92-93). As is generally the case with Longhi, this exhilarating piece of rhetoric, far from being an end in itself, aims at the illumination of a stylistic problem; in this case, how it came to pass that such North Italian painters as Mantegna and Tura, under the impact of the new, classicizing Florentine art represented by Donatello, could not but produce (in Longhi's view) "a medieval interpretation of the Renaissance."

9. R. Longhi, *Carlo Braccesco*, Milan, 1942; reprinted in LV, pp. 267-85. The passage quoted is on p. 272.

10. Ibid., p. 270. Longhi is here quoting from his own travel notebook of 1920. (It is entirely characteristic that, while drawing special attention to the rose-garden setting, Longhi should ignore the flower's traditional iconographic association with the Virgin.)

11. R. Longhi, "Piero dei Franceschi e la pittura veneziana" in *L'Arte*, XVII (1914) pp. 198-221 and 241-56; reprinted in SG, pp. 61-106, where the passage here cited appears on p. 87. Note that in the descriptions of both paintings, things are imagined as if in movement, as though the painting had but frozen an instant in a dynamic process. In the Antonello, the

pyramid "rotates," the page "slices," the shadows "turn"; in the Braccesco, the carnations "tremble," the ribbons "flutter" (to say nothing of the dynamic thought processes of the Virgin herself, who becomes a sort of fictional character). All this is further evidence of Longhi's "narrative" tendency.

12. R. Longhi, review of *Luca Giordano* by E. Petraccone, in L'Arte, 1920, pp. 92-93; reprinted in SG, pp. 455-60, where the passage quoted occurs on p. 456.

13. *Idem.*

14. Quoted in M. Praz, *Mnemosyne,* Princeton, 1974, p. 36.

15. *Ibid.,* pp. 29-54.

16. To what extent has what we may call "Praz's law" already become operative in the case of Longhi? In one sense, Longhi's most fundamental attitude—his emphasis upon the primacy of the stylistic components in a work of art, to the practical exclusion of all others—is in itself a "period" phenomenon, deeply rooted in the "aesthetic" current which was such an important feature of European intellectual and artistic life at the end of the last century. But what of the style of the texts themselves? There is no denying that, in their most elaborately wrought form, they can give off a certain whiff of D'Annunzio and may even remind us of the sinuously decorative qualities of Art Nouveau. At the same time, Longhi had learned very well the lesson of the most immediate model for his "verbal equivalents," the French critic and painter Eugène Fromentin (1820-76). Like Fromentin's, Longhi's texts proceed, every step of the way, on the basis of direct observation of the work itself (however subjective and fanciful the language in which the observations are then expressed). For this reason, Longhi's transcriptions, like Fromentin's own, do continue to describe and illuminate the pictures they discuss, to a much greater extent than do the apparently analogous productions of such writers as Pater or Ruskin, which by now would appear—whatever their literary merits—to have become utterly unglued from the objects which called them forth. (For Longhi's initial stylistic dependence upon Fromentin, see G. Previtali, op. cit., p. 144, and R. Longhi, *Carlo Braccesco,* in LV, p. 270, translated in the present volume). We must observe that Longhi's prose grows progressively less elaborate over the years, regardless of the subject he is discussing; the language of the early "Piero dei Franceschi ..." might reasonably be described as Baroque, while the late monograph *Caravaggio* is written in a style of classical sobriety. This development, which is quite independent of the style of the works of art dealt with in Longhi's text, clearly suggests that the text is not a pure verbal equivalent of its subject.

17. Recent deconstructionist literary theory, with its insistence upon the ultimate impossibility of ascertaining definitively the "meaning" of any given text, would posit that there is no way of verifying the identity of two artifacts presented as being equivalents, since neither one can ever be fully known even in itself: the very act of interpreting them involves a process of subjective recodification on the part of the critic or reader. (As he states in the text quoted in the main body of this study, Longhi does indeed acknowledge the inevitability of a "personal factor" in the writing of history.) The very fact of

Longhi's texts being written in Italian may serve to make the English-language reader aware of the pitfalls inherent in the idea of "equivalency"; if one can see a painting for oneself, but cannot read Longhi's description of it in the original, then to what extent can the two things be true equivalents for each other? And if one reads a translation of Longhi's text, to what extent does that experience duplicate the experience of reading the original? As anyone who has ever attempted to translate Longhi (or any other writer, for that matter) can attest: "Less than fully." In short, a text and its translation are already significantly different, although both use the medium of words. How much more so must this difference exist when two works are created in different media!

18. One may very cautiously and tentatively suggest that, whatever theoretical superstructure Longhi·may eventually have reared to justify his "verbal equivalents," the most important motivation may have been the unconfessable desire to "recreate" the work of art in such a way as to usurp the role of the artist who created it: to, so to speak, murder the artist and marry his picture. Certainly the need to identify the verbal creation completely with its figurative model, so that it actually becomes *the very same thing* as the work under discussion, would seem to be the only explanation for this astonishing assertion in the *Breve ma veridica storia...*, p. 128: "Quando sarete riusciti a dar senso ad ogni parola di questa resa letteraria di un'opera pittorica potrò credere che abbiate finalmente compreso che cosa precisamente sia l'incanto magico della sintesi prospettica di formacolore." To understand the literary rendering is to understand the painting, Longhi says; but we must add that this can only be really true if the lit-

erary rendering *is* the painting; otherwise it may be that one has only understood a literary text. This ambition of total fusion between text and subject does tend to confirm Longhi's assertion, cited in the main body of this study, that his verbal transcription's "literary merit" does indeed depend on an adherence to the figurative model; but it is perhaps a moot point whether it follows that Longhi's prose is at all times at the service of the work of art, or whether there is not at certain moments an insidious inversion of values, with the work of art becoming merely a necessary precondition for Longhi's writing.

19. L. Strachey, "Gibbon," *Portraits in Miniature and Other Essays*, London, 1931; reprinted in *Biographical Essays*, New York, n.d., where the passage quoted appears on p. 142.

20. The Italian critic and connoisseur Federico Zeri, in M. Bona Castellotti, *Conversazioni con Federico Zeri*, Parma, 1988, p. 21, states his conviction that Longhi was one of the two greatest Italian writers of our century, independently of subject matter. (The other, he says, was D'Annunzio.)

21. The most orthodox of Longhi's adherents would maintain that this very question implies a misapprehension of the nature and value of Longhi's work. An example is C. Garboli, "Longhi lettore," in FRE, pp. 121-22: "...un discorso 'letterario' non è un fatto che si aggiunga alla professionalità longhiana e si possa isolare e scremare, studiandolo separatamente dalla totalità dell'opera di Longhi in quanto storico e critico d'arte. La letteratura longhiana non è un 'plusvalore'...; essa è un elemento primario dell'attività di Longhi storico dell'arte." It is perfectly

true that Longhi's literary style constitutes a necessary precondition for the definition and verbal communication of his insights into visual style. But to go beyond this recognition, arguing an absolute identity between the vehicle and the information it conveys, would seem to be a sort of mysticism that ultimately risks inadvertently emptying Longhi's writings of any true independent content.

22. R. Longhi, BV, p. 36.

23. Cf. Federico Zeri's harsh criticism of Longhi on this score in M. Bona Castellotti, op. cit., pp. 20-21.

24. Longhi wrote in 1941 that art history was "una storia di persone prime: quelle degli artisti ...còlt[i] sempre in atto di servirsi di una tradizione per già affermarne un'altra (che, a sua volta, potrà o non potrà servire ai sopravenienti) ... [L]'arte cresce soprattutto sull'arte ... " (AI, p. 3).

25. R. Longhi, review of *Luca Giordano*, by E. Petraccone, in *L'Arte*, 1920, pp. 92-93; reprinted in SG, p. 453. Longhi's view of art history as essentially the history of style obviously presupposes that stylistic traits are the defining characteristics, the very essence, of the individual work of art. This view had in fact been propounded by, among others, Adolf Hildebrand (*Das Problem der Form in der bildenden Kunst*, 1893) and Benedetto Croce (*La teoria dell'arte come pura visibilità*, 1911), both of whose work the young Longhi read with intense although never acritical enthusiasm. Art having been defined as essentially a matter of style, it becomes possible to theorize an art history which is, accordingly, a history of style; here again, Longhi has antecedents and (partial) analogies in

the work of Witkhoff, Wölfflin, Berenson, and others. (For the youthful Longhi's reading and theoretical interests, see PRE, pp. 9-27, 145-51.) More recently, the theoretical implications of the notion that even representational art's relationship to other works of art is direct, its relationship to the rest of the world relatively oblique, have been brilliantly explored by E. H. Gombrich in *Art and Illusion* (London, 1960).

26. In *L'Arte*, XVII (1914), pp. 198-221, 241-56; reprinted in SG, pp. 61-106.

27. The most important is "Quesiti caravaggeschi: i precedenti," in *Pinacotheca*, vol. 5-6 (March-June 1929), pp. 258-320; reprinted in MP, pp. 97-143. See also the monograph *Caravaggio*, Rome, 1968, indispensible even though meant for a popular audience; the text, shorn of illustrations and of its slender critical apparatus, is reprinted in CON, pp. 801-75. The chronology of Caravaggio's works Longhi sets forth in this book has not won general acceptance.

28. R. Longhi, "Quesiti caravaggeschi: i precedenti," in MP, p. 98.

29. Idem. (It is worth noting that, theoretical premises aside, practically everything Longhi wrote bears witness to his mastery of the documents—at least the published ones, for, as may be imagined, he was no researcher in the archives—and, for that matter, of the art-historical literature. On those rare occasions when the written documents are Longhi's primary concern, as in the splendid essay devoted largely to Correggio's *fortuna critica*, he handles them with grace and skill: cf. R. Longhi, "Correggio e la camera di San Paolo a Parma," in CC, pp. 29-60.)

30. Longhi always insisted on the primacy of the visual evidence. See for example the already cited review from 1920, of Petraccone's *Luca Giordano* collected in SG. On p. 458 Longhi writes: "...per questa storia delle forme la critica figurativa pura non ha intellettualmente bisogno sostanziale dei sussidi biografici e cronografici della critica storica; i quali potranno semmai servirle di facilitazione quasi amministrativa, nel corso del lavoro; potranno talora risparmiarle tempo, permettendole di giungere con più rapidità alla constatazione critica alla quale soltanto importava di giungere; ma non avranno di ciò il più piccolo merito, come non l'ha nell'opera d'un filosofo il calamaio e la penna con cui egli stese le proprie teorie ..." Cf. Berenson, writing in 1901: "the history of art should be studied much more abstractly than it ever has been studied, and freed as much as possible from entangling irrelevancies of personal anecdote and parasitic growths of petty documentation.... I, for one, have been for many years cherishing the conviction that the world's art can be, nay, should be, studied as independently of all documents as is the world's fauna or the world's flora.... Then, and only then, and chiefly for the convenience of naming, might one turn to documents.... " (BER, p. vii). The affinities of such ideas with Wölfflin's famous hypothesis of a *Kunstgeschichte ohne Namen*, a method of art history conducted so exclusively along stylistic lines as to be able to dispense with the artists' very names, will be readily apparent; see SG, p. 458. The references in the Berenson passage to the study of flora and fauna come close to making explicit the underlying assumption that the development of artistic style, and the taxonomy of the resulting species and subspecies, proceed according to rules similar to those postu-

lated by Darwin as governing the world of living things. The scientific positivism of the late nineteenth and early twentieth centuries, then, appears to have pervaded the outlook of even certain "formalist" practitioners of art history, who, whether consciously or not, aspired to validate their own intellectual methods by analogy with those of the natural scientist. (See also, in this context, the references to botanical methodology in H. Wölfflin, *Classic Art*, London, 1968, p. xi.) Despite the obvious parallels between Longhi's outlook and those of Wölfflin and (especially) Berenson, our Italian critic seems in practice to have been pretty much immune to pseudo-scientific excesses, both as a result of his intense appreciation of artists' personalities and because his theoretical apparatus made room for the historian's subjectivity, given his recognition of "le relazioni di fondamentale identità tra arte e storia" (SG, P. 16); to Longhi, the practice of history was an art.

It is worth noting that, more recently and in less Darwinian-sounding terms, Gombrich has explored the idea that a new artistic development is never so much a direct response to "reality" as to previous works of art—an idea ultimately implying something not utterly unlike Longhi's "historically developing series." E. Gombrich, *op. cit., passim.*

31. *Vide* note 13.

32. R. Longhi, review of *Luca Giordano* by E. Petraccone, SC, p. 456.

33. Cf. Berenson's conviction, cited by M. Gregori in PRE, p. 134, that "the sense of quality" is the most important requisite for a connoisseur.

34. In PV, pp. 3-39.

35. Although Longhi made significant contributions to connoisseurship and criticism of literally hundreds of artists of every sort, his special sympathy was always engaged by those he thought of as sensitive and original personalities standing outside the mainstream. "...[Artisti] come il Lotto, il Caravaggio, il Rembrandt, finiscono sempre come dei vinti, quasi al bando della società in cui si trovano ad essere ospiti indesiderati, perché in contrattempo, perché più moderni di essa" (PV, p. 15). Written as late as 1945, this passage—even though it contains a grain of historic truth—sounds very much like an inheritance of that nineteenth-century Romantic conception according to which the great artist will naturally find himself pitted against society: yet another "period" characteristic, to set alongside Longhi's aestheticism and evolutionary positivism? (See notes 16 and 30, above.) Or is the attitude it reveals primarily an expression of Longhi's "novelistic" relish of idiosyncratic characters? At any rate, Longhi consciously opposes artists such as Lotto, Caravaggio, or Rembrandt to those who, in his view, express the "official" artistic tendencies of their time, such as Canova, "the sculptor born dead, whose heart is in the [church of] the Frari, whose hand is in the Accademia, and the rest, I don't know where" (PV, p. 39). In 1951, Longhi even read over the radio an imaginary dialogue he had written between Caravaggio and Tiepolo, in which the former extols the pursuit of "truth" in art, while the latter— a brilliant master in whom Longhi could see little more than a complaisant decorator to the rich—goes on about the importance of giving your patrons what they want (CON, pp. 1026-34).

In the presence of a received, hieratical style, Longhi's capacity for empathetic understanding evaporates utterly; and it is this evaporation which explains the most extraordinary (and, perhaps, regrettable) polemic of his entire career: the "Giudizio sul Duecento," *Proporzioni II* (1948), reprinted in GD. Never before, one suspects, has a meticulous critic of artistic styles, usually given to making the nicest distinctions, launched such a blast against the entire artistic output of a culture. What Longhi saw as the standardizing, depersonalizing tendencies of the Italo-Byzantine culture led him, in essence, to "pan" violently pretty much all the painting done in thirteenth-century Italy.

36. " ...[N]on aspettate da me copia di nomi, di date, di biografie più o meno aneddotiche ...," the youthful Longhi had told his *liceo* students in 1914 (BV, p. 36), in a polemical defense of the theoretical independence of "la critica figurative pura" from any need for "sussidi biografici e cronografici" (SG, p. 458); he nonetheless displays in his writings an alert interest in the relevance of biography and even anecdote to his stylistic studies. One good example is his consideration of the vexed question of the young Correggio's Roman journey, which he considered to be surely demonstrable on the basis of the artist's evolving manner (CC, pp. 61-78); another is his startling development of a chance remark of Titian's into an acute analysis of the differing basic assumptions of Venetian artists on the one hand, and their Brescian and Bergamasque contemporaries on the other (CON, pp. 922-45). In any case, theoretical *parti pris* aside, practically everything he ever wrote clearly reveals his delighted response to artists' personalities for their own sake.

37. See for example "Cose bresciane del Cinquecento," SG, pp. 327-43; "Due dipinti inediti di Giovan Gerolamo Savoldo,"

SR, pp. 149-55; "Dal Moroni al Ceruti," CON, pp. 922-45; "Quesiti caravaggeschi: i precedenti," MP, pp. 97-143. Compare for example Longhi's reading of Moroni's style with the less sympathetic one in Berenson's *Italian Painters of the Renaissance*.

38. "Momenti della pittura bolognese," PV, pp. 189-226; "Mostra della pitura bolognese del Trecento," PV, pp. 155-87; OF, pp. 7-10, p. 62.

39. See for example "Frammento siciliano,"FM, pp. 143-47; "Genio degli anonimi: Giovanni di Piamonte," FM, pp. 131-37; "Macrino d'Alba," FM, pp. 179-82.

40. *Officina ferrarese* (see bibliography). Longhi's other two full-length monographs are *Piero della Francesca*, Rome, 1927, reprinted several times, including Florence, 1963 as vol. III of the *Opere complete*; and the already cited *Caravaggio*, aimed primarily at the general reader.

41. Actually more than fourteen, because some of the fourteen "volumes" in the Florentine publisher Sansoni's edition of the *Opere complete* are themselves in several volumes, and because the *Breve ma veridica storia* and certain other texts are not included. The most convenient and economical access to Longhi's work is provided by the reader *Da Cimabue a Morandi*, G. Contini, ed., Milan, 1973, published by Mondadori in the series "I Meridiani." It contains a generally well-chosen selection of his articles, along with full texts of the three monographs; all the works are presented without their original illustrations and notes.

42. See for example Longhi's rejection of the art-historical construct of Mannerism in favor of Vasari's non-programmatic term *maniera*, in CC, p. 82; also his opinion that Riegl "makes excessive use of the negative concept of 'anti-Classicism'" and his negative judgment on Wölfflin's "rigid scheme of Italian classicism," both in CC, p. 59. A good instance of Longhi's rejection of sweeping but ultimately undemonstrable generalizations about history is the essay "Arte italiana e arte tedesca," AI, pp. 3-21. Written in 1941, at the height of the period during which the Fascist and Nazi governments were busy propagating nationalist mythologies, it subtly but firmly expresses Longhi's dissent from notions of "national spirit" and of the *Zeitgeist*, reformulating the problems associated with such concepts exclusively in rational terms of local traditions. (Such essentially mystical ideas had, of course, been a notable feature of Wölfflin's 1915 *Kunstgeschichtliche Grundbegriffe*, later translated into English as *Principles of Art History*; Longhi's disagreement with Wölfflin becomes explicit with his mention of the elder historian on page 13 of the article.) Despite the whiff of brimstone suggested by the very fact of its having been delivered as a paper at a scholarly conference held in Florence in 1941 on the topic, "Romanità e Germanesimo,"—a politically charged theme which it does indeed take as its point of departure—Longhi's essay on "German Art and Italian Art" nonetheless manages to remain an outstanding example of critical precision and wide-ranging erudition.

It should be noted that, in contradistinction to Longhi's lifelong rejection of overly neat *historic* schemata, he had at the outset a strong interest in the *aesthetic* categories posited by Hildebrand, Fiedler, Berenson, Wölfflin, and others. (Cf. note 25.) Their influence is apparent in the theoretical model elaborated in such early works as the *Breve ma veridica storia...* and

the "Piero dei Franceschi ...," both of 1914 (the year before Wölfflin published his own fully-developed system in the *Grundbegriffe*); although Longhi continues to rely on this model to some extent down through the monograph *Piero della Francesca* (1927), it rapidly yields thereafter to a more purely empirical method of description.

43. H. Wölfflin, *Classic Art*, London, 1968, p. xii.

44. D. Levi has shown, in *Cavalcaselle*, Turin, 1988, that the great nineteenth-century connoisseur relied upon his collaborator Crowe to write up his findings for publication.

45. Berenson bridges only partially the traditional dichotomy between the connoisseur and the eloquently "literary" art critic. His cool and formal prose is certainly equal to any task of exposition; one has only to think of the brilliant discussions of "tactile values" and "functional line" in his *Florentine Painters of the Renaissance*. But even where he closeiy engages individual works, as in *A Siennese Painter of the Franciscan Legend*, he neither achieves nor aspires to feats of evocation or effects of sheer linguistic virtuosity comparable to Longhi's; as we have seen (cf. note 1), he in fact rebelled when the youthful Longhi attempted to perform such feats for him.

46. Cf. P. Rosenberg, "Longhi e il Seicento francese," in PRE, pp. 209-218.

47. The contemporary connoisseur Federico Zeri says that Italian culture "is basically a courtly culture, a verbal culture of rhetorical rhythms, at which Longhi was a master" (quoted in M. Boni Castellotti, op. cit., p. 21).

48. For the "period" elements in Longhi's thought, see above, notes 16, 30, and 35. The "belatedness" probably has something to do with the decidedly provincial and peripheral nature of Italian culture during Longhi's formative years.

49. Since sweeping generalizations are dangerous, it is worth noting that recent years have brought us some important books on Italian art based entirely upon careful and sensitive looking. Two examples are P. Hills, *The Light of Early Italian Painting*, New Haven and London, 1987; and S. Alpers and M. Baxandall, *Tiepolo and the Pictorial Intelligence*, New Haven and London, 1995.

Masolino and Masaccio

Translated by David Tabbat and David Jacobson

A detailed account of the burning issue that Milanesi[1] called "the most important in the history of art" would constitute, once its implications were grasped, a prime case-study in the development of the critical methodology of our field, from Vasari down to the present day. It is a task some young scholar might undertake, for the benefit of all his colleagues. But the present essay, having a different purpose, can at most hint at some possible points of departure for such an enterprise. It will suffice if my study reminds the reader of the principal events in the question's history, as they have recently been set forth by Professor Salmi.[2] If anything, I would emphasize even more strongly than he does (here I go, already taking sides!), the incontestable fact that, though Vasari's neat, pellucid distinction between what is the work of Masolino and what is the work of Masaccio in the Brancacci Chapel may have been obscured by the indifference of critics during the two centuries following Vasari, it was never wholly forgotten. It survives in the pages of Lanzi and Rumohr, written in the late eighteenth and early nineteenth centuries; and it is taken up again with renewed energy towards the middle of the last century, first by the troop of Tuscan archivists, then by the pure connoisseurs – Morelli, Frizzoni, Richter, Wickhoff, Venturi – reinforced by those young warriors Berenson and Toesca: all spurred to fierce action against Cavalcaselle's[3] extraordinary, astonishing mental aberration, and still more against his defenders, almost all of them Northern: outstanding among the latter are Schmarsow, notable for his serious sense of mission and for what I am tempted to call his investigative sufferings; and Van Marle, active until just yesterday, and conspicuous above all for sloppy superficiality. Though the energy of the two armies may sometimes flag, there is still, so far as I know, not the faintest sign of a truce in the offing. Victory belongs to no one as yet; and some new arguments are long overdue, in order to bring matters to a head. This is the sole reason for the present essay, which is certainly not prompted by the desire (so common in our ranks) to earn for its author the obligatory quotation in discussions of the great issue.

* * *

When modern critics have taken up the question of the Brancacci Chapel, they have surprisingly neglected (apart from various vague and ineffectual lamentations) to study and meditate on the written and visual records pertaining to those portions replaced during the restoration of the vault and the two large lunettes in the eighteenth century. And yet, in the light of recent technical reports,[4] such research appears more urgent

than ever, since it seems all hope of recovering any trace of the originals must be abandoned.

At this point, one should reread the passage in Vasari – and do so with the correct punctuation of the first printing (1550 edition, p. 279) – concerning the sections executed ("with the greatest diligence") by Masolino: "as in the vault containing the Four Evangelists. And Christ calling Andrew and Peter from their fishing nets: Masolino painted him bewailing his sin of denying Christ, and after his preaching to convert the people. He made the stormy shipwreck of the Apostles, and Saint Peter freeing his daughter Petronella from evil. And in the same story, Peter and John going to the Temple." The inference immediately arises that, had the *Calling* and the *Navicella* survived, then these two major compositions, which once initiated the cycle in the main lunettes of the long walls, would surely have afforded us a clearer understanding of the following frescoes as well; especially the story of *Tabitha and the Cripple,* long a special bone of contention in our never-ending historical conflict.

With no better proof than their own imaginations, the "Masolinians" take Vasari's passage as a basis for telling us right away about the important role the maritime background must have played in both these lost scenes; citing a Masolino who was an "expert in seascapes," they reconfirm the title of "landscape painter" earned by the artist as early as the Castiglione d'Olona frescoes.[5] It is obvious: the scenes must be by Masolino! To which Schmarsow's ghost would reply that subject matter does not predetermine treatment, and that Masaccio would have been equally able to batten down all those maritime details, just as he did in the *Tribute Money* episode, where Saint Peter looks for his change in the mouth of a fish: subject matter that, in Masolino's hands, would undoubtedly have formed the focal point of the episode. Things are not all that simple then! Both lunettes may well be the work of Masaccio.

There's no denying that, hypothetically speaking, both sides might be right. But isn't it possible to go beyond mere hypotheses and uncover the facts that tip the scales? I think so, at least for one of the two great scenes now lost to us, namely the *Calling.*

It just so happens that I have known, for over twenty years, a painting which has always struck me as a faithful copy of the lost *Calling of Andrew and Peter* in the Brancacci Chapel (and perhaps I have shirked my duty by not presenting it sooner). Until quite recently, one could examine this painting in the celebrated Giovanelli collection in Venice,[6] where it bore an unspeakable attribution to Gerolamo da Santacroce; and one might find it cited, with no further comment, by N. Barbantini, in an article on that

Pl. 14

Pl. 4

collection in an issue of *Emporium* dating back many years, where the reproduction of the picture might have offered all manner of edification to anyone who cared to seek it.

This small panel, about 30 centimeters wide by 20 centimeters high, Pl. 15 displayed a chequered gilt background, like some evenly patterned false mosaic; but, far from betokening the era such a practice would suggest, it betrayed in countless ways – above all in its faithful reproduction of an earlier style, such as can be achieved only in times of a certain historical and philological self-consciousness – a quite later date, presumably already safely within the eighteenth century.

These elements, wholly exempt in this case from those intentions of disguise or simulation that later came to be used, for commercial ends, in concealing the replacement of an old original in some collection or church, suggest that this copy, scarcely less legible than a modern color photograph, could only have been intended as a record, meant to preserve the memory of a celebrated work on the brink of being destroyed or hidden: the record, therefore, of a fresco rather than a panel painting. This supposition is confirmed by the sheer expansiveness of the compositional plan: even on first examination, it conjures up an idea for a mural, rather than the narrative minuteness of a predella.

And within the brief chronological period the painting faithfully evokes – the first decades of the fifteenth century – stylistic factors point with certainty to a fresco by Masolino rather than by any of his fellow practitioners of the "poetical" style, such as Gentile, Pisanello, or Sassetta. It is true that nothing survives of Gentile's mural cycles;[7] but he did undoubtedly manage, even as a mural painter, to suffuse everything with his dense and precious palate, so reminiscent of polished enamel. The same may be said of Pisanello; in his case, however, the range of colors is pink and blond, save only for the somewhat deeper chiaroscuro of the figures. As for Sassetta, apart from the fact that he resorted only very rarely and belatedly to chiaroscuro, here there is none of the constant, inimitable relationship one finds in his work between captious formal observations and ecstatic attention to the setting. Rather, everything speaks to us here of Masolino's idea for a mural – perhaps the greatest such idea he was to bequeath us.

His is the peaceful coexistence between action and spectacle, with indeed a certain prevalence of spectacle over character. His is the concept of a vast but poetically imprecise space, a space in vacillation, eternally inexplorable, which here opens out with a surge into the great ocean bay of the *Calling,* just as it does at Castiglione, in the delicate encircling

mountain chain of the *Baptism of Christ*. More particularly, his is the modulation of the gently worn, eroded shore, and as we already know from the landscape in Palazzo Branda at Castiglione, his is the sinuous

Pl. 14

tracing of paths that, winding away from the gates of some orientalized Tuscan city, a sort of Lucca- or Pisa-Capharnaum, slowly, sluggishly fade away as the sand progressively buries them. His, too, are the gently bulging mountains, curving as do the hills around Rome in the episode in Santa Maria Maggiore. Let us slyly get ahead of ourselves in order to add that, exactly as in the fresco of *Tabitha and the Cripple*, center stage is empty of action and functions as a caesura, serving at once to split the composition in half and to unite – in accordance with Saint Luke's text – the miraculous catch of fish with the two Apostles' definitive acceptance of Christ's call. We will thus have said enough to make it clear that, if this little painting does indeed faithfully follow a story in a cycle by Masolino on the life of Peter, this cycle must certainly have been the one in the Brancacci Chapel, regarding which Vasari precisely cited the opening scene as "Christ calling from the nets" not, be it noted, Peter and Andrew, as stated in the texts of Matthew, Mark and Luke, but precisely "Andrew and Peter," which is the order of names in the Gospel according to John.

At this point, the only ostensibly valid objections to be made would be that the panel is not, proportionally speaking, so wide in relation to its height as are the scenes of *Tabitha* and of the *Tribute Money*, and that the gold background does not suggest derivation from a fresco. But these objections prove to be significantly interrelated. From Vasari's descrip-

Pl. 4, 6

tion, which cites the *Calling* and the *Navicella* as being very near the vaulting, we deduce that both compositions also filled the area of the two large ogival spaces, so that the scene, in the original, had to be higher and thus tilted more sharply towards the picture plane than the scenes below them. From this it may be inferred that the copyist, trying to accommodate himself to the shape of the panel he was working on, disregarded the upper part of the field, occupied by a uniform sky, and made a rectangle that was, proportionally speaking, higher than the scene below it. As for the gold background, it is likely that the copyist wrongly interpreted, and so falsely "restored," the red underpainting laid bare when the ultramarine in the upper part of the scene flaked off in the usual way; that is, he took it to be the preparation for an original gold background which had never existed; while the hint of mosaic tessellation also hints at derivation from a wall composition.

Yet another element in support of my hypothesis can be deduced from the surviving frescoes; more specifically, from the relation between their

narrative sequence and their arrangement of light. For a person entering the chapel, the narrative moves (if one follows the sequence of the textual sources) in the normal direction of writing: from left to right, and from top to bottom. Take as examples these sequences: the *Tribute Money* and *Tabitha; Saint Peter Enthroned* and his *Martyrdom*. It follows from this that the *Calling*, being the opening scene, must have been situated above the *Tribute Money;* and thus, even without knowing about the copy, we should have been able to assert that, for reasons of optical unity (probably suggested to Masolino by Masaccio, as we shall see), the light had to come from the right, as in the *Tribute Money* and the *Saint Peter Enthroned* (while the facing frescoes receive their light from the left), given the prevailing naturalistic fiction of a light streaming from the central window. Now, the rediscovered panel most definitely reveals this very choice of lighting, exactly as we might have foreseen: an excellent confirmation that what we are looking at is indeed a faithful copy of Masolino's *Calling* in the Brancacci Chapel.

Masolino's? Or, here too, as Cavalcaselle and Schmarsow would have hastened to correct us, Masaccio's? I think not; because, as I have asserted, getting ahead of myself, the highly accurate copy insistently reveals to us traits of landscape and staging which, even more than the *Tabitha* and the *Saint Peter Preaching*, link it with Masolino's undisputed works at Castiglione d'Olona, thus assuring us that the idea set forth in the *Calling* is basically Masolino's: so that even the admixture to this base of a slightly acidic Masaccesque chiaroscuro (not enough to produce any true, authentic "salt of the earth") can be readily explained as the influence of the younger artist on the elder, rather than as his actual manual intervention. Even without some sense of Masolino's temperament, it is conventional wisdom to remark that a forty-year-old man is taking a risk by wearing "shorts" or overalls, or by trying out some new fashion trend which stands, alas, in woeful contrast to his ageing features; unlike a young man, who has learned to conduct himself in a certain style (rather than fashion), and who truly inhabits that style, knowing nothing of the past – least of all, of the recent past.

* * *

This seems the appropriate moment to address the underlying opposition between Masolino and Masaccio, and its effect on our understanding of their possible points of contact.

Lest it seem that I am merely marching along behind the better-

drilled troops by roughly following the distinction Vasari makes between Masolino and Masaccio in the Brancacci Chapel, let me tell my comrades-at-arms right away that I have never found their fighting methods convincing: it is useless to shrug one's shoulders and flaunt one's scorn for Cavalcaselle and Schmarsow, if one is merely going repeat their selfsame theoretical errors, including those regarding stylistic analysis or their interpretation of the documentary sources.

Let us take the theoretical error first. Masolino, the elder artist, is a "naturalist:" Masaccio, the younger, is a "naturalist:" so nothing could be more logical than that a bridge should exist between the two, and the toll for crossing it can be paid only by the younger artist to the elder, and not the other way around. Incredible as they may be, these commonplaces of the old-fashioned biological Positivism, with its belief in "progress," bear upon the question more than one might think; in the present instance, they are exacerbated by discussions of the relationship between a supposed master and a supposed pupil. On the subject of the Castiglione *John the Baptist Preaching,* Toesca wrote in 1908 that Masolino "grasps and interprets, down to the subtlest temperamental differences, the human nature that falls under his gaze; so vivid is his delight in objective reproduction of the real, that he may well be numbered among the pioneers of the new naturalistic art of Tuscany." Here, however, the real issue is precisely what it was that fell under Masolino's gaze. It is true, of course, that the error thus revealed risks being perpetuated when the question is posed, in inverted form, by the pedants of Idealism: not when it comes into the hands of observers more respectful of the concrete individuality (at once idealistic and subjective) of specific artistic achievement. It is at this point that Masolino's and Masaccio's "naturalisms" look like two "idealisms," as opposite and distinctive as the manifestations of alleged "naturalism" in their respective artistic personalities. Thus, to confuse the resplendent sequence one finds in Masolino – a sequence of details, a world wholly melodious and varied in its coloration, its "Nature" being that of a late-Gothic illuminated manuscript, a florid, lively Gospel, a courtly Genesis set in a light-filled and imprecise space – with the Masaccesque understanding of "Nature," of life as a grave and serious matter, a daily drama of forms and gestures set in an inconfutable space, under a raking, practically accusatory light, is to indulge in a confusion so basic that it would seem to deserve nothing so much as pity.

This error might have been avoided had early consideration been given to Masolino's cultural and aesthetic background. Those who recognize only that, being an authentic artist, he burned his bridges to the artistic

practice then current in Florence, characterized as it was by the arid grammar of artists like the Gerini and Agnolo Gaddi, and that he resisted even the lure of that purely linear elegance, tinged with exoticism, imported into Florence at the start of the century by Starnina and soon brought to its peak in the cold calligraphy of Lorenzo Monaco – those who recognize only this much still risk going astray when they try to describe his "naturalism." Even the clearer perception (the work of Toesca above all) of the relationship between Masolino and the "International Gothic" manner – exemplified by Gentile da Fabriano, the Sanseverinati, the Burgundian miniaturists – failed to produce the progress it should have. From Courajod on, no one managed to grasp (despite Jacques Mesnil's moving efforts) that there could be no such thing as a "transition" between the radiant, alert, fastidiously courtly world of the International Gothic and that other world of plastic and moral *virtù* inaugurated by Masaccio. Anyway, the comparison between Masolino and the others remained vague, and the profound differences within that "cosmopolitan" language (the only term for which we are at all indebted to Van Marle) had yet to be elucidated. How many times has one heard the Sanseverinati spoken of as folk artists, when in fact they must have been nurtured upon the most polished examples of French tapestry of the second half of the fourteenth century? Or heard Gentile spoken of, with civic pride, as the last off-shoot of the tradition of Nuzi and Ghissi,[8] when he must instead have bloomed in the hothouses of the secular miniature art of Lombardy, in the period of Giovannino de' Grassi? Whereas for Masolino, no one has gone beyond remarking that vague affinity. It is significant that he should be the only one whose explanatory caption in Berenson's indexes[9] contains no genealogical account, indeed remains entirely blank. Perhaps this is because the high level of Masolino's art, offering itself to us already in a state of completeness, has eluded overly schematic study. It has been necessary therefore to measure it anew, using a broader gauge, capable of registering his gift for meditating on and assimilating a Trecento that – however stupendously it spoke from certain walls in Florence – was not wholly Florentine or even Tuscan; so that, despite his profound spiritual affinity with [the anonymous artist known to us as] "Giottino," and except perhaps for some rare stimulus afforded him by the brilliant and nuanced chromatic intensity of Nardo di Cione, he passed unscathed by the dry, narrow-minded mentality of the Orcagnesque and Agnolesque drawing instructors.[10]

So the tradition in which Masolino was nurtured must have been, I would suggest, a more worldly and modern one, one he might have

found in Florence in the works of Giovanni da Milano:[11] an artist whose largely extra-Florentine significance and whose initial connections with the lovingly empirical naturalism of Trecento Padua, from Vitale [da Bologna] to Tommaso da Modena, are still insufficiently understood.

Even without going into the particular cultural situation of this great artist, one whose thinking was still developing as late as 1370 and possibly even afterwards (that is, no more than thirty years before Masolino was trained), we need only reconsider without preconceptions a work of his like the *Pietà* in the Martin Le Roy collection, in order to concede that Giovanni's spiritual anticipation of Masolino, of the anonymous painter usually given the name of Malouel, or even of Sassetta, could not be clearer. Here everything hints closely at that web of delicate truths, verging on indiscretion, that so stings us in the art of Masolino and Sassetta: the delicate illusion, almost carnal in its treatment of intimate matters, of, shall I say, the most private emotions, which are nonetheless set forth as though in an invaluable, nearly scandalous document; the extremely true-to-life quality of a rare, yet familiar, even homely sentiment, bordering on affectation, as in the downy, sweating skin of Christ, that frail child who should never have been born, and in that gesture of the Virgin's, betokening her nobility. A significant recurrence of this sensibility may be seen, for example, in the Casa Serristori *Pietà* in Florence, variously ascribed to Sassetta or to some anonymous follower of his,[12] but in any case situated at the exact juncture between Sassetta and Masolino, under the old constellation of the great fourteenth-century Milanese painter.

And as for Sassetta's cultural background, anyone accustomed to speaking in this connection about [the Siennese Paolo di Giovanni] Fey or even about Pietro Lorenzetti should consider whether it might not be more useful, for example, to make a simple comparison between the detail of this intense *Christ the Judge,* with its almost malign characterization – the work of Giovanni da Milano – and that made by Sassetta in around 1423-26 for the altar of the Chapel of the Wool Guild.

And why do those who seek in Burgundy and Brabant the source of Masolino's profane additions to sacred scenes forget so easily the fashionable coxcomb, with suede gloves and miniver lining, introduced many years earlier by Giovanni da Milano into a religious fresco in Florence, the *Christ in the House of Martha* in the Rinuccini Chapel?[13] How forward-looking the smooth, relaxed manner, the soft handling of color, the intense and continuous gradations!

Another typical case that argues in favor of my hypothesis is the *Saint Francis* in the museum at Bordeaux; ascribed to Sassetta (but having

Pl. 17

Pl. 18

no more to do with him than with Masolino) in Berenson's lists, but correctly restored to Giovanni da Milano by Professor Richard Offner and subsequently also by John Pope-Hennessy.[14] That a work of such wearily mystic elegance could be dated nearly a half century too early, with practically no alteration in its inner meaning, strikes me as pretty good proof of how far-reaching Giovanni da Milano's aims were and of where, precisely, he was headed.

It is this harmony between sacred and profane poetics, already present in Giovanni da Milano, and inherited by him from Giusto de' Menabuoi, that seems to flower afresh, with new personal inflections, in Masolino and Sassetta; and it is just this which sets these painters apart from the more intense secularism of a Gentile [da Fabriano] or a Pisanello. Now, might a similar definition ever be applied, even by extension, to Masaccio, creator of a humanity that (for all that it is indeed contemporary) is fierce, peremptory, brimming over with the single, fundamental sentiment of an intense will to action; a humanity certainly not given to complacent observation, to dreaming of some chastened happiness while staring down at its own fingernails? Is it really just by chance that one artist bears the affectionate nickname Masolino – "dear little Tommy" – while the other, Masaccio, is known by a pejorative denoting irritation and pessimism: "big, rude, clumsy, hulking Tom?"

* * *

And yet, the collective objection will be raised, there remains the incontrovertible fact that Masaccio was Masolino's pupil. Assuming this to be so, the question arises whether an external factor such as having been someone's pupil, a factor reflecting only a difference in age, is enough to leave indelible traces on the pupil's mental formation. There are plenty of teachers who, when a youth is taking wing and flying far beyond the flock, hastily re-examine their records in the hope of being able to exclaim – "But he was my pupil!" – and mightn't Masolino have been one of them? To tell the truth, there is no reason to suspect him, since no writer before Vasari ever said that Masaccio had been a pupil of Masolino's in the first place. And as for Vasari himself, why is it, after all this time, that people still haven't managed to read him properly?

In both editions of the *Lives,* Vasari in effect says that Masaccio "began to work at the time when Masolino da Panicale was engaged upon the Chapel of the Brancacci in the Carmine at Florence, and he followed as closely as possible in the footsteps of Filippo [Brunelleschi] and

Donatello, although he practiced a different art."

What we have here, then, is the precise opposite of an affirmation of discipleship, as the comma between the two propositions is clearly adversative, signifying a vigorous "but." Yes, that it to say, Masaccio did indeed start out as a painter when Masolino was at work on the Brancacci Chapel (i.e., alongside him, on the very same work), *but* (that is, contrary to what you might expect) without showing the least affinity with his elder colleague; *on the contrary,* he followed as far as possible his true masters, Brunelleschi and Donatello.

It couldn't be clearer. And yet one already finds the false inference in Borghini, who wrote just a few years after Vasari; it may be that the notion draws additional support from the vague and confused praise Vasari added to the second edition of the *Life of Masolino,* where he unfortunately sketched out his principle, as celebrated as it is antihistorical, of the "transitional style," to which he claimed the artist belonged. Borghini's statement is repeated by Baldinucci; after that, it takes stubborn root in modern criticism. Naturally, it is always touching to return to the cautious, tactful observations of Cavalcaselle (among the least academic echoes of this criticism) regarding the analogy he believes to exist between the case of a still Masolinesque Masaccio and that of a still wholly Peruginesque Raphael. The analogy does not hold good, however; for it is one thing for Raphael to purify into sublimity linguistic constructions already in use, a labor that is always a matter of historical filtration; and another thing entirely for Masaccio, quite on his own, to make innovations in art, and perhaps not only in art.

And if collaboration with Masolino was, for Masaccio, no more than a matter of practical convenience, it doesn't follow that the same goes for Masolino's attitude towards Masaccio. Instead, to me it seems that his intellectual curiosity regarding every new occurrence could not help but include an interest in the latest artistic doings, in the newest pictorial styles. And what innovations were more amazing than those of Masaccio at the Carmine? Masolino must have deluded himself into thinking he could capture something, were it only a shadow, of Masaccio's dramatic concentration; not understanding that this quality came from something within Masaccio – I would say, from that little Brunelleschian piazza that Masaccio had built in his mind – nothing one could just fix on a surface with a little earth, shadow and some converging perspective lines. And yet this self-delusion was at the origin of Masolino's extraordinary Masaccesque adventure, which was to last roughly five years; while no corresponding adventure on Masaccio's part ever took place.

For if ever an artist sprang fully armed and fully defined from the head of painting, it was Masaccio. Thus, it would be meaningless to attempt to write any pictorial prehistory for Masaccio; and it is, in fact, high time that we say how little sense it makes to ascribe to him the wretched, ill-begotten fresco of Montemarciano.[15] Sense there is, however – and plenty of it – in citing intellectual precedents in Brunelleschi's space and a certain vitality of growth in Donatello. Vasari might immediately put in, "although Masaccio practiced a different art." We may further emend Vasari's text today to "precisely because his art was identical to theirs."

From the start to the finish of his work on the Carmine frescoes, Masaccio's spirit matures enormously, surpassing only itself, growing "without scaffolding," comparable in this only to Brunelleschi's nearby dome; and this caused the greatest wonderment among the Babelic workmen of Florence's Duomo, and the scarcely less Babelic workmen who labor in the History of Art.

* * *

But I have no intention of evading the objection that many will make to me at this point. On the contrary, I have actually been seeking out such an objection, since it offers me a way of pointing up, after the theoretical and heuristic errors, a further error in the area of stylistic definition. The objection is likely to surface when we come to the *Madonna and Child with Saint Anne,* formerly in Sant'Ambrogio in Florence, and now in the Uffizi.

This picture has always served as everyone's irrefutable proof of Masaccio's apprenticeship under Masolino, an apprenticeship characterized by an emulation of his master so humble and pious that for Lindberg (and a fine way of testing things this is!), there is no point in trying to distinguish where the handiwork of the master ends and that of his pupil begins. In other words, it is supposed to be a collaboration as complete, as inextricably unified as, say, that of the the French Gothic stonemasons. And yet, the crux of the famous dispute is to be found entirely within this work, in the reluctance, that is, to "make distinctions" within it.[16] When Schmarsow, in an effort to show that the fresco of *Tabitha* is the work of Masaccio, turned for corroboration to the Saint Anne of this panel, it might be thought that anyone who contradicted him on this point was either willfully blindfolding himself or acting in bad faith. Thus, one cannot draw any conclusions about the Brancacci frescoes without having first drawn conclusions about the Saint Anne painting; and

to draw conclusions, one must once again make distinctions.

What if someone were to put things to the test once and for all, in the most ruthless fashion; say, by taking a pair of scissors to the photograph, to see if after dissecting it in this way, one could still speak of a "Masolinesque Masaccio" rather than of a "Masaccesque Masolino" – to use the tongue-twister so dear to our colleague Offner?

Well, here go the scissors; and they move more obediently than does a magnet drawn towards iron. Setting forth from the convincingly three-dimensional platform of the throne, they pick out the irrevocably seated group of the Madonna and Child, and then trim away the angel holding the first loop of the cloth of honor on the right, who is as round and geometrically precise as any in [the sculptures of] Nanni di Banco. All the rest: the Saint Anne, hoisted somehow or other against the invisible back of a throne, with a honey-sweet hand so gentle it interferes with the foreshortening; the two angels at the top and on the left; the two censing angels flanking the throne, weary of being flushed so pink and weary of their censer-swinging, yet not bold enough to be daubed with a new shadow or to twist the censer's small chain over their hands in any unusual way – these remain in the limbo of a Masolino who, like Belacqua [in Dante's *Purgatorio*], seems to implore Masaccio to stop it, please, to leave things well enough alone. What's the use of "forcing the shades"? Here begins the adventure of Masolino, made Masaccesque by his willingness to accommodate his associate.

I think it is possible to demonstrate that this willingness on Masolino's part is not entirely of our own imagining, by making another observation, also new (unless I am mistaken). The relative positions of the main figures' haloes, and the notably larger dimensions of Saint Anne's, serve to prove: first, that the original plan must have called for a vertical organization, from the top to the bottom of the picture plane, as was common in fourteenth-century examples of this subject;[17] second, that Saint Anne was originally allotted the place of main protagonist. And since we cannot imagine that Masaccio would have wanted to conform to such a compositional plan, we must simply deduce that the instructions given to the gilder, which obviously predetermined the compositional scheme, were given by Masolino, who was thus the one who had actually received the commission for the painting; just as (in this very same period, I believe) he was entrusted with the work of the Brancacci frescoes. A *Virgin with Saint Anne* by Bicci di Lorenzo, dating to around 1430, excellently testifies to the way in which Masolino would have intended to arrange the composition. The placement of the haloes and their respective dimensions are the same as

those in the Florentine painting, but, in accordance with tradition, Saint Anne is seated in a manner befitting the most important figure; the Virgin, a tiny adolescent girl, sits modestly at a lower level, practically slipped in between her mother's knees. How Masaccio – here, too, Masolino's independent assistant and not his pupil – could have had a hand in the details of the Florentine painting is something better suggested than related in detail. To judge by the rather awkward accommodation that Masolino is constrained to devise for the figure of Saint Anne, placing her (worst of all choices) in the middle distance, as though he had found the place traditionally reserved for her already occupied, and diminishing the size of her head while retaining its canonically largest halo, the most obvious proposal one can make is that Masaccio, with undeniable arrogance and in full disregard of the original instructions, immediately set to work on the group of Mary with the Holy Child; thus leaving the elder artist to make do with the remaining space, except where the young master showily added the first angel on the right.

That this extraordinary turn of events also marks the first "public" appearance of Masaccio's art is evident from the fact that, once the portions by the two artists have been isolated, Masaccio – already showing himself to be highly innovative – seems to go at his innovations with an almost childlike enthusiasm, as though transferring for the first time the most important lessons of Brunelleschi and the newer sculptors into painting. Of the grave outline he diligently establishes for the group of Mary with the Child, one can only say that it expresses an architectural, Brunelleschian outlook; upon close inspection, this contour is seen to be not "pyramidal," as is often claimed – after all, neither Masaccio nor Brunelleschi was Cheops's court architect – but rather, wedged into a rib vaulting which, as it turns, grows ever "more magnificent and expansive" as in [Brunelleschi's] famous [Florence Cathedral] cupola of this same period. Elsewhere, as is always the case at the outset of a genius's career, the young artist seems to offer up, at least in hints, all the possible variants of his formal thinking, for others to work out in detail at a later date. A certain harsh linear emphasis in the face and in the white drapery over the Virgin's shoulder proposes ideas that artists will eventually draw upon, [Fra Filippo] Lippi, for instance, in around 1435 and Castagno still later; the power of the Virgin's flexed right-hand wrist is a distant anticipation of the ideas of "anatomists" like Michelangelo; in the Christ Child, the solidly formed yet flexible masses of the limbs mysteriously manage to evoke the Dionysus of the Parthenon, thus prefiguring Piero's unwittingly archaic figure-types; the nearly desperate effort to bring perspective into

the slightest details, into the eye sockets of the Child, for example (which, fully modeled as they are, yet droop softly), will be taken up again by Paolo Uccello in 1443 in the heads for the Florence Cathedral Clock, and even in his later works. We have mentioned the angel on the right; here one can only add that, in the well-proportioned purity of the neck-line, in the calculated inclusion of the head within the circle of the halo, in the abrupt cropping at the waist, in the rapid, prehensile gesture, a clean break is made with the languid, melting angels of Masolino; at the same time, though, Masaccio nonetheless reveals here – unexpectedly, unrepeatably – a spiritual affinity with Ghiberti, with Nanni di Banco and the youthful Fra Angelico; an affinity plausible only at the moment when he "begins to practice" his art.

Pl. 21

As has been pointed out, Masolino shows, in his contributions to this work, a sort of timid deference to his young assistant, of which there had been no trace just a short while earlier, in the *Bremen Madonna,* bearing the very useful date 1423; whereas in the first Brancacci Chapel frescoes, put by the most careful chronologists at around 1424, we find him working in the same manner – one which suits him ill – as in the *Saint Anne,* which may accordingly be dated to this same year.

So we find ourselves at the start of work on the Carmine Chapel, where Masolino's adventure will continue; and we must follow it in detail.

* * *

We may conclude that Masaccio was working alongside Masolino, as an independent assistant, right from the start of the Carmine frescoes; not only on the basis of our more careful reading of the passage from Vasari, with its "when" referring at least as much to place as to time, but also from the fact that, once again according to Vasari – whose distinctions within the famous cycle appear increasingly unimpeachable – Masaccio not only insinuates himself (as Professor Salmi has very aptly said) among Masolino's paintings in the middle register, with the *Baptism of the Neophytes,* but has previously figured in the uppermost register as well, with the minor episode of *The Resuscitation of the Dead:* an Act which, coming in the story after the *Denial of Peter,* must have been situated to the right of the large window, in the space already made irregular and partially curvilinear by the proximity of the vault.

It would be pointless to force any inference about the appearance of that missing composition; we will do better if we confine ourselves to suggesting that its characteristics matched those found in those portions

of the *Saint Anne* panel which we have just singled out for attribution to Masaccio. Yet we have already come upon an echo of Masaccio's presence on this level of the scaffolding – a level we would be wise to study closely, as it crops up in every work of mural decoration in this period[18] – in the form of the slightly strained chiaroscuro and drama Masolino brings to his great vision of the sea in the *Calling*, restored to us through the Giovanelli copy already discussed. Following our arrival at the distinction in the *Saint Anne,* we can here repeat with firmer emphasis that this is not Masaccio himself, but just a tincture of him, adding just a touch more density to Masolino's running water.

Pl. 15

Pl. 3

An independent collaborator when he managed to appropriate a part of the cycle for himself, an irritating mentor when the elder artist was trying to get on with his work: so Masaccio must be imagined during the initial phase of the painting of the Carmine Chapel. Endless suggestions, peremptory declarations of principle and, for all one knows, even rebukes and threats. It seems safe to say – the extraordinary yet practically documentary *Saint Anne* painting is there to bear us out – that on the scaffolds of the Carmine there must have resounded dialogues, perhaps even noisy arguments, that were among the most decisive that any historian can imagine (and after all, a little imagination isn't a bad thing in an historian); in certain respects, a resumption of discussions that had gone on more than a century earlier, on the scaffolding of the Upper Church at Assisi, between Cimabue and Giotto (though my American colleagues might wish to emend the latter to read "the Isaac Master").[19] Baldini was on the point of giving a by no means crude literary approximation of these earlier debates back in 1919, in the magazine *la Ronda;* it is a pity he shifted the scene to an inn in the [Tuscan region of the] Mugello.

Perhaps Masaccio spoke, categorically and incomprehensibly, of a return to Giotto; and Masolino answered by telling him of an extremely old uncle who had been acquainted with Giovanni da Milano, or, who knows, by going on about his first journeys to the courts of Lombardy, where he had heard in the piazzas the last of the Franco-Veneto minstrels. Masaccio retorted by driving a nail into the wall, the better to drive home Brunelleschi's spatial doctrines; and Masolino, after having studiously ignored him, finally said: just draw me the perspective grid, and I'll put in the figures. Whereupon Masaccio made gestures of desperation.

Meanwhile, the uppermost register having been finished, the scaffolding was moved to the middle order.

* * *

Pl. 19 The second group of frescoes comprises *Peter Preaching to the People*,
Pl. 5 the *Baptism of the Neophytes,* and the two largest sections: one with two
 evenly balanced episodes to either side of the center (a sure sign of
Pl. 6, 20 Masolino's presence), showing respectively *Peter Raising Tabitha* and *Peter*
Pl. 4 *Healing the Cripple;* the other depicting *The Tribute Money.* Here, too, a
 sincere and unbiased investigation, while it may not profoundly alter
 Vasari's excellent distinction, can still usefully take us a step farther along
 the road than have the long and strenuous labors of the "Vasarian" brigade.

 For example, if we consider nothing more than the moral relation-
 ship between the actors in *Peter Preaching to the People,* there is still a very
 vivid contrast between the crowd of listeners, curled up like fat, lazy cats,
 as though they found the gospel being preached a little too fantastic and
 apocryphal, and Saint Peter, who has anything but the air of a storyteller.
 A formal contrast sets the tone for this moral one. For if the extended
 arm and the head of Peter's sculptural, almost neo-Giottesque profile still
 allow us to admit that this is Masolino himself, striving to archaize,
 yielding to the obscure imperatives of his young mentor, one must recognize
 that the rest of the figure, of a classical, stately solidity, extruded in a sud-
 denly more violent light, with feet finally planted on the solid ground, was
 executed by Masaccio. And unexpectedly, the three young hooligans in
 headdresses are also typical Masaccio types, presented – like precisely cal-
 culated fixed points in an ever-changing spatial arrangement – the first in
 profile, the second in three-quarter view, the third frontally; their surly,
 modern temper well suits that tragic, anti-bourgeois irony that Masaccio
 seems to express so incomparably even on occasions which struck other
 artists of his time as high-spirited and decorative: for instance, in the sul-
 lenness of the hired musicians called in for the festivities in the Berlin
Pl. 30 *Desco da Parto.*[20] The grave ethical tone aside, Masaccio creates, in these
 three scornful listeners, a powerful, elastic outline akin to that in his
 youthful Gardiner portrait,[21] and provides a foretaste, as in certain portions
Pl. 3 of the *Madonna with Saint Anne,* of the dynamic "line" of Lippi and
 Castagno.

 Apparently, then, work was moving along quickly. Hard by, in the
Pl. 5 *Baptism of the Neophytes,* Masaccio seems all at once to create the sense of
 a rapid and total circulation of light within an apparently free composi-
 tion; a composition, indeed, whose freedom is by no means without ele-
 ments of improvisation which take their cue from Donatello. That this,
 too, is an utterly novel impulse for Masaccio, though still rather crude in
Pl. 4 comparison with the *Tribute Money,* is evident from certain passages,
 above all from the much celebrated figure of the "trembling nude," still

bearing traces of a fourteenth-century spiritual prototype. In fact, Sassetta, just a few years later, was to find a use for it in the beggar at the foot of his *Saint Martin Crucifix* (1433).

Then too, as has been correctly noted by Professor Salmi, the figure of Saint Peter (much less successfully integrated into the whole, one might add, than the one in the *Saint Peter Preaching*) betrays the intervention of Filippino [Lippi, who completed the Brancacci frescoes]; but it must be pointed out as well that the two young boys (no longer young hooligans) behind the Saint, with their ineffective repetition of a nearly identical three-quarter view, are so detached from the rest of the scene – a scene modeled in a hard, direct light – as to arouse the suspicion that they are a deft interpolation of Filippino's, in an area that Masaccio had carelessly left unfinished, or had barely sketched out on the first, preparatory layer of plaster.

At roughly this same period (let us bear in mind, in fact, that the same scaffolding remained in place throughout the painting of this entire register), Masolino was able to turn his attention to the large bisected area with the two *Miracles of Saint Peter*. Here, too, it should be made clear Pl. 6 to what extent Masaccio certainly exercised a two-fold influence: first of all, he once more stirred Masolino's tender heart, leading him back to the neo-Giottesque, to a simpler kind of dramatic action; but also, he actually intervened personally, in order to compensate, by means of a solid spatial definition of the background, for the dangerous tendency of the terrain in the foreground to stand up straight against the picture plane.[22] One can have no hope of ever understanding anything about the art of perspective, if one is not struck immediately and forcibly by the profound contrast between the foreground, where the two porticos and the terrain ascend a gradient so steep as to be utterly incompatible with everything depicted in the scene, and the background, where the common tenements establish a novel vision of the cityscape, which one might call Pl. 20 neo-Romanesque were it not for the new certainty of the space: in the two cramped alleys, one caught in shadow, the other struck by the sun; in the house in the center, jutting out over the others; in the way the fixtures for hanging cloths in front of the windows turn slowly and precisely, coming to a halt at the vanishing point, set the exact center of the width of the entire fresco. This vanishing point, already studied by Mesnil, is even marked on the plaster by a perforation, still quite visible and undoubtedly made by a nail, from which, using a piece of string, the various converging radial lines were determined and drawn. And I will confess that, since the nail was surely driven in by Masaccio himself, and not Masolino,

I find it deeply moving.

Masaccio, therefore, – we may well be approaching 1425 – is still deep in his Brunelleschian phase, and busily searching for a perspective framework to provide certainty to his entire composition. It is utterly plausible that he should confine himself, for the moment, to achieving it on the margin of a fresco of Masolino's, shoring up as best he could the elder artist's relaxed and shaky sense of structure. And our conviction is strengthened when we note that even the small background figures, whether alone or in a group, have been carefully inserted with special additions of plaster, rather smaller than the *giornate* normally prepared for a continuous stretch of work. It is true that Professor Salmi thought he had noted in those parts a story-like treatment that could only be credited to the "garrulous Masolino." But this strikes us as a content-oriented bias, invalidated by the artist's feeling for the wretchedness and poverty of this Florentine day, spent for the first time within this novel space. Thus, not even the little monkey-figures running along the ledges, making the poles screech in their jambs, the humble bed-sheet hanging from the windowsill, the small cage or the small basket, can particularly surprise or distract us; and none of these things conveys to us anything save the grave mood of an uneventful late afternoon, with the old man holding forth, seated outside the door; the young boy in a tunic, choking down his resentment, rubbing his shoulder against the freshly-laid mortar of the block of houses; the burgher's wife, who on re-entering her house, leans absentmindedly against the shutter, and even the young child who, followed by a pious-looking, strait-laced aunt, whimpers and squirms because they're making him go to Vespers. Perhaps I have already gone astray, reading too much into these few observations of the artist's, here making their way into painting for the first time. What I wish to convey is that this is no enchanting but empty story, but rather the common life of every day: poor, naked glimpses of humanity, huddled near those high deeds of apostolic power (such as those of Saint Peter), which – at least to Masaccio's way of thinking – ought to have emerged into the foreground.

And because it is high time to say that in these main sections, Masolino failed in his intent, producing extremely poor work, full of howlers, fillers and plagiarisms (which in truth should have been enough to keep these passages from ever being attributed to the early career of a genius as wholly original as Masaccio), it is also right and proper to puzzle over the reason for the elder artist's serious failure, considering that it might also have had something to do with his inconvenient work partner. And, for that matter, think first of Masolino's untrammeled happiness in

the 1423 *Madonna,* and again of how that bliss returns in the frescoes of Pl. 21
1435 in the Baptistry at Castiglione. One is immediately prompted to say
that the period of Masaccesque terror had ended for him – even that it had
been erased from his memory. During the time he was painting the two
deeds of Saint Peter, however, that terror was at its height. Not that
Masaccio sinned in this regard, though he surely was to blame for the
terror. Masolino had still managed, like the Apostle himself, to survive the
waves of the *Calling* and the *Navicella.* But Masaccio, like Christ, was
waiting for him on the shore, and was not about to grant him a moment's
peace.

"Don't you think that if you made the space more definite, you'd
be able to join the two episodes, but keep them distinct at the same time?
Or would you really rather 'tell' all your stories in a single breath, like
Hail Marys on a rosary, and have Peter following Peter? You can get away
with that in the *Calling,* but only because it is two moments in the same
event. And by the way, have you ever noticed how Salome turns her back
on Salome in Giotto's scene in Santa Croce? Bring the sides of two build-
ings together at the center, and set the action near where they meet: you'll
see, it'll work like a charm. Meanwhile, I'm going to mark the mid-point
of the height for you with this nail: this is where the lines should come
together from both sides, the ones from the temple with the ones from the
house of Tabitha. And although I myself would set this nail rather low, for
you I'm going to drive it in at a good height, just so you can make your
figures smaller without any problems. The perspective will be pretty odd
– Brunelleschi would sneer if he saw it; but still, it will all more or less hang
together."

Even so, poor Masolino tripped up more than once in drawing the
lines of the temple, distorted the arches, pulled Tabitha's room forward
toward the center as though it were a chest being pried open, and, after
much effort, sent the two Peters out with a companion to do some heavy
patrolling: Peters who conspicuously turn their backs on each other, as
though they wouldn't even be able to recognize one another at sight.

The ground, meanwhile, kept giving way; and in order to reach it,
the legs of the Apostle kept growing longer and longer.

"A fine mess you've got me into! Now I have no choice, I've got to
fill in this middle area left over between the two stories. You say I should
put in a couple of youths, who just happen to be passing by. All right; but
then, was it really worth your bothering me with all that stuff about
Giotto and the Apostles' costumes and 'truthful dramatic action'?"

"I didn't say you had to put them in, it was just an idea. But it is true

that even modern figures will work in a narrative scene, just so long as they seem natural and don't look like they've been dragged in by force. As for costumes, do you want me to suggest one? I'm pretty sure people have always worn coats and caps."

But even here, Masolino got it wrong; so that there materialized, as though by magic, the two unspeakable young boys in fancy dress and headdresses, looking like patterns for the 1424-25 collection of some very fashionable Florentine couturier. Indeed, as proof of Masolino's mental disarray at this point, these two figures are so brazenly suited to some "society column" as to seem out of their element and anachronistic even in relation to Masolino himself; that is, in relation to his heavy-handed archaism in those two scenes where the old prophets, having practically stepped out of some stained glass window by Taddeo Gaddi (albeit with their wigs tidied), are trying to move about and act in a drama that is all pout and scowl. This, Masaccio must have said, was not the quality I meant by "truly modern"- these useless people falling to pieces. And the better to clarify his ideas to Masolino, he asked his permission to keep a little space of his own in the background, for four Florentine tenements of the kind we see today. This allowed him to straighten out Masolino's space, at least in that portion; and then, almost as if to teach the two hapless passers-by a lesson, he painted – after having redone the buildings from top to bottom – various patches of plaster with the old man lecturing to the youth, the reluctant infant, and the ill-tempered idler.

I am aware, of course, that many people would have preferred me to give a colorless account of a truth which has, in fact, been arrived at by measuring everything to the millimeter. But let anyone who wishes to do so make note of the key points on the wall, re-examine the perspective grid, locate the seams in the plaster, compare the various dimensions, and then say whether the history of the execution of these frescoes does not reconstruct itself, of its own accord, more or less the way it has been transcribed here.

* * *

On the other hand, there can be no place in this historical narrative for certain ideas frequently propounded even by modern critics, who speak of various other contributions by Masaccio to this same fresco of the two *Miracles of Saint Peter,* above all in the figure of the cripple. In self-defense, I should point out that it is precisely the most serious criticism that falls most readily into traps whose nature is, if not fictitious, at any

rate ornamental and antihistorical. The claim to find an expression of Masaccio's thought in a figure so wholly devoid of artistic coherence (one need but think of the cripple in Giotto's *Resurrection of Drusiana,* or of the famous ones by the Bolognese painter of the Camposanto at Pisa)[23] is nothing but a return to a suggestion of Vasari's, in the well-known eulogy where he says that the figure "truly seems to pierce the very wall." But why didn't this praise appear in the first edition? It can be explained only in relation to all the other variants in Vasari's second edition, and not only in the *Life of Masolino,* but also in the *Life of Masaccio.* I don't know whether anyone else has thoroughly compared them, and perhaps one could not do so before having better clarified the relationship – partly human, partly stylistic – between Masaccio and Masolino. Certainly, on rereading today the first edition of the *Life of Masolino,* the praise for his portions of the Carmine frescoes rings hollow, vague, stilted; for instance, the observations on the "relief and power of draughtsmanship" conflict with those on the soft coloring, and are further depreciated by his final insistence on the artist's "diligence" and love of meticulous workmanship. As for the high hopes the people had placed in him, expectations cut short by premature death, this is a stock phrase, scarcely different from that used for Starnina, who dates back even further, among the painters of the "first age." More important, however, is the passage immediately following, which concerns Paolo Schiavo, whose outdoor fresco of the Madonna at Canto dei Gori in Florence is described as containing "figures whose feet are foreshortened above the frame," and about whom it is said immediately afterwards that he "took great pains to imitate the style of Masolino, and likewise of Masaccio." Oddly, this reference to Masaccio, too abrupt not to be considered in direct relation with those "feet foreshortened above the frame" (the implication being that this was not something Schiavo could have learned from Masolino), has been struck from the second edition, and in its stead is substituted the new and more ample apologetic interpolation of Masolino, the one concerning his "difficult foreshortenings," and "the relief and power of his draughtsmanship," and his "considerable skill in perspective." This eulogy – in which, as I have already said, Vasari seems to attempt a delineation of that always misleading critical category, the "transitional master" – even here trails off towards the end; breaks off, rather, with a meager: "although this is not perfect in all its parts." It seems almost as though Vasari no longer found convincing the conception he had once had of Masolino; as though someone or something had forced him to make that addition.

What is at issue here will be somewhat clearer after we have paid

parallel attention to the variants that have made their way into the *Life of Masaccio*. In the first edition, the catalogue of Masaccio's works is straight-forward and, it may be said, almost free of errors. Vasari even guards him-self against recalling the painting with Saint Anne, though it is cited in Albertini, perhaps because it didn't seem to be entirely the master's work; after having hastily cited it in the *Life of Paolo Uccello,* he appears now to refuse to accept in its entirety the Carnesecchi triptych in Santa Maria Maggiore, alluding instead only to its predella; qualifying its value, more-over, with that attribute of "diligence" he formerly used for Masolino. Thus, Masaccio's distinctness from Masolino is still altogether clear; so that we cannot regard as a genuine sign of confusion even the mention of [Masolino's] frescoes in San Clemente [in Rome], in which Masaccio def-initely had a hand. Rather, the confusion reaches its height eighteen years later, in the second edition. It is here that the Saint Anne painting enters into Masaccio's catalogue, with no distinctions made regarding its execution; by the same token, the Carnesecchi triptych is ascribed to him in its entirety; and, worse still, whereas in the first edition Vasari had had the excuse of not being able to recall any paintings of Masaccio's in Rome, since they all had either been destroyed or were in unknown locations, now – unfortunately – he also adds the panel of *The Founding of Santa Maria della Neve* to the catalogue; because, I would guess, the aloof Michelangelo Buonarroti must have "authenticated" the work with a single, evasive phrase.

Indeed, this entry *en masse* of works by Masolino into Masaccio's formerly slender catalogue obliges us to distrust even the reference, in which so many still to this day place their faith, to the *Annunciate Virgin* from San Niccolo sopr'Arno [in Florence]. Obviously, I should like nothing better than to find an *Annunziata* by Masaccio; but I maintain, as a matter of good philology, that Vasari's reference really means "Masolino," both because it is of a piece with the other incorrect references in which the writer confuses Masaccio and Masolino, and because if the work were a definite creation of the "most excellent Masaccio," the prince of the "second age," his biographer would not have failed to recall it already in the first edition.

And so it is that Vasari, at the pseudo-critical instigation of Michelangelo or some other expert, loses his sense of the fundamental difference between Masolino and Masaccio. Misled ever after by the fact that the latter – at least in the works insistently ascribed to him by so many people in Rome and Florence – appears even more "Masolinesque" than Masolino himself does in the Brancacci Chapel, he ended up feebly reasoning that a certain merit in the way of evolutionary anticipation

could not be denied to the elder painter; and thus he decided to praise him. This is the context for the reference that was our starting point, our proof that it was indeed an ornamental statement, no more than a routine, rhetorical flourish added insincerely, so as to form a symmetrical pair with the praise of Masaccio; just as it is true that the choice of wording for the figure of the cripple, "who truly seems to pierce the wall," is artfully close to the phrase inserted into the new *Life of Masaccio* to describe the painted vault represented in [Masaccio's fresco of the] *Trinity* in Santa Maria Novella, where the rosettes in the painted coffering "are so excellently foreshortened that the wall seems to be pierced straight through."

And now let us return to the Brancacci Chapel, with no more worries about a poor foreshortened cripple (or a crippled foreshortening, which amounts to pretty much the same thing).

* * *

The same scaffolding would have stayed in place for the execution of the *Tribute Money*. From this it would be logical to assume that, as early as the days of the *Tabitha,* there was debate between Masaccio and Masolino (and let it not be forgotten that the latter was the artist commissioned to do the work) as to the way of conceiving and developing the great facing scene as well. But here everyone will want to muzzle me with the observation that there are no grounds for discussion, at least in relation to the certainty that it is Masaccio alone, and, Masaccio, moreover, in his peerless maturity, who appears in the *Tribute Money*. And I am with them whole-heartedly, – with the two armies, I mean, the Vasarian and the anti-Vasarian, which on this point have at long last banded together.

Yet in the universally accepted proof, I must at least point out an anomaly, one I find particularly jarring, as I hope it will be for everyone who has followed my line of reasoning thus far. It is this: it is all well and good to speak of a mature Masaccio; but in that case, why should everyone boldly, unabashedly declare that Christ's head is still inspired by Masolino? The "Vasarian" brigade would tolerantly allow that Masaccio had to the last what we might call episodes, lingering relapses, of the Masolinesque tendencies that were in him. In which case, why don't they move directly into the enemy camp? And as for the enemy: after having so carefully subdivided the development of Masaccio's artistic personality into its successive phases, they might at least have admitted that the head of Christ had been painted by Masaccio in a first, Masolinesque period, and all the

Pl. 4
Pl. 6

rest executed later, after a notable interruption in the work. But not even this has been propounded.

Well, then? Well, *audiatur et tertia pars*, "Let the third party be heard." If my research shows that, right from the start of work in the chapel, Masaccio has appeared not at all Masolinesque, but rather in a form all his own, acutely and entirely original, then there can be but one explanation for that Masolinesque passage (which, be it noted, also occupies quite a small patch of plaster) in a work by the mature Masaccio: the head of Christ in the *Tribute Money* is by Masolino himself; but by a Masolino so limply and heedlessly Masaccesque as to abandon the main actor, poor defenseless lamb, to the tender mercies of Masaccio's Apostolic wolfpack.

Pl. 25

At this point, it behooves me to recall that even Professor Toesca's "alternative hypothesis" concerning the Christ in the Empoli *Pietà*, where the critic considers the possibility of a collaborative effort between the two artists (thus coming close to Schmarsow's unpopular theory), was probably arrived at by studying the very similar handling of Christ's head in the *Tribute Money;* this matter, too, resolves itself just as soon as the latter is recognized as Masolino's handiwork.

And how can one not recognize it as such? Professor Salmi remarks that the face "expresses goodness"; but, once one has admitted that Masaccio was not permanently exempt from depicting this much-prized, fundamental endowment, there seems to be no doubt that he always sought out the non-contemplative variety thereof – active, energetic, productive goodness, which is not at all the sort that Christ exudes in the fresco. On the contrary, this face of wax and honey, vivid in its coloration but deficient in modeling, is wholly immune to the harsh chiaroscuro that furrows the whole scene, giving each Apostle a perennially aggressive air; a Christ, then, less resolute, less firm in action than His own disciples: something unthinkable for Masaccio. Haven't we got, in the fragment of the Pisan polyptych, a crucified Christ of whom it can be said that not even death can calm the violence of His indomitable spirit? Or, in the fresco of Santa Maria Novella, a Christ broken by time and by mankind, yet still potent and full of energy?

If I were asked, ironically, to suggest further how Masaccio might have rethought the Christ of the *Tribute Money*, had it been decided to do over entirely the piece of plaster painted by Masolino... Why, in that case, I should avail myself of the *Christ Freeing the Possessed Man* in that metal plaque which, in the Louvre, still goes under the name of a minor artist, Pietro da Milano.

Pl. 26

In regard to this extraordinary monument of Florentine art from the first half of the Quattrocento, I am happy to have managed, in a parenthetical remark on p. 65 of my essay on Piero della Francesca, to have called it to the attention of Professor Salmi, who in fact speaks of it in his *Masaccio* (p. 129), saying that I would ascribe it to the master himself. That was not really my intention. But what is true is that I suspected, at that time, that the composition derived from a painting of the same subject attributed to Masaccio by Vasari, and which, instead, to judge from the biographer's own description, I now realize corresponds more closely to the painting in the Johnson Collection [in Philadelphia], the execution of which should clearly be credited to the mediocre Andrea di Giusto. I did not intend to ascribe the little plaque to Masaccio himself but rather to some goldsmith of similar genius. In any event, it is worthwhile to return to the topic which, given the work's extraordinary quality, is of paramount importance. I know how difficult it always is to persuade the art public that it is worth straining their eyes to decipher, in a plaquette a few centimeters wide, one of the greatest compositions in Italian art; but this human limitation, which penalizes objects presenting special difficulties for the viewer, should not be allowed to impede our research; and anyway, a decent enlargement can simplify this research for all concerned.

I must point out that Professor Salmi misses the fact that the plaque (7 x 10 cm), which used to be enameled, was originally contained by a frame now used for another object in a different part of the same museum. And the round inserts with the four Doctors of the Church, still bearing their enameling, which are clearly a product of the early Florentine Renaissance dating from the first decades of the Quattrocento, likewise appear in a late Gothic frame of this same sort, strongly cadenced and Italianized. The scene on the plaquette has the same look, only it has been made more legible by the loss (which I would call providential) of the enamel that once stifled it as much as it enriched it: a composition so surely calibrated, within the perspective grid set up by the piazza's pavement and by the buildings enclosing it, as to reveal itself instantly as one of the most imposing formal plans in the new Renaissance style.

As in the *Tribute Money*, the vanishing point of the converging orthogonal lines is centered on the axis of Christ; while the semicircular mountain chain of Apostles crowned with three-dimensional, heavily scored haloes establishes, when taken together with the spatial gap created by the two Apostles seen from behind, something of a concentric, double-structured plan that wastes no time in reminding us of Brunelleschi's double cupola. But what, then, is one to say of the architectural ideas

that constitute the setting? The students of Brunelleschian thought have not taken the trouble to meditate on this admirable scheme of urban planning, with its many echoes of Rome, from the oculus windows of Eurisace to the barrel-vaults of Settizonio, and the square windows, and the funerary monument grown into a windowless building, harmonizing ancient and modern into a new temple, stupendously conceived on a central plan, having an ample transept with a low drum surrounded by four small domes, and gabled doors and windows, and cornices whose lively moulding is as varied as in the [Florentine] Palazzo di Parte Guelfa, the walls sheathed in vertical rectangular slabs of marble, superimposed as in the drum of the Duomo, garlands, decoration punctuated by heads, as below [Brunelleschi's] cupola, the scaly covering of the little domes recalling the Pazzi Chapel – all of this redolent of order, of calm energy. The neglect of such a work strikes me as an omission marking a low point in architectural scholarship.

The extremely high quality; the host of purely Brunelleschian architectural forms, and, what's more, of forms bespeaking a Brunelleschi not yet grown old (free, for instance, from any hint of cambered surrounds for the roundel windows); the clarity, iconographic and formal, excluding any reference to a Donatello grown ever more heavy-laden and crowded: all this points directly to the possibility that the work must be ascribed to Brunelleschi himself. Nor is this likelihood belied by its intimate spiritual friendship with Masaccio, who conceived of human action as taking place on just such a stage as this.

Here we find an extreme *gravitas* in arranging the figures, and at the same time, an infinite freedom in the way these togas, these faces full of infirmities and vigor, have been imagined: precisely as in Masaccio. Masaccesque, too, is the drama shouldered by men determined to resolve it; the occasional accents provided by background figures truly subordinate, not obtrusive and interfering as in Donatello; and the shrieking angularity of the three women, the old one possessed by a demon, and her relatives, their wild gestures curbed by the circle of the apostles.

In the center stands Christ, the infallible exorcist, already certain of the effect his imposing gesture will have, dominating the surrounding space, the other figures, their mingled emotions; and this, to return to our point of departure, suggests how Masaccio, had he had *carte blanche* (or rather, blank plaster), might have imagined the figure of Christ in the *Tribute Money*. If, as seems to be the case, Brunelleschi is indeed the artist who conceived the Louvre placquette, then this work confirms the personal rapport between the two like-minded geniuses; it should take its

place – permanently, I hope – in the history of the Brancacci cycle, as an essential commentary on the practical circumstances surrounding the *Tribute Money*: circumstances we can now more easily reconstruct.

* * *

So: as early as the period of the *Miracles of Saint Peter*, there was Pl. 6
debate between the two artists over how to structure the scene on the opposite wall. Masaccio managed to convince the older artist that it was finally time to abandon the "centrifugal" composition, with its successive sections showing mutually enfeebling episodes, and that it would be crucial for the authority of the narrative to align the principal figure with the perspective center of the composition. Perhaps in the future some clever technical study of the fresco (hidden from view at the time of writing) will better clarify whether certain inconsistencies, certain *pentimenti* clearly visible on the right side of the composition, are related to some initial vacillation on Masolino's part. In any event, it is only after an initial false start on this right-hand wall that the perspective begins to develop, diagonally, establishing the optical and moral center of the composition precisely at Christ's throat. Doubtless such a focal point was imposed, even dictated, by Masaccio to Masolino, who meekly, in a sharply delimited area of plaster, fussed and lingered over Christ's vivid, perfunctory, futile head; perhaps after having drawn in *sinopia* on the underlying plaster the vague outline of the figure, against whose disjointed slackness not even Masaccio himself could accomplish much.

But it is at this precise point, i.e., with Masolino's first attempt, that there occurs the great caesura in the work on the entire cycle; now, a great silence falls over the scaffolds of the Carmine. Masolino's glib chatter and Masaccio's insolent thunder fall dumb. Now it is time for us to track the two artists down; and I doubt we shall be able to find them in the streets of Florence.

In fact, when one realizes that Masaccio reveals, upon his resumption of the *Tribute Money*, an intellectual growth explicable only through the immediate knowledge of that magical, poetical complex that the world of Roman antiquity represented for an artist at the start of the Quattrocento, the urgent need arises to make sense once more of Vasari's statement; when, from the first edition on, the author – still unaware that the artist had died in Rome on a second brief stay there – accepts the much more important traditional belief that he had been taken there prior to resuming, in his own right, the work in the Carmine chapel, the

inception of which he had witnessed as a very young man: when he "began to practice at the time when Masolino da Panicale was engaged upon the chapel," etc.

That tradition connected Masaccio's sojourn in Rome with the frescoes in San Clemente, even if in the process it erased the name of Masolino which surely figures in that work; and now that today, by another route, namely by way of the deep and sudden caesura between the early and later Masaccio in the Brancacci Chapel, one regains a sense of certainty regarding his first journey to Rome, the question of San Clemente is automatically opened up again; and with improved prospects of a definitive clarification.[24]

Pl. 27

Today anyone reexamining the *Crucifixion* in San Clemente with a more experienced eye will recognize that, even disregarding those parts rendered indecipherable by the eighteenth-century restoration (when the group of the Marys was redone, along with the kneeling boy and the maiden by the cross on the right, all from the very plaster up, leaving no hope of their proper recovery), the interpretation of the painting still reveals, to a precisely definable extent, a basic and sudden shift in its syntax.

In the uppermost area, the three crosses rise to an exaggerated length, and are so arranged that the one in the center comments upon the Gothic lunette, making a flat surface of the pictorial space that the crosses to the sides were feebly pretending to suggest. The figures of the two thieves do not quite manage to conform to the pattern of convergence implied by the crosses, and so take off wildly into the void. This "half-perspective" study, purely empirical and allusive, is precisely what one would expect of a Masolino inadequately adapting himself to the influence of Masaccio; much like the Masolino we have seen in the Carmine Chapel, in fact. The group of Pharisees in the left corner also shows the same manner, with its weakly constructed chiaroscuro and pointless brooding, that Masolino had employed in the foreground of the *Tabitha* just a bit earlier. Similarly, the fact that all the foreground figures look stretched on the ground below the horizon, i.e., on a surface tilted towards us, just like the principal figures in the *Tabitha,* can be explained only by conceding that Masolino did impose the general plan. But now there intervenes that syntactical turnabout, precisely along the crest of Golgotha: not the hillock of salt one might expect of the older artist, but rather, a sharp ridge that detaches itself in space so sharply as to throw into the far distance the landscape behind it. The sudden change is all the more acute for the artist's having imagined the land beyond the ridge as falling away steeply; we are persuaded

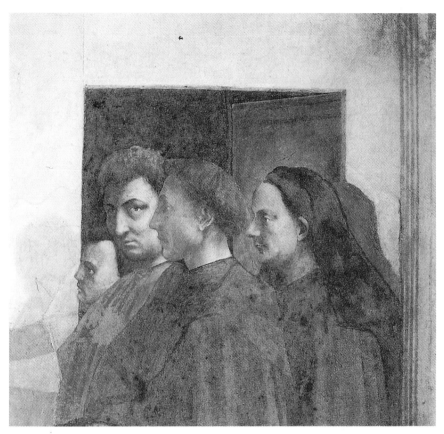

Masaccio, *Four Portraits, Masolino, Masaccio, Alberti and Brunelleschi*

Attributions of all works illustrated in this book are by R. Longhi.

32

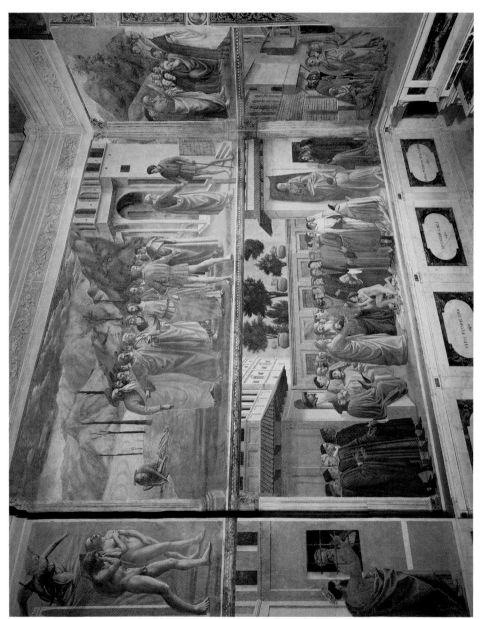

Plate 1a: Interior of the Brancacci Chapel, S. Maria del Carmine, Florence

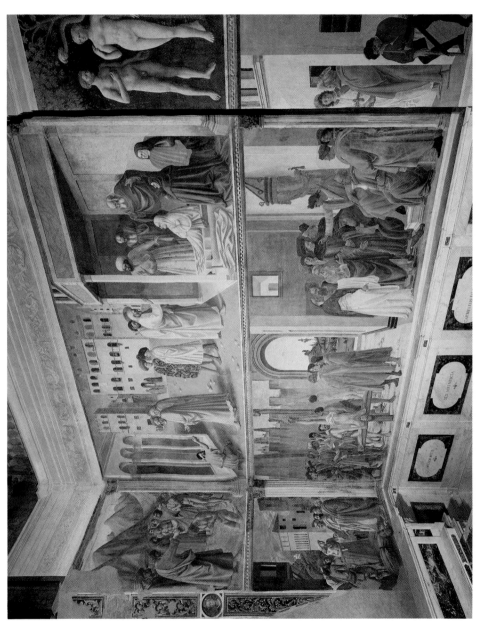

Plate 1b: Interior of the Brancacci Chapel, S. Maria del Carmine, Florence

34

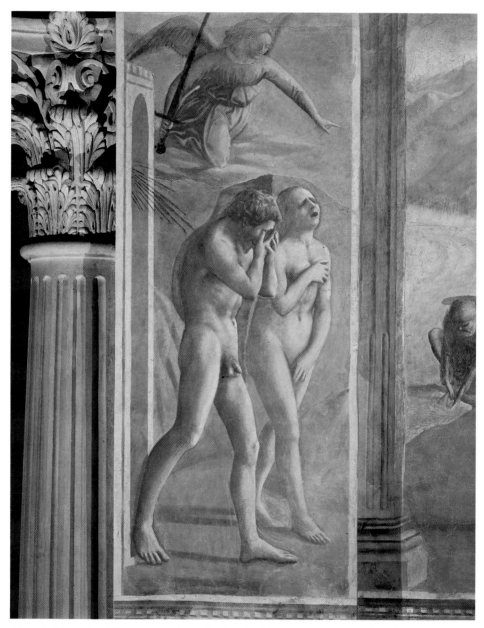

Plate 2: Masaccio, *The Expulsion from the Garden,* Florence, Brancacci Chapel

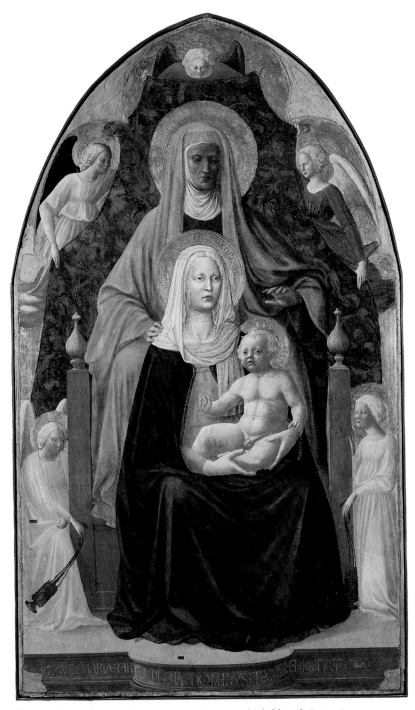

Plate 3: Masaccio and Masolino, *Madonna and Child with Saint Anne,*
Florence, Uffizi

36

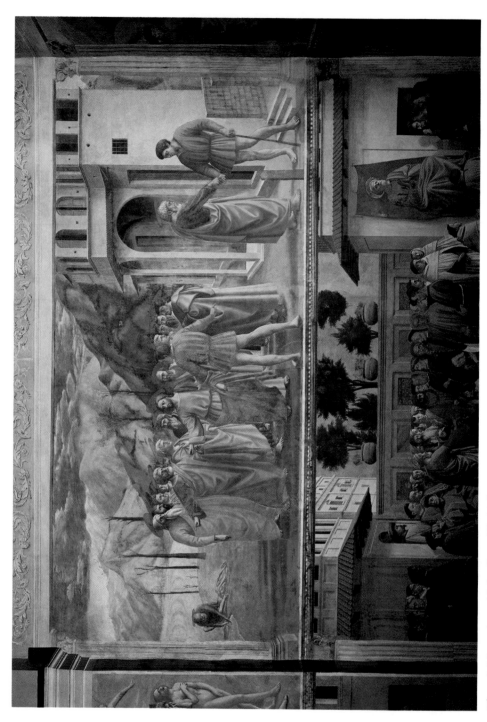

Plate 4: Masaccio and Masolino, *The Tribute Money*, Florence, Brancacci Chapel

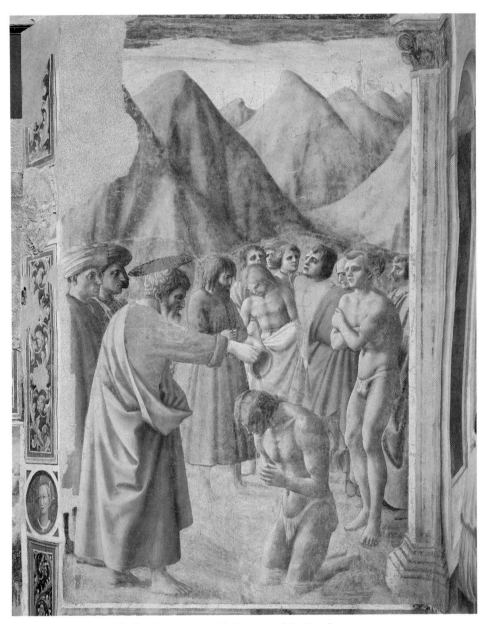

Plate 5: Masaccio and Filippino Lippi, *The Baptism of the Neophytes,*
Florence, Brancacci Chapel

38

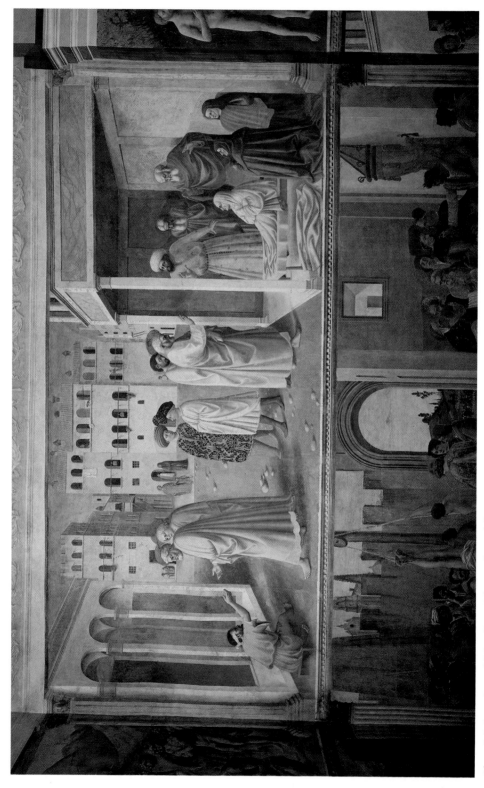

Plate 6: Masaccio and Masolino, *The Healing of the Cripple and the Resurrection of Tabitha*, Florence, Brancacci Chapel

of this lay of the land by the numerous groupings of modern riders: unusual figures who, varying in proportions and pose, coming up and going down, tilting their lances and banners at different angles, convey the clear sense of a precise and complicated movement in space. Knights and horses seen from the side, the front, the back, complicated crupper-straps, the forward thrust of dilated horses' nostrils: everything transports us here into a new and different world, one from which Piero della Francesca and Paolo Uccello will later derive considerable profit. The convincing illusion in this section of the painting, and this section alone, is so strong, so abrupt, as to make it almost incredible that discussion – which has been endless – should ever have focused on any other point but this, so obvious is the insertion.

To define this point precisely: it reaches its limit in the outer outline of the cross on the right, excluding that weary officer who seems so reluctant to issue commands. Considered in the overall context, the insert gives off the same savor, takes on the same function, as do the four tenements placed by Masaccio in the background of the *Tabitha*. There through the basic geometry of the converging casements, here by means of the human form with its new challenges, Masaccio is still searching with keen determination for perspective, thus confirming that this extraordinary exercise belongs to the same mental phase, i.e., it precedes the Pisan polyptych and the resumption of the *Tribute Money;* proving once more, by another route, that the first sojourn in Rome falls right at the break we have alluded to in the Carmine frescoes, with the start of work on the *Tribute Money.*

In addition, a recently conducted trial recleaning of portions of the *Crucifixion* in San Clemente (luckily entrusted to the best technician currently in Italy, Mauro Pelliccioli) has justified my suspicions beyond my boldest expectations. Witness, for example, the partially cleaned detail of the knight raising his astonished face and his arm towards the cross of the bad thief, while urging on his horse, which twists and turns so admirably in the effort to climb the hill. The bent arm holding the lance and the shoulder still belong to the old restoration, unfortunately irreparable; but the horse's face reveals that terrible intensity of form sought within space, such as Paolo Uccello will strive to recapture in his famous battle scenes; revealing, moreover, an intensity of physiological pulsation rivaled only by certain horse-heads by Leonardo. The knight's face, raised in a rapid foreshortening, with the deeply dug shadow over the right side of the nose and the eye socket, the eyes glowing in amazement, already heralds the head of Saint Paul, kneeling beside the resuscitated son

of Theophilus in the last fresco in the Brancacci Chapel.

As the work of restoration continues, many other salient features will no doubt come to light that are at present only partially legible: the precisely graduated distances within the apparently free movement: from the fuller profile of Longinus, to the formerly reduced foreshortening of the knight shielding his eyes with his hand, to the absolute frontality of the extremely young page, his face harshly divided between light and shadow, an effect Masaccio had striven for, perhaps only a few months earlier, in the frontally viewed head behind the two mocking youths, shrewdly inserted into Masolino's *Preaching*. Nor is it too vague a suggestion if we say that the marvelous knight, whose shining armor, complete from helmet to leg-guards, encloses him utterly, will strike the fancy even of Piero della Francesca, who conjures up his image in a well-known passage of the *Victory of Heraclitus* in Arezzo. Indeed, this echo, together with those in Paolo Uccello and Leonardo, would suffice to establish the fact that it is Masaccio at work here, offering proof that in the San Clemente *Crucifixion* the greatest artists of the Renaissance knew, better than the critics, how to draw upon the passages suited to their needs, while ignoring Masolino's rambling slackness.

It would be too risky, before cleaning reveals the remains of the original, to speculate on the possible parts Masaccio also executed in the vaulting and on the front and soffit of the entrance arch (that is to say, in all the sections which, in keeping with the standard practice of mural painting, were the first to be executed); but I can state that, so far as the vault goes, Professor Salmi's cautious inferences about Masaccio's likely intervention in the figures of Saints John, Matthew, and Jerome (though I would not venture to say Saint Luke) strike me as worth bearing in mind. Peering through the disgraceful botch-work of earlier "restorers," I have always thought it possible to make out faintly that, in the angel of the *Annunciation,* the violent division into light and shade, the esoteric classicism of the profile, and the gravity of gesture far surpass – just as Masaccio far surpasses Masolino – the Madonna fashioned purely on a surface, and executed in a continuously lambent shading of color; and I hope the sense of these opinions, offered here by way of anticipation, will become clearer at some future date.

But why, one will ask, shouldn't so much as a trace of Masaccio appear on the walls of the chapel as well? I think it is for the sufficiently strong reason that at this point an obvious caesura occurs in the work at San Clemente as well; which suggests that Masolino executed the walls later, after the death of Masaccio. In the *Crucifixion,* in fact, we have rediscov-

ered a Masolino bogged down at the point of the first Brancacci frescoes, particularly the one with *Tabitha* and the *Cripple;* while in the *Scenes from the Life of Saint Catherine* of Alexandria and (to the extent that its state of conservation permits us to say anything about it) also in those dedicated to Saint Ambrose, it is evident that Masolino is already forgetting the stimuli his young friend had provided and is, if anything, blandly recasting them in his own loose way, reducing even the most daring inventions of perspective – architectural vistas, coffered ceilings, receding streets, and so on – into some curious novelty, some trendy and superficial fashion: it's more or less the same thing we'll see later on in Jacopo Bellini's pseudo-perspective, or in Masolino's own panel of *Santa Maria della Neve,* and in his only slightly later frescoes for the Baptistry at Castiglione d'Olona.

Pl. 28

Furthermore, we need but re-examine a fragment of the *Catherine Tortured on the Wheel* following the first partial cleaning (until only yesterday we were not studying the works of Masolino, but, rather, nineteenth-century oleographs executed over their tattered remnants) to note that we are entering into the ambience of blessed, multi-colored martyrology that will reappear once more in the scenes of John the Baptist at Castiglione and which had already appeared in the young Masolino, before his encounter with Masaccio; the chiaroscuro, now reduced, in the glowing flesh of the assiduous turner of the wheel, to a continuous chromatic shading, seems to speak anew the language of Tommaso da Modena and Giovanni da Milano. The almost classically pure profile of the saint herself is so simple as to its derivation from Angelico or Ghiberti, rather than from Masaccio, who is already dead and buried: not least in the mind of Masolino.

The clean break must therefore be recognized in the San Clemente frescoes as well, immediately after the execution of the parts in which Masaccio's presence is perceptible, and agrees entirely with the most logical chronology: after the start (well documented as having taken place in 1424) of work in the Carmine Chapel, and after this first Roman sojourn in 1425, there is not much time left before Masaccio must be sent off to begin the Pisan polyptych, which it will take him all of 1426 to execute. Still it is possible that, near the end of '25, for whatever reason (their taste for roving may have been the only trait they had in common), the two artists leave Rome, each by a different route: Masolino perhaps already bound for Hungary, after a probable last stop on his home turf; Masaccio traveling toward Pisa, where he will stay for roughly a year.

Returning to Florence after the work in Pisa, at the start of '27, and more famous now, Masaccio is thus enabled, in the absence of Masolino

(and perhaps, as Vasari states in the first edition, thanks to Brunelleschi's intervention), to climb the scaffolding of the Carmine on his own. Here, alone with the wall, his mind still enlarged by recollections of Rome, he resumes and completes the *Tribute Money* (perhaps having first touched up Masolino's head of Christ, being unable to eye it without irony); he then goes on to the *Expulsion of Adam and Eve from Paradise,* the minor episodes of the lower register, and the well-known sections of the *Resurrection of Theophilus's Son* and of *Saint Peter Enthroned;* whereupon his unabated restlessness once again goads him towards Rome, where he will leave behind only his life. How, from the rough trial runs executed on the model of Brunelleschi and Donatello during the first work on the Carmine frescoes, and during the interlude of the *Crucifixion* at San Clemente, he grew to the point of uniting, on the one hand, the action of human beings possessing all the grandeur and authority of the ancients, and, on the other, the altogether new spatial certainty of the Tuscan Quattrocento, is a subject with which my present investigations can no longer be concerned; and besides, many worthy men have labored to define the final form of Masaccio's style.[25] We can, however, continue to clarify the position of Masolino.

Pl. 4

Pl. 2

* * *

We have shown how feebly and reluctantly he followed the suggestions, to him fairly obscure and esoteric, of the young assistant fate had sent him. There are enough signs of this to let us foresee how readily he was to free himself of this influence, just as soon as he was no longer subject to its determining cause: by which I mean, of course, Masaccio's physical proximity. From this one deduces that everything in Masolino that bespeaks a nearness to Masaccio must of necessity date from the time when Masaccio was alive, literally a living reproach to Masolino; while everything that takes its distance from Masaccio attests to a chronological distance from that time. Moreover, the few chronological facts established for certain paintings not yet considered agree with such a scheme. The Detroit Museum's *Trinity* agrees, if only stylistically, with the portions by Masolino painted in the *Saint Anne;* one must nevertheless mentally remove the dove of the Holy Ghost, too drastically foreshortened not to belong to an era much nearer our own. The Empoli lunette with the *Madonna and Angels,* almost surely connected with the well-known document of '24, likewise matches Masolino's weary efforts in his portions of the Saint Anne panel. So we are still in 1424. As for the Empoli *Pietà,* it

Pl. 3

Pl. 33

takes its place right alongside Masolino's most desperate attempts to focus
the action, as in the Brancacci scenes of *Tabitha* and of the *Cripple;* while
the head of Christ in the Empoli picture is a good match for that in the
Tribute Money, probably executed at the start of 1425. The surfaces in
both are the same neo-Giottesque idiom, to which Masolino turned only
at Masaccio's prompting.

Pl. 6, 25

I will not try my colleagues' patience by attempting to recreate the
conversations Masolino and Masaccio must have had in Rome; but still,
I can only imagine that, just as in Florence Masaccio had obscurely urged
upon his companion the necessity of a return to Giotto (perhaps asking
him, à propos of the *Navicella,* if he did not by any chance find among
his old notes some record of Giotto's celebrated version in Rome), in
Rome he cannot have failed to lead him through the major basilicas,
where the Roman-inflected Giottism of Cavallini still predominated.
Certain busts in the series of the Apostles in the soffits of the entrance arch
at San Clemente suggest this, as well as the ponderously grandiose idea
Masolino hit upon for the *Crucifixion* (where Masaccio brusquely inserted
that shaft of ardently illusive space). Up to a point, these are the signs of
a return in the direction of the Cavallinesque medieval style of Rome.
But there are still concrete proofs of this style's having exerted a more
enduring influence on the elder artist's ideas than on the newer thoughts
of Masaccio. These proofs are visible in those works of Masolino's that seem,
for other reasons, to date between '25 and '30, i.e., between his first and
second stay in Rome; even without taking into consideration that possible
earlier sojourn to which Vasari alludes.

Pl. 27

Looking, for example, at the *Madonna* of the Carnesecchi triptych
(formerly in Santa Maria Maggiore in Florence, present whereabouts
unknown), included by Vasari – with obvious mental reservations – among
the works of the younger artist, it must be pointed out that Masolino's
assimilation of Masaccio's idiom is still strongly apparent: the Christ
Child, for example, in His swift gesture, and in the significant motif of the
folds created by this gesture, shows the immediate impact of the amazing
figure on the right in the Berlin *desco da parto* ("childbirth plate") and of
the Pisan predella; but, at the same time, the rounded, fluid and abundant
form of the Virgin is one of the most intense reminiscences of the great
Roman *Hodegetrias*[26] of the late thirteenth century.

Pl. 29

Pl. 30

When one realizes that the *Saint Julian* from the shutters of this
same triptych, while persisting in the aim of imitating Masaccio's high
seriousness and intensity, reveals at the same time an additional inten-
tion of calling back into play the broad, arching rhythms of the late

Gothic, then there can be no more doubt: the revival of an archaicizing Roman style in the Madonna of the central panel, together with the revived Gothic style in the figure of the saint on the shutter, dates the work to immediately after Masolino's return from Rome, perhaps at a time when Masaccio was still present in Florence, and prior to Masolino's journey to Hungary (1427); and thus, in all likelihood, in 1426, precisely the date shown in the documents brought to light by Stechow regarding the endowment by Berto Carnesecchi of the chapel [in Santa Maria Maggiore, Rome].

The date of Masolino's return from Hungary remains uncertain. He probably lost no time in coming back after the death of [his traveling companion] Pippo Spano, in 1428; and surely he had reappeared before 1431 at the very latest, since that year marks both the termination of Cardinal Branda's claim to San Clemente (which sets an *ante quem* for the completion of the chapel there) and the end of Martin V's pontificate (which, to judge by the clear heraldic allusion to that papacy in the shutter of the Johnson Collection, sets a terminal date for the Santa Maria della Neve triptych). Nor is there any lack of stylistic evidence of the sort needed to persuade us that the *Scenes from the Life of Saint Catherine* and – so far as can be deduced today – also those of *Saint Ambrose* belong to the same phase as the triptych with the *Miraculous Snowfall*.[27]

Pl. 28

In both cases, the reminiscences of Masaccio gradually fade away; while, alongside the hints of Ghiberti and Angelico already noted, there linger still-perceptible echoes of Roman thirteenth- and fourteenth-century art. These persist to such a degree that, in the panel of the triptych showing the *Miraculous Snowfall*, Christ and the Virgin Mary – who promote the foundation of the Church of the Neve from within their little circle of Heaven – are copied almost verbatim from the mosaic variously ascribed to Rusuti, Gaddo Gaddi, or the school of Cavallini, in the upper part of the atrium of Santa Maria Maggiore. And it is clear that Masolino is an artist who knows thoroughly how to thresh the seeds of his own culture, and how to nurse them along with his own gentle remedies. If I have said that he takes his distance from Masaccio, it is because this distance is perceptible at every turn, almost calculable. I would say, in fact, that Masolino forgets nothing of his chance involvement with Masaccio, save only the essentials. He had even learned something from Masaccio, between 1424 and 1425, about the immense innovation of Brunelleschian perspective, of which he had not had an inkling in 1423, only to transform that perspective later into the self-indulgent profusion of arches that go bounding out toward the hills of Latium in the *Snowfall*, preceded by

a vanguard of great cloud-banks. Who knows whether Masolino might not have uttered, years earlier than Paolo Uccello, something like the latter's famous phrase [quoted by Vasari] to his sleepless wife about "sweet" perspective. Only, Masolino would likely have chosen an adjective along the lines of "cheerful."

There is something else to note in the shutters of the *Neve* polyptych, identified with certainty by Lionello Venturi despite his unconvincing commentary.[28] This critic speaks of the heroic Masaccism that he claims emanates from the figures of the four Saints; but, this term's inappropriateness aside, he should first have indicated the great difference in quality and style between the two parts. Saint Peter and Saint Paul have a subtly rhythmical essence in one panel, and are exquisitely linked across the intervening space, which is itself reduced, however, to purely linear tracery between a Peter in frontal view and Paul in profile; there thus passes over the Gothic a breath of atavistic medieval Classicism, as in the most distilled, almost Attic, moments of Ghiberti and Nanni di Banco: a spirit that blends easily with the ineffably Roman and Cavallinesque mood of the two figures. There is none of this, or almost none, in the other panel, where Saint John the Baptist and the Bishop Saint Liberius, below the remains of Pope Martino Colonna, seem simply to be blocking each other's way, and taking up the same space quite by accident; so that the outlines of the two vestments on the ground get tangled up into one extremely feeble ornamental motif. There are almost undefinable, yet certainly Siennese, characteristics in both figures: Saint John's almost bovine visage, though Masolinesque in its subtle shading, recalls the qualities of a Paolo Schiavo or Vecchietta in their very early phases. Did Masolino already have with him, in this return to Rome sometime between '28 and '30, some of the assistants who were later to accompany him to Castiglione d'Olona? We should, in any case, conclude that this shutter was largely delegated to some pupil, and that the admiration Vasari indiscriminately bestows on the entire work is thus unwarranted and stereotyped.

To my mind, the same felicitous meeting among seeds of various cultures is discernible in the *Annunciation* in the Goldman collection.[29] Ghibertian in cadence, somewhere between the Gothic and the classicizing, are the stately evolutions of the gold trim on the Virgin's mantle; the serenely devout, smooth roundness of form in her face and hand has affinities with the Angelico of around 1430. Equally close to him are certain reminiscences of "Cosmatesque work"[30] (another medievalism of Roman stamp), such as were already visible in certain passages of the *Scenes from the Life of Saint Catherine* in San Clemente; and, as for the per-

spective, we feel that by now the artist must have been using it for rather a long while; otherwise, he wouldn't have risked this showy, virtuosic view from below, even if only in order to turn it (as is obviously the case) into yet another bit of purely empirical prettiness. But there is another seed of yet a different culture that blows our way in the form of the radiant angel. Doubtless the *estofado* motif of the enormous rosettes crammed flat against the red velvet is freely drawn from the great flowers imprinted by Gentile [da Fabriano] upon the night-colored mantle of the *Quaratesi Madonna* in 1425. Thus that year marks the last possible date for Masolino's painting, even suggesting perhaps that it was painted for some Florentine church. If the church of San Niccolò sopr'Arno comes to mind, that is not only because it once housed this very work of Gentile's, with which Masolino's *Annunciation* seems eager to get along.

Our analysis of the catalogue of Masaccio in the second edition of Vasari (where, as we have seen, a host of paintings by Masolino suddenly try to get themselves transferred to Masaccio) enhances the likelihood that, in citing Masaccio's *Annunciation* in San Niccolò sopr'Arno, the biographer was referring to none other than Masolino's Goldman *Annunciation*. Nor does Vasari's description, from which Lindberg has drawn so many unconvincing conclusions, seem to me to be in conflict with this new suggestion. Essentially, Vasari does not dwell on a mathematical perspective, but rather upon a "dazzling" perspective; that is to say, of the empirical and chromatic kind typical of Masolino; and that "dazzling" might well allude to the soft sunlight which, flooding through an invisible window, fills the Virgin Mary's humble chamber, illuminating the bed, with its pale wooden frame, and the gauze of the curtain: an admirable prelude to the imminent Domenico Veneziano. Then too, the fact that Vasari should cite the painting as standing in the middle of the church, without mentioning that it served as an altarpiece, strikes me as quite in keeping with the painting's almost square form, with the false arch at the entrance to the composition, and even with the choice of low-angled perspective for the strangely suspended little portico; almost as though the painting were placed high up in the center and perhaps at a tilt, in the manner of the paintings on old-fashioned iconostases. In this way it seems to me that Lindberg's case begins to collapse, not so much through his denying that the Goldman painting is Masolino's (this does not even warrant discussion), as through his asserting with absolute authority the appearance of a Masaccio *Annunciation* which, unfortunately, never existed.

Not long after, as the documented fresco at Todi (1432) attests,

Masolino shows that he has done an even better job of forgetting his several years' association with the innovative genius of Italian painting. Not that all trace of it is lost, for instance, in the fanciful design of the throne with its arms seen from below (something which, it should be noted, links the work in time with the perspective viewpoint of the Goldman *Annunciation*); but what has vanished is precisely whatever small shred of moral concern had at least touched the *Saint Anne,* the Brancacci frescoes and the Empoli *Pietà.* Here the angels' careful devotion has Ghiberti and Angelico as its source, while the Christ Child turns back into a frail little spider whose reality is only relative.

Not that Masolino is losing his powers; on the contrary, these years restore to him that facility he had formerly possessed, for which Vasari praises him: an ease in capturing and making his own every fleeting experience, every novelty that comes his way, including stylistic ones. Perspective becomes the simple expansive immensity of the storyteller; in Masolino the rhythmic sense of the late Gothic artists, including Lorenzo Monaco, grows more florid than ever.

Anyone seeing, for example, the *Madonna of Humility* ascribed by me to Masolino when it passed, years ago, from an English collection into that of Senator Contini-Bonacossi in Florence, might suppose he was standing before the earliest of Masolino's *Madonna*s, precisely because of the obvious way its grandly spiraling, almost conchshell rhythm evokes Lorenzo Monaco. But on observing more closely how the violent darkening and brightening of the deep blue models the dense chiaroscuro of the Virgin's lower knee, with no loss of local chromatic intensity; and upon noting the delicate power in the tapering lines of the hand proffering the breast to the Holy Child's lips, one must conclude that Masolino could not have arrived at such a facility for cultural harmonization without having already gone through the great adventure of his collaboration with Masaccio. So the likely dating would seem to be between '30 and '35; the more so when we note that the Christ Child, peering out at us, dazed and animated as a newborn fawn taking the dug into its mouth for the very first time, has the same superficial petulance we see in the faces of certain Apostles who appear, their hair done up in neatly tonsured mops, in the scene at Castiglione where John the Baptist is presenting Christ to the crowds as though he were some strange new "attraction."

And even at Castiglione, above all in the Apostles spread across the [Baptistry] vault, the Gothic rhythms build continuously from one register to the next, finally bursting out in an excess of wearisome backwardness in the [second] vault of the Collegiata, hard by the more

"scientific" explorations of the artist's young assistants.

I have already hinted at the opinion that strikes me as most correct regarding the two cycles at Castiglione. If certain people's insistence on the old dating of the Collegiata frescoes to Masolino's youth has already been shown wrong by the research of Professor Salmi, who has thoroughly documented the chronological closeness of the two Castiglione cycles, I think we must go a step further and, inverting the commonly stated sequence of composition, say that the works of the Baptistry came first, those in the Collegiata second.

Pl. 28
Pl. 24

Indeed, although the painting of the Baptistry was finished in '35, there are still readily apparent stylistic affinities with the frescoes of the *Life of Saint Catherine* in San Clemente and with the panel of the *Miraculous Snowfall,* both completed, as we have seen, after 1427 and before 1431. The ever more airy and carefree reduction of perspective to a mere *divertissement,* I am almost inclined to say to the level of a parlor game in a country house, comes later; while in the Evangelists of the vault he just barely intensifies that reflowering of linear rhythms apparent since the Carnesecchi *Saint Julian.* Henceforth Masolino, having reached the height of his new intellectual freedom, wholly liberated from Masaccio's dramatic indecorousness, expresses himself as if he were again recounting, in boldly executed miniatures, tales of his journey to the East, reminiscences of blond Slavic mustaches and white-bearded Prince-Bishops and ermine mantles. Many years ago, it is quite true, Professor Toesca thought he could cite, as proof of this cycle's coming after the other, an increase in Masolino's mastery of perspective, particularly in the two scenes of the *Feast of Herod* and the *Naming of John the Baptist.* But it must be pointed out

Pl. 31

at once that the two scenes cited do not, in this respect, belong together. On the contrary, the *Feast of Herod* marks the very summit of Masolino's use of perspective for purposes of fabulous storytelling with nothing scientific about them: a summit that the mind of Masolino, as we should have expected, could not climb beyond for the sake of exact inquiry. And because the scene of the *Naming* is instead the only passage, together with that of the *tempietto* in the scene of *John the Baptist in Prison,* to show us a truly unexceptionable "rationale" for its perspective, we can only conclude that here some assistant stepped in; one who, having grown up in a more modern generation, could well have acquired the necessary and sufficient notions of perspective without any special effort. There is excellent proof of this, moreover, on the door of the *tempietto* with its neat little arches, in the false terracotta depicting Adam and Eve working, where the manner of execution is so clearly similar to Quercia's, almost

anticipating Federighi, as to show itself the work of a Siennese artist; in all likelihood, the same one who reappears in certain parts of the Collegiata: Lorenzo Vecchietta.

In the frescoes of the Collegiata, together with the younger painters' emphasis on a perspective grown by now "rational" rather than merely empirical, one notes Masolino's own revival of Gothic extremism; to the point where, so far from showing himself a progressive, he is actually moving backwards. This revival, traditionally interpreted as a medieval holdover within a Renaissance in full bloom, is today more accurately explained as a tired reprise, in the light of what we have learned about so many other regurgitations of Gothic linearity in Florentine painting between '30 and '40, and even later. Even Lindberg, in his mediocre book, managed to note that the frescoes in the Collegiata already suggest a cultural context similar to that of the chapel of the *Assunta* in the Duomo of Prato, painted around 1445 by none other than Paolo Uccello, in whose company was an artist who had even had the great fortune to collaborate on Masaccio's Pisa polyptych, namely, the wretched Andrea di Giusto.

The presence, then, in the Collegiata, alongside Masolino, of a Paolo Schiavo, already making small change of a certain current phraseology of Masaccio's, and above all of Vecchietta, born around 1412, and here intent on violent experiments in foreshortening and articulated perspective, naturally bring the dating of the cycle up to around '35 and possibly even later, rather than pushing it back toward '30, as Professor Salmi suggested before Vecchietta's presence had been noted. This same critic's hypothesis that, once Masolino had executed the vault, his pupils may have carried on with the frescoes of the walls, the master being busy with the Baptistry, strikes me as over-ingenious and unlikely; it does not seem to have been by any means common practice for a master to leave a project expressly entrusted to him in the hands of assistants (especially ones so marginally loyal to his artistic ideas), letting them arrange entire areas on their own, without his giving them so much as a compositional outline. Indeed, the very fact that, in the Baptistry, Masolino figures as the sole executant while, on the other hand, in the Collegiata he allows collaborators to step in as early as the vault (since, for example, the clever perspective of the convex temple in the *Wedding of the Virgin* is no longer his own work), utterly abandoning to them the episodes on the walls, strongly suggests that, having begun this last work of his, he may have defected outright, deserted, simply going off somewhere else. To this day, of course, it has not been our lot to rediscover him in his last years, numerous as they

were if it is indeed true that he lived until '47; but this date has sometimes read as '40, which seems more logical, and perhaps explains why he never finished the Collegiata cycle.[31]

I do not intend to pass over in silence the fact that Vecchietta's presence in that cycle, which I pointed out as early on as 1928 and which has met with general acceptance, is rejected without any comment by Pope-Hennessy in his recent volume on Sassetta.[32] I feel certain, however, that this young scholar, with his subtle intelligence, will not persist much longer in denying plain evidence – so plain as to assure us that Vecchietta's share in Castiglione can antedate by a few years at most his fresco in the Pellegrinaio dell'Ospedale in Siena, documented as having been executed in 1441. So his work at Castiglione must fall only a little before '39 (a date compatible both with Schiavo's having still been in Florence as late as '36 and with other evidence to be presented below); and 1439 is, in fact, the year in which Vecchietta's presence is once again documented at Siena, following a silence beginning in 1426. In the intervening period, the Siennese artist must therefore have tried to make his way in Florence: one among that party of astonished painters who, while they assisted and followed the wayward Masolino, nonetheless came back whenever they could in order to gaze, heart in throat, at the few, amazing relics of Masaccio.

* * *

However much (or little) terrain we have conquered thus far, my investigation would not be very fruitful were it to end here. I think we must cultivate it more, to see what it signifies in the elucidation of Florentine art, in Masaccio's time and shortly thereafter.

Masolino's incredible course, ending in a flight towards the old, as though his encounter with Masaccio had never taken place, and the appearance in around 1435 of the first among the "dazzled" (dazzled, that is, by Masaccio) at Castiglione d'Olona – all this should already suggest that the so-called Renaissance evolved, even in Florence, in a manner rather more tortuous and awkward than one might be led to believe by accounts reflecting a cultural outlook that is, nonetheless, widely held to this day. How many people would like to believe that, one radiant morning in 1425 or 1426, the artists of Florence passed the word around: "All right boys, it's all settled: from here on in, it's the Renaissance, and no turning back!" Which is more or less the historical psychology of the lower-class Roman in the *Discovery of America*: "And then they were there."

A more rigorous investigation must, however, start from scratch, very cautiously, with the earliest possible quotations from Masaccio in Florentine and non-Florentine art, never losing sight of the mental schemes that other artists can only have derived from him. But how far back must one go?

It is true that Masolino shows absolutely no knowledge of Masaccio in 1423; but we have already seen that, in Masolino's case, learning what was new can only have taken place through direct human contact; to wit, the occasion of shared work in the Brancacci Chapel. It is also true that due weight has been given here to the passage in Vasari where it is stated that Masaccio "began to practice" when Masolino was painting in the Carmine; but this passage is to be understood only as an account of the first public appearance of the young innovator's art. When we recall that, as early as January 1422, he had been registered among the painters of Florence, we can well assume he had already been in town for some years. And where, if not Florence, might an adolescent have been found who was so troubled, so stirred by the demon of the new painting? At Montemarciano, perhaps, circa 1420? Here is a pilgrimage best left to the critics who still nurse the claim of discovering Masaccio as tadpole, as embryo, amoeba, etc., in order to then get him to climb, nicely, respectably, all the biological steps of glory. Let any who will, believe that a young boy of genius can evolve in five years from the zero of that fresco to the immensity of the *Tribute Money;* I, for my part, prefer to imagine that the artist who painted the *Tribute Money* at twenty-five must already have appeared long before as a rare specimen of precocity; and I am certain that Pl. 4 by the time he was about seventeen, which is to say around 1418, there was more than one person in Florence who understood what had emerged from the "extreme carelessness" [Vasari's explanation for Masaccio's nickname] of that young boy who lived so "haphazardly." The marvelous hope of being able one day to rediscover incunabula of the Masaccio of those years of immaturity ought, for now, to draw strength from the capacity of Masaccio's art to pass instantly into other spirits. If we fail to keep this fact fixedly in view, we risk rewarding with the title of "forerunner" those who are, in fact, mere subordinates. Nor has that risk always been avoided. Perhaps, on the contrary, the advantage of my research has been to clear away, once and for all, the legend of Masaccio's "antecedents"; for this man had no antecedents, with the solitary exception of Brunelleschi. If we plant this notion in our hearts, we will be certain that when, in some Florentine painting from the end of the second decade, the light models rather than modulates; a hand grasps rather than strokes; a belt

clasps rather than adorns; a color permeates an object rather than coats its surface – it is because Masaccio has already passed this way.

And since our talk has been of sense and mental schemes, the point one must stress most forcefully, and which research seems on the contrary curiously anxious to avoid, is precisely one concerning Fra Angelico: this man usually relegated to a paradise really inapplicable to him, merely by dint of that friar's habit whose belt clasped him so well that he was the first to grasp Masaccio's meaning. Here, too, how can one fail to recognize the great merit of Vasari, who places Angelico's name at the top of the list of those great artists who studied in the Brancacci Chapel? Yet the modern critic is accustomed to note with suspicion: "The Blessed Angelico was fourteen years older than Masaccio." In addition, more than one critic is slowly arriving at the conviction that Angelico executed no paintings before 1418, the date of his return to Florence, when he was already in his thirties (or just under). In order to prove or disprove this conviction, it will clearly be useful to make finer distinctions in the great fuss over the miniatures of San Marco and the Laurentian Library.[33] In the meantime, however, it is precisely this fact of his being older and, moreover, endowed with the highest genius in Florence after Masaccio's own, that suggests that it did not take him long to recognize and understand the newness of the young revolutionary. And for this reason alone, the earliest examples of a well-defined Masaccesque phase in the context of a personal, different outlook cannot, with any likelihood, be credited to an artist other than Angelico.

I know of no earlier instances than those visible in the drawings, just barely tinted with watercolor, loaned to the 1930 London show (nos. 418 and 420) from the Oppenheimer Collection, and which originally served as illustrations for the tale of the journey to the Holy Land of Frate Pietro della Croce, a Dominican like Angelico. The date of 1417, which putatively applies also to the drawings, probably pertains only to this copy of the narrative; a date which can be stretched a little, on the other hand, in the case of the very lovely art of a draughtsman who instills new vigor into the latest rhythms of Lorenzo Monaco in his rendering of rocks and trees, while already investing the heavy habits of the traveling friars with a new chiaroscuro. Certain rivulets of darkness amid the folds, a new tread, heavier, more resolute, leave no room for doubt.

These admirable drawings are closely connected with the well-known painting of the *Thebaid* in the Uffizi.[34] And although, in that panel, the artist was obliged to follow the model of the great wall painting of the *Hermits* [in the Camposanto at] Pisa, itself based on some Byzantine com-

position, and so was unable to unify his entire tale in perspective (for you can't synthesize a calendar or a list without leaving some of it out), we can still deduce that he knew more about space than one would think at first glance, as we will see if we view each episode separately: to cite the most complex one, the lamentation over the dead hermit, on the left. And that he knew more about articulating forms than those short-breathed cadences writ in Gothic festoons in certain draperies might suggest, is clear from many other passages, showing young friars looking for things or carrying them about; stout lay brothers whose life begins only in the period inaugurated by Masaccio, a period here already filtered through the mind of the young Angelico: to whom, in fact, the Quattrocento confidently ascribed the painting.[35]

That the issue of the young Angelico is intimately linked to that of the young Masaccio and, perhaps, of Masolino as well, in his period of mental confusion at the outset of work in the Carmine Chapel, may also be deduced from the fact that the *Saint Jerome* in the Mather Collection at Washington Crossing, so similar to the more wizened hermits of the famous Uffizi painting, has at various times been proposed as a work by Masolino or by Sassetta. This is oddly to ignore the existence of Angelico, whom the painting's idol-like, piously violent woodworking suits quite well; particularly at the time of his strongest affinity with a still young Masaccio. Which makes it all the more valuable, therefore, for the propositions we have been advancing, that the date, arrived at by the heraldic signs of this small painting, is almost certainly 1424.[36]

My hunt for an Angelico who closely resembles Masaccio does not immediately involve the study, in this phase of his activity, of works such as the Fiesole altarpiece, with its predella; or the Madonna formerly in the Cassirer collection, customarily credited to Arcangelo di Cola like the Stroganoff *Virgin with Four Angels* in Leningrad, though both are in fact indisputable and admirable works by the Friar. But since this small group (to which can be added only a few other items such as the two Saints at Chantilly, the small Frankfurt altarpiece and the Parry predella) shows unexpected and, I am tempted to say, reluctant traces of Gentile [da Fabriano]'s novelties applied as a sort of overlay on the early Masaccesque style, I think the whole group already suggests a date falling within the time of Gentile's sojourn in Florence; beginning, however, as early as 1424, when the Mather *Saint Jerome* reveals, as yet, no signs of the latter's direct influence.

Immediately afterwards, to my mind still between '25 and '30, Angelico shows that he is once again paying close attention to Masaccio's

extraordinary growth, taking place right next door; the proof is in a group of paintings that criticism has to this day preferred to undervalue rather than to understand properly, pictures standing at an extremely intense and mysterious meeting-point between the two masters.

For instance – for how long has the admirable little panel in the Cook Gallery at Richmond borne the convenient name of the Umbrian Boccati! Only in his most recent "lists," I believe, has Berenson given thought to the work's extremely high quality, linking it with Domenico Veneziano. Stylistic differences aside, the cultural context of this painting predates Domenico's arrival in Florence. Nothing, in fact, permits one to date it beyond '25 to '30; for its friendly proximity to Masaccio is so vivid as almost to suggest shared work between the two artists. Who would venture to imagine that at the time of this work there existed a third artistic figure of such high caliber? Yet I know one critic who, when years ago he used to fool around with the crumbs of the Italian language and with the first packets of photographs, never failed to propose a nickname: in the present instance, it would have been either "Masangelico" or "Angelicaccio" (take your pick).

As for us Italians: if the intuitive understanding of that great artistic idea of ours called perspective had not fallen almost into nearly universal oblivion, there would long have been ample appreciation of the greatness of this composition, where the *hortus conclusus* ["enclosed garden"] of the cosmopolitan artists [of the International Gothic] is transformed for the first time into an Italian architectural garden, it too an outgrowth of Brunelleschi's thinking: it is square in scansion, and everything respects this structure, from the baldacchino to the sturdy figures of porters and the central group, placed in the middle of a meadow become a square flowerbed; or rather, a rustic woolen carpet, with a coarsely woven floral pattern.

Only two of the figures – the angels to the right of the Virgin – are executed in a manner closely resembling that of the still-young Angelico. All the rest, starting with the Virgin, who is clearly derived from the one
Pl. 3 in Masaccio's painting with Saint Anne from around 1424, manifest such deliberate weight in their gestures and power in their vestments, such emphatic contrast between light and shadow, as to come almost closer to Masaccio than to Angelico. Witness the supremely plastic episode of the
Pl. 34 foreshortened Angel who bends over the Virgin's shoulder, confidentially resting his hand, festooned in black lace, upon it; or the almost surly profiles of the two "lay" angels behind the central group. It is true that the dark blue of the Virgin's mantle, hollowed out by the chiaroscuro as neatly as

if it were a chunk of lapis lazuli, is marked with those extremely fine parallel lines of light we see in certain drawings of Angelico; but the abstract beauty is so monumental as to serve as a link between Masaccio and the sublime lessons Leonardo later offered in the drawing of drapery. And the intervals of background between the haloes in perspective: here is something rarely repeated in the rest of Angelico's work!

Whatever one is to conclude – and it seems almost shameful to have to abandon to anonymity a work of such high caliber – it is certain that the painting seems to mark the precise, intense constellation of two stars that almost touch, indistinguishably mingling their light: the constellation Masaccio-Angelico, at an early date, between '25 and '30.

A few other paintings, moreover, seem to hint at this most logical conclusion: paintings illumined by the same beams, and more certainly the work of Angelico; though sometimes, with the utmost indignity, put in quarantine.

If there is any truth in the gossip reaching me from across the ocean – and it is too good to resist repeating! – then, at the recent New York exhibition, there was no lack of doubt cast even on the best-known work in this group, the small Uffizi panel of the *Naming of the Baptist*. Be that as it may, few paintings so clearly reveal Angelico's brilliant intuitive understanding of Masaccio's most subtly perspectival moment, as it is expressed in that masterpiece the Berlin *Birth Plate*. The same may be said of the other Pl. 30 small painting that in some respects would seem to be its companion (and perhaps, given their similar dimensions and their intense affinity, they were indeed companion pieces) in the collection of the Duc du Cars at Paris; with a rare symbolic figuration of Christ transmitting to the Apostles the right to bind and loose – subject matter which might be said to bear a precise relation to Masaccio's thinking in the Brancacci cycle, where, as has been penetratingly suggested, he replaced the *Giving of the Keys* with the more unusual subject of the *Tribute Money*.[37] And in the picture in Paris, the figure of Christ, powerfully wrapping his hidden arm in his tunic, is not unworthy of the Masaccio of that period; while the *Tribute Money* is freely followed as the source for the strongly modeled head of the youth interposed between Christ and the Apostle. And one cannot be too adamant in opposing anyone who persists in leaving in limbo other pieces created in the same spirit, such as the predella of *Saints Cosimo and Damian*, exhibited in London in 1930 (no. 192), on loan from the Spencer-Churchill Collection (even if, in some parts of the execution – for instance, the figure of the sick man – one might well suspect the intervention of Andrea di Giusto), or the other small painting in the museum

at Cherbourg depicting a young saint (Julian, perhaps?) who, in a florid landscape, is weeping with his hands over his face, a brilliant variation on Masaccio's Adam [in the Brancacci Chapel]; in Berenson's lists, the work is credited to the mediocre "Master of the Castello Nativity."

Again, Angelico's affinity with Masaccio, who is either still alive or, at least, still breathing in spirit in the fresh lime of the Carmine, can be read in two admirable little paintings in the gallery at Forlì. It is true, of course, that they have suffered somewhat, and that judgment should accordingly be limited to a cautious deciphering; but it is quite one thing to voice the appropriate suspicion that they may be copies, as was done in a recent monograph on the city, and quite another to overlook them altogether, as in Berenson's lists of Italian paintings. No doubt they belong to the same period as the *Naming of the Baptist* and the small Du Cars painting; indeed, their identical height (26 cm), the similarity of the haloes, of the gold trim on the garments, of the rhythms of the light, drenched grass, might suggest their belonging together, the more so in that the subjects of the two little paintings in Forlì do not seem the most appropriate for forming a diptych. But what in fact needs urgently to be pointed out here is that the acuteness of spatial structure in the two paintings is the most penetrating ever found in Angelico. In the *Nativity,* the reminiscences of Gentile's tender nocturne and, for that matter, of the crackling chill of Lorenzo Monaco are resolved with almost dramatic realism by that late-twilight sky, on which is carved the most powerfully looming, and at the same time the most keenly articulated, Italian mountain ridge ever rendered in painting; while in the foreground, the motif of luminous radiation that gently grazes the solid form of Saint Joseph, totally enclosed in his yellow mantle, is a detail of uncommon intelligence. In the *Christ on the Mount of Olives,* the vertical structure so madly exaggerated by Lorenzo Monaco in his small 1408 painting in the Louvre is now almost unrecognizable, so knowingly has the artist managed, in that narrow aperture, to open up space in every direction – the hut, the hedge, the rocks, the haystack – wherein move the most Masaccesque figures ever seen outside of Masaccio's own work. The Saint Peter quite clearly descends from that figure "flushed from bending" who is looking for the coin in the *Tribute Money;* Andrew, thrown to the ground and stiff-legged, in a red-lined cloak, falls asleep like some young *carabiniere* after a long round-up in the countryside; in front of him, the very handsome Saint John tosses and turns in his sleep, dreaming of his symbolic, poetical calamities. There is a host of contrary yet compatible motions, which only Raphael will be able to recreate, in the three Apostles writhing on the

crest of Mount Sinai. I hope that a careful cleaning of the two paintings will decisively justify my profound admiration for these works.

If I have perceived it correctly, this moment of extraordinary fraternity between Angelico and Masaccio must have arisen, I repeat, during the latter's lifetime, and by direct association between the two artists; but I shall spare my colleagues the transcription of those conversations one would do well to reconstruct in detail in one's imagination; in this case, too, with the purpose of vividly representing the real substance of the artistic history of such decisive years: a representation which is strangely in conflict with those who would deny "influences," as though mental exchanges between men were not a serious affair, growing the more weighty in direct proportion to the higher spiritual caliber of the parties involved. I, for my part, can see no nobler task than this for historians; nor do I see any task more essential for representing artists as "people" rather than robots or possessed souls.

Even dispensing with such conversations, the fact remains that this period, with Angelico learning from Masaccio, largely predates 1430; as I think can be gleaned from the fact that, as early as 1433, in the sublime Linaioli altarpiece, Angelico revises his cultural experiences in a more personal fashion, fitting them into a more severely liturgical setting: in essence, into a new form of "supernaturalism" from which, to the end of his career, he will never again depart. Should anyone ever succeed in putting precise dates to several consecutive pictures in the group whose monumental summit is reached in the Louvre *Coronation* – where the firm, brightly illuminated structure seems to have been the true spiritual school for Paolo Uccello and Piero della Francesca, while the predella, above all in the apparition of the "Brancaccian" Apostles to Saint Domenic, in the shadows of the brand-new Brunelleschian nave, still bears traces of Masaccio's idiom, traces scarcely stronger than those in the small paintings we have just examined – then I think the findings proposed today will meet with further corroboration. Meanwhile, I recall that the panel depicting the *Naming of the Baptist* was copied in 1435 by Andrea di Giusto,[38] on the step of the altar at Prato; and because a painting was usually copied only when time had already ripened its fame and, so to speak, allowed the most basic of author's rights to expire (a period which at the time ranged from five to ten years), I find here additional confirmation that a significant number of pieces in the new series naturally ought to be placed in the five-year period I have proposed ('25 to '30). To cite another clear-cut instance: Bicci di Lorenzo does not copy Gentile's Quaratesi polyptych until eight years after the date of the great original.

* * *

Apart from this extraordinary and very early parallel, readily apparent in Angelico's work even before '33, there is very little, in the Florentine art of the third and even fourth decades of the century, that can be profitably set alongside Masaccio's innovations. I regret that those banners announcing the grand opening of the Renaissance must stand fading for so long; but there is no hushing up the fact that, for twenty years afterwards, most work in the dominant (and, one deduces, most eagerly requested) manner is done by mindless calligraphers, followers of Don Lorenzo Monaco and his anonymous rival "just back from Spain:"[39] artists like Rossello di Iacopo Franchi, the Master of Borgo alla Collina, the Master of the Brozzi *Annunciation,* the Montefloscoli Master, and an endless stream of others; or by lazy cynics like the pseudo-Ambrogio di Baldese (possibly Buonaiuto di Giovanni, as Dr. Pudelko has suggested) or – an even better example – Bicci di Lorenzo, who, lasting until 1452, attests to the will to hold on as long as possible to his proud position as leader among those who could not be bothered. If it is true that, in his *Feast of Saint Egidius,* this last-named painter imitates Masaccio's work in the Carmine, he nonetheless could not have better shown the unresponsiveness of his heart than by making, as he has, all essence of modernity evaporate from the scene. He even refuses to take seriously Masolino's worries, readily apparent on the nearby wall! And we can forget about Giovanni dal Ponte as well: while he displays an awareness of Masaccio's existence, he nonetheless refuses to take the point, reducing everything he touches to a hasty stereotype.

From the "mindless" and the "uninterested," we pass on to the "confused." They at least do not trample upon the new with the all-purpose glibness of Giovanni dal Ponte; and they do make an effort, so far as their slight gifts permit, to filter the novelties into their other received ideas. To add to their touching confusion – so like Masolino's own – all that was lacking was the arrival in 1420 of Arcangelo di Cola, and, in 1422, that of the magnificent spendthrift Gentile da Fabriano! Everyone tries to make the most of this new turn of events. The first to give some sign of these vague stirrings is the "Master of 1419"[40] (a date, we immediately note, that is in itself sufficiently remarkable); and 1410, out of the limbo of the *Camaldolites,*[41] rife with cedars and raspberries, there emerges, showing intermittent flashes of individuality, the "Master of the Griggs Crucifixion,"[42] with his allusions to Masolino and to Arcangelo di Cola

(who had himself,[43] rapidly and in a fashion testifying to his unusual intelligence, joined up with the "confused"); and here, too, we have Francesco d'Antonio, the first who ventured to isolate the motifs of the young Masaccio;[44] and Paolo Schiavo[45] as well, who, moving along the same path, will almost manage, toward the halfway point of the fourth decade, to get himself received among the "dazzled." Among the visitors to the Carmine in those years there were, unfortunately, only a few above-average painters: the first was Sassetta[46] who, nurtured (as we have noted) in the same soil as the young Masolino, nonetheless presented very astute and precocious references to Masaccio as early as 1430 or thereabouts; but remaining ever, and quite intensely, himself, so that fortunately he keeps us from enrolling him in any faction. Another equally free and lofty spirit, was, I believe, also Siennese: Pietro di Giovanni d'Ambrogio.

As for the "dazzled," who start to form a pack in the Carmine as early as 1430, without a doubt the most restless leader among them was the young lay brother Fra Filippo [Lippi]; and his early form will be sufficiently clear if we but recall that period when hundreds of critics, including the most renowned, were taking turns hurling themselves into their own personal discovery or rediscovery of the Trivulzio lunette,[47] the *Confirmation of the Carmelite Order*,[48] and other such works. In the enthusiasm of those none-too-remote days (1935-36), people were perhaps forgetting to notice that, for all Lippi's merits, these works contain many forced notes and even constitute − why not say it? − a caricature of Masaccio. And because that word, in this and similar instances, signifies the willful taking out of context of one or another aspect of an art consummately harmonious and utterly free of dogma, as is Masaccio's, there can be no doubt that here there already looms up (to be more precise) that dangerous and persistent isolation of the medium of "line" at which Masaccio, as we have seen, had barely hinted "when he began to practice": in certain passages of the *Madonna with Saint Anne*, in the Gardner profile[49] or in the portraits he added to Masolino's *Saint Peter Preaching*: a tendency in which Lippi will obstinately persist even after his journey to Padua, egging on, in turn, other seriously "dazzled" artists, such as Andrea del Castagno.

Pl. 3

But already, towards 1430, others of the same faction were buzzing about in the Carmine chapel, most of them from Siena. It would seem, in fact, that Lippi was usually the one responsible for enticing them there, if it is through his mediation that certain of Masaccio's ideas seem to enter the work of the Siennese Domenico di Bartolo, as Dr. Pudelko has asserted: but he overstates his case, given that the *Virgin with Saints Peter*

and Paul (at the Duveen gallery in New York) is no longer the work of Lippi but rather already that of the Siennese painter, executed around 1435.[50]

Moreover, in Domenico di Bartolo[51] – as in certain isolated but recurrent passages in the mature Sassetta and even more in the young Vecchietta, with his modernizing ferocity at Castiglione d'Olona, circa 1437-89 – a new abstract impulse is manifest: a straining to the utmost to isolate, in the living body of Masaccio's art, the motifs he had cautiously sought in his first years, motifs of the most subtly experimental perspective. In such disciples, this perspective has now grown hypertense, absconding and then thrusting out again into diminishing arches there, into converging checkerboard floors here, into oculus windows and receding scallop-shell moldings, into hide-and-seek columns, thresholds seen from below, the problematical sharp edges of tilted haloes, all constantly changing in the pursuit of "greater difficulty." Quotations, therefore – always quotations from Masaccio, rather than his meaning, even in the century's third decade; and always fabulous, unreal, abstract reversals and reductions of the new, altogether concrete elements in his art.

Only as we approach the year 1440 does Florentine painting get back on the straight and narrow, leaving Siennese painting to its own specious destiny and showing a renewed awareness of Masaccio's revelations, including those subtly airy and coloristic aspects[52] on which the master, in his urgent synthesis, seems to have lavished a particular care. Then we witness the growth of the frescoes by an anonymous artist in the Orange Cloister at the Badia:[53] a master whose simple, powerful way with both closed form and extended, compact color is such as to singularly presage the manner of an Antonello; and, in the same period, even on the narrow walls of Sant'Egidio, there is vividly set the brilliant narrative of an artist new on the scene, Domenico Veneziano, who has with him on the scaffolds none other than the young Piero [della Francesca] from Borgo San Sepolcro.

And of course at this point, having seen how, for almost twenty years, artists were often caught up in over-clever quotations, people from several camps will ask me whether I have by any chance forgotten the existence of Paolo Uccello, as though I were a rank novice at art history. But the "critical fortune" of this painter who is still viewed, owing to the erroneous placement of his biography within Vasari's framework, as one of the patriarchs of the new painting of Tuscany, almost on the level of Masaccio himself, is too instructive to be summarized in a few lines. I shall tell the tale of that critical fortune another time, giving here only the results, all too negative, of a study showing the painter to have participated

only feebly, and always notably late, in the actual growth of Florentine art. Has proper weight ever been given to the fact that Alberti, in the famous passage of 1435, does not think Uccello can be cited among the great spirits of art's rebirth; and that Domenico Veneziano's 1438 letter to the Medici cites only two painters of the first rank in Florence, neither of them Paolo Uccello? At the very least, how is one not to suspect that Vasari's strained insertion of his name into the famous quotation (transferred, in every other respect, almost verbatim from Alberti's text) is not just a simple mistake in historical interpretation? The works, moreover, exist to prove it. Led into this misconception by a birth-date earlier than Masaccio's (ah, these distant preludes to the *Theorie der Generationen*!), Vasari does not even bother to cite, among the "dazzled" of the Carmine Chapel, this artist who was farther gone than any: last on the scene, his mind full of Northern fables about the "quaternary" world of an immemorial Genesis, as we read in the first frescoes of the Green Cloister [at Santa Maria Novella]. Then too, Uccello was the one most prone to believe that the "sweet art" of perspective was worth using only as a deceptive architectonic specialty, as we see at Venice in the Chapel of the Mascoli [in San Marco], where he draws for "spatial reasons" upon the last edifices of the Gothic, although for his figures he tends to adopt the manner of the Venetian master Michele Giambono.[54] What are we to say, then, if we find him still uncertain of his path in the heads on the [Florentine Duomo] clock of 1443, in the Prato frescoes (c. 1445), in the Quarata predella and even in the predella of Avane, now among the deposits of the Uffizi which bears the incredible date of '52? By that time, all the loftiest words in the Tuscan art of the Quattrocento had been uttered. Only between '55 and '60 does Paolo Uccello manage to express in a manner, if not exactly supreme, certainly very rigorous, his tortuous, cantankerous wit, in the famous Battles[55] and in the *Stories of Noah* in the Green Cloister, and in the green, red and black *Hunt* at Oxford, only to plummet again thereafter, in the Urbino predella, to the level of a punctilious artisan. This is evidence enough for us to conclude that the recent grandiose apologies for his genius are largely the concoctions of surrealists who, having once sniffed out something odd, have mistaken it for the esoteric; whatever truly esoteric elements there may be in Uccello's art (assuming that they matter) must instead be sought up front, so to speak, right there on the picture's surface; and not around the back, behind the panel.

From a closer look at this abstruse artisan, at this paradoxical builder of strong-boxes, there will finally emerge with greater clarity, without make-up or disguise, another main feature of the Florentine painting of

the Quattrocento; to this end, though, it was first necessary to explain, as I have attempted to do here, the immediate fate of Masaccio's spiritual heritage. Still, it is fitting to conclude, for now, with the same words which appear, clearly and heartrendingly (for all that they refer merely to such worldly goods as he left behind) in the first documents after the artist's death: *et non si truova chi sia rede* – "and no heir is to be found."

NOTES

Roberto Longhi's notes appear without brackets.
Notes within brackets are editorial notes.

1. [Gaetano Milanesi (1815-1895), Siennese paleographer and art historian whose publications of source documents still constitute an important contribution to the study of Italian art. His edition of Vasari's Lives (in *Le Opere di Giorgio Vasari, con nuove annotazioni e commenti di G. Milanesi,* 9 vols., Florence, 1878-85) was considered the standard version for over a century. (Ed. note)]

2. In his volume *Masaccio* (Rome, no date), to whose bibliography I refer the reader for the quotations of Schmarsow, Toesca, Mesnil, et al. that will repeatedly occur in this article. It would, moreover, be a slight to the reader to presume that he did not know, line for line, the most important writings on the history of the question.

[Longhi sets out to clarify the historically confused situation regarding the division of hands in various works attributed to Masolino and/or Masaccio, including the vastly influential fresco cycle in the Brancacci Chapel in the church of Santa Maria del Carmine in Florence. In a broader sense, what is at issue is the nature of the artistic and stylistic relationship between Masolino (Tommaso di Cristoforo Fini, born at Panicale in Valdarno, 1383-1440) and his fellow-Tuscan and sometime collaborator Masaccio (Tommaso di Ser Giovanni Cassai, born at San Giovanni Valdarno, 1401-28). (Ed. note)]

3. [Cavalcaselle followed the tradition according to which Masaccio was said to have been a pupil of Masolino; as Longhi demonstrates, this tradition was based upon a misreading of Vasari's text in his *Life* of Masaccio. The pioneer of Italian connoisseurship also accepted Vasari's statement that the Colonna altarpiece and the frescoes in San Clemente at Rome were by Masaccio; modern criticism gives the altarpiece to Masolino and recognizes that the same artist also painted most of the Roman fresco cycle.

But the "astonishing mental aberration" refers specifically to Cavalcaselle's views regarding the frescoes in the Brancacci Chapel. Rejecting outright Vasari's accurate statement that both Masolino and Masaccio had worked there, Cavalcaselle, in his monumental *A New History of Painting...* (London, 1864-1866), assigned the entire cycle (except for the important passages added later in the fifteenth century by Filippino Lippi) to Masaccio alone. Naturally, this position obliged him to find some other explanation for the numerous portions which he clearly recognized as being in Masolino's manner. He accounted for them by saying that it was natural for the youthful Masaccio to imitate his master and then to have discovered and developed his own personality as he went along. In order to clarify and buttress this position, Cavalcaselle insisted upon the supposed analogy with Raphael, who imitated Perugino early on and then rapidly found his own genius. (In his enthusiastic annexation of other artists' work at the Carmine to the *corpus* of Masaccio, Cavalcaselle even went so far as to claim for Masaccio the *Confirmation of the Carmelite Rule* in the adjacent monastic complex, accurately described by Vasari as the work of Filippo Lippi.)

Among the various participants in the decades-long debate precipitated by

Cavalcaselle's radical exclusion of Masolino from the Brancacci Chapel, Bernard Berenson will need no introduction to English-language readers. Gustavo Frizzoni, who started out as a disciple of his fellow-Bergamasque Morelli, published his important *Arte italiana del Rinascimento* in 1891. Born at Modena in 1856, the self-taught Adolfo Venturi was one of the pioneers in the introduction of the professional art-historical discipline in Italian academic life. Pietro Toesca, Longhi's teacher at the University of Turin, did his most enduring work in the field of late medieval Lombard painting but also published a monograph on Masolino (Bergamo, 1907). Raimond van Marle's survey *The Development of the Italian Schools of Painting* (6 vols., The Hague, 1923-25) once enjoyed wide currency. (Ed. note)]

4. Cf. Procacci, "Relazioni su lavori eseguiti nella Chiesa del Carmine," in *Bollettino d'Arte*, 1933, p. 327 ff.

5. [Castiglione d'Olona is a town near Varese in Lombardy where Masolino left two separate fresco cycles. The Scenes in the Collegiata church, painted with the assistance of the Florentine Paolo Schiavo and the Siennese Lorenzo Vecchietta, are often said to have been executed in 1428 (the year of Masaccio's death), but their dating remains a matter of dispute. The *Scenes from the Life of John the Baptist* in the adjacent Baptistry, dated 1435, contain notable passages of landscape painting. The nearby Palazzo Branda Castiglioni houses a fresco constituting a very early example of pure landscape, regarded by most historians, including Longhi, as the work of Masolino. (Ed. note)]

6. [Now in the collection of Ezio Matteini in Florence, the picture is reproduced on page 151 of the catalogue *L'età di Masaccio: il primo Quattrocento a Firenze*, Milan, 1990. (Ed. note)]

7. The only record of frescoes by Gentile, probably from the Lateran cycle, is a graphic one: the drawing, certifiably in the master's hand, but attributed to the Tuscan school (no. 6), in the Albertina Museum in Vienna. It depicts a Saint (perhaps Saint John the Evangelist) in prison; on the verso are studies of animals.

8. [Sanseverino Marche, in the Marches, boasts a significant local school of late-Gothic painters, known collectively as the Sanseverinati. Allegretto Nuzzi or, more usually, Nuzi (1315-c.1373) and Francescuccio Ghissi (doc. 1359-95) were painters active in Fabriano, another important center in the same region. (Ed. note)]

9. [The famous "lists" of works attributed by Berenson to the various Italian masters, published in his *Italian Pictures of the Renaissance*, Oxford, 1932 (revised editions, 1957 and 1963). Longhi sardonically described them as "that new timetable of the Italian artistic railways which many people, out of mental cowardice, take as Gospel" (*Officina Ferrarese* Rome, 1934, p. 9). (Ed. note)]

10. [The followers of Agnolo Gaddi (?-1396) and Andrea Orcagna (1308-c.1368), leading Florentine painters of the second half of the fourteenth century. (Ed. note)]

11. *The training of Giovanni da Milano; Maso, Stefano, Giusto, Giottino.* One cannot hope, in a brief note, to present, in its turn, the complex training of Giovanni da Milano. Berenson's caption says he was

probably schooled in the "Milanese Giottesques, but influenced by Orcagna and Nardo di Cione." The second part of this proposition is, as has been said, inadmissible, while "Milanese Giottesques" is too vague a term, borrowed from Toesca's cautious observations in his nevertheless important book on painting in Lombardy. Today we can say with certainty that the greatest Tuscan artist working in northern Italy before 1350 was Giusto de' Menabuoi. It is interesting to note that he appears to have come of age in Florence within the most "pictorially" refined circle of the new generation already blossoming at the time of Giotto's death; I am referring to the circle of Maso and the master often confused with him (perhaps the Stefano discussed by Vasari), whose profile can be reconstructed not only from the stories of San Stanislao and other similar frescoes at Assisi, but also from the splendid *Crucifix* in the Louvre (no. 1655) and the Vatican panel (no. 170, formerly no. 43) usually ascribed to Pietro Lorenzetti, *Madonna Enthroned with Saints*, which should be placed together with another panel formerly accompanying it, now reduced to only the center part, the *Crucifixion* in the Kress Collection.¹ From this splendid cultural background spring Giusto's first works in Lombardy, that is, the frescoes, not yet recognized as his, in the lantern of Viboldone (1349). Giusto later reconciles this early manner with the more severe, arcane manner of the Veneto, as I clarified elsewhere (*Pinacotheca*, 1928).² From the exquisitely liturgical poetics to which Giusto gave expression in his Paduan frescoes, in the sublime *Apocalypse* of Fuerstenau (exhibited as no. 85 in the Mostra Giottesca, as belonging to the Neapolitan school), and in the Petrarchan pre-Humanist miniatures in the two copies of the *De Viris Illustribus* at the Bibliotheque Nationale in Paris (no. 6069, I and F), which Toesca attributed to Altichieri's school (cf. *Le Miniature Hoepli*, Milan, 1930, p. 36; and see reproductions in *Art Bulletin*, 1938, p. 103), Giovanni borrowed the more solemn manner of his Florentine frescoes. Yet his inimitable way of altering this manner with more worldly and "portraitistic" aspects in certain details of *Joachim in the Temple*, *Christ in the House of Martha*, etc., must be taken as a subtle reconciliation on his part with other, more typically "Paduan" approaches, which in fact we've already commented upon, from Vitale da Bologna to Tommaso da Modena. It is above all with regard to this side of Giovanni da Milano that the invocation of "Milanese Giottesques" is, of course, unsatisfactory. With such a curriculum vitae, it thus seems natural that Giovanni, upon arriving in Florence, would find only one local painter capable of fully understanding him — this painter being the author of the famous *Pietà* of San Remigio and the *Tabernacle* in Via del Leone, who might be the "Giottino" invoked by Vasari, and was in any case a master of the 1360 generation and thus should be seen as clearly distinct from Maso, with whom Toesca, however, insists on identifying him (*La Pittura firoentina del '300*, p. 64). The clear, necessary distinction between "Maso" and "Giottino" was first pointed out in a passage in my essay on Giusto (*Pinacotheca*, 1928, pp. 143-144 and note 1) and seconded a year later by Offner, as concerns Maso, in his essay on the master (*Burlington Magazine*, 1929, LIV, p. 224).

While we are on the subject, I also believe it may be useful to recall that another similar "encounter" between "Paduan" and Tuscan painting has yet to be deciphered in the nevertheless rather famous *Assumption* on the door of the

Camposanto of Pisa. It is common knowledge that Vasari, with considerable wavering, attributes it first to the mysterious Stefano, then to Simone Martini; less known is the fact that in Berenson's *Indexes* it is ascribed to Traini, with the addition, for support, of Antonio Veneziano. Utterly new, on the other hand — as far as I know — is the idea that the work belongs to a master to whom we also owe the best frescoes in the lantern of the Charterhouse of Chiaravalle near Milan. Here we have a good opportunity for figuring out who these "Milanese Giottesques" might be. The master of Chiaravalle and Pisa seems indeed Florentine, though not Giottoesque, but rather a participant in that profound and, at times, highly personal trend away from the art of Giotto which one can read between the lines in Vasari's accounts of the Lives of Stefano and Giottino and which can be gleaned from the works that can be most convincingly associated with these two names. The cultural background most similar to that of the unknown master is that legible in the San Remigio *Pietà*, the Via del Leone tabernacle, and the splendid Louvre *Crucifixion* usually attributed to Daddi (no. 1556A). Only by unearthing new works will we ever settle the question of whether it is possible to establish from all these paintings a simple relationship among similar personalities, or, as I am inclined to believe, the itinerary of a single, great figure, that of Giotto di Maestro Stefano, known as Giottino.

12. Perkins (*La Diana*, 1931, p. 23) attributes it to Sassetta; Pope-Hennessy (*Sassetta*, p. 170) ascribes it to a follower of the master, whom he attempts to embrace under the label of "Castelli-Mignanelli Master"— though he is hardly consistent in doing so, since some of the works of the proposed group are, at least in theory, by Sassetta himself (e.g., the *Annunciation* of the Robert Lehman Collection), while the authenticity of the *Madonna between Two Angels* of the Walters Collection seems highly dubious.

13. [In the church of Santa Croce in Florence. The cycle to which this fresco belongs probably dates from around 1365. (Ed. note)]

14. Another panel of Giovanni da Milano that certainly belongs to the same polyptych (as the identical gap that has formed between the wood and the primer should suffice to prove, provided the measurements tally) is a *Saint Anthony Abbot*, reduced to a half-figure, in the Kress collection, New York.

15. [The little oratory of the Madonna di Montemarciano, in the Tuscan countryside, houses an early-fifteenth-century fresco which is sometimes attributed to Masaccio, but which modern criticism has tended to give to Francesco d'Antonio or else to leave anonymous. Paul Joannides, *Masaccio and Masolino: A Complete Catalogue*, London, 1993. (Ed. note)]

16. As far as I know, only Dr. Procacci, in his essay *Gherardo Starnina* (Florence, 1936, p. 94), adds the qualification of "in part," when discussing the Uffizi panel as a work of the young Masaccio. Yet what parts of the work he might be referring to I cannot say.

17. These examples were also recently studied by M. Pittaluga in *Arte*, 1931, p. 105, especially in regard to the Figline tabernacle, though without yielding any arguments useful to our study.

18. A critic who took the trouble to follow this order, while drawing, however, false inferences from it (indeed, having the scaffolds reconstructed twice), was Marrai in the *Miscelleana per Masaccio* of 1903. The only person I know of to insist recently on the same need is Ruth Wedgwood Kennedy, in her review of Prof. Salmi's *Masaccio* (*Art Bulletin*, 1934, p. 396).

19. [Ever since the publication in the *Burlington Magazine* in 1939 of Richard Offner's "Giotto, Non-Giotto," there has been a great gulf fixed between English-language art historians and their Italian colleagues over the issue of Giotto's participation in the cycle of the *Life of Saint Francis* in the Upper Basilica at Assisi. On the strength of Offner's stylistic analysis, the former have generally denied Giotto's involvement; while the latter, faithful to their historiographic tradition, have continued to affirm it. In an effort to reconcile the early tradition of Giotto's presence at Assisi with their own reading of the stylistic evidence, some American historians have identified Giotto with the anonymous Isaac Master whose work appears higher up on the same wall. The classic statement of this position (written more recently than the present article by Longhi) is to be found in Millard Meiss, *Giotto and Assisi*, New York, 1960. (Ed. note)]

20. [A *desco da parto* is the painted tray on which upper-class Florentine women in the fifteenth century were traditionally served their first meal after childbirth. Such trays were generally painted with subjects auguring well for the newborn child's future. (Ed. note)]

21. [In the Isabella Stewart Gardner Museum, Boston. One of a group of four undocumented profile portraits, often studied together, others of which are now in Chambéry and Washington. They have been variously given to Masaccio, Paolo Uccello, Domenico Veneziano and others, and are not all by the same hand. The attribution of the Boston painting to Masaccio is now generally accepted. For a summary of the overall situation regarding these pictures, see Fern Rusk Shapley, *Catalog of the Italian Paintings* (i.e., in the National Gallery of Art), Washington, D.C., 1979, pp. 181-184; for a detailed account of the Gardner profile, see Paul Joannides, *Masaccio and Masolino: A Complete Catalogue*, London, 1993, p. 456. (Ed. note)]

22. The generic assertion of an intervention by Masaccio in the background of this scene was already made in 1928 by C. Gamba in an article in *Marzocco*.

23. [The figures of cripples here mentioned by Longhi are part of the famous cycle of the *Triumph of Death* in the Pisan Camposanto or burial ground. The works were seriously damaged by an Allied air raid in World War II, but are still vividly legible. Although Longhi suggests an attribution to a Bolognese master, the frescoes have more generally been ascribed over the years to a variety of Florentine artists, including Francesco Traini or Andrea Orcagna. In recent decades the attribution to Buonamico Buffalmacco, a mysterious painter mentioned by the fourteenth-century Florentine writers Boccaccio and Sacchetti, has come into favor, although certainty as to the identity of the Master of the Triumph of Death may always prove elusive. See L. Bellosi, *Buffalmacco e il Tronfo della Morte*, Turin, 1974; also Alastair Smart, *The Dawn of Italian Painting*, London, 1978, pp. 116-

68

119. (Ed. note)]

24. In recent years even Venturi, Toesca and Salmi have been inclined to admit that Masaccio intervened to some degree at San Clemente, especially in the *Crucifixion*; yet aside from Venturi, who broadened the hypothesis too much, they all limited themselves to wholly generic allusions.

25. ON OTHER WORKS OF MASACCIO NOT CITED IN THE TEXT: *Our Lady of Humility*, New York, Duveen House. I had a chance to study this work at the Parisian Exhibition of 1934. Inclined to accept the commonly accepted attribution proposed by Berenson, I have abstained from discussing it because the piece's condition makes it difficult to place it precisely in the master's development. It is not possible, for example, to conclude anything from the foreshortened image of a dove, which belongs entirely to the modern restoration.

Holy Family with Female Donor, Altenburg Museum, no. 156. I cautiously proposed attributing this work to Masaccio in 1926, since there was no question of the work's belonging to Ansuino, to whom it has been attributed on several occasions, and since the idea seems worthy of the great Tuscan's youth. But here too some reservation arises due to the state of the work, which has been too patched up by restorations. Nor can I concur with the attribution advanced by Pudelko (*Art Bulletin*, p. 104 ff.), who ascribed it to the young Fra Filippo. Only the removal of the repainted parts would make it possible to make a definitive judgment.

Story of San Giuliano, Florence, Horne Museum. A recent volume on Masaccio declares that it is impossible to judge this work because of its state. But a panel that has not been repainted, however abraded it may be, can always be judged, even if a little finger is all that is left; and here there is much more, as Gamba and Salmi noticed when they ascribed the work to Masaccio. There is no doubt that the painting is consistent with the Pisan predella for which Masaccio strangely assigned the execution of the same subject to Andrea di Giusto. Although in this period San Giuliano and his stories were sprouting up everywhere, it would almost seem natural to imagine that the panel, which has now been broken up and was certainly originally more extensive than the part relating to this story in the Berlin panels, might have been prepared by Masaccio for the Pisan polyptych and then set aside while the artist forced the subject into a smaller space so as to leave sufficient room for the story of San Nicola as well. The first idea could have arisen from the desire to reserve a greater space for the story of the Saint of the same name as the man commissioning the polyptych; and it might have also been at the behest of the same patron that the panel had to be redone in the new form, a task which Masaccio may not have taken the trouble to execute personally. Or else it may be that the reworking was undertaken because of the patron's dissatisfaction with the overly elliptical, silent manner in which Masaccio had here treated the episode of the parents' murder.

WORKS ATTRIBUTED TO MASACCIO OR TO HIS IMMEDIATE CIRCLE: *The Eternal Father Giving His Blessing*, London, National Gallery. This is a work of the Venetian school from between 1450 and 1465, with a special affinity to the early period of Giovanni Bellini, then under the influence of Antonio Vivarini, who nevertheless had

been a Masolinesque painter. Thus, rather than being the apex of Masaccio's Pisan polyptych, as has been suggested, it might actually have sat atop a Bellinian polyptych — one of the Carità polyptychs, for example, which are much more complex than they may appear and were originally provided with predellas of which a remainder (aside from the well-known panels of the Kaufmann Collection), featuring the *Adoration of the Magi*, is now in the Contini-Bonacossi Collection in Florence.

Two portraits of Casa Medici, Zurich, Landolthaus. For Berenson, these were copies of Masaccio. Pudelko (*Burlington Magazine*, 1936, p. 235) suggests Andrea del Castagno. Salmi maintains they are derivations from Paolo Uccello. To me they seem copied from very strong Flemish originals of the age and manner of Petrus Christus. And if they are indeed portraits of Medicis, as would seem to be confirmed by the coats of arms and by the fact that in Florence there is no lack of other copies of Medici personalities from the first half of the Quattrocento derived from Flemish originals of the same genre, one might well ask oneself if there didn't perhaps at one time exist, in Florence, a large Medici altarpiece from Petrus Christus's hand where all these portraits appeared together, involved in some action, a notion suggested even by these two copies, which look somewhat uneasy in their current, halved form. The whole series of the great Florentine "Adoration of the Magi" scenes from the second half of the Quattorcento, with their overuse of secular and patrician portraits within a strictly religious subject, seem in fact to draw upon a Flemish, not Italian, idea — starting with the "Adoration of the Lamb." This is, of course, an idea that could only be proved by those with a profound knowledge of Tuscan archival sources, such as Poggi, Tarchiani, Procacci, et al.

26. [The original *hodegetria* was an icon believed to have been painted from life by Saint Luke, the patron saint of artists. Acquired in Jerusalem by the Empress Eudocia in 438, it was repeatedly copied and became one of the canonical *topoi* of Byzantine art. The subject depicted is the Virgin standing and supporting the seated Christ Child on her left arm. The Child holds a scroll in his left hand and blesses with the right. The Child's nimbus is cruciform, while the Virgin's is a perfect circle. (Ed. note)]

27. [Longhi is referring to Masolino's Colonna altarpiece, the panels of which are today divided between London, Naples, and Philadelphia. The scene of the *Miraculous Snowfall* celebrates the circumstances surrounding the foundation of the Roman basilica of Santa Maria Maggiore, which Pope Liberius was said to have started in the fourth century on the site traced out by snow that fell on August 5th, 356. The event is still commemorated every year by a shower of petals from the ceiling of the Pauline Chapel in the church. (Ed. note)]

28. *L'Arte*, 1930, p. 165.

29. [Now in the National Gallery in Washington, D.C., where it forms part of the Andrew W. Mellon Collection. (Ed. note)]

30. [The Cosmasteque style is a type of architectural decoration, characterized by geometric motifs carried out in mosaic inlays of polychromed marble and other materials such as colored glass. It takes its name from the Cosmati, a family of

Roman craftsmen who perfected it in the twelfth and thirteenth centuries. (Ed. note)]

31. WORKS BY MASOLINO NOT CITED IN THE TEXT: *Madonna with Child and Four Angels*, Munich Gallery. There is no question that this piece is from the beginning of the period of association with Masaccio, shortly before the Empoli lunette.

Annunciation in two parts, New York, Kress collection. This is probably from around 1430, shortly before the Goldman *Annunciation*. Though the influence of Fra Angelico on Masolino is evident here, excessive restoration has regrettably served to overemphasize this fact unduly.

Crucifix – Death of the Virgin, Rome, Pinacoteca Vaticana. The implication of the Gothic rhythms in Saint John's robes leads me to imagine that the two works, clearly fragments of a single whole, are from Masolino's late reversion, after 1435. This would eliminate Schmarsow's old hypothesis that they might have belonged originally to the Roman triptych of Santa Maria Maggiore.

WORKS ATTRIBUTED TO MASOLINO: *Crucifixion* at Montecastello. See the note on Arcangelo di Cola.

Annunciate Virgin, New York, Lehman collection (reproduced in Van Marle, IX, fig. 204). Variously attributed to Sassetta (Van Marle) and Masolino (Valentiner, Pope-Hennessy). Berenson attributed it to Sassetta in 1932, and to Masolino in 1936 (*Indexes*). Pope-Hennessy proposed dating it before the Bremen Madonna (1423). Yet just on the basis of the reproduction, one can preclude its attribution to Masolino. Much more likely is the authorship of Sassetta, clearly the early period, around 1425. The complex scalloping of the Virgin's cloak

seems more in keeping with the contemporary Veronese painters than with the Camaldolite style of Florence. Might there be, here too, some possible relations with Cecchino da Verona? See my observations on this Cecchino in note 43.

32. [John Pope-Hennessy, *Sassetta*, London, 1939. (Ed. note)]

33. THE FLORENTINE MINIATURE IN THE FIRST DECADES OF THE 1400S.

In his book on the *Hoepli Collection* (Milan 1930, p. 40), Toesca noted that its classifications were still confused, even in the individual studies, such as that of D'Ancona. An important step forward (*L'Arte*, 1932) was then made by Dr. Ciaranfi, who distinguished, in the *Diurnus Domenicalis* of the Biblioteca Laurentiana, which bears the date 1409, the parts by Lorenzo Monaco from others that pointed to the presence of Angelico at the very least, suggesting, albeit a bit too timidly, that the latter were added later, as often happened. The suggestion becomes absolutely compelling when one realizes that Angelico's presence always presupposes in turn the precedent of Masaccio. Thus whether these pagess are by Angelico himself or, as to me seems more likely, by some pupil of his, such as that Battista di Biagio Sanguigni whose profile was outlined by Toesca (*Rassegna d'Arte*, 1917, p. 117 ff.), it is nevertheless certain that their execution should be pushed up toward 1420, especially when we recall the point at which the Florentine miniature found itself in that year: I am referring to the miniatures indisputably by the same Bartolomeo di Fruosino (cf. R. Salvini, *Rivista d'Arte*, p. 205 ff.) who was also responsible, around the same period of time, for the *Crucifixion* pub-

lished (with reservations) by Berenson under the name of Rossello di Iacopo Franchi (*Dedalo*, 1932, p. 193), and whom Salvini (op. cit.) rather improbably credited with the polyptych from the Galleria di Parma, which I have attributed to Piero di Puccio (cf. A.O. Quintavalle, *Catalogo della Galleria di Parma*, Rome 1939, p. 185).

It is also possible that shortly prior to this moment, the Florentine miniature had already been lightly tinged with novelty. It is curious to note, for example, that in the very group of Laurentian codices that Van Marle, with typical confusion, wanted to attribute to the circle of Lorenzo di Niccolò, some miniatures, such as the one (Bibl. Med. Laur. Cod. Conv. Soppr., no. 457, D'Ancona, Plate LV) representing the *Martyrdom of Saints Peter and Paul*, or the one with the *Story of the Three Maidens* ("Storia delle tre donzelle") from San Nicola, are, at least iconographically, unquestionably related to the well-known scenes of the Pisan predella by Masaccio and Andrea di Giusto, much more so than the panels by Giovanni dal Ponte usually invoked in this regard. Or could it be that we are dealing here with a latecomer instead of a precursor, if only from the point of view of the iconography? The only painting that shows some relationship to these fine miniatures is the predella no. 1540 at Edinburg, which presents Saint Francis with his stigmata and Saint Anthony Abbot preaching — a work which Berenson, in the *Indexes*, lists, with a question mark, under the name of Andrea di Giusto, though it is surely by another master of the "Camaldolite" circle, one whose obvious qualities merit further research.

The general clarification of the problem is also made more difficult by the fact that very often, late-century neo-Giottoism (which in fact was stronger in northern Italy than in Tuscany), though it had nothing substantial in common with the imminent Masaccian developments, nevertheless yields results that could easily be taken as full-fledged Quattrocento. It is not uncommon to run across Bolognese miniatures from the time of Iacopo di Paolo and the real Iacopo Avanzi which seem, on first glance, more modern than they really are. The same is true of certain Emilian-Veneto miniatures of the same time. I am referring in particular to the fact that no less an expert in miniatures than Toesca (op.cit., p. 121, Plates 108, 109) attributed to the circle of Bartolomeo Viviani, thus to the second half of the Quattrocento, some pages by a certain Martirologio of Veneto origin in the Hoepli colleciton. The critic was led into error by the fact that the book included miniatures from two different periods, the later ones being in fact from well into the Quattrocento, and rather weak at that, such as the *Martyrdom of San Basso*. This is not true, however, of the others, lightly tinted with watercolor, whose quality is much higher and whose style situates them around 1400-1420 in the quadrilateral of Verona-Bologna-Ferrara-Padua. Of the names Iacopo da Verona, Iacopo di Paolo in Bologna, the anonymous master of the Evangelists at Ferrara, and the Paduan Miretto, the latter seems the most likely candidate for attribution in this case; but it will certainly be impossible to decide before the famous frescoes in the Palazzo della Ragione [in Padua] are made more legible by a decent cleaning. We would hope, moreover, that the book from which the two pages discussed by Toesca were drawn, and which later came into the same Mr. Hoepli's possession, will soon be published in its entirety, since it is one of the most important monuments of Veneto-

Emilian miniatures between the Trecento and Quattrocento. Another partial drawing in the same hand, and possibly extracted from the same whole, is in the Print Collection in Berlin, where it was attributed to Bicci di Lorenzo on the advice of Sirèn (cf. *Lorenzo Monaco*, p. 176, note 1), which was seconded by Van Marle, who reproduces it in Fig. 17 in volume XI, yet another confirmation of the confusion reigning all too often between late Trecento Paduan painting and later Tuscan painting.

34. THE THEBAID. Periodically, scholarly opinion concurs in attributing the famous panel of the *Thebaid* at the Uffizi to Starnina. In the text I have sought to demonstrate that it is instead the work of Angelico around 1420, at a time when Starnina had already been dead for a number of years. Moreover, in a more general consideration of the question, so studiously investigated by Dr. Procacci, one must not forget that Vasari places the Life of Starnina among those of the artists of the "first age," who do not in any way go beyond the spirit of the Trecento. And Vasari was more familiar with the frescoes of the St. Jerome chapel in Santa Maria del Carmine than we could ever be from the few revived remnants. The only suggestion one may draw from these, in fact, is that Starnina may have been the first to introduce to Florence, in the early years of the Quattrocento, after his journey to Spain, some new ornaments of a strongly graphic, somewhat exotic Gothicism, which could have been used by the circle of Lorenzo Monaco and his followers, at least in some areas. Nor do the fresco fragments from the Carmine seem to me consistent with the works in the Cappella Castellani, which have been attributed to Monaco, as early works, on the basis of

Vasari's indications — whereas in fact they show nothing more than the rough mediocrity of an anonymous pupil of Agnolo Gaddi. There is little, moreover, to be gleaned from the many embellishments Vasari gives this Life, which was clearly written in that same decorative spirit with which the biographer, every now and then, sought to enliven the reading of his text. But see also the note on the "*Maestro del Bambino vispo*" ("Master of the Spirited Child").

35. In Lorenzo de' Medici's inventory, one reads: "A small wood panel circa 4 *bracci* [in width], in the hand of Fra Giovanni, with stories of the Holy Fathers painted on it." The measurements correspond very closely, since the Florentine *braccio* is equivalent to .583 meters. The quotation is from Müntz, and Procacci cited it in his well known essay on Starnina. (*Rivista d'Arte*, 1936, p. 79).

36. Offner analyzed the painting as a work of Masolino (*Art in America*, 1920); in Berenson's *Indexes*, it is listed under Sassetta's name, an attribution later refuted by Pope-Hennessy.

37. [The *Tribute Money*, in which Christ instructs His disciples to "render unto Caesar that which is Caesar's," is such an unusual subject that historians have generally taken it as axiomatic that Felice Brancacci, who commissioned the cycle, intended it to refer to some specific and topical political question. It has frequently been suggested that the allusion is to the *catasto*, a new property tax which, although not definitively enacted until 1427, was being hotly debated in Florence throughout the period when Masolino and Masaccio were working on the cycle. An interesting alternative is the newer

theory that the matter at issue was the decision, in 1423, that the Florentine Church was liable to taxation; for this proposal, see A. Molta, "The Brancacci Chapel, Studies in its Iconography and History," *Journal of the Warburg and Courtauld Institutes,* vol. 40, London, 1977, pp. 50-98. For the most recent summary of the debate surrounding the political significance of the scene, see P. Joannides, op. cit., p. 319. (Ed. note)]

38. ANDREA DI GIUSTO. In Berenson's catalogue many works are attributed to this artist which surely do not belong to him, some of which we have already routed in other directions, such as: the two small Altenberg paintings, which seem to be by Schiavo; the two Carcassonne panels, which are part of the predella to the Grenoble triptych by Francesco d'Antonio; the predella no. 1540 at Edinburgh, made by a miniaturist around 1420; the later miniatures of the Diurno Domenicale at the Biblioteca Laurentiana, made by a follower of Angelico, perhaps also after 1420; the Narbonne *Pietà*, also by Francesco d'Antonio; the two small panels with *Stories of Esther* (Kress, Johnson), in a Siennese hand, perhaps that of Domenico di Bartolo, as Dr. Ragghianti has suggested in this periodical (no. XVI-XVIII, pp. xxii-xxiii), or more likely, perhaps, that of Vecchietta, some time before the Castiglione work; numbers 18 and 19 of the Johnson collection, probably by Arcangelo di Cola; the Montecastello *Crucifixion*, also more likely by the latter artist; the polyptych of San Giuliano in San Gimingnano, which Pudelkho reinstated as a work by the "1419 Master"; the Madonna with Four Angels in the Loeser collection, which is by the "Master of Montefioscoli" (Florence, Mostra d'arte sacra, no. 367 and 473, already reunited by

Offner), a small caricaturist probably also responsible for the Madonna no. C 589 at the Galleria of Bologna; and the two *cassoni* with stories of Susannah at Rennes (3450 and 51), which are by Domenico di Michelino.

Once these works have been separated from the true and somewhat paltry context of Andrea di Giusto, the artist, after his brief association with Masaccio — to which we owe, based on outlines by the great master, the well-known parts of the Pisan predella and the *Miracolo dell'indemoniato* ("Miracle of the Possessed Man") of the Johnson Collection — appears in the 1430s to have been a coarse interpreter of Angelico's manner; with the passage of time he then seems to approach as much as he can the relaxed, gigantic, "quaternary" forms of Paolo Uccello, with whom he in fact collaborated around 1445 on the frescoes of the Assumption in the Cathedral of Prato.

39. "MAESTRO DEL BAMBINO VISPO." G. Pudelko recently provided an elegant acknowledgement of this artist in *Art in America*, April 1938. It was a shame to see it weakened by some rather specious arguments of abstract historicism, such as the one that, for reasons of mere chronological precedence, goes so far as to assume that the "cosmopolitan" style to which the delicate and fanciful master belongs was one of the preliminary conditions that put Masaccio in a position to carry out his revolution; or like the one that claims that this stylistic current supposedly remained alive for the entire Quattrocento, as proved, allegedly, by the works of Botticelli.

Aside from these flaws, however, Pudelko has reconstructed the master's stylistic development in an almost unexceptionable manner, which the subject

certainly demands, since it involves a painter with an unquestionable ability to express himself within the limits of a subtle, mannered elegance, with a fanciful play of line so unrealistic that it points to exceptionally close relations with contemporary northern art, especially in its Spanish ramifications. On this matter P. has pointedly indicated, with more insistence than has been shown by anyone else thus far (except in an intelligent allusion by Berenson), the specific relationships that certain of the master's works have with Spanish pieces usually attributed to the Valencian group of Pedro Nicolau and Andrés Marzal de Sas (Saxony, that is). He has also correctly highlighted the fact that one of these works comes from Mallorca, and even manages to establish its date as 1415. It is unfortunate that he didn't draw the by now necessary conclusions of such premises; or perhaps he was prevented from doing so by not knowing the Valencian material *de visu* or even from Post's latest volumes on Spanish painting. In the appendix to his seventh volume (1938, pp. 790-793), Post goes so far as to glean, from examples inconsistent with Pedro Nicolau and Andrés Marzal but almost entirely consistent among themselves, the existence of a "Gil Master" (named after Vicente Gil, who commissioned the altar of Saint Vincent and Saint Giles [Sant'Egidio], formerly in San Juan del Hospital in Valencia, now in New York), who in fact shows such strong internal similarities of stylistic growth to the Maestro del Bambino Vispo ("Master of the Spirited Child") that one may certainly assume him to be the configuration of the latter's activity in Spain.

The stylistic precedent of the works in question is without doubt the much-contested Portaceli "retablo" at the Valencia Museum, which was painted shortly after 1400 for Bonifacio Ferrer and points — though it cannot with any certainty be ascribed to Starnina, as has sometimes been suggested — to authorship by an Italian painter of the "Agnolesque" [Gaddi] circle, with a slight hint of Spanish influence. I note in passing that the Florentine painting most similar to the predella of this retablo is the Saint Jerome in cardinal's dress with a kneeling patron, which belongs to the depository of the Uffizi, but is now in the small Museum of the Academy of Carrara (Phot. Cipriani no. 6492). Whatever one may say about the author of this piece, it certainly appears to be a concise preface to the Spanish activity of the "Maestro del Bambino Vispo."

We must, however, remove a few pieces from the group of the "Gil Master" constituted by Post, to wit: the two "deeds of Saint Vincent" at Barcelona and Paris (Post III, fig. 274; VI, fig. 246) and the Jackson-Higgs *Crucifixion* (Post IV, fig. 237), which are by a Spanish collaborator of the master, perhaps the man to whom we owe the center of the retablo of the Santa Cruz at Valenzia and certain parts of the altar of Saints Giles and Vincent. All the same, to this period of the painter's activity can be attributed the many parts of the above-mentioned retablos where Florentine characteristics of the first and second decades of the century are so straightforward as to indicate clearly the Tuscan formation of the painter. These include a part of the predella of Saint Mark, in the Tortosa Collection at Onteniente together with the altar (Post VI, fig. 245), the very beautiful retablo with *Stories of Saint Michael the Archangel* in the Lyon Museum (Post, IV, fig. 241), and the *Madonna with Angels* in the Apolinar Sanchez Collection in Madrid (Post, VII, fig. 305), which is a slightly

more Iberian edition of the Thyssen altarpiece first published by Sirèn in his *Lorenzo Monaco* (Plate LIV). We also now have a definite reference point for this Spanish period of the master, the 1415 date that Pudelko has determined for the *Last Judgment* now in the Munich Picture Gallery, but originally from Mallorca and perhaps, before that, from Valencia.

For the Florentine period as well, which for Pudelko begins right after that time, there is only one certain date: 1422, the date of the altarpiece for the Cathedral of Florence, commissioned in memory of Cardinal Pietro Orsini. Regarding, however, the attempts made by various scholars before Pudelko to reconstruct this altar on the basis of the three pieces of the predella, it should be pointed out that the Johnson *Madonna*, which even Pudelko accepts as the centerpiece of the work, could never, given its size and style, have been part of it, especially since it is highly doubtful the piece is even Tuscan. I believe instead that the lost centerpiece can be more reliably reconstructed by uniting the two former Benson *Angels* (which were not, as Pudelko believes, once part of the predella, but indeed an integral part, at the bottom, of the middle panel) with the fragment of a Madonna in the Dresden Gallery and with the little musician-angel in the Lord Carmichael Collection; since the latter piece displays on the right the edge of a cloak on a layer of clouds, it indicates that the representation in the center was of a "Madonna in glory with a choir of angels," a most favorite subject of the "cosmopolitan" circle.

While, moreover, the side panels of this altarpiece — that is, the wings in Bonn and Stockholm — show that the painter, in 1422, was trying, for so noble a destination as the Cathedral of Florence, to adapt to the most soberly traditional style of Tuscan painting, which was still "Trecentistic," there is no doubt that the memories of the recent sojourn in Spain are still very much alive in the little stories on the predella, thus reconfirming our attempted reconstruction of his first period. Thus in his Spanish phase, while in close contact with the most unrealistic flights and the harshest forms of expressionism of his foreign associates, he still emits a tone of restraint, of rhythmical grace, which leave no doubt as to his stylistic nationality; and on the contrary, when back in Italy, though having remedied his foreign caprices, he still does not fail to sound, among his Italian associates, a somewhat "Saracen" note.

As he was an intrepid traveler with a great interest in alien experiences, it is entirely plausible that he might have taken down in a notebook, like so many other "cosmopolitans," the many things he saw; and in my opinion, this notebook is the one in the Uffizi that Demonts (in *Rivista d'Arte*, October-December 1938) called the work of the "Master of the Ortenberg altarpiece." Indeed, aside from the definite sense of stylistic consistency it presents with the artist in question here, most of the drawings in it are directly connected with the style of the Florentine *cassoni* of the 1410s and 1420s (which we should like to call the "Francesco Datini" style) and with sacred paintings of the same circle. As for the not infrequent borrowings from foreign works, they may serve further to confirm our hypothesis, since it can be observed that their source seems not German, but indeed that variant of Westphalian and Rhenish art that was flourishing at that moment in Valencia. Note, for example, the *Saint Catherine* of drawing no. 11, which seems transcribed from the original of a master much like the splendid artist to whom we owe the

Saint Michael at Edinburgh, the *Saint Bartholomew* of Worcester (Post, III, fig. 286-287), and the *Saint Barbara* in the Bosch Collection of Barcelona (Post, III, figs. 276-277).

There remains the question of what actual relationship the manner of this well-known master had with the obviously similar art of Lorenzo Monaco. Without claiming to advance the research on this matter in a mere footnote, one might nevertheless suggest that the import of this not insignificant master was to have brought back from his journey, around 1416, a second wave of the manners hinted at in Starnina's *retour d'Espagne* in the very first years of the century — since, in fact, Lorenzo Monaco's first change of this sort occurs as early as 1404, with the Empoli Madonna. There also must have been a number of mutual exchanges between the two artists in the second decade. As for the early, and surely Tuscan, formation of this excellent master, already evident in the Spanish works, which can be dated still in the first decade, it may have taken the precise form of relations not only with the "Agnolesque" circle, but indeed with the master close to Lorenzo Monaco whom I and later Offer have identified under the name of the "Master of the Strauss Madonna." He was a noble artist who in works such as the *Annunciation* in the Accademia in Florence shows that he started out in the last years of the Trecento and was thus of the same generation as Monaco and perhaps slightly older than the "Master of the Bambino Vispo"; whereas in later works, such as the *Saints Francis and Catherine* at the Accademia, he does not hide the fact that he, too, gladly turned toward the more fanciful exoticism of his companion in art. As for the new developments, he seems not to have wanted to partake of them

except in the smallest of doses; it is significant, however, that in the Rothermere Madonna, which Pudelko correctly dated before 1423 — since in that year it was already copied by a closely associated pupil onto the altar of Borgo alla Collina — a slight reliance on the forms of the early Angelico is in evidence. Equally significant is the definite relationship between the *Martyrdom of Saint Lawrence* in the 1422 predella and the same subject treated by Arcangelo di Cola in the predella to the altarpiece made the same year, and here discussed, for the church of Santa Lucia de' Magnoli.

To the rich catalogue of the master's work compiled by Pudelko, I would like to add a *Saint Nicholas of Bari* in the Kress Collection of New York and the *Christ Giving his Blessing* in the Staedel Institute in Frankfurt, which Berenson published as a work of Lorenzo Monaco (*Medieval Studies*, fig. 88). To his circle also belongs the *Madonna with Saint Bonaventure and Saint Francis*, attributed to the school of Gentile, in the Tivoli Museum. I would also like to remove: the Johnson Madonna, for the reasons explained above; the *Cristo di Pietà fra Maria e Giovanni* ("Dead Christ between Mary and John?"), formerly with Durlacher, which looks more like the work of a Spanish collaborator with the master; the Berlin *Annunciation* (no. 1111), which is instead from the early period of Paolo Schiavo; the two *Saints Stephen and Vincent* in the Boston Museum, a Siennese-Pisan work akin to Martino di Bartolommeo; the *Madonna* reproduced by Van Marle (IX, fig. 134), too ruined to warrant a definitive judgment; the *Madonna with Child on Clouds and Two Saints Below*, formerly in the Spiridon Collection, which is a later Florentine work, from around 1450-1460; the *Madonna with Angels* from Parma,

which is the work of the "Master of the Brozzi Annunciation" (another interesting anonymous artist of the time also responsible for the famous Vatican triptych [no. 246 {86}] often attributed to Arcangelo di Cola); the fragmentary fresco of the *Raising of Lazarus* in the Museo dell'Opera di Santa Croce (no. 10), more similar to the work of Lorenzo di Bicci; the *Beheading of a Saint* in the Museum of the Sforza Castle in Milan, a work too ruined to allow for a precise attribution; the drawing from the Albertina, published earlier by Sirèn, which appears to be the work of a Siennese sculptor of the early Quattrocento. Finally, one can only agree with Pudelko's exclusions of works from Berenson's index, the most important of these being the well-known frescoes of the *Life of Saint Benedict* at Subiaco, very lively works by a local "expressionist" to whom we also owe some of the frescoes in the cathedral of Celano and the better known frescoes in the Morronese Abbey at Sulmona. Also acceptable, for the most part, is the catalogue Pudelko gives for the main collaborator and follower of the "Master of the Bambino Vispo," that is, the painter who, based on his principal work, dated 1423, is known as the "Master of Borgo alla Collina." Some reservations are in order, however, regarding the Altenburg painting, no. 26, and the fresco in the Opera di Santa Croce, of the *Madonna all'arcolaio* ("Madonna with wool-winder"), which seems more likely the work of Rossello di Iacopo Franchi.

40. THE 1419 MASTER. This is what I call, together with Pudelko (*Art in America*, 1938, p. 53) — based on his best known work, dated 1419, the *Madonna* formerly in the Crawshay Collection in Rome with the false signature of Gentile da Fabriano (and published by Van Marle,

VIII, p. 261, as the work of Arcangelo di Cola) — a painter who, having come out of the Lorenzo Monaco circle like so many others, is one of the first to demonstrate slight misgivings about the new themes. He is also responsible for the *Madonna and Child* of the Drouot Auction, June 8, 1937, no. 38, attributed to the Tuscan school, and with the same date as the prior piece; the altarpiece exhibited under the name of Arcangelo in the Italian Exhibit at Amsterdam (no. 81), featuring the *Madonna Enthroned with Saints Anthony, Elizabeth, Julian and Catherine*, slightly later than and similar to the older form of Paolo Schiavo; and, most importantly, the triptych of *Saint Julian, Saint Anthony Abbot, and Saint Martin* in the San Gimignano Museum, attributed to the circle of Iacopo Franchi by Van Marle, and to Andrea di Giusto, "with query," by Berenson. Here the artist, having attained his highest level, is at his closest to the Masolinesque style tinged with Masaccio, at the time of San Giuliano Carnesecchi — thus probably around 1426. Pudelko also makes reference to other works unknown to me (*op.cit.*).

41. [Now in the Uffizi. (Ed. note)]

42. THE MASTER OF THE GRIGGS CURCIFIXION. Professor Offner has given a sufficient catalogue of this artist's career in *The Burlington Magazine*, 1933, LXIII, p. 166, also highlighting the master's relations with Arcangelo di Cola. The work in which the connection between the two artists seems most certain is the *Adoration of the Magi* in the Dodge Collection in London, which is not cited by Offner but recognized as such by Pudelko as well, and published by Berenson (*Dedalo*, 1932, p. 190), with much doubt, as the work of Rossello di

Iacopo. To Offner's list should also be added a wedding *cassone* in the Kress Collection, New York, formerly in the Artaud de Montor Collection (Schubring, no. 428), very similar to the one in the Berlin Museum. A work that closely combines elements of Schiavo and the Griggs Master is the predella featuring the *Flagellation, Saint Jerome in Penance,* and the *Martyrdom of Saint Catherine* in the Boston Museum, commonly attributed to Sassetta (cf. L. Venturi, *Italian Paintings in America,* I, Plate 142), but now ascribed to the Florentine school by Pope-Hennessy (*Sassetta,* p. 184), who situates it, however, after 1440 — too late, in my opinion. The date could be set back by at least a decade.[3]

43. ARCANGELO DI COLA DA CAMERINO; CECCHINO DA VERONA.

The former was probably more prominent than his surviving works would suggest today. But that does not mean I agree with Prof. Salmi's thesis (however advanced with due caution) regarding the possible influence of Arcangelo on none other than Masaccio himself, through Masolino; one need only raise the usual unimpeachable reasons against such a position. Besides, Arcangelo doesn't appear in Florence until 1420, when Masaccio must have already existed on his own terms, whereas the artist from Camerino, to judge from his oldest works, such as the Osimo fresco and the Camerino *Madonna,* must have only figured, upon his arrival in Tuscany, as a modest trailblazer for Gentile, who in fact arrived two years later. And I hope it is not necessary to insist on the differences, indeed the diametrical opposition, between Gentile and Masaccio. "Où sont les neiges d'antan?" Where indeed are the days when Schmarsow could still believe that the Quaratesi predella was by Masaccio? One could, at most, suggest that a certain Riminese manner, a likely starting point for Arcangelo, might have easily reflourished upon contact with the first Masaccian manner, just as, under the influence of Masaccio, a certain neo-Giottesque manner revived in Masolino. Developments of this sort would appear to be suggested not only by the *Crucifixion* of the Frick diptych but also by an exquisite, if somewhat ruined panel formerly in the Aynard collection, with a two-level division, in the manner of the Riminese, featuring a Madonna enthroned on top between an Evangelical saint and a patron, and Saint Ludovico, Saint Leo (?) and a sainted nun on the bottom. Also clearly in the Riminese tradition is the gold background with lobulate motifs. But since in the saints in the lower part the influence of Gentile is already great, and hence after 1420, it is possible that the almost formless, yet still powerful mass of the Virgin, and the clever placement of the heavily cloaked saint behind the throne and the halo at a perspective angle, are fortuitous yet highly felicitous encounters, in Arcangelo's certainly worthy mind, between the old Riminese traditions and Masaccio's new manner.[4] Definite proof lies in the Bibbiena *Madonna,* where the Child sucking his fingers is clearly borrowed from Masaccio's Pisan altar, thus demonstrating that Arcangelo must have continued to sojourn in Tuscany even after 1426.

In the very difficult task of sorting out the "confused" who are not yet "dazzled," one cannot help but include, among such names as the Master of the Griggs Crucifixion, Francesco d'Antonio, Paolo Schiavo, and Andrea di Giusto, that of Arcangelo di Cola as well — albeit, of course, with the subtlest of qualifications.

For example, I now believe I recognize him in the two panels, formerly in the Toscanelli collection in Pisa and now in the Johnson Collection in Philadelphia (nos. 18-19), of the *Presentation of the Child in the Temple* and *Christ Among the Scribes*; my reason for this is that, of the vast group of second-rate works nevertheless important to the new development of Florentine art, they seem to me among the few that display an early grasp of Masaccio, though it is tempered by grain, by a "Gentilesque" impasto, and always some arcane echo of the Riminese tradition. Such a definition applies as well to the Aynard panel. The same stylistic mixture can also be seen in a small panel of the Gentner Collection in Florence that features a very lively depiction of the *Martyrdom of Saint Lawrence*. Clearly a fragment of the predella of a dismembered altarpiece, it is a very well-known work, not only for its obvious quality, but also, in all likelihood, because it seems to be the only extant part thus far identifiable of the altarpiece painted by Arcangelo in 1422 for the Florentine Church of Santa Lucia de' Magnoli, more specifically for the chapel of Saints Lawrence and Hilarion. The predella was thus supposed to contain events of the lives of these two saints. This, then, is probably a precise reference for the chronology and development of Arcangelo's life, and is further confirmed by the close relationship it has with the treatment of the same subject, during the same year, by the "Master of the Bambino Vispo" in the predella of the Orsini altarpiece for the Cathedral of Florence (Rome, Casa Colonna).

Later derivations from Masaccio, which remain, however, combined with the old Riminese tradition and the Gentilesque impasto, can also be seen — and could be better seen, I believe, after a prudent cleaning — in a certain predella in the Galleria of Modena (Cat., no. 20: *Deposition, Martyrdom of Saint John the Evangelist, Martyrdom of Saint Catherine, Crucifixion of Saint Andrew, Funeral of a Sainted Bishop*), where the workmanship of the haloes is identical to that in the Frick diptych, while the organization of the Martyrdom of the Evangelist is a definite echo of Masaccio's famous Pisan predella. Further proof, this, of Arcangelo's prolonged stay in Tuscany. Perhaps also belonging to the same predella was a small panel from the Serristori collection in Florence featuring the *Martyrdom of Saint Philip*. In another, variously contested work as well, the Montecastello *Crucifixion* (attr. by Salmi to Masolino), I see a prevalence of the Gentilesque features of the Camerino painter, combined, or rather laboriously confused, with the manners of Masolino and Paolo Schiavo.

Lastly, it is possible, as always, to derive some gain inductively from certain former attributions to Arcangelo that are now clearly outdated. For example, from Berenson's attribution of the Scandinavian Bergen *Madonna*, now convincingly ascribed by Offner to the Master of the Griggs Crucifixion, we may glean that certain early innovations of this painter — who must have started out as a simple copyist of Lorenzo Monaco — came to him by way of Arcangelo (you'll forgive me my Norwegian-Siberian quibble). From the attributions I myself proposed for the *Saint Benedict and Totila* of the Providence Museum (Rhode Island), the *Saint Francis with Father* formerly in the Sterbini Collection, now in the Kress, and the *Death of Saint Francis* formerly in the Woodyat Collection, now in the Walters, one may infer with great assurance that Bartolomeo di Tommaso da Foligno, who painted them, must have emerged, as the

dates certainly confirm, in the same Marchesan-Tuscan milieu as Arcangelo, later drawing a few Siennese ideas from him. From still other attributions one can glean nothing, but only set them right: such as those of Colasanti, much repeated and expanded by others, for paintings by the young Angelico (the Cassirer *Madonna*, the Stroganoff *Madonna* in Leningrad) or by his school (the Oppenheim *Madonna*, published by Procacci in *Rivista d'Arte*, 1929, p. 159). Nowadays, of course, there is no longer any doubt that Angelico's circle was quite distinct from that frequented by Arcangelo. A few other corrections remain to be made as well in Berenson's fluctuating Catalogue. The (somewhat doubtful) attribution of the small altarpiece in the Fogg Museum (no. 5) to Arcangelo, for example, has already been corrected for some time now (*Pinacotheca*, 1928, p. 35) and included in the master's index of the tondo of the *Judgment of Paris* at the Bargello. This Florentine "alter ego" of Giovanni di Paolo, as I called him at the time, has proved to be of increasing interest, especially for having perhaps brought elements of a Veronese character to Tuscany and then having subtly combined them with forms of late Tuscan Gothic. For this reason I would not identify him, as Pudelko has suggested, with one of the minor masters of the Green Cloister [in Santa Maria Novella], who is merely a weak imitator of him. Though northern in background, his most precise links remain with the Siennese art of Giovanni di Paolo and Sassetta. I wonder therefore if it might not be plausible to relate this group of paintings to that certain Cecchino da Verona, who appears first as a witness for Sassetta in the documents for the great Duomo altarpiece, then in Chiusdino, today in Contini-

Bonacossi (1430-32). Cecchino is again cited in Veronese documents several decades later, and it is to this late period that the triptych of the Diocesan Museum of Trent must belong, a work that clearly shows a certain provincial regression, but is not apparently without some echoes, though radically changed, of the artist's former home in Tuscany. One might even legitimately assume that the curiously Veronese character of the pen and ink drawings of Giovanni di Bindino in the *Chronicle* completed in 1416, today in the Piccolomini-Cinughi Collection (cf. *La Diana*, 1930, p. 55), reflect the presence of Cecchino in Siena. This explanation could even be expanded to include certain works of Parri Spinelli, especially his unmistakable drawings, so northern in character.

One final attribution of Berenson's to Arcangelo, again with a question mark, is no. 715 of the Walters Gallery: a small portable altarpiece with the Madonna enthroned among four saints and, in the cusp, the Crucifix amidst a tree-filled landscape. The work is not from the Marches, but rather the Abruzzi. More precisely, it is by Andrea Delitio, who was not, as the caption in Berenson's Indexes states, a pupil of Gerolamo di Giovanni da Camerino, but rather — as he shows in this very work, as also in many parts of the charming Atri frescoes — proves to have been schooled among the "dazzled" of Florence around 1440 (Uccello, Domenico Veneziano). Only later would he display some crossover with the art of the lower March in the second half of the 1400s.

To conclude, let us suggest, with some reservation, that Arcangelo, a tireless wanderer, may have reached, aside from Rome (1423), also Naples: a *Madonna Enthroned between Two Angels* in the Church of Santa

Monaca shows strong similarities with the forms of the young Arcangelo at Osimo and Camerino. In Rome one discerns his sensibility in the two frescoes in the church of Saint Agnes (cf. Van Marle, VIII, figs. 282-283), and if they were to be attributed to his documented 1423 sojourn there, they would show him to be wholly involved once again in Marchesan Gothic.

44. FRANCESCO D'ANTONIO AND THE MASTER OF THE ADIMARI CASSONE.

Professor Salmi, in his essay on the subject in *Rivista d'Arte*, 1929, gave a thorough profile of Francesco d'Antonio, rectifying, among other things, my old confusion of that painter with Andrea di Giusto for the Grenoble triptych. There is no doubt that Francesco d'Antonio di Bartolommeo (and not Banchi, as Berenson's Indexes, among others, would have him; cf. Gronau, *Rivista d'Arte*, 1932, p. 382), born in 1393 and mentioned until 1433, was schooled on Lorenzo Monaco. The triptych at the Fitzwilliam Museum in Cambridge (1412 or 1415) is definite proof of this. It contains no trace of novelty, as some others have claimed, only a desire to inflate the master's style (as Giovanni dal Ponte, with livelier results, also attempted to do), a quality one also sees clearly in the Figline frescoes. The date suggested by Salmi for these frescoes, the second decade of the Quattrocento, is disproved by the miniature of the *Crucifix between Mary and John* in a missal of San Pietro in Mercato, for which Toesca (*Rassegna d'Arte*, 1917, p. 125) pointed in the right direction when he analyzed it as belonging to the school of Lorenzo Monaco. Clearly it is the work of Francesco d'Antonio, who was also a miniaturist. And since that page can almost certainly be dated 1418, it indicates, as do the Figline frescoes, that the

artist had not yet encountered Masolino. In fact he gives signs of having met him later on, precisely during the period of the adventure with Masaccio, which is of great interest to my research.

The bridge between the period inspired by Lorenzo Monaco and the Masolinesque period can be seen in works such as the *Madonna Enthroned* and the two *Saints John the Baptist and Anthony Abbot*, all in the Kress Collection and all strikingly similar to the supposed Masaccio of Montemarciano.

Belonging to an interval later influenced, in part, by the art of Gentile, and perhaps for this reason situatable around 1425-26, are such works as the *Madonna with Six Angels* (no. 1456) in the National Gallery in London and the *Martyred Saint*, in fresco, over the first altar on the left in San Niccolò sopr'Arno.

As for the moment of Francesco d'Antonio's greatest proximity to the Masaccesque Masolino, this can be seen in the famous panels of the organ of Orsanmichele, now back in Florence after many peregrinations, and documented as being from 1429. The *sott'in su* point in the two choirs of angels (though the artist neglected to give the two parts a logical convergence toward the center) is the same as that used, for similar reasons of organization, by Masolino in the Goldman *Annunciation* (the likely "Masaccio" of San Niccolò sopr'Arno), at a date that we can now see coincides with this one. We may also infer from this that the four Evangelists on the outside of the panels, with their wan, sorrowful expressions, rather faithfully mirror what Masolino's Evangelists in the Brancacci vault will look like, which we have already had occasion to assume to be tinged with a Masaccesque gloom.

To this same phase of Francesco

D'Antonio also belongs the Grenoble polyptych, in which the artist actually ventures to imitate the style of Masaccio alone in the *Virgin with Saint Anne*. The predella, as I have already said elsewhere, with its figures of Saint Jerome and possibly Saint Ranieri (which was the patron's name), has now been broken up between the Museums of Carcassonne (the side panels) and Bourger (centerpiece). Berenson was thus mistaken when he listed the two Carcassonne panels under the name of Andrea di Giusto and the Bourges part under that of Francesco D'Antonio. The same confusion occurs with the *Pietà*, no. 243 in the Narbonne Museum, which is also definitely by Francesco D'Antonio and from his phase of Masacciasque Masolinism.

To the Francesco d'Antonio catalogue between 1425 and 1430 should also be added the Strasbourg *Redeemer*, too often cited unduly as close to Masaccio, and a small arched panel with three levels — an *Annunciation* on top, a *Crucifix with Many Saints* in the middle, and nine more Saints in the lower compartment (as well as a piece of writing commemorating the name of the patron "Maestro Antonio de Guarguagli da Lucca Medico") — sold at auction a few years ago at Christie's (Cooper, 92971). The *Crucifix with Mary and John*, a fresco on a pilaster in the Cathedral of Pisa (reprod. in Papini, *Pisa*, I, p. 104), should be dated after 1430.

There is no need to repeat that many of the works attributed to the "Master of the Adimari *Cassone*" in Berenson's catalogue should be removed. This master was a rather lively person of a later generation (as proved by the certain 1449 dating for the tondo of the *Triumph of Fame* in the New York Historical Society), who was trained, as I see it, around 1435-40 in the milieu of Vecchietta and Paolo Schiavo.

Indeed, some collaboration with Paolo Schiavo can be proved in at least one case: the two panels with musician angels in the Oratorio della Madonna at San Giovanni in Valdarno, of which only one is Schiavo's (not both, as asserted by Salmi in *Dedalo*, June 1928); the other is definitely by the Adimari Master. A rather precise catalogue of this master's work, following the initial indications I gave in *Piero della Francesca* (pp. 109, 120, 145) and the article on Giovanni di Francesco (*Pinacotheca*, 1928, p. 38),[5] was drawn up by Pudelko in a note to his *Studi sopra Domenico Veneziano* (*Mitteilungen* of the Istituto Tedesco di Firenze, 1934, p. 163). I disagree only on no. 1456 in London, which is by Francesco d'Antonio, and on the panels of San Giovanni Valdarno, for which Pudelko, reversing Salmi's suggestion, does not distinguish the work by Paolo Schiavo.

To the list of the "Adimari Master" should also be added the following items:

Arezzo, San Francesco: fresco of *Madonna and Child with Saints Christopher and Catherine*, in my opinion the earliest of the known works;

New York, Kress Collection: two predella panels of the *Temptation of Saint Anthony* and *San Bernardino Preaching*;

Ibid.: *Annunciation* in two parts (cited incorrectly under the name of Francesco D'Antonio by Berenson in the Curtiss collection at Beaulieu);

Florence, Horne Museum: *Madonna and Child with Two Angels*, a late work (Phot. Brogi, no. 24593);

Pisa, Civic Museum: Cassone with the *Triumph of Emilio Paolo* (Schubring, *Cassoni*, fig. 117);

Paris, Cluny Museum: Cassone with the *Trojan Horse* (Schubring, fig. 123);

Ibid.: Cassone with a *Battle* (Schubring, fig. 144);

Ibid.: Cassone with *Dido Greeting Aeneas's Messengers* (Schubring, fig. 145);

Ibid.: Cassone with the *Battle of Zama* and the *Triumph of Scipio* (Schubring, fig. 110, 111);

Ibid.: Cassone with a scene of a *Tournament* (Phot. Bulloz);

Ibid.: Cassone with a *Roman Triumph* (Phot. Alinari, no. 25375);

New York, Historical Society: Cassone with the *Triumph of Caesar* (Schubring, fig. 126);

Somerset, Eastnor Castle: two Cassoni (Schubring, figs. 286-290);

Formerly in Paris, Spiridon collection: two Cassoni with the *Sciences* and *Virtues* (Schubring, figs. 339-340).

Schmarsow incorrectly divided most of these works among the Anghiari Master, the Master of the Santa Croce Tournament, and the Master of the Cassoni, all non-homogeneous groupings. Still others were reproduced by Berenson under the name of Francesco D'Antonio, *Dedalo*, II, 1932, pp. 533 to 539. It is not difficult to retrace the artist's development through the many items in the series, starting, for example, with the *Triumphs* of the round chest formerly in the Uffizi and now in the Horne colelction (Schubring, figs. 208-211), which are still closely related to the early Arezzo fresco and display the artist's affinity with Siennese art around 1440, and even after, with the early efforts of Matteo di Giovanni (as one can see, for example, in certain well-known parts of the *Wedding* and *Visitation* in the Johnson Collection). The later work, which includes the *Madonna with Two Angels*, also in the Horne Collection, seems not to go beyond 1460; it is thus possible to reconstruct, between these two periods, the path taken by this artist, who, as I suggested in my essay on Piero della Francesca, may have been from Arezzo and might, perhaps miraculously, be identified as Lazzaro Vasari, great-grandfather of Giorgio. These origins and possible identity appear to be suggested not so much by the works left behind in Arezzo as by the artist's obvious sympaties for Piero's sunny tones, not to be found in any other Florentine *cassone* artist — and by some actual borrowings from the Arezzo frescoes [of Piero], almost impossible to find in Florence. The documents produced by Milanesi declaring Lazzaro to be a saddler in no way preclude the possibility he might have also been a painter, especially given the quasi-industrial order of the time.

45. PAOLO SCHIAVO. The most accurate and complete account of Schiavo is that given by Pudelko in his *Kunstler Lexikon* (XXX, 1936, pp. 46-47). I would like to add a few observations to this. Born in 1397, a few years before Masaccio, Paolo Schiavo is not recorded among the painters until 1429, that is, after his thirtieth year; it is thus likely that his earlier period still remains to be discovered. In 1436 he is mentioned in some Florentine documents, and signed the fresco in San Miniato al Monte that same year; his activity in the Castiglione Collegiata thus should probably be moved up to 1437-38, from before '36, which is when Pudelko places it; also because of the already demonstrated stylistic necessity of placing it after the Masolino frescoes in the Baptistry. The four fine predella panels of the Johnson Collection (nos. 124-127: *Visitation, Nativity, Adoration of the Magi, Flight into Egypt* — all assigned to Arcangelo di Cola by Berenson) can clearly be ascribed to a time preceding the Castiglione period, since they show the recent study of Gentile's predellas (1423) and should therefore probably be dated

to the 1420s.

But the possible relations between the young Schiavo and Alvaro Pirez, whose Volterran polyptych seems to allude to a more primitive form of Schiavo still partially under the influence of Lorenzo Monaco, have yet to be studied. There may be something there, since documentation exists of Alvaro Pirez's relations with Volterra in 1422 (*L'Arte*, 1921, p. 124), when Schiavo was already twenty-five years old. It is probably to this earlier period of Schiavo that one should ascribe, among other things, the *Annunciation*, no. 111, in the Berlin Museum. I also recall that the 1933 Exhibition of Sacred Art in Florence featured the side panels of a polyptych from the Empoli Collegiata (nos. 276-277) by the school of Lorenzo Monaco, where the gable panels are attributable to Paolo Schiavo. Here too, as evidenced in another early work — the *Saint Ansanus* in fresco in the church of the Annunziata (Alinari, 44326) — he would appear to have come out of that same circle, like so many other painters of his generation. Once he abandoned that milieu, Schiavo absorbed, still in the 1420s, the first idioms of a modernized Masolino, which yet remained commingled with other, temporary idioms from Gentile, just like Francesco d'Antonio. In the 1430s, he attempted to organize and consolidate this new education, as one can see in his finest works at San Miniato and Castiglione d'Olona, where he is probably also stimulated by the proximity of a true "dazzled" painter such as Vecchietta. The other principal works of this decade of his maturity are: the Beets (formerly De Burlet) Cassone, which is superior to the one in the Jarves Collection, which is also ruined; the Vespignano fresco published by Procacci in *Rivista d'Arte*, 1932, p. 348; the small Kress panel of the *Flagellation*, which I attributed to him along with its companion piece, the *Crucifixion*, in the same collection; the Altenburg panel with the two scenes of *Christ in the Garden* and *Saint Jerome Doing Penance*, which represent Schiavo's closest approximation to Masaccio, to whom Schmarsow actually attributed them; the *Madonna and Child with two Angels*, formerly in the Villa Galletti at Torre del Gallo, which is very similar to the Beets Cassone and in which Schiavo, like Francesco d'Antonio, ventured to imitate only the Masaccian part of the *Saint Anne* panel. The small panel of the Castiglione *Annunciation* should also be dated to the same time as the Collegiata frescoes and is, perhaps due to the stimulus of Vecchietta, Schiavo's boldest experiment in perspective; I do not think, however, that such experimentation allows one to infer, as Pudelko has done, a derivation from the lost *Annunciation* of Paolo Uccello — who, at this time, as I shall attempt to demonstrate in another essay, was still uncertain of the path he would take. To the decade of the 1430s can also be dated the *Saint Jerome* in Cardinal's dress, a fresco in the Pisa Cathedral (reprod. in Papini, *Pisa*, I, p. 111). Later still, that is, after 1440, Schiavo limited himself almost exclusively to scraping by on his meager memories, as can be seen in the *Crucifix* fresco at Sant'Apollonia (1440-1447), where the Masolinesque Christ is once again accompanied by the archaizing rhythms of the "Camaldolites"; the 1460 works at Santa Maria della Querce further show him at a barely modest level of craftsmanship.

Moreover, Offner has revealed that Schiavo was also a miniaturist (still another parallel with Francesco d'Antonio, and further proof of their common origins). One may add to this the fact that he provided cartoons for embroiderers as well;

indeed, one of his finest compositions — also, I believe, from the 1430s — is the one used in the embroidery of the *Coronation of the Virgin*, in the Lederer Collection at Vienna.

By way of conclusion, the story of the worst philological misadventure suffered by Schiavo in very recent times is one worth telling. After the restoration of the Collegiata at Castiglione, as a kind of comment on and confirmation of Schiavo's presence in those frescoes, it was thought appropriate to place one of his paintings in the apse of the Church, taking it from the rich artistic wealth of Florence. The idea was already risky to begin with, since it suggested a false representation of the artist's activities in Lombardy; worse still, however, was that the choice in fact fell upon a work that wasn't even by Schiavo, but attributable to the early period of Neri di Bicci. As there will be no attempt soon made to right this twofold absurdity and return the painting to its natural place, it is to be expected that in fifty years or so some young researcher will not fail to assume that Neri di Bicci went to Castiglione, and thus will attribute Schiavo's and Vecchietta's frescoes to him as well. And so proper art history will have to start its Sisyphean labors all over again.

46. SASSETTA. Pope-Hennessy, in his recent book on this master (London 1939), finally resolved to highlight his many and precious Florentinisms, thus dispelling that pseudo-Buddhist atmosphere in which prior decadentistic studies had enveloped him. Another quotation from Masaccio, the beggar in the San Martino *Crucifix*, was mentioned here in this text. And Pope-Hennessy for his part has not failed to point out the degree of intellectual independence with which Sassetta used the new motifs. Only as con-

cerns the artist's formation do we take some exception to the fact that Pope-Hennessy did not stress, as required, the intense congeniality between Sassetta and the older Masolino. I also fear that he is a bit too simplistic in his attempt to explain the transition from the forms of the early works (Chiusdino, Cortona) to those of the Asciano Polyptych and Osservanza Triptych, concluding apodictically that Sassetta had suddenly become a Gothic painter. Since the later works of certain attribution link back up with the style of the early ones, might it not be more prudent to assume that this Gothic phase belongs to a different artist who indeed would seem to be responsible for a great many paintings almost always given under the name of pseudo-Pellegrino di Mariano and now the "Vatican Master," a group which includes, in the Galleria of Siena, the very predella of the Osservanza altarpiece, which in no way differs in form and quality from the work which originally stood above it? A consolidated catalogue of this noble artist, whose cultural background runs parallel to Sassetta's but is more insistently archaic, might also include, in addition to the Asciano Polyptych (and the fragment that was once part of it, in the Crespi Galleria) and the Osservanza polyptych (and its predella): the Triptych at the Siena Galleria, no. 177; the three panels belonging to a single predella: the *Christ in Limbo* in the Fogg Museum, the *Christ on Calvary* in the Johnson Collection, and the *Flagellation* in the Vatican Museum; the *Saint Anthony Abbot* half-figure in the Louvre, attributed both to Giovanni di Paolo and to Neroccio; and the *Redeemer* in Minneapolis, which is of particular interest to us because it is sometimes pointed in the direction of Masolino. But if I were to express my thoughts on this master in

full, I should not be believed; thus I shall limit myself to advising some young scholar to reexamine in the light of this noble spirit the famous "Stories of Saint Anthony" scattered about in different American collections, whose well-meaning insertion among Sassetta's *corpus* seems to me as unlikely as that of the Asciano polyptych and the Osservanza altarpiece.

47. [Now in the Castello Sforzesco in Milan. (Ed. note)]

48. [In the cloister of Santa Maria del Carmine in Florence (the same church where Masolino and Masaccio painted the Brancacci Chapel). (Ed. note)]

49. [Leon Battista Alberti, *De Pictura.* The original Latin version of this important treatise was completed in 1435, the Italian adaptation *Della Pictura* a year later. (The earliest printed editions appeared respectively in Basel in 1540 and in Venice in 1547.) The famous list of artists to which Longhi alludes actually appears in the dedication, dated 1436, of the Italian text to Filippo Brunelleschi; Alberti singles out as "in no way inferior to any of the ancients" Donatello, Ghiberti, Luca della Robbia, Masaccio and, of course, Brunelleschi himself. For a conveniently accessible translation, see L.B. Alberti, *On Painting,* trans. Cecil Grayson, ed. Martin Kemp, London, 1991, where the list of artists appears on p. 34. (Ed. note)]

50. As was already pointed out in that review by Dr. Ragghianti (no. XVI-XVIII, p. xxii).

51. DOMENICO DI BARTOLO. It is true that he appeared in Florence in 1428, but one would do well to question whether he immediately figured among the "daz-zled," especially once one has eliminated the possibility, suggested by Dr. Brandi, that he might be ascribed Masaccio's *desco da parto* [birth plate] in Berlin. It is much more likely that he made himself known in this period in a manner similar to Sassetta's around the same time. This idea finds support in the observation that the two small panels of Saints Michael the Archangel and Nicholas in the Lehman collection, attributed to Sassetta, seem more likely to be the products of Domenico di Bartolo's first period, around 1430. It is further confirmed by an examination of the gabled altarpiece that clearly stood originally between those two panels: that is, the *Madonna,* no. 63c, of the Berlin Museum. It too was long believed to be by Sassetta himself, but Pope-Hennessy first set it on the right path by attributing it to Vecchietta — a name easily confused with Domenico's, which here is the more correct one. The Madonna and Child appear to have been created at almost the same moment as those of Sassetta in the great 1430 altarpiece, yet they display a more direct, and more connected, grasp of the early Florentine motifs. It is obvious that, if we are to better define the figure of Domenico di Bartolo, we must also reject other undue attributions: such as the *Madonna with Angels,* no. 207, of the Siena Galleria, which looks like a later work and in any case has already been expunged from the catalogue by Dr. Brandi; and the *Madonna* of the Babbott Collection in New York, which belongs to Sano di Pietro (Van Marle, IX, fig. 343).

Much more akin to Domenico di Bartolo than to Pesellino, to whom it is attributed in the official catalogue, is also the small altarpiece at the Metropolitan Museum in New York (P. 431-1), with the *Madonna between the Baptist and a Young Martyred Saint.* In any case it is definitely

a Siennese work from around 1430, under Florentine influence.

52. GENTILE DA FABRIANO AND CONTEMPORARY FLORENTINE PAINTING.

On the subject of the revival of the sense of "air and color" as well as naturalistic detail in Florentine painting around 1440, we now have this timely note on Gentile da Fabriano. Without it, this study might otherwise have seemed a bit too silent about this master, especially now that his role has been asserted with particular insistence in the above-mentioned regard in the most recent critical studies, especially those by Pudelko — and not only as concerns the late Gothic masters of the "Camaldolite" circle, but also with regard to Lippi, Paolo Uccello, Domenico Veneziano, et al.

Before testing the consistency of these new assertions we would do well to recall that the research on this great but eccentric master cannot boast of terribly brilliant results, neither as concerns the education, however obscure, of the artist, nor as concerns his ultimate developments. Worse yet, the most acute observations — such as Lanzi's on the apparently miniaturist origins of Gentile and Cavalcaselle's on his probable affinities with Taddeo di Bartolo — have been set aside to make way for the most antihistorical flights of fantasy regarding Gentile's supposed descendance from Allegretto Nuzi: an opinion that one might imagine to be parochial in origin if it weren't proved to have come from Berenson, who as early as 1897 wrote in his caption: "Pupil of Allegretto Nuzi" — a definition which was still more or less repeated in the 1936 indexes. This is what is called letting oneself be overly impressed by a few meters of fancy cloth, spread out before one's eyes by both artists. Yet although not a single scrap

of critical foundation could ever be cut from it, and even though Berenson himself, in his essay on the Umbrian painters, had shown himself capable of improving on the paltriness of that assertion, nearly all subsequent scholars modeled themselves on it, especially Colasanti in his monograph (1909); and it is all the more unpleasant to find notable traces of it in L. Venturi (1915) and even in Molaioli's slim volume (1927), which was, moreover, intended only for a limited, polite readership, at a time when Gentile's place at the heart of the "cosmopolitan" current was quite clear. On the part of the Florentines, meanwhile, Poggi in 1903 had not failed to declare that the famous *Adoration of the Magi* in Santa Trinita "won the attention and admiration of Masaccio himself." And this was the slippery slope of the customary adjustments between "naturalism" and "naturalism", *a*, *b*, *c*, ad infinitum — along which continue to slide blissfully to this very day the manuals in which Gentile is either still sheltered in the shadows of Renaissance banners or at the most receives the usual label of "transitional artist" and his Gothic naturalism is thus considered an antechamber to Renaissance naturalism.

Not that there haven't been a few at least potentially better-informed minor observations as to Gentile's relations with Nelli (Mason Perkins, 1907) and Lorenzo da Sanseverino (Rothes, 1908; Venturi, 1915); but they have almost always been set against the inescapable backdrop of Nuzi. Nothing new in Mayer's article (1933) or in Serra's digressive treatment (*L'Arte nelle Marche*, II, 1934). More recently still, Pudelko, aside from the already mentioned considerations of the supposed influence of Gentile's art, says in passing that the artist was certainly "schooled in Siena by the works of the Lorenzetti brothers." It is an assertion that

demands proof, but with which from the start, given its generic flavor, one cannot agree, since one will recall that in those good old days the schooling of an artist, especially a great artist, was always "current," "modern," and not based on the exemplars of seventy or eighty years earlier.

Almost everything, in short, remains yet to be done in the interpretation of Gentile. In a brief note, however, one can only hope to point out a few initial requirements. One must, in the meanwhile, go back to the neglected observations of Lanzi and Cavalcaselle on Gentile's affinities with the Siennese art of the later Trecento and, attempting to better place them, see whether the milieu most apt to offer an education to Gentile, born at the edge of Umbria, might be not Siena, but Orvieto, that local but exquisite medieval wellspring of enamels, stained glass, mosaics, and "sculptilia et pictilia." When one deciphers the lacquer-like or gold-on-gold subtleties with which he treats the angels, oligochromic little souls, in the background of the Perugia Madonna or the Goldman-Kress Madonna; or when one rereads Tizio's passage on the *Pietà* in the lost Siena altarpiece from 1425, where "angeli duo sunt aereo colore tam tenui picti, tamque exili lineatura in tufeo lapide, ut nisi quis etiam ostensis acutissimum figat intuitum conspicere non valeat" ["two angels are so lightly painted, like a vein in tufa stone so delicate that not even one with the keenest perception could be believed to see it"], it is hard not to lean toward the supposition that Gentile's beginnings should be sought as much among the goldsmiths, enamelers and miniaturists as among the painters. And the choice of Orvieto is suggested by the realization, perhaps for the first time, that if there is one painter of the later Trecento who prefigures many aspects of Gentile's

manner it is the Orvietan Ugolino di Prete Ilario, much neglected in spite of the fact that he far surpasses such Siennese contemporaries as Bartolo di Fredi, Andrea di Bartolo, Taddeo, Niccolò di Buonaccorsi, and similar patent mediocrities.

How it was that Gentile then managed to graft, onto this initial education, likely gained in Orvieto, the shoot of northern, predominantly Lombard art, has yet to be explained, since nothing is known about his early years, starting with his birth: is it 1360? '70? '80? When? For this reason it is rather surprising to see the blitheness with which people group together certain works, all from before the journey to Venice (that is, at least before 1408), which have very little in common, such as the Romita polyptych, the Fornari *Saint Francis*, the Berlin altarpiece, and the Perugia *Madonna*. Though we may note, for example, that in the Brera altarpiece the Siennese antecedents prevail while in the Berlin one it is the references to Lombard miniatures that predominate, the problem, for now, cannot be resolved; and I doubt that it will be, until we have unearthed works that can be attributed with certainty to sojourns by the artist in Venice or Brescia.

Equally unexplored is the question of Gentile's definite affinities with Giovannino de' Grassi, especially the use of an atmospheric "pointillism." Does the answer lie in a hypothetical journey to Lombardy? And when would that have been? Or could the widespread diffusion of miniatures, and his contact, in Venice, with artists already steeped in those continental currents, have been enough to influence him? And who might these artists have been, in particular? I can see that the first to be mentioned will probably be Niccolò di Pietro, who appears to have

come back from Bohemia painting Siennese and Emilian horses with French caparisons. See the Rovigo *Coronation*, reinstated to him by Fiocco, which is already very Lochneresque *avant la lettre*. It is also curious, and not insignificant, that in the same year, 1408, Gentile and Niccolò di Pietro were working for the same patron, each on a different altarpiece. In any case the loftiest monument in the Veneto background of this supposed duo of Gentile-Niccolò di Pietro can no doubt be found in the three small panels of scenes from the life of Saint Benedict, recently taken into the Cannon colleciton at the Uffizi as works of the Veronese school. It is so high in quality that one hesitates to ascribe it to Niccolò, while it is tempting to see it as an example of Gentile's Venetian phase: such a judgment, of course, will have to be rigorously suspended for now, and perhaps for a long time to come.

And yet it is easy to understand how important it would be to ascertain "how" Gentile actually painted in the early years of the Quattrocento in Lombardy, Venice, or who knows where. I would bet that the waves of the storm painted in the Palazzo Ducale [the Doge's palace in Venice] between 1408 and 1414 and much vaunted by Facio, a great admirer of the Flemish, once belonged to the same astonishing family as those around the boat of Julian and Martha in the *Turin Hours*; unfortunately, such a wager cannot be made. The fact remains, however, that we, especially we Italians, should be a little more concerned with establishing whether Gentile painted "like" the Limbourgs or the young van Eyck *before* or *after* 1400-1410. For in the first of the two cases, since the developments of art always start with one man, it could be that the balance of the "cosmopolitans" would tip

considerably in our favor. Yet one prefers instead to speak vaguely of something in the wind, only to have it thrown back in our faces that this wind is blowing from Burgundy.

From the master's later works (and I doubt that those we are familiar with are always late works) one may nevertheless glean more than enough to conclude that his careful, detailed naturalism, held together by the soft and even somewhat flaccid rhythms of latter-day Gothic, could never have been transmitted in any way to the spirit of Masaccio. One would, if anything, have cautiously to assume the contrary — that is, that during the artist's Florentine sojourn a few strokes of innovation may have caught Gentile's subtle eye: indeed, the Madonna at the center of the Quaratesi polyptych, flanked by attentive, self-possessed angels, displays a tendency toward simplicity that is purely Tuscan — not necessarily Masaccian, of course, but certainly suggestive, at the very least, of Masolino, Ghiberti, or Angelico. Also, when one sees, in the Orvieto fresco, the almost unbridled laughter of the Christ child, and his gesture of twisting the Virgin's hand, not to mention the latter's grave, sunken cheeks, one senses that Gentile did not deny himself at least the intention of shifting the caste of his characters from the "courtly" to the "common," instilled in him by the new Florentine mood; but it is clear, of course, that in his own mind, which is too self-enclosed for real innovation, the endeavor mutates and remains distracted and episodic, and a harsh naturalness is only curiously touched upon, not deeply felt.

Perhaps Dr. Alberto Graziani will have a few other observations to add when (after the needed restoration) he chooses to comment upon Gentile's second polyptych for the church of San Niccolò

sopr'Arno, which he recognized after nearly centuries of oblivion — after, that is, it had been granted brief contemplation by the nearly infallible eye of G.B. Cavalcaselle (*History of Painting in Italy*, Douglas-Borenius ed., vol. V, p. 203).

That Gentile, even in the final years, had no intention of exceeding his limits, and if anything was delving ever deeper into them, will become clear to anyone who studies, in the proper manner, the Quaratesi predella — especially now that a timely cleaning of the four Vatican fragments makes closer reading possible and justifies the admiration Vasari bestowed especially on this part of the work. The story of the "balls of gold" is truly as beautiful as a Pol de Limbourg or a Malouel, and displays a bourgeois intimacy without parallel in Italy. In the *Miracle of the Sea*, the long wave whitening at the front and darkening in the distance gives us a sense of what the lost Venice "tempest" was like. Until today, however, we were unfamiliar with what is perhaps the most intense panel of the series: that of the *The Pilgrims and the Sick at the Tomb of Saint Nicholas*, cited about a century ago by Gaetano Milanesi as being in the Tommaso Puccini collection in Pistoia, later passing into various foreign collections where I had a chance to see it, it has most recently entered the Kress Collection, in the National Gallery in Washington, D.C. I thus think it appropriate to present it for the first time to Italian readers, precisely in the context of an article concerning Masaccio, especially when I think back on the curious intellectual turn of critics who in 1895 could ascribe the entire Vatican series to Masaccio. Today, however, I do not think one will hesitate to recognize, especially in this fragment, the abyss that lies, unbridgable, between Masaccio and Gentile.

I do not know whether everyone can immediately appreciate the exceptional quality of the figuration itself, which, though contained in a series of holy stories, avoids conventional iconography and offers us a modern genre scene, a kind of exquisite ex-voto. What we see in fact is nothing more than a pilgrimage to the tomb of a saint who doesn't even figure in the scene by way of supernatural apparition. If anyone could point out to me a work from these same years, and from outside this circle, with a sacred story without the protagonist in action, and without haloes, I would be forever grateful. As for myself, I cannot look at this panel of Gentile's without recalling the modern, supreme intellectual freedom of Jan van Eyck in the *Requiem Mass* in the *Milan Hours*. Of course I would never dream of expecting from Gentile the integral magic, more real than the real, of the van Eyck page, yet it seems clear to me that since the undeniable precedent of the Ambrogio Lorenzetti predella in the Uffizi (which served as a rough model for the organization), Gentile has come a long way along this intimate, shadowy road. In the end, one can only look at what happens at that hour. An afternoon light falls on the columns, capitals, and worn-out steps of an old Romanesque church. That gentle, circular motion which begins with the sound of a crutch and the heavy step of the two carriers, with shaved necks, bearing up the crippled woman, arm dangling, continues with the Oriental couple stiffly climbing the stairs; it mingles in the half-light, under and around the sarcophagus, in the group of the madwoman and the figures of the young burghers looking along the tomb's junctures for the transudation of the famous "manna"; and then it returns toward the exit with the miraculously healed man who very quietly,

crutches on his shoulder, cautiously, almost mistrustfully, tests his revived leg. Or perhaps it is all seen through the eyes of the curious sacristan appearing in the aisle of the church, in the sacristy doorway: the gilded altar-frontals shine in the apses; a Duecento Madonna also glows, and a Gothic Crucifixion in fresco is already patinating while in the half-dome over the saint's tomb the old Byzantine mosaic glitters and sets the thematic tone: "Christ between the Virgin and Saint Nicholas." The best of Pisanello and Jacopo Bellini is already here in purer, more direct, less precious form. Gentile never expressed himself more loftily. But there's still more. Under that mosaic, in the hemicycle of the apse, shines a series of frescoes in five frames; and although they are muted, enveloped by their distance from the viewer's eye, one is amazed to discover that they are, in the end, *ad litteram*, the five stories of the Quaratesi altarpiece — including this last one, which has just been recounted. As if, on the one hand, the painter wished to tell us, almost slyly, that all he had to do was copy what he saw down there, on the walls of the old church of San Nicola; and on the other, as if he wished, with an almost "trompe l'oeil" sharpness, to give us the internal and as though mirrored document of his vision. It is not going too far to say that he prefigures, in naively symbolic form, Jan van Eyck's invention of the convex mirror reflecting the Arnolfini couple and the painter himself on back wall, in the famous 1434 portrait. One almost feels like transposing the famous text from that piece to the present one: "Gentilis de Fabriano fuit hic." And here, indeed, is his place: that is, alongside Pol de Limbourg and Jan van Eyck, not next to Masaccio.

This exceptional result will not, however, let us forget Gentile's constant limitations, the very ones that must have sufficed to backdate him and make him seem insurmountably "Trecento" to the new Florentines of the 1430s and 1440s: his pointed, granular, eternally dusky realism, his sun, that gilded knob throwing a melancholic lacquer onto the hills of the Marches, that shadow that gathers like a symbolic, chill nest around forms. It is as though everything were filtered through the stained glass of a Gothic cathedral; so that, compared to him, Masolino's light, though equally unreal, has the sense of a sunny, springlike beginning, more likely to blossom, as indeed happened, into the art of Domenico Veneziano. As for the many seeds of reality in Gentile, caught as they were in the feeble fetters of Gothic rhythms, of what use could they have been to an age when it was already not uncommon to see in Florence some prodigious examples of lenslike, absolute realism, by the hand of the greatest Flemish painters? And that this was in fact already happening is clear from the background of Domenico Veneziano's *Adoration of the Magi* (ca. 1435-40), now in Berlin, where the more distant figures are now dissolving in air, daubed and formless.

Gentile was thus alone in Florence, and very lofty in his aloneness, yet without any local echoes aside from some secondary, momentary phenomena. These — occasional moments in Angelico, Arcangelo di Cola and other "confused" artists — I have already cited in the text and elsewhere in these notes. In northern Italy, on the other hand, his influence is another story, due indeed to the natural resistance of those regions to the arrival of Renaissance "reason"; and the fruits of this transfer can be seen in Pisanello, Jacopo Bellini, and even in the young Foppa — in other words, until after the

half-century.

There is no need to point out that all the attributions made in recent years to the name of Gentile are, to say the least, irreverent, especially those of Van Marle in his Volume VIII and in articles in the commemorative local review *Gentile da Fabriano* (1928). Much more convincing is the very brief catalogue compiled by Berenson (Ital. ed., 1936), to which, however, must be added: the panel here discussed of the Quaratesi altarpiece; a *Madonna* with the Christ child standing on her knees, in the Kress collection; an *Annunciation* in the Depositories of the Vatican Gallery (no. 41 Q), which, though unfortunately ruined, would, if cleaned, reveal the master in person and in the act of copying, with the usual additions of ornate subtlety, the celebrated Florence "Annunciata." There is no question that the painting belongs in fact to the master's Florentine period.

53. Attributable perhaps to a certain Giovanni da Portogallo (mentioned in documents from 1436-39 relating to the cloister and immediately following its construction), though sometimes ascribed to the Master of the Castello Nativity (Berenson) and Domenico di Michelino (Pudelko), both artists of far more modest achievement than these splendid frescoes. Salmi (in *Paolo Uccello*, etc., Milan, undated, p. 139) attributes them to Uccello's followers.

54. Not only in the *Visitation*, as I said as early as 1926 (*Vita Artistica*, p. 129), but also in the *Presentation of the Virgin*, as Pudelko, upon my spoken advice, suggested in *Art Bulletin*, 1934, pp. 253-254.

55. [According to an inventory of 1492 now in the State Archives in Florence,

Uccello's three large scenes commemorating the Florentine victory over Siena at San Romano in 1432 once hung in "Lorenzo [the Magnificent's] chamber" in the Palazzo Medici; the group of "six framed pictures" decorating the room is stated in the document to have also included two other works by Uccello, showing respectively "battles between dragons and lions" and a "story of Paris" [the Trojan], as well as a sixth painting by Pesellino. A more summary mention by the chronicler now known as the Anonimo Magliabecchiano would appear to confirm this information. Dating most probably from sometime around 1455-1460, the battle scenes are now divided between the Uffizi, the Louvre, and the National Gallery in London. (Ed. note)]

[1] See also what Longhi later wrote on the subject in the essay "Stefano Fiorentino," in *Paragone*, 13, 1951, pp. 18-40, later reprinted in vol. VIII of the *Opere Complete di Roberto Longhi*, Florence, 1974, pp. 64-82.

[2] Article later republished in vol. IV of the *Opere Complete di Roberto Longhi*, Florence, 1968, pp. 7-20.

[3] Longhi later attributed this painting to the Master of the Sherman Predella; see pp. ____.

[4] Longhi later attributed this painting to Giovanni da Modena; see pp. ___.

[5] Now in the *Opere Complete di Roberto Longhi*, vol. IV, Florence, 1968, pp. 21 ff.

Roberto Longhi's notes are translated by Stephen Sartarelli

Editorial notes David Tabbat

Caravaggio and His Forerunners

Translated by David Tabbat and David Jacobson

When a painter wipes the historical slate clean and starts all over again, as does Caravaggio, then the usual scholarly investigation of his origins (entailing the hunt for certificates of apprenticeship and similar documents) resembles an effort to account for a revolution by scanning the news items printed the day before the explosion. A broader, wider-ranging measurement is surely in order: we must search back, as far as necessary in time, among the works produced over time, seeking out seeds, ferment, restlessness, rebelliousness, intimations of change.

So I have always found it significant that when Federico Zuccaro[1] was asked to give an historical assessment of *The Calling of Saint Matthew,* which Caravaggio unveiled around 1593 at San Luigi dei Francesi, he felt compelled to connect it with a phenomenon dating back more than a century: "Giorgione's ideas." The method was sound, at least in its scope. Only when we recall how hazy the conception of Giorgione had already become, do we realize that Zuccaro's phrase really means: Caravaggio is a product of "that region up there near the mountains," of the artistically semi-barbaric *ultima Thule* that northern Italy represented for Vasari and indeed for all Tuscan and Roman academic culture. But which (possibly uncharted) part of "that region up there" are we actually speaking about?

* * *

At this point I must mention, however reluctantly, some of my earlier research. Although slight and poor use has been made of it, it still seems to me to offer the best answer to the vital question. It is true that few readers know my dissertation of 1911 (written for the University of Turin), where an entire chapter is devoted to "the precursors of Caravaggio's naturalism," including Moretto, Moroni, Lotto, and Savoldo; yet, every time the topic of the precedents for Caravaggio has come up, I have been obliged to draw upon my extensive early treatment of the subject.

In 1913 (in *L'Arte,* p.162) I pointed out the moment, around 1595, when Caravaggio first seemed to aim at a fusion of the painterly style of the Venetians with that other manner, that blend of the plastic with the painterly practiced by "his first provincial sources of inspiration, the painters of Brescia and Bergamo." I characterized him in 1915 (*L'Arte,* p.132) as "the early Caravaggio, in essence a follower of Lorenzo Lotto"; and a year later (*L'Arte,* p. 250) I explicitly referred to him as "a follower of Lotto and Savoldo." In 1917, in order to prevent these assertions from being reabsorbed into a generalized explanation in terms of the art of the

Veneto,[2] I dedicated an essay ("Cose bresciane del Cinquecento, in *L'Arte,* pp. 991-1014) to further clarification of the basic differences between Brescian and Venetian art of the sixteenth century. This amounts to providing a historical justification for all "pre-Caravaggesque" art. In that same year (*L'Arte,* p. 62), I devoted a passage in another essay to pointing out the value of reconstructing "the roundabout way that Antonio Campi's[3] painting could have been useful to Caravaggio." It was no accident that, a few lines further along, I mentioned Peterzano,[4] whom newly discovered documents have since identified as Caravaggio's first teacher. And it was, in fact, right around that time that, having followed the high road of influence – that of his Brescian precursors – I was busy digging up a long-forgotten group of works by two like-minded painters, Antonio Campi and Peterzano; and in these works I found still-visible traces of "a little by-way that, after a short hike over the Campi, comes out on the road to Caravaggio"[5] (*L'Arte,* 1918, p. 240), as a fondness for seventeenth century metaphorical language led me to think of it. The main road to Caravaggio ran through Brescia in any case, for it was "only after having renewed themselves by following various signposts set up by the restless seekers in Bergamo and Brescia in the first half of the sixteenth century sign posts that pointed towards naturalism and an entirely painterly approach, that Antonio and Vincenzo Campi had the luck to inspire, however crudely, the first efforts of Michelangelo Merisi [da Caravaggio]." (*Vita Artistica,* 1927).

In Italy, at least, my interpretation of Caravaggio's prehistory quickly became common knowledge, and to some purpose. It was cited in 1914 ("G.B. Moroni e i pittori bresciani" in *L'Arte*) by Biancale (whom I incidentally advised to publish, as a most striking specimen of "pre-Caravaggism," Savoldo's *Saint Matthew,* just at that time on its way to New York's Metropolitan Museum). In 1921 Professor Venturi, in his graceful little popular introduction to Caravaggio, noted that I had "quite rightly drawn attention to the artist's debt to Lotto and the most important provincial painters of Brescia and Bergamo." What a pity he could find no space for that note in the book's second edition in 1925, when the critical apparatus was revised to keep pace with much of the new information that had emerged from the recent exhibition in Florence on seventeenth-century painting. A year later my early opinions were still being cited in a lively monograph on the Brescian artist Romanino (*Il Romanino,* Brescia, 1926, p. 17); yet, bound though my protest was to create more confusion, I had to object to the author's attempt to grant this painter membership in the Pre-Caravaggesque Club, and I reminded him (in *L'Arte,*

1926, p.148) that "having taken pains to distinguish the true pre-Caravaggesque painters – the Brescians Moretto and Savoldo – from typically Venetian ones, such as Romanino, I am distressed to see Caravaggio's name brought into a discussion of Romanino's achievement as though he were some by-product of it, when in fact the two were following entirely different roads." Meanwhile, my observations about the pre-Caravaggesque traits in Antonio Campi were becoming common coin, even turning up in 1925 in the catalogue of the auction of a well-known Florentine collection of seventeenth-century art: "influenced Caravaggio," declared one startling note on a work attributed to Antonio. The study of stylistic history worms its way into the most unlikely places!

At this point in our controversy of location, what could have been more welcome than support from the foreigners most interested in these issues? Instead, to my great amazement, the seedbed of learning that was Germany produced but a single essay, by that truly enlightened expert Hermann Voss (writing in the 1923 *Preußisches Jahrbuch*); it unexpectedly shifted the origin of pre-Caravaggesque painting to Rome, and more alarmingly still, to Scipione Pulzone,[6] without so much as a mention, whether favorable or hostile, of the Brescian context I consider so crucial to the understanding of Caravaggio's art.

Only adding to the confusion, Hadeln raised his pen shortly thereafter with an article (in *Art in America, XIII*, 1925). He set forth as his own rediscovery the affinity between Savoldo and Caravaggio, by that time a commonplace in Italy; worse still, he went on from this comparison to a general condemnation, as crude as it was antihistorical, of Caravaggio's art.

We do not wish to do an injustice to Voss, whose surprising study was at least interesting, by citing his work in the same breath with certain other worthless little books that Germany, for some strange reason, has recently been churning out on Caravaggio. We can find no words suitable in these pages to express the revulsion inspired by aberrations like Benkard's or deliberate falsifications like Zahn's; if I mention them at all, it is only to point out the ignorance that informs these earlier accounts. But insolence and stupidity never need to find converts; left unchecked they would add to the confusion among critics. So let us try to restore reason by taking a larger view of the problem.

* * *

Any account of the prehistory leading up to the tidal wave that was Caravaggio might as well, it seems to me, make its way upstream, back past

Lombard Mannerism and the Leonardoesque style, all the way back to the local Quattrocento painting of Brescia: the town that was at that time the most active hotbed and crossroads of Lombard art, thanks (let it be said immediately) to Vincenzo Foppa.[7]

Unfortunately, historical evaluation of the Lombard art to which Foppa is central is still weighted down with academic criteria for defining what is best and worst in art, criteria dating back to the Renaissance. Vasari's all but total silence about an art he considered little more than barbaric makes more sense, in a way, than the effort of the local writers, from *Calepino* down through Lomazzo,[8] to portray Foppa as a fifteenth-century superman, the precursor to Bramante and Leonardo. Not even modern writers have seemed able to escape such pompous apologetics (similar to many other provincial attacks on Vasari). Blind to the real, if narrower, originality of their regional art, they claim that it is fully representative of the great Renaissance achievement. Cavalcaselle[9] viewed Foppa as a follower of Mantegna; Venturi[10] detected the impress of Tuscan art in his thoroughly Lombard frescoes in Sant'Eustorgio [in Milan]; and even Berenson, despite some good observations on Foppa's tonalities, could find no better terms of comparison than Piero della Francesca and Giovanni Bellini. Yet when one considers what Foppa made of his experience in Padua among the artists of Squarcione's[11] circle, and how his later development differs from that of his probable companions Crivelli, Zoppo, Tura, Butinone, or Mantegna himself, then one realizes that, while of course he had mastered the basic rules of Renaissance grammar, the intention behind all his work – and we are speaking of a career spanning more than half a century – is nonetheless to modify those rules to serve a more relaxed, less rigorously architectural syntax, a more fluid and flexible language, and a more truthful setting; and he aimed to achieve all this through close observation and through tonality: both pre-eminently anti-Renaissance elements, disembodied, anti-sculptural, completely naturalistic and even accidental.

Pl. 37

In 1456, with the Paduan lesson still fresh in his mind, Foppa painted the *Crucifixion* (now in Bergamo) whose ostensibly classical structure is imbued with, and in places corroded by, a light and shade no longer Gothic – the space they flow through is too real for that – yet having nothing is common with Masaccio's chiaroscuro either, because it clings with a sort of tenderness to the forms, lingering over them and blending with them.

Pl. 38

Saint Jerome, another youthful work, is the first painting whose light source, rather than being transformed into the "universal light" of the

Renaissance, is concentrated into a highly specific instance of side-lighting: indeed, it is a study of light grazing a rock-face. The form this light rains down upon is still generally something preconceived and autonomous, as in the drapery, evocative of Donatello's practice of modeling drapery after wet cloth. But the saint's hands – uncanny anticipations of an almost Ribera-like naturalism, with light-animated fingers – are something new and different; and so are those pebbles on the ground, gleaming in the sun. This is, I believe, the first Caravaggesque painting in Italian art.

Around 1465, when Giovanni Bellini was still painting in the Mantegnesque manner, Foppa began to fresco the Chapel of Saint Peter Martyr in Sant'Eustorgio [in Milan], a typically Tuscan structure; the construction of this cycle reveals a certain indebtedness to the frescoes [by artists of the school of Squarcione] in the church of the Eremitani [in Padua]. The underside of the arches, where the Doctors of the Church are painted, seems to violate the integrity of the wall, standing out in perspective: in itself, of course, no more than a touch of naturalism; but Foppa's art truly reveals itself in the illusionism of the lighting he applies to his perfectly constructed views seen from below; it really begins only where the glancing light laps at the vaulting – where a silvery dove flutters against Saint George's cheek, with a near-miraculous luminosity that you'd be hard-pressed to match among those Doctors of the Church painted in the Eremitani.

This illusionism, in full control of the mathematical excesses of perspective, carries over into the scenes from the Saint's life that, glimpsed within the lunettes' irregular spaces, seem almost like kaleidoscopic snatches of real life. These scenes have the moody bourgeois energy we see in Tommaso da Modena's[12] story-telling, and even more in Altichiero's,[13] which Foppa might have studied at Padua even before seeing the work of the artists imported from Tuscany. Here we are truly turning back to the sources of naturalism in "Lombardy," those "purely pictorial" characteristics we perceive ever more clearly as an essential part of the north Italian Trecento. Yet, while scenes by Altichiero and Tommaso still seem in many respects to dangle from invisible wires suspended from the Beyond, Foppa's are more modern, the Renaissance having thrust upon him a more immediate awareness of space as something the human eye constructs and parses. The "optical pyramid," not the "optical map," has made these views possible. But I would like also to emphasize once again that the mathematical framework the Florentine artists idolized has now been nearly toppled and smashed; and the eye, as though reborn to new vision, follows its empirical impressions more casually through a natural space that

spills over, so to speak, into a mysticism of the here-and-now, inseparable from the particulars of this "melancholy garden" in which we live.

This is why some of these frescoes, far from adhering to the lucid formal extremism of the Florentines, point directly toward the luminous space of Dutch seventeenth-century painters, whose interiors are like gleaming boxes, spilling blessedly out into their fragrant surroundings. To find anything comparable to the miraculous scene of the *Saint Healing a Young Boy's Foot,* one would have to search not among contemporary Tuscan frescoes, but rather among Pieter de Hooch's Dutch courtyards, as we see them in the wonderful examples in the National Gallery in London.

And in another of these frescoes, another event of similar importance: in *The Death of Saint Peter Martyr* the landscape takes on such a life of its own as almost to eclipse the scene's main action; or rather, since its promotion to star status would be too systematic a subversion of the Renaissance's humanistic scale of values, the landscape is simply accorded a dignity and truth equal to that of the figures. A landscape not subordinated to, but coordinated (or perhaps commingled) with the triumphant figure of Renaissance man: here we have an art historical event whose momentousness is matched only by its neglect by students of landscape painting; and, what is worse, its modernity so baffles skeptical modern biographers of Foppa that they have explained it away as the handiwork of whatever nineteenth-century restorer rescued these frescoes from their plaster oblivion. Please, please! – in the Lombardy of the 1870s, before Carrà's late period, who would have been capable of painting a landscape so genuinely observed, so pictorial? Only some new Foppa, one in whose existence we do not believe.

I can hear the objection that Bellini's *Agony in the Garden,* a more or less contemporary work, is also a landscape. Just try, though, if you can, to imagine it for a moment without human figures. Feeling reaches a certain intense pitch, beyond which the silence must be shattered by some invisible human being's lament. The rocks will forever form a *prie-Dieu,* empty as the podium awaiting the Maestro who is to conduct this emotional *Symphonie pastorale.* But no note of human life, or human drama, ever quite impinges on Foppa's scene. Not even the "bloody deed of Barlassina,"[14] as the murder of the famous Dominican inquisitor might be called, can ruffle the calm of this landscape, which, if it were not in a painting by Foppa, would seem a vivid description in Manzoni.[15]

Take away the figures (how curiously they still reveal traces of the fourteenth-century soul!) and you would still have before you all the

reality and fixity of the trodden earth, the path winding between the tree trunks, there for everyone's use, but just now deserted; the hut belonging to no one in particular, and, sloping against the sweet sky, hills reflected in the lake at dusk: in a word, a stroll through the Lombard countryside.

Can painters really leapfrog the philosophy and beliefs of their times, as Foppa's landscapes would seem to suggest? Of course they can. Every painter's vision can express his own philosophy, which may not coincide, may even conflict, with the reigning one: a fact the historians of neat spiritual concordances are apt to forget, busy as they are linking soulmates, decade by decade: a painter with a philosopher, a poet with a scientist, a cardinal with a general... But let us get back to Foppa.

* * *

Critics, from Lomazzo on, have all, or nearly all, been quick to praise the *Saint Sebastian* in Milan's Castello Sforzesco as a marvel of perspective technique, and thus as proof of Foppa's obvious debt to Mantegna. I have never been able to concur in this view; Mantegna's *Saint Sebastian* in the Louvre has always irritated me with its acrid airlessness and the vagueness of the time of day, like some sublime agate cameo you can never see clearly for lack of proper lighting. Foppa's, on the other hand, has always impressed me with what I like to regard as a great beauty of *historical* specificity: of time of day, of light, of ambience. It seems to be saying: the martyrdom occurred at dusk, the faces of the marksmen were already in shadow, but their arms were brightly lit as they took aim; you could see the far-off countryside.... Here's the way it happened.

Gray is the color everyone remembers in Foppa. This halfway point between white and black is essential to him, serving to veil, ensnare, and subdue the whole color spectrum; his work is thereby based on luministic gradations of tone, rather than on those positive chromatic relations that remain the foundation of Venetian painting down to the end of the Cinquecento: we even hear them blaring through the chiaroscuro tempests of Tintoretto. Color which, from the Middle Ages on, had been, so to speak, linked to the purity and rareness of precious materials – their gemlike, elemental beauty – now awaits the random influence of light and ambience. For the first time, paintings can include serges and monks' robes, wood and walls, in colors of the humblest materials; the peppery-red of Lombard brick or the dull gray of a friar's habit. There remains a place for the old sumptuous colors too: who could ever forget Foppa's golds? But who is also not aware that they too – crucial event! – lose their

brilliance as they enter the realm of tonal values, descending from their superhuman height to a level no less real, no less significant, to share (if I may put it this way) luminous adventures with other new companions.

Many signs seem to point clearly to the fact that Foppa did plan ultimately to involve form in all this, rather than keeping it in a splendid, impregnable isolation; even if he generally seems, where form is concerned, to be biding his time, or even pretending to acquiesce in the approach of his contemporaries. I have spoken of the hands of the Bergamo *Saint Jerome,* and I have referred elsewhere to the seventeenth-century look of Saint Gregory's hand in the Sarasin collection at Basel; in this connection I should add the ordinary, even ungainly naturalistic figure type he employs in the *Madonna* (now badly damaged, alas, and kept in storage in the Berlin Museum). In other works he is more cautious, almost elusive: the *Madonna* in Milan's Castello Sforzesco looks as though it had been inspired by a Tuscan terracotta. Yet his own particular aesthetic takes over as soon as he stops trying to compete with such sculptural effects and views a scene as being enveloped by air. Foppa, even in his most symmetrical compositions, his most Renaissance ornamentation, still melts and recasts and polishes the material of his figures and objects: his execution, his impasto, his touch – expressions of light – have a basis in the Lombard art of the time.

I once tried to explain to Berenson what I found so remarkably fertile (potentially, at the very least) in the two fine examples of Foppa's work in his collection: the angel in the *Martyrdom of Saint Sebastian,* seemingly shapeless save for the form provided by the sky's bright, abundant light; or the *Madonna and Child,* wholly bordered, wholly defined by an infinitely varied play of tiny strokes of glimmering light. As ever, the lucky owner insisted these were merely provincial versions of motifs from Bellini. Well, we may have to wait a while, but Lombardy's day will come.

Were an interpretation such as Berenson's adequate, Foppa would be beneath all consideration. Not a single hand or head in all his work would merit serious regard as drawing or modeling. Compared to Cima's *Saint Sebastian* in Strasbourg, or Bellini's in San Giobbe – to say nothing of Botticelli's – Foppa's *Sebastian* in Orzinuovi would become the work of a country bumpkin. Luckily, however, "tactile values"[16] are not essential criteria for all the art of mankind; and here, the bumpkin was out to paint a man in a landscape, not the latest embodiment of some noble lineage. Nothing provincial about that. Foppa, of course, had seen Bellini's *Madonna*s and the architecture of Mantegna; and yes, his work was a blend of Gothic and Renaissance elements. But as for the finished product

Color Plates

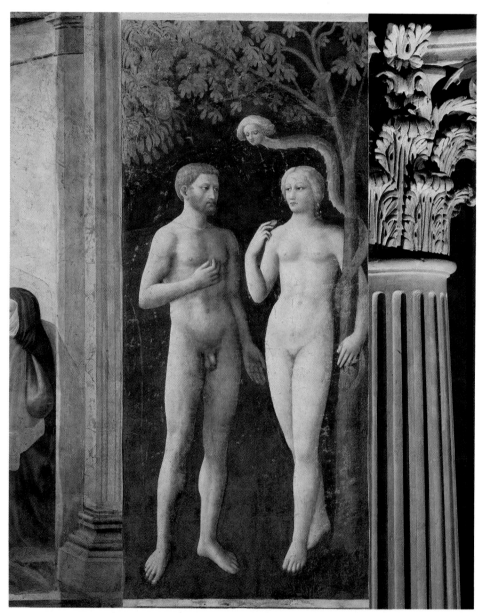

Plate 7: Masolino, *The Temptation of Adam and Eve*, Florence, Brancacci Chapel

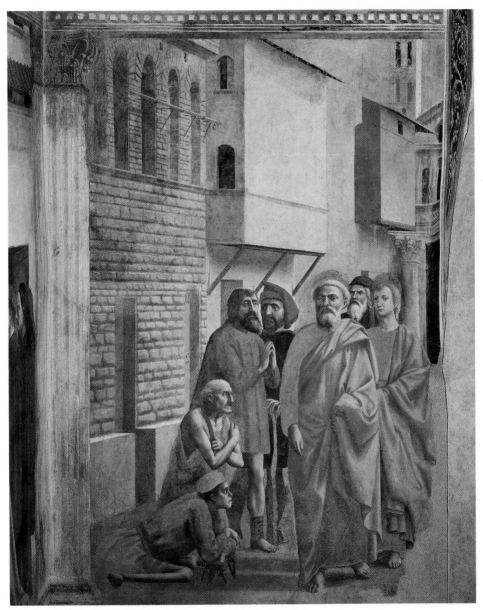

Plate 8: Masaccio, *St. Peter Healing with the Fall of his Shadow,* Florence, Brancacci Chapel

Plate 9: Caravaggio, *Still Life*, Milan, Pinacoteca Ambrosiana

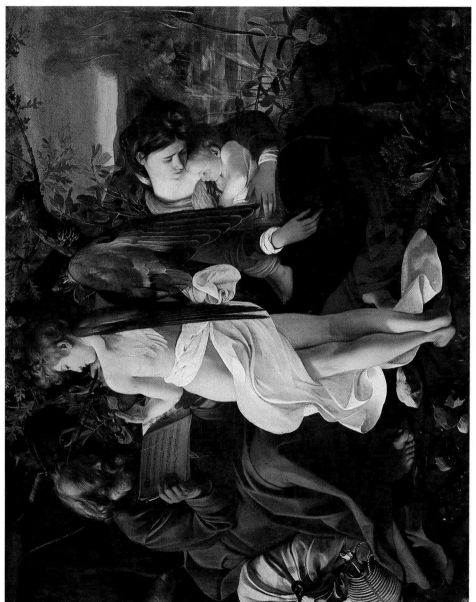

Plate 10: Caravaggio, *Rest on the Flight into Egypt, Rome*, Galleria Doria Pamphilj

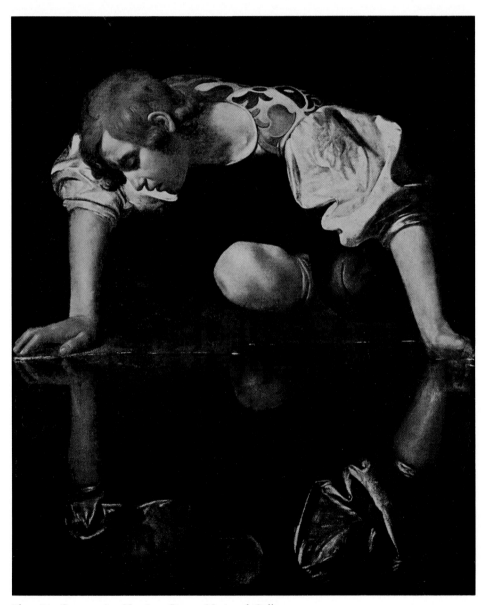

Plate 11: Caravaggio, *Narcissus,* Rome, National Gallery

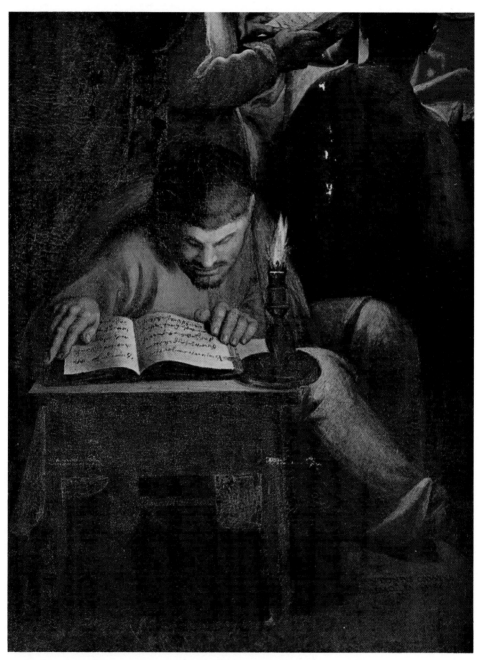

Plate 12: Antonio Campi, *Death of the Virgin* (detail), Milan, San Marco

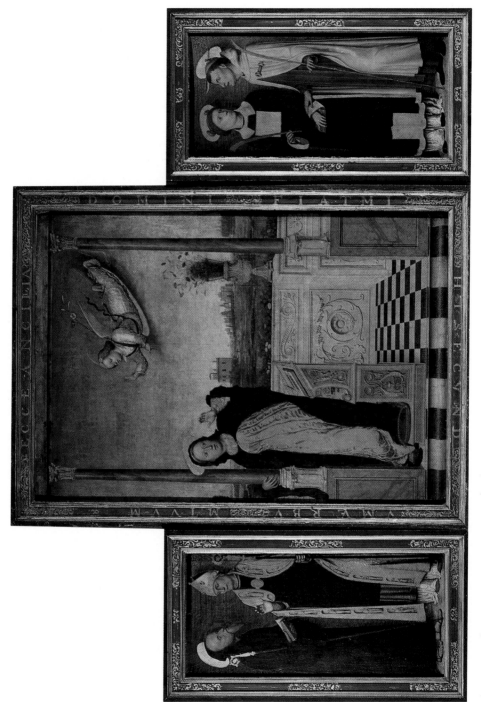

Plate 13: Carlo Braccesco, *Annunciation with Four Saints*, Paris, Louvre

—what a world of difference between Mantegna's and Foppa's polyptychs in the Brera! The bodies of Mantegna's saints are unified by one long and steady line which ignores the surrounding air, albeit in a well-proportioned space. Foppa's saints by comparison would clutter the elaborate composition like slack, useless mannequins, were they not made from a substance more illustrative and affecting, were they not harmonized in tone by the lighting which achieves by luminosity (in the baldachin jutting out over Mary's head, for example) what Mantegna does by spatial mathematics. There is, then, a simple architectonic and, as it were, social expediency to this composition. The Renaissance, Foppa seems to be saying, is really just a pageant, a ceremony, one that well suits, even cries out for, pictorial representation – which is exactly the way to elude it.

If form is veiled or blunted here, line broken, and modeling dimmed and clouded, this occurs, I believe, because Foppa knew intuitively that he could best express himself through diminution, through patinas and values – through effects of light; and he wanted his form to be determined by these realities, not preordained according to the sculptural precepts of Humanism. This was no small matter: to achieve it meant virtually breaking with all surrounding forms of life and established custom. Ritual and social proprieties could only hinder Foppa, even if other artists who took these conventions in their stride or blithely conformed with them were undoubtedly much more important. And who, after all, would have allowed, much less commissioned Foppa to paint realistic figures from everyday life in Lombardy – much less the roads they walked on, or the villages and countryside around them? Yet paint them he did whenever he could, despite all conflicting obligations. His relationship to Renaissance art was like that of Ambrogio Lorenzetti to Giotto more than a century before, when the artist could paint the harvest scenes and shop-stalls of Siena only within allegories of *Good and Bad Government* – and so settled for painting them in those contexts. Foppa was the true heir to every naturalistic subtlety the north Italian Trecento produced, but with an added luministic coherence that let him quietly elude the formal, stylistic constraints the Renaissance imposed on him. He eluded them, I would emphasize, not by flights of romance or fancy, as did the artists of Ferrara and Murano, but plainly, naturally, objectively.

* * *

Thus, to the extent he could be, living when he did, Foppa was a Quattrocento luminist, and a painter of night scenes. The initial innovation

this represented for painting, for vision in general, should be apparent from the fragments of work I have alluded to: the landscapes in particular, unique in their time, and animated by the same aesthetic that would later prompt the young Caravaggio to paint the *Basket of Fruit* now in the Ambrosiana [in Milan].

We need not go over the entire history of fifteenth-century Lombardy, least of all in its most Renaissance aspects. The Treviglio polyptych [by Zenale and Butinone][17] may have, for instance, gold more subdued in tone than Foppa's; but then, Zenale is certainly a more classical, humanistic painter. Butinone and Bramantino[18] offer subjective interpretations of what is, after all, the Renaissance subjective phenomenon par excellence, namely, perspective; and their Romantic tendencies are irrelevant to the present discussion. Not so the region's pervasive Leonardism, in all its ramifications; its abidingly Lombard aspects warrant study and would no doubt support my arguments, but would also distract us from our main topic, which finds more direct exemplification elsewhere.

Some of these artists seem to have ended their careers without followers, without having made any impact at all, either because they worked in such remote spots or, more probably, because other, more compelling innovations eventually supplanted the tendencies they embodied. Spanzotti[19] of Vercelli is one example of a significant artist without a following; a close Piedmontese equivalent to Foppa, he managed to insert at least three strictly "local" night scenes into his frescoes at Ivrea. His *Denial of Peter* truly anticipates the Caravaggesque; and though his training was obviously more complex than Foppa's, his style heavier yet smoother and more grammatical, his affinity with both the Renaissance and with Northern naturalism is still incomprehensible without Foppa's sublime empiricism: if I have mentioned him here, it is not by chance.

Foppa's method of eluding Renaissance strictures returns, indeed reaches great intellectual heights, in another painter, from Pavia this time, who worked in the late fifteenth and early sixteenth centuries; one who fully absorbed – picked dry, as it were – the expressive resources of an entire century, and concocted from these his own subtle, highly original sustenance, achieving sublimities of landscape and tonal mastery virtually unrivaled in the whole of Italian art. I am referring to the Master[20] of the *Annunciation* in the Louvre. Here, however, we are dealing with a figure too exceptional and too solitary to support any generalizations; nonetheless, he offers further evidence of the typical Lombard response to classicism.

What, then, of Bergognone?[21] He is generally acknowledged to be an

heir to Foppa, although the distorted view of what constitutes Lombard art has rendered this recognition fruitless, a dead letter. Now, at least, we can happily admit that if Bergognone is Foppa's disciple, he is so by virtue of a shared mindset: he, too, demonstrates both an acceptance of the outer trappings of the Renaissance (to such an extent that his work at the Certosa of Pavia was long attributed to Bramante[22]) and a deeper resistance to Renaissance formalism. The most essential elements of his paintings – their light, their physical substance – are Lombard, as is the Foppesque landscape, now even more deliberately isolated, forming almost a picture within a picture. They are among those humble miracles some now know, *tant bien que mal,* through the efforts of an English-speaking critic who thought he was paying them a compliment by likening their effects to Whistler's. Yet the density of Bergognone's landscapes, all the more remarkable because it was invariably obtained from the few tones their gray atmosphere permits, is radically naturalistic in spirit, absolutely devoted to fundamentals, and is thus quite unlike that American painter's pathetic "Oriental" froth.

Of course, even Bergognone set up elaborate symmetries in his polyptychs; sometimes he, too, liked to pattern his figures according to the cubical and cylindrical artist's models brought to Lombardy by Bramante. Yet who would deny that the real art of an altarpiece like the *Saint Ambrose Preaching* in the Certosa of Pavia resides in its lighting effects: the dim glow that pervades the entire scene, the constant play of one light source against another?

Or in the Louvre *Circumcision,* note how the painter handles the festoons that, ever since the Squarcionesque painters, had served to show off perspective illusion, or delicacy of line, or harsh sheens. Bergognone's art triumphs, rather, where the oculus window is deliberately opened in the architecture to frame a large, sweet, succulent peach, dangling against a gray-blue sky. One half-suspects a certain malice in such evasion-by-use of Renaissance motifs. Nor, as I have mentioned, was Bergognone content Pl. 39 with glimpses through narrow apertures; he consciously heightened the positive value of his natural settings by isolating them. The two views inserted straightforwardly into both sides of the Visconti-Venosta *Madonna* are a good example. How tellingly they differ from the background landscapes of Bellini's *Madonnas,* which, for all their excellence, remain humble and subordinate. Here, on the contrary, the chilly canals, ducal lodges, poplars and bell-towers, piazzas deserted at dawn, bishops' palaces, town halls peopled in twilight... they all pass by, a procession of realistically present images in the eye of some indefatigable pilgrim.

The Lodi *Annunciation* takes place in an ornate chamber of well-nigh Oriental splendor; yet just outside, the Sforza estate is bathed in a dazzling brightness: out there we hear the peacock's cry, the treble of the swallows perched on the ironwork of the arches; we see the sun-streaked door, the eaves, the low wall streaked with ever-shifting shadows, the closed side gate leading to the murmuring orchard and beyond all this, in the mist, a Lombard village.

Or take the spot in the little town along the Po, in the Bergamo *Madonna,* where poplars mingle with house tops, hens peck in the cool shade between door and walk while, up above, the last light of day grazes the trees leaves, lapping and salving the belfry's mouth.

Similarly tender, yet equally objective in their naturalism, are what seem to be the first true still lifes, placed along the steps of the Holy Virgin's throne in Bergognone's altarpieces. I have spoken of the giant peach in the Louvre canvas; but I think I have yet to remark that it is in Bergognone and his Lombard contemporaries that baskets of fruit make their first appearance in altarpieces, no longer as decorative details of a mystical luxury, or as curios, but adored for their own sake, even if they are still disguised (and how pregnant this fact is!) as tokens offered to divinity. It is certainly no accident that the brimming basket set on the steps before the throne in Bergognone's altarpiece in the Ambrosiana will turn up again in a work painted roughly a century later, and now in the same room of the Ambrosiana: in the *Caravagiensis fiscella:* the wicker basket painted by Caravaggio, given by Cardinal Del Monte to Federigo Borromeo.[23]

Pl. 40

* * *

But what about the century-long wait that follows?

The natural response to this question would be to turn to the art of sixteenth-century Brescia. Once again, though, the havoc wreaked by a despotic academic criticism all but bars our way. Inevitably, just as Foppa was viewed as a mere provincial version of Mantegna or Bellini, the Brescians of the Cinquecento – Moretto[24] in particular – were written off as minor rustic versions of Titian. Still, I shall keep to my policy of explaining local history with the aid of the most relevant critical sources from the period. Thus we shall pass over Vasari, who obviously could only lament that Moretto's Raphaelism was too restrained (though we must remark that he refers to Moretto's "diligence": a fine and versatile term, of course, but the very one Baglione will apply to the young Caravaggio,

and one which Vasari, in any case, never uses for any purely "Venetian" art). And we shall certainly disregard Lomazzo, who more than matches the extravagance of Vasari's having interpreted Lotto in terms of Correggio with his own Titianesque interpretation of Moretto. Let us begin instead with Lanzi. Admittedly, he was a slave to classicist tradition – yet he managed to correct or at least temper it with a direct and genuinely original power of observation. Not that he would go so far as to posit a "school" of Brescia: Moretto is mentioned strictly in relation to Venetian art, with an echo of Vasari's "Raphaelesque" characterization. Eventually, though, he does explain that, having passed through a Titianesque phase, Moretto "created a style so novel and so charming that some lovers of art made the journey to Brescia for the pure pleasure of viewing his work." And Lanzi – who of course could not have guessed at the Foppesque origins of this new style – goes on to give a subtle description of it, above all as regards color. "As for its palette," he writes, "Moretto's method is full of startling new effects. The most characteristic is a remarkable balance of white and dark tones over rather small, well harmonized, neatly contrasted masses. This device he employs for both figure and ground; the clouds too he sometimes describes in similarly opposed colors...," whereupon Lanzi's observations grow less felicitous. Yet even these initial remarks show how fully he knew what constituted the basic difference between Moretto and the Venetians – namely, his chiaroscuro, or, let us say, his particular use of black and white: a lighting scheme whose intensity anticipates the luministic imagination of Caravaggio.

The apparent innovation of Cavalcaselle's history of Italian painting – the devotion of a separate chapter to "the Brescians" – actually owes less to a changed historical conception than it does to the editorial necessity for easy classification. It is interesting nonetheless to see the old man's divining rod pulling him along towards the "pleasant naturalism" in Moretto – and, in the case of the large *Adoration of the Shepherds* (formerly in Santa Maria delle Grazie, now in the town's Pinacoteca), even towards an affinity with Velázquez. For after all, if the analogy overshoots the mark, we must remember that it was made in an age when the author could hardly have stopped short right at Caravaggio, as we can do today.

On the strength of Morelli's clinical observations of Moretto's silvery grays, Berenson arrived at the happy historical insight that the *Quattrocentisti* of this region were linked to the tradition of Foppa. His only mistake was in limiting this link to technique, rather than extending it to a general conception of picture-making. Which is to say that, artistically speaking, just as he considered Foppa Bellinian, he made Moretto

Titianesque: either a backwater epigone, or a zealot doomed to look slightly foolish in his effort to blow the hero's trumpet.

Moretto's *Elijah with the Angel,* for example, reminds Berenson of a depiction of "the centaur Chiron mounted by Victory" – amusing, almost, this notion that mere archaicizing, a crutch for fledgling or mediocre artists, might somehow ensure an archaic result! And when Berenson speaks of the *Saint Justine* in Vienna as one of the heroic creations of Italian art, of its partaking of antique grandeur and directness, one returns bemused to the painting itself, to find that it will speak on none but its own terms: namely, with an air of intimacy (not without a hint of bad faith) that draws the worshiping figure too close to his patron saint, like some fortyish bachelor, tied to mother's apron strings. Or, to take a final example: when Berenson echoes Cavalcaselle in regarding the *Supper at the House of the Pharisee* in Santa Maria della Pietà in Venice as a shining anticipation of Veronese, one must protest that, on the contrary, it is this work that shows most clearly what sumptuous Venetian classicism really meant to the Brescian painter. For Moretto it meant – as it had for Foppa and Bergognone – a series of social circumstances and nothing more: occasions for pomp, ceremonial symmetries, ornamental graces, from the stance of the figures to the way the flower becomes a kind of cerebral horticulture. A mode of life, to be sure, but not necessarily a mode of art. The art comes elsewhere. We can still sense its presence in what little simplicity, what modicum of reality the Brescian painter could smuggle into the forced gala: in the texture of the table-cloth, the host's gesture – or that hopelessly "central" platter, with the cold chicken lying on it! Home again, Moretto will undo this scaffolding. The masterpiece he paints in Brescia's Santa Maria Calchera, on the very same subject, is the archetypal anti-Venetian statement – and, as we shall see, the most "pre-Caravaggesque" of all his paintings.

The objection will arise that Moretto's portraits are nonetheless quite aristocratic; and so they are, especially the early ones. Yet even when their roster is properly expanded to include the superb portrait of the *Protonotary Giuliano* in the National Gallery in London (where it still bears an attribution to Lotto), I would insist that they differ fundamentally from those of Titian. The Munich *Ecclesiastic* has more in common with a Holbein than with a Titian, and its careful definition of setting recalls the detailed interiors sometimes found in Foppa (as in his Frizzoni *Madonna,* now in the Castello Sforzesco in Milan) and so frequent in Bergognone. The same holds true for the portrait of *Protonotary Giuliano:* its faithful expression of a particular temperament is entirely at odds with Titian's tran-

scendence of the actual model, and his use of intense coloristic effects to raise the sitter to a state of all-purpose sublimity.

And let us note straightaway Moretto's superior attentiveness to whatever provincial longing or fancy stirs in the breast of each Brescian gentleman. *Martinengo,* for one, is so patently heartsick that he all but makes a genre figure of himself. *Averoldi at Prayer* (National Gallery, London) is the first portrait we have of a modern believer, as inwardly devout as he is undemonstrative (as will become apparent when we compare him with [Titian's] Vendramin family, who seem cynically to repeat their motto "non nobis Domine non nobis" as they pray before the family altar). The list could go on. As for the full-length portrait of a *Nobleman* dated 1526, also in London (the first Cinquecento portrait in this particular format, to my knowledge), is it too much to call it the ancestor of a line that descends from Moroni's bourgeois gentlemen and men-at-arms, not to the heroic monarchs of Titian's school, but rather to Caravaggio's dynamic yet peaceable figure of Wignacourt?

Here, of course, I am merely summarizing the sketch of Moretto's career I provided in my essay "Cose bresciane del Cinquecento."

While I have also to leave aside the question of Moretto's very first works, so full of deference to the elder painter Romanino (and hence to Venetian innovations), I cannot overlook the fact that, as early as 1518, in his Bergamo *Christ with a Worshiper* and in other less important works roughly contemporary with it – the London *Christ with John the Baptist* (Layard, 3096) or the Metropolitan's *Christ Among the Beasts of the Desert* – Titianesque though the color scheme may be, once again the relation of figure to landscape is thoroughly anti-Venetian, truly Foppesque. But let us move on to other paintings from the crucial year 1521, and to the Chapel of the Sacrament in the Church of San Giovanni Evangelista [at Brescia].

Here, as is well known, Moretto and Romanino divided up the work they were committed to completing within three years, with Moretto taking on the entire right side of the chapel. We find in his contribution a variety of conflicting elements (Venetian chromaticism combined with the composition of Leonardo's *Last Supper,* hints of Raphaelesque prints in the *Manna;* an early-Michelangelesque anatomical emphasis in the *Saint Mark,* extreme archaism in the *Elijah,* etc.), all pointing to one essential fact: Moretto had firmly resolved to break once and for all with the contemporary Venetian style, i.e., from the chromatic classicism of Palma and Titian. "To embrace Mannerism," I hear the enthusiasts of that highly intellectualized phenomenon in Italian art exclaiming – to

which we must reply: "No, to reclaim and renew, as quickly as possible, the tradition of Lombard art."

The very predominance the new classical world accorded to Man had convinced Moretto that a painter's *dramatis personae* should be given greater prominence, express more action and volition than their mere appearance and self-presentation had granted them in the age of Foppa. Yet inevitably, as Moretto's Lombard eye pulled figures forward, something happened: light and objects came forward too; and light, with its function of drawing plastic things nearer, led him not to new anatomical dreams, but rather to surface truths of flesh and blood. Unhampered by the musculature of the nude, their pictorial effects were altogether pre-

Pl. 41

Caravaggesque: *The Drunkenness of Noah* is a striking prefiguration of Caravaggio's *Saint Jerome*.

The vault of the chapel I have referred to confirms the fact that Moretto had, even by this stage, decided that the world's spiritual significance could be transferred, with no loss, from the human realm to that of the light and shade surrounding it: here, prophets arm themselves with vast papyri against the scorching rays of a sun that strikes obliquely from low-hanging clouds, enveloped and masked in a darkness sufficiently dramatic to provide a direct foretaste of Caravaggio. Or at any rate, Caravaggio seems to allude, in his own *Seven Works of Mercy* (at Naples), to Moretto's nude *Micah* dressing himself. In similar fashion, one of those Prophets generally attributed to Romanino in the *Malachai* segment of the chapel (but so naturalistic that it must instead be by one of Moretto's assistants) offers, if I am not mistaken, a clear precedent for the chiaroscuro of Christ's head in *The Calling of Saint Matthew* in San Luigi dei Francesi [in Rome].

Yet we know that the bulk of Moretto's *oeuvre* consists of a great many altarpieces scattered in and around Brescia. And, aside from some feeble attempts at classicism, such as the 1526 *Assumption of the Virgin,* Moretto was apparently inspired chiefly by Quattrocento art. I mean that certain portions of his work are as much mere "presentation" as I have said Foppa's were: the Brescia *Annunciation,* for instance, the Venice *Saint John the Baptist,* the Brera *Saint Francis,* the Milan *Saint Ursula* (based on a work by Antonio Vivanni), the *Resurrected Christ with the Virgin Mary,* the Orziunuovi altar, the Frizzoni *Madonna,* etc. There is nothing extraordinary about such an historical continuity. Elsewhere the painter seems to allude to architectural settings represented by Bellini, Cima, et al. Yet, indifferent now to the rigor with which those Masters' architecture has been constructed, he seizes on the votive format to try out novel, and yet characteristically Lombard, effects of intense illusionism, no longer obtained

through the well-worn mysteries of perspective, but rather through the play of raking light and formal inventions which suddenly burst the bonds, so to speak, of the picture frame. The latter is a most significant indicator. An instance occurs in the *Pentecost,* where the shadow streaks three times across the marble floor, and where the two apostles in the foreground – or rather, jutting beyond the foreground and into our space – lean against the last pier, showing, against all decorum, the soles of their bare feet. And what huge shadows the two protectors against the plague cast across the dais of the throne at Orzinuovi! What an illusion the shadow casts about itself as it streaks down upon the rug of the *Rovelli Madonna*'s throne! What originality of conception in the bishop's hand outstretched to us, a hand arrested for an instant by light, in the Brescia altarpiece; or in the little black hog grunting as it stretches its hoof out of the canvas, at the first step of the altar in Comero! What a commanding entrance those two white-clad monks make in the altarpiece now in Berlin!

Or take, for instance, the biblical and allegorical compositions, the scenes of Simon Magus now in Santo Cristo: the protagonist's "flight" and "fall" are among the century's most astonishing and enigmatic compositions. Their structure may be somewhat Bramantesque; but in no case is it Venetian. Mastery of perspective serves instead to convey corporeality in sudden foreshortenings, in a tangle of forms and realistic figures so brutal as to read like a catalogue of Caravaggesque motifs. As he topples headlong, Simon Magus prefigures the angels of San Luigi dei Francesi, just as *Saint Peter Upholding the Church,* in the third painting at Santo Cristo, is, to say the least, close kin to the young Caravaggio's *Saint Matthew.*

One could adduce numerous other examples. Foremost, perhaps, the *Elijah* in the Chapel of the Sacrament, Saint Joseph and Saint Michael in Pl. 42 the altarpiece at Santi Nazario e Celso, or the uncouth *Prophet* in the Brera. If these are such plausible antecedents, it is precisely because Moretto is the first painter to lower the social standing of his sacred figures; when he can, he takes them from the same lower classes that will provide Merisi with his. We have before us, then, the first half-clad, beggarly prophets; the first Evangelists sitting cross-legged as they fish for ideas in the inkpots on their desks; the first bald, sun-parched hermits; and even an occasional saint is worldly and bourgeois enough to resemble one of Caravaggio's cardsharps.

Moretto's *Madonna Appearing to a Shepherd on a Path* at Paitone – apparitional, but concrete, a product of earthly faith and thus no mere figment – is also the immediate precedent for Caravaggio's famous scene of

the two aged pilgrims visited by the *Madonna of Loreto*. In both cases, spectators of humble origin have been enlisted as actors rather than mere worshipers.

The entire conception of the *Nativity* in Santa Maria delle Grazie anticipates the rustic simplicity of Caravaggio's version of the same subject at Messina. Or need one say more about the prominence Moretto gives such so-called details as the basket of linen?

Pl. 43

Another moment of near-divination on Moretto's part comes in a work I have alluded to in passing, the *Magdalene at the Feet of Christ* in Santa Maria Calchera. I am tempted to call this a "monumental genre scene," of the sort Caravaggio will conceive for similar gospel themes. Its setting is defined and focused by the slanting light that cuts diagonally across the base of a wall – a common practice of the young Caravaggio. Form is less volumetric than solid, less tactile than sharp and tangible, at once drawn and painted (note, in the foreshortening of Christ's hand, how the outline also serves as a tonal accent); the servant holding a fruit-basket, the table's still-life might almost be lifted from either of Caravaggio's versions of the *Supper at Emmaus*. These realistic elements: the white weave of the tablecloth, the dense shadow of its folds, the divided loaf of bread, the fish-head in the tin plate, the carving knife at the end of the table, when you juxtapose these elements with Titian's *Emmaus* in the Louvre, which is a mere pretext for ranging a few sparkling highlights over broad masses of color, they confirm neatly Moretto's opposition to Venetian classicism, his progress toward those solutions Caravaggio was to find.

Moretto's work abounds, of course, in examples of still life disguised as a religious offering, whose pictorial appeal and interest – whose truthfulness – signal the imminence of the moment, however, when such fragments will acquire an artistic and ethical value free of all hierarchical dependency upon a "subject" (much in the way Bergognone's pictorial interest in landscape had broached the imminent possibility of pure landscape). The reader may take his pick: the little pear boughs along the steps of the Vatican altarpiece; the rose that has been plucked and tossed to the ground in the San Nicola altarpiece; that full spray of flowers in the allegory of *Faith* in Saint Petersburg; or any number of the sacred props raining down into earthly settings: books, keys, instruments.... Beyond the fragments in Santa Maria Calchera, though, it will suffice for our present purposes to single out a fruit-basket in the Sant'Andrea altarpiece at Bergamo, to which the young Caravaggio might almost have put his signature.

Evidence this obvious and impressive will, I trust, illuminate not only

his Ambrosiana *Fruit-Basket,* but also another, more important early still life by Caravaggio[25] which I reproduce here for the first time. Perhaps if one had been able to corner the artist and prod him into explaining his subject matter, he would have answered perfunctorily: "I painted a horse for a *Conversion of Saint Paul* in Santa Maria del Popolo, and that fruit-basket for a *Supper at Emmaus."* Yet, were you to turn the latter canvas over, a rare period inscription on it would identify it more realistically as: a painting of "fruit and carafe" by Caravaggio.

To cite another instance of Moretto's naturalistic treatment of his subject matter: whereas everyone remembers the horse that dominates Caravaggio's *Conversion of Saint Paul,* no one, to my knowledge, has ever remarked that Moretto had already hit on the same idea for a signed work in Santa Maria presso San Celso: in Milan, that is, where Caravaggio would have had ample opportunity to see it as a boy. Furthermore, Moretto was working out a method of diagonal composition in which, with the great mass arising at full tilt – and with precious little regard for then-current ideas of "decorum" – he comes within a hairbreadth of filling the foreground with the animal's hindquarters. Is it not conceivable, then, that Lomazzo's *Treatise* (VI, 284) refers to just this outrage when he urges that "in the...decoration of religious edifices, pictures should be suited to the noble faculty of vision; so that the hind parts of horses and other animals never should face us, but be turned away, as parts unworthy of our sight?" Doesn't this passage provide a strong foretaste of the moral objections Caravaggio's work will inspire fifty years later?

If, on the other hand, I were to be asked for evidence in Moretto of the famous Lombard attention to landscape, I would have to say that his preoccupation with defining his rustic saints and arranging them in the foreground makes him neglect the rural setting somewhat; we must even admit that, at times, his backgrounds can be as generic as Palma's. Not that he was oblivious to this part of his artistic heritage: in the *Drunken Noah,* for example, alongside the most "Romanizing" figure Moretto ever painted,

there trails a vine shoot with foliage so lush it could have been seen and sketched by the likes of Cuyp.[26] The delicate delineation of plant life in the foreground of certain early Caravaggios (*The Rest on the Flight into Egypt* and the lost original of *Saint Francis Supported by an Angel*) is reminiscent of things in Moretto, such as the *Burning Bush* painted for the Novarino ceiling (now in the Gallery at Brescia). Elsewhere the foliage and the basic tonalities of the landscapes grow thin and Foppesque, as in the setting beyond the ledge of the Brera's Saint Francis altarpiece, or the *Death of Saint Peter Martyr* in the Ambrosiana which, while demonstrating the artist's familiarity with the Titian of San Zanipolo, far more closely resembles Foppa's version of the same subject in Sant'Eustorgio.

It is with this painting that I wish to end my discussion of Moretto's pre-Caravaggesque character – since all aspects of his work, and not merely his landscape, look ahead to the next century's great revolutionary. In many respects this *Saint Peter Martyr* is like a rehearsal for Caravaggio's *Martyrdom of Saint Matthew:* in the tragic fervor of the saint's eyes, suffused with shadow (and what could be more anti-classical than that?); in the executioners' volcanic physical violence; in the intense sculptural treatment, conveying the imminent horror of gushing blood and violated flesh. The novice fleeing in panic, turning in the scene's chilly air, is rendered with the startlingly bare, clear concision (if not with the plasticity) of the early Caravaggio: the brief cry he utters sounds like that of the *Boy Bitten by a Lizard.*

* * *

Thus, in ways that go beyond just his use of color – a theme on which I have allowed Lanzi to speak for me – Moretto emerges as a Caravaggio *avant la lettre*. Naturally, the relationship between his work and that of certain painters who deviate from the chromatic classicism of Venice (namely, Lotto and Savoldo) should encourage us to examine them, as well, for hints of the imminent Caravaggesque style; although Moretto alone bears the distinction of having fused those hints of a new painting style and two centuries of Lombard regional tradition.

Which is not to dismiss the question of Lorenzo Lotto, and least of all that of his early development: a question scholars have hardly even broached, much less resolved. Berenson, ever the ironist, ever eager to recant his own youthful findings, has certainly thought over and over about revising his old Lotto monograph.[27] The book never dealt, of course, with the artist's relation to Lombardy, nor once so much as named Moretto.

Yet when we stop and consider that, as I have mentioned, the portrait of the *Protonotary Giuliano* in London, still attributed to Lotto, is really by Moretto, are we not to assume that, between 1515 and 1520, the spiritual paths of these two artists converged? It is, of course, already hard enough to account for the early, or rather the earliest landscapes of Lotto – the landscape in the *Danae,* for example, or in the *Saint Jerome,* or the one in the predella of the Asolo altarpiece[28] – merely by reference to Venetian tradition, or, for that matter, by substituting some vaguely Belliniesque interpretation for Berenson's long-discredited hypothesis of Lotto's stylistic dependence upon Alvise Vivarini and the school of Murano.

Let us leave aside issues largely irrelevant at present, and come to the period around 1512, when Lotto's cultural horizons truly begin to expand. For beyond all doubt he is more advanced than Moretto, who did not change direction before 1520; early on, Lotto showed a receptiveness altogether more modern, subtle and enlightened. He obviously traveled, making the direct acquaintance of works by Raphael and Giorgione, Leonardo and Dürer; he borrowed from all of them, but treated them as his equals, not his masters; nor did he get his idioms mixed up in the translation, as Moretto did: instead, he coined neologisms. These contacts were not enough to turn Lotto into a classicist. He became something quite different, in fact; hence the offense his work gave to the high-handed critics of the capital, who found it full of inexcusable errors. When Dolci[29] cited Lotto's masterpiece in the church of the Carmini – the purest landscape in all of Cinquecento painting, a composition that calls to mind Rembrandt or Ruysdael – he did so only to condemn it for its poor coloring. Three centuries later, the Baron von Rumohr could only marvel that the citizens of Bergamo did not stone Lotto. These two extreme positions pretty well sum up several centuries of unfairness to this artist. Certainly no justice is done him in Vasari's Venetian interpretation in the second edition of the *Lives* (the first merely mentioned his "diligence"), nor in Lomazzo's Leonardesque interpretation; though the latter at least points in the right geographical direction.

For all the weight of his stylistic armature, Lotto's way with the classical formula was, in fact, altogether Lombard: elusive, cautious, premeditated; the results, fully in keeping with regional tradition. While the question of his first landscapes is still unresolved, it is safe to speak of him, from 1515 on, as a Lombard landscape painter. The setting of the 1517 *Susannah* (ex-Benson Collection) has certain qualities one finds in Trecento Lombard miniaturists or in Foppa; the central motif of the Madonna in the Museo Correr (which, no matter what Berenson may

claim, is an indisputable original from around 1525) is characteristically Lombard, decidedly un-Venetian; the sublimely "popular" Trescore murals parallel Moretto's Novarino frescoes in their combination of two kinds of illusionism, one based on perspective and one on light (the latter a blend of the Bramantesque and the naturalistic); and the radiance of these scenes' interiors shows a conspicuous debt to Bergognone. To suggest at this point that Lotto's more complex personality brought a wave of innovation to the Brescian art of the Cinquecento is to admit that his notably keener mind gave him a clearer insight into the Lombard tradition than the Brescians themselves could have before he came along: he is like some staunch friend, stronger and more clear-headed, helping his rustic neighbors – drunk on some young wine of the Veneto – to find their way back home: upon arrival, he still has to lead them to the door and turn the key in the lock.

Certainly, Lotto's peculiar temperament and the delicacy of his intuition would have been harder for Caravaggio to assimilate than the bluff simplicity of much of Moretto. Yet even Lotto's art – when it is seen against the epic, aristocratic, stereotyped Venetian manner embodied, for instance, in Titian's "Heroic Majesty" – seems like some vast naturalistic inventory of humble particulars, degenerating at times into caprice, it is true, but more often invested with objective, ordinary light and "values." Naturally, I am leaving aside Lotto's magical phase, his moment of *sensiblerie,* of that emotional mysticism (paralleled by Domenico Campagnola's incredible prints) that unites him with Grünewald. His dramatic contrasts of light-sublimated color surpass anything of the sort in Caravaggio, coming very close to Rembrandt (see the latter's Louvre *Woman Taken in Adultery,* for example). Yet, as these extreme contrasts abate, his handling of light comes once again to seem naturally consistent with earlier Lombard tendencies, at once serving the composition and enhancing its realism.

Lomazzo described Lotto as a "master in creating effects of light," and in most of his compositions – the Ponteranica and Jesi *Annunciations,* the Celena *Assumption,* the Monte San Giusto *Crucifixion,* the Jesi *Scenes from the Life of Saint Lucy* – the lighting does indeed play a decisive role.

Note too that this new lighting, far from assuming any Renaissance form, is fluid, elastic, above all various; its beauty is always bound to the character of the scene in an infinitely permutable form and, in the best sense of the word, popular.

Isn't it obvious, then, how all this must have appealed to Caravaggio? Berenson, describing the lighting of Lotto's interiors, repeatedly com-

pared it with Vermeer's. But the road that really leads to Vermeer is by now well marked.

I have said before that Caravaggio's early *Rest on the Flight into Egypt* was chiefly influenced by Lotto; to appreciate this fact, you need only view it beside the Louvre *Sacra Conversazione,* the Bergamo *Bethrothal,* or the Brescia *Adoration with Two Donors.* The tones of both artists are cold and polished, their "values" very high; but they are also alike in the way they turn the Venetian "sacred conversation" into an intimate gathering that commingles, indeed merges the character of the divine and the human participants. And the celebrated beauty of Caravaggio's angel – a beauty of sound body and natural elegance, beauty born in Nature's nursery, not in the hothouse of style – isn't it close kin to Lotto's angels in Bergamo, which Caravaggio might so easily have visited? The two angels in the San Bernardino altarpiece, for instance, have those broad, powerful predators' wings – features of a rare naturalism – that will eventually turn up in all the Caravaggesque workshops of Rome. Pl. 10 Pl. 44

The memorable Monte San Giusto *Crucifixion* anticipates Caravaggio in several respects. The intense, oblique light, issuing perhaps from some opening in the clouds, makes the Cross cast a shadow like a blindfold across the eyes of one of the Roman horsemen (almost as though a moment of worry or moral uncertainty had taken on a natural form, expressing itself in a lighting effect): here is an epoch-making, a truly far-reaching invention. In the left foreground, having made his way through the crowd, an angel explains the symbolic meaning of the scene to the prelate, who seems in fact to require such an explanation, just like Caravaggio's *Saint Matthew* – who also gets put straight (so to speak) by an angel. How similar are the two artists' inventive imaginations! Or, if you want to see how truthful and how simple Lotto can be about form in his more sober and less honied moments, and thus how pre-Caravaggesque, then look at the Saint Laurence in the Ancona altarpiece, a figure made out of light, just like Caravaggio's figures fifty years later.

In general, the relationship I've already mentioned between gods, men, and saints, a relationship no longer lofty and allegorical, but instead intimate and down-to-earth, is frequent in Lotto; it has an obvious parallel in the common people painted by Moretto, and it leads straight on to Caravaggio. Having cited Moretto's Rovelli and Paitone *Madonnas* in this connection, we should mention also Lotto's *Saint Anthony Giving Alms* [in SS. Giovanni e Paolo in Venice], a work unprecedented in its respectful aesthetic treatment of a poor, anonymous crowd; also the *Madonna of the Rosary* in Cingoli, which comes quite close to Caravaggio's

handling of the same subject in a painting now in Vienna.

Lotto's night scenes are relevant to our present discussion only insofar as they present special instances of the artist's luminism; beyond this particular point of interest, they are too original not to risk leading us astray. In the same way, the *Nativity* in Venice, even if it were not – in our opinion – a seventeenth-century copy of a lost original, would offer up a scenario too visionary and apocalyptic to be pertinent. But when Lotto worked with this same subject matter on another occasion – unfortunately, the work has come down to us only in a copy (Uffizi, ex-Galleria Ferroni) – his ideas were better focused, less contrived.[30] This copy, by the way, unlike the one in Venice, suggests the work of some Caravaggesque *petit-maître* such as Elsheimer or Saraceni[31] – which is itself a telling fact, though by no means an isolated one. Elsheimer's *Ceres* in the Prado is a little piece that would appear to have been inspired by the subtly luminous figure of the serving girl in Lotto's *Nativity*, who is also seen from a low angle; but then, I could easily cite other cases of minor Caravaggesque painters using Lottesque motifs. Borgianni[32] obviously did so in his *Saint Christopher* and in several versions of the *Holy Family*, as did Saraceni, in the crowd of beggars at the base of his altarpiece in the church of San Zanipolo at Gaeta. But since these painters' ultimate master had himself been in part a Lottesque painter, such borrowings should come as no surprise. Conversely, they help to explain how aspects of Lotto's work could pass directly into Rembrandt, not only from Caravaggio himself, but also by way of the much-maligned "minor Caravaggesques."

The relationship between Lotto and Moretto on the one hand and the Brescian painter Gerolamo Savoldo on the other is a received idea in criticism, the image of Savoldo as a "pre-Caravaggesque" being practically a commonplace; and so we should include him among the artists relevant to our subject. But there is an equally accepted notion of him we need first to dispel: Savoldo's role as a "Giorgionesque." If this were true at all, it would undermine the coherence of the Lombard history I have attempted to construct here.

In several previous discussions of Savoldo as a specifically Brescian and Lombard artist,[33] I have touched on three essential points: the similarity of his "studies of form" to Moretto's; the likely influence upon him, formal as well as pictorial, of the most complex lessons of the Tuscan Quattrocento (Piero di Cosimo);[34] and the fundamental difference between him and the school of Giorgione. I demonstrated the latter by comparing every aspect of his *Shepherd Playing the Flute*[35] with the genuinely Giorgionesque style of another *Shepherd* by Mancini.[36]

As a rule of thumb, one might of course make a concession regarding some minor point, the better guarded to refute false inferences on more important matters. I shall grant, then, that certain Giorgionesque themes, or rather certain non-essential motifs, involving amours or astrology, sometimes appealed to Savoldo and other like-minded artists. But how much more strange and significant it is that, as soon as these artists left Venice for the *terra firma* (from which most of them had come in the first place), their work grew clearer and more straightforward almost at once: that, in a word, they ceased to be Giorgionesque. Naturally I am not referring to *Giorgionisti* like Caprioli or Gerolamo da Treviso, who merely became Raphaelesque, or to Mannerists like Pordenone and Romanino, Pellegrino da San Daniele or Campagnola. But at the first opportunity even Licinio firmed up his impasto, became sharp and meticulous; the fine series of apostles now in the Galleria Barberini, studies for a *Last Supper,* have all the rude vitality of a group out of Caravaggio. The art of Verona is full of such cases of retreat from the Giorgionesque manner; one example would be the superb group of apostles in the church of Santa Chiara (the work of Torbido, I believe). The number of defectors increases as one gets closer to Brescia, Lombardy's old art capital. Again, I do not include Romanino; like Campagnola and Pordenone, he renounced the Giorgionesque manner, but only to opt for a grotesque, obsessive Mannerism. I do, however, include Calisto Piazza,[37] trained in his native Lodi, whose painting grew more tangible, clear-cut, and realistic the further he got from Venice – and whose *Coronation* or whose *Concert* (Johnson Collection, Philadelphia) might almost pass for very early Caravaggio. But the best examples, of course, remain the already-cited Brescian and Bergamasque artists I have been discussing, and Savoldo, with whom the present discussion began.

Savoldo strikes us in fact as a more seminal figure for "pre-Caravaggesque" painting than Lotto. His temperament, for one thing, is more akin to Caravaggio's; compared with Lotto's, both are more formal and lucid, more given to clear declarations of intent, less dreamy and mercurial. Light – which for Lotto is at times a sort of Jacob's ladder, rising towards the realm of dreams, with something persistently supernatural about it – becomes in Savoldo more integral, less fantastic, entering into more life-like relationships, meeting with more substantial form. To be convinced of this one need only compare the Lotto *Nativity* cited above with the one by Savoldo (formerly in the Crespi Collection), in Pl. 46 which, as in Caravaggio, light adheres to form by means of broad, firm, balanced brushstrokes. To be more precise: the proximity of the light

source is what allows his brushstrokes to turn plasticity into lighting effects, in the same way that Caravaggio's will later on. There is no better example than Savoldo's *Saint Matthew* (Metropolitan Museum, New York).

The deep coherence between inner and outer worlds in the visual arts gives Savoldo's pastoral motifs their formal integrity, a certain country-bred sincerity and directness that sets them as far apart from the wistful bucolics of the school of Giorgione as it brings them close to the spirit of early Caravaggio. Or, more specifically, the spirit of Savoldo's holy encounters, the rustic vigor of his Treviso angel, his shepherds, his Tobiases, pass into the younger painter's comely angels, beguiling musicians, and Narcissus figures; just as the hermits, apostles, confessors and saints of Savoldo's manger scene turn up at analogous points in the works of Caravaggio's maturity.

Pl. 47, 49
Pl. 48, 11

A new notion of action is inaugurated here: a new way of worshiping, marveling, emoting: a surfacing of eager gestures that pierce the canvas deeply, pressing form into new foreshortenings whose "tonal hieroglyphics" eliminate the role of *disegno*. The clarity with which these innovations are achieved often makes them look like nothing so much as the product of great acuteness of observation, bordering perhaps on a certain lack of imaginative vision. It is, in fact, a quality so long misconstrued as "dryness" or "effortfulness" in the young Caravaggio that, even until recently, his draughtsmanship was likened to Bronzino's or Pulzone's: a historical appraisal so radically off the mark as to risk muddling the whole question of his historical significance and, as a consequence, that of all painting for the several centuries following.

To stress the connection between these two painters in another way: the surest moral precedent for Caravaggio's grand inspiration for the [Vatican] *Entombment,* which sorrowfully portrays Christ as a man murdered by fellow men, is to be found in Savoldo's poignantly human masterpiece on the same theme in the Liechtenstein Collection. The austere, earthbound conclusion Caravaggio's work will reach is adumbrated by Savoldo with a true-to-life concreteness. The swarthy man's deathly pallor; the garments dangling against naked flesh; that flesh against stone; linen and stone, and a weight of real flesh, not the fictively transfigured, gravity-defying "weight" of Michelangesque anatomy: here, standing out starkly against the empty sky, Savoldo's enormously bulky illusion forces us to admit the reality of the calamity.

In its purely Lombard affirmation of the predestined coexistence of man and nature, as well as in the "artful descriptions of darkness" remarked upon

by his contemporaries, Savoldo's landscape art thus leads directly to Caravaggio, however few specimens of landscape he may actually have composed or left behind. The small shafts of light that must have gleamed in the night setting of the lost original of Caravaggio's *Saint Francis Supported by an Angel* (painted around 1593) recall effects in Savoldo's *Magdalene* in London. The bits of landscape in *The Sacrifice of Isaac* (circa 1590-3) and *The Agony in the Garden* (circa 1605) are no less Savoldesque. Yet even if Caravaggio had not left behind these relics of his landscape sensibility, would we not be able to infer its character from the manner in which he paints the prison courtyard in the Malta *Beheading of John the Baptist,* or from the basket of fruit in the London version of the *Supper at Emmaus?* By the same token, would we not be able to imagine the look of Savoldo's still lifes (though he may never have painted a single one) on the basis of that same fruit basket?

That small patch of countryside in a corner of Caravaggio's [Rome] *Flight into Egypt,* deliberately "cropped" so as to let it remain fragmentary, has hitherto seemed enigmatic in its utterly unromantic, unsentimental modesty. We can recognize it now as a relic of the Lombard landscapes of a century earlier, a loving bit of naturalism added entirely for its own sake; although at the same time, with its dry brush and evergreens, its four twigs and baked rubble, it marks a trail towards the modern landscape.

* * *

Without wishing to over-burden the present essay, I would like at this point to devote a few words to an exceptional figure among the Lombard artists: Giambattista Moroni.[38]

Exceptional, that is, because he painted almost nothing but portraits; including those previously mentioned ones of placid "men-at-arms" which, together with Moretto's full-length portraits, are definite precedents for Caravaggio's portrait of Alof de Wignacourt [in the Louvre]. Yet, short of basing our discussion on a comparison with Caravaggio's few extant portraits, we may more generally observe that Moroni's very limitation was what enabled him to extend the range of traditional Lombard interests. His portraits go beyond the usual affirmations of social rank; they particularize, showing greater concern for composition and temperament, a greater awareness of genre, mood, and setting.

The same broadening of human concern that Moretto, Savoldo, and Lotto brought to traditional sacred themes may well have a counterpart in the social diversity of Moroni's subjects. When we read that as early as

1590 Caravaggio may have conceived of doing a "portrait of the inn-keeper in whose lodging I stayed during an illness," our astonishment might well lessen, or be qualified, as we learn that, twenty to thirty years earlier, Moroni had painted a "portrait of the tailor who made my clothing." The principle underlying both enterprises is the same.

But Moroni's ideological affinity extends beyond subject matter into pictorial style as well, with its gray tonality, its backgrounds cleft by diagonal shadows, its always explicitly "depicted" dryness, in whites that range from chalky to ashen. All these are familiar elements of Caravaggio's early output in particular: the *Magdalene* in the Doria Pamphili Collection is seated in the same sort of stark but translucent ambience Moroni created for a number of his female models.

Furthermore, in those of his sacred compositions where Moroni abandons his habitual imitation of Moretto, he sometimes strives for a simplicity that appears to be more than just the result of archaism or puritanical constraint. There are some superb and original moments in the *Last Supper* at Romano; the stupendous Saint Paul in *profil perdu* in the Parre altarpiece is closer to Caravaggio than to Moretto: its soaring, well-nigh perpendicular handling of space resembles that of the *Madonna of Loreto*. The vivid portrayal of two saints at the far left of the *Assumption of the Virgin* (Brera, Milan) could have shown Caravaggio how to introduce the figure of his patron into the *Madonna of the Rosary*.

Nor is it irrelevant to note in conclusion that, having lived until 1578, Moroni had the singular honor of leading the art of Brescia, in its almost uncorrupted state, practically to the threshold of a new era. When Caravaggio reached an age where he could start investigating the art around him, the paint was hardly dry on those famous portraits. And now let us leave Moroni.

* * *

We have seen, in fairly ample detail, how the painters of Lombardy, based for two centuries in Brescia, nurtured an empirical and still fragmentary variety of naturalism, one devoted to the immaterial, anti-sculptural elements of light and "values." In the Early as in the High Renaissance, these inherited concerns meant that Lombard painters had either to reject the basic Renaissance postulates or else adapt them by bending their rules: a Dantesque ordeal for investing these postulates with a greater concern for "truth."

The likelihood that Caravaggio was aware of these developments and

even, however vaguely, of their anti-Renaissance implications, is strength-
ened by the fact that he was born and bred – artistically speaking as well
– quite near the birthplace and established center where these developments
had come into full flower.[39]

But then there was that persistent thorn of dissent. Of course, with the
exception of Moroni – a very special case – this art of dissent was decades
old by the time Caravaggio was of an age to begin defining various aes-
thetic preferences. Since, however, it would be anachronistic to envision
him as a wandering modern art-historian, stalking the work of his own
alleged forebears in the dark churches of Brescia and Bergamo, and since
the young always base their expectations on available, current facts and
examples, we should like to suppose that he had available some immediate
link with earlier Lombard painting.

Not that we need suppose: the events in question are readily identi-
fiable, however rashly historiography has chosen to ignore them. What is
more, they were going on in Milan all through the period of Caravaggio's
unquestionably stormy apprenticeship. It is only a matter of finding an
instance of such a linkage. I have believed for years now that one may be
found in the case of Antonio and Vincenzo Campi, who, after having
been full-fledged "Romanists," made a sudden about-face, returned to
early Cinquecento Brescian and Bergamasque sources, and began pro-
ducing paintings which, with all their crudeness, blunders, and short-
comings, still would have been powerful enough to make an enormous
impression on the brilliant youth.[40]

Artists from Cremona were the source of most of these developments
in Milan, and so the character of Cremonese art represents another impor-
tant element in Caravaggio's pre-history.

Cremona had been an art capital nearly surpassing Milan in impor-
tance ever since the second quarter of the sixteenth century. At the time
of Boccaccino's death, it must have had something of the spirit of a smaller
Antwerp: diametrically opposed trends converged there, and it became
chiefly an import center – with inevitable consequences for local artists,
who were exposed to the innovations of Venice, Brescia, and Ferrara.
Romanino and Pordenone were in residence, Correggio and Parmigianino
a day's journey away, as were the Raphaelesque artists of the Via Emilia,
with artists of the Treviso region close by. Giulio Romano's[41] grotesque clas-
sicism was changing the complexion of the entire nearby city [of Mantua].
Add to all this the inveterate Lombard tendency to naturalism, and the
retardataire perspective illusionism of the Bramantesque school, still flour-
ishing in Milan (Bergognone died in 1523, Bramantino in 1536). Picture

this jumble of styles, absorbed against the patient, immutable background of the Cremona Duomo's Romanesque nave, the true standard for the town's artistic tradition, and you will appreciate in just how many directions local taste was suddenly being teased. In the absence of any one genius, there was a vast choice of imported heroes, and with them, depending on one's temperament, the option of either staking everything on the wrong one, or turning cunningly eclectic. Gianfrancesco Bembo must have been amassing his immense erudition at this exact moment in Florence, likewise Sojaro in Parma. Giulio Campi was now Cremona's champion of eclecticism: so much so, in fact, that while Lanzi[42] views him as a reformer, a sort of proto-Carracci, certain greatly confused modern critics have made him the convenient, catch-all author of whatever "mixed" styles of portraiture the Cinquecento brings their way. Camillo Boccaccino, the most spirited and fervent among the local painters of the Parmigianino school, was the source of Bernardino Campi's Mannerism (softened and, so to speak, Christianized though this Mannerism became in the latter's hands).

None of this would be relevant to the present study, were it not for the fact that the vital essence of the old indigenous style – which was Romanesque and Gothic – had not died out. Still active, it tended as ever to naturalize all classical expression, to regard it as something artificial or skin-deep. So Antonio Campi and his circle gave the second-generation Roman style, imported into Cremona with all its anatomical and sculptural excesses, an odd, illusive twist: it was Romanism in the true "Romance" sense of the word. And though that term is sometimes reserved for Northern artists, I think it applies to the artists of Cremona too; it well describes their direct transposition of plastic and anatomical motifs into heightened, fantastic illusion, a sort of optical acrobatics.

Before discussing the Campis, by the way, it would be worth pointing out that this Lombard sensibility also began, unsystematically of course, to affect the work of outsiders visiting Cremona. That, at least, is the only way I can explain how Pordenone,[43] two years after the typically Mannerist and Baroque frescoes he painted for the nave of the Duomo in 1520, came up with a *Deposition* by the main door that relies totally on naturalistic illusion and owes nothing to the "classicizing" example of Giorgione and Titian at the Fondaco dei Tedeschi in Venice: yet another of those remarkable *terra firma* defections from the Giorgionesque.

Similarly, twenty or twenty-five years later, a Lombard artist like Sojaro can still be seen following this itinerary: his *Pietà* for the church of San Domenico (now in the Louvre[44]) is clear proof that a painter trained

in Parma could easily return to his native heritage. Pordenone's modeling also grows sharper and more concise, closer to those of Moretto and Savoldo. The mood of authentic weightiness is, unmistakably, the same one that will pervade Caravaggio's *Entombment*.

We know that around this same period, that is before 1559, the year she was summoned to the royal court of Spain, the [Cremonese] painter Sofonisba Anguissola was zealously absorbed in portraiture. As a student of Bernardino Campi, with decided leanings towards a Mannerist preciosity, Anguissola would scarcely warrant our attention here were it not for what Lanzi might have called a "philosophy of subject-matter." Her models were posed as genre figures; or, as Baldinucci would have it (1845, II, p. 619), the artist works out her composition and narrative "while keeping to her task, that fine way she has of portraying people." It is doubtful this could have happened without some Brescian influence (such as Lotto's Odoni portrait or Moroni's *Tailor*, etc.). The resultant series includes the famous family portrait of the *Game of Chess* (Racszynski Collection, Posnan) and drawings probably even more famous, such as the *Old Woman Learning to Read, Mocked by a Little Girl*, and – note the title! – the *Boy Bitten by a Crab*. I do not know what has become of the first-mentioned drawing, but the second, which even Vasari praised (in his *Life of Properzia De Rossi*, V, 81), recently resurfaced, bearing an attribution to Santi di Tito.[45] There is also a replica of it in the collection of the Naples Pinacoteca. It does not take much effort to realize that this piece has more than subject matter in common with the *Boy Bitten by a Lizard* that Caravaggio would paint thirty years later: it evinces the same keen physiological observation (the sudden reflex motion, the pained muscle contraction) that will figure so prominently even in his early works. Let us move on now to the Campis.

Giulio, as I have said, was the local champion of eclecticism. He remained so down through 1540 (the San Sigismondo altarpiece) and beyond, and his eclecticism was as classicizing as it could be, given his provincial situation. The Mannerism of the frescoes in Santa Margherita came later, but it is the work of 1577, in the vault of San Sigismondo, that interests us. There, right in the midst of Bernardino Campi's pure ornamentalism, right where the vault opens out, the artificially lighted *sottinsù* of the *Descent of the Holy Spirit* turns the whirlwind, contrapuntal, proto-Baroque foreshortening of Correggio into a problematically naturalistic effect, which is not without its share of archaism.

These were the portions of Giulio's art Antonio Campi would adopt. But Antonio, incidentally, is also an unusually complex social figure: his

hauteur, outward show, refined and bookish manner, the breadth of his activity, all suggest that he aspired to become a Cremonese Vasari, and, by rendering all he had unto Caesar, to ape the courtly Titian as well. Yet even at the outset of his career (for instance, the frescoes of 1561 for the presbytery of San Paolo in Milan, and roughly contemporary works in Cremona) the extremism of his modeling, a curious blend of Giulio Romano and Parma-style *capriccio,* created "Romanist" effects, perhaps by the very motley it wears. These effects, as we have seen, inevitably lead to naturalism, of however subjective a variety. The *Resurrection of Christ* in Milan's Santa Maria presso San Celso, with the huge, half-clad soldier looming in the very foreground, looks less like the work of an Italian than it does, say, that of Floris.[46] Certain portions of the *Sacred Conversation* (no. 333 in the Brera), which I would date slightly later, could pass for Heemskerck:[47] here, where Mannerist modeling has strengthened to sharp, tangible optical consistency, we perceive the same impulse that guided Moretto's "Romanistic" efforts. Many more signs of a shift come later. But already in 1566 the *Pietà* of the Cremona Duomo marks a return to the unusual foreshortening technique of Pordenone. A year later, Lotto's cold, glazed colors make their first appearance in Antonio's work, in the altarpiece for San Pietro al Po; and still from the year 1567, the *Beheading of John the Baptist* in San Sigismondo marks a crucial turn in the painter's thinking.[48] It is an almost brutally austere composition; only the figure of Salome is "correct" and classicizing. The executioner's arm thrusts out of the picture plane in a foreshortening Caravaggio echoes, consciously or not, in his *David.* The contrast between living and dead, as he plants his foot on the back of the corpse in the foreground, is appallingly convincing. Hues and shading are cold; all in all, the combination of the learned and the empirically observed comes extraordinarily close to the rendering of the same theme by certain Northern proto-Caravaggesques with strong Mannerist roots: Finson, for one, in a canvas now in Braunschweig.

The same conspicuous coupling of Mannerist style with naturalistic illusion occurs in the Prado *Saint Jerome,* or other versions of this subject (the one in Sant'Eustorgio in Milan, for example). The saint's head is rendered with an exaggerated attention to anatomical detail, and his muscles are so taut that they seem on the point of snapping; his left wrist is flexed in a gesture of "super-plasticity." Yet his gnarled fingers are also wrapped in wholly realistic light and shadow. Twice in his youth (between 1593 and 1595) Caravaggio recalls this hand: for the Barberini *Saint Catherine* and for the figure of Christ in the *Road to Emmaus.*[49] But note also how bourgeois Campi has made his saint. He is portrayed as a car-

dinal at work in his study, the walls of which are streaked with an oblique shadow. The idealistic affectation of his facial expression is in direct contrast with his prosaic, indeed rather homely pose: he leans back in his chair, letting the goose-quill dangle in the hand, with his arm propped on the chair-rest. The memorable features of the painting, however, are the marvelous, rather chalky "soiled whites" of his surplice, and the beauty of its delicately shaded pleats and creases. The angel prompting the young Caravaggio's *Saint Matthew* will have the same values; and obviously, Antonio Campi himself derived them from still-recent examples in Brescian painting and in Lotto.

The elaborate fresco Campi painted in 1577 in Cremona's church of San Sigismondo, showing *Christ and the Magdalene in the House of Simon*, manages to be highly appealing despite its ponderous elaboration. Yet, for all the many times I have seen this work, its characters never quite stick in my memory; they get swallowed up in the painting's machinery. Some things do remain unforgettable, however: the brutal emphasis in realistic highlights falling on the little boys' period costumes; their white collars laced with light; the intense effects of lighting-from-below; the rustic simplicity of the meal set on the table (bread, cheese, pears, the slice of lemon on the plate, the drinking glass broken in two); the bright white linen of the serving girl's apron; the gleaming metal bowl with the Michelangelesque nude on the right side. Even the display of architectural erudition serves its purpose. Naturally, all this is as coarse and jejeune as can be – the bronze ornaments on marble capitals, the red bricks, the rustication – but how tangible, how urgently real the illusion! All about there is a play of distinct hues – of reds, light and dark browns, yellows, whites – all cast directly into chiaroscuro: the charred smell of the Caravaggesque is everywhere. And isn't this the pepper-red floor we will see again in the *Madonna of the Serpent*?

It was many years ago that I discovered the same date, 1577, and the name of Antonio Campi on the triptych in Milan's church of San Marco (formerly in the Cusani chapel, it now hangs on the wall of the left aisle). The *Assumption* in the center is obviously indebted to Sojaro, but the reds and light blues of *Flight into Egypt* recall the leafy coolness of Lotto; the *Death of the Virgin* is even more clearly derived from Savoldo. Antonio Campi may have been consciously striving to create an Italian equivalent of Brueghel the Elder's painting, which he might have known through prints; be that as it may, it is most certain that the apostle in the foreground, fervently reciting the office of the dead by candlelight, is a quotation from Savoldo's *Saint Matthew;* that the hazel and deep green of his gar-

ments anticipate Caravaggio's somber palette; and that the whole conception gives a hint, however faint, of Caravaggio's flawless, justly celebrated treatment of the same subject.

The Adoration of the Magi in the Monastero Maggiore (1579) and the *Adoration of the Shepherds* in San Paolo (1580)[50] are further testimony of Antonio's gradual return to Brescian sources. But as his last works are even more instructive in this regard, let us turn to them instead.

Pl. 51 Campi signed his *Martyrdom of Saint Laurence* (also in Milan, in San Paolo) in 1581. The original stimulus to produce a "nocturne" probably came from still recent and very well known examples by Titian. The result, however, is the very opposite of Titian's magical impressionism: relentless illusionism. Vast, brutal, deeply felt fragments of reality are offered up here for the sole pleasure of seeing them founder in the backlighting as they are thrown together in the illuminated open spaces. What cast shadows, even in the most slipshod passages! It is almost incredible how strongly this work prefigures Caravaggio's *Flagellation* in Naples: for example, in the sheer physical coarseness of those bravos of his, looming violently in the artificial lighting, with black mops of hair and practically ape-like biceps. Even a conservative appraisal of such a conception – one that acknowledges its remnants of academic draughtsmanship – would have to deem the final product at least as modern as the painting of any of the academic *Caravaggeschi* forty years hence (Lionello Spada, for instance, in Bologna's San Domenico). One would swear, in any case, that this *Martyrdom* was painted *later* than Caravaggio; and don't forget, if it is dated 1581, the original idea for it goes back even further!

Pl. 52 In roughly these same years, Campi painted a *Beheading of John the Baptist* for another altar in San Paolo. I once owned his preliminary sketch for it,[51] and I trust that connoisseurs will know enough to be amazed at the artist's innovative concentration of the artificial light in the prison interior, at his use of a few actors in modern dress to create a contemporary execution scene much like the one Caravaggio will paint on Malta. Nor can I help but suppose that the overwhelming figure of the torturer will be a prototype for the even more brutal one on the right-hand side of the *Burial of Saint Lucy* in Siracusa.

Pl. 50 Yet I think that Antonio Campi shows his most astonishing prescience of Caravaggio's imminent solutions in the large canvas of *Saint Catherine in Prison,* in the first chapel on the right in Sant'Angelo, Milan (the date on its companion piece would seem to place this work in 1583).

Just as it was possible to deduce a superficial borrowing from Titian's nocturnes in the *Martyrdom of Saint Laurence,* it is easy enough to see

this *Beheading* as an attempt to juggle the three types of light – natural, artificial, supernatural – that Raphael had once used for his *Liberation of Saint Peter* and Parmigianino after him in the lost *Circumcision* Vasari refers to in his life of the painter. But regardless of his intellectual intent, it is obvious how vastly his work differs from its presumed models. To naturalize, phenomenalize these three lights, to mark their contrasts, was this artist's only means of laying even the most rudimentary foundation for a new marvel in painting: the wondrous *stile di macchia*.[52] In his waning years Antonio Campi would grow more fervid in his drive to perfect his technique of luministic illusion – as tireless as Paolo Uccello had grown sketching headgear and octagonal vessels: here is the zeal of the primitive.

The perfect rendering of the shadows cast on the pavement by prison bars, in a bright empty space, has come to mean more to Campi than the cranking out of yet another set of academic muscles bathed in "universal light." For this reason, the charm of the empress's hand in this *Saint Catherine* lies not its structure, but rather in the wonderful shadow it clutches in its clenched palm. The illusions of light and counterlight are compounded: light comes from above and from below; but, whatever the source, the light is trenchant, raking, intense: moonlight, torchlight, the glow of angels or even the light of a lantern held high in a young porter's outstretched hand, which not only backlights the hand itself, but also bathes his face in the first real glare of artificial light from below ever attempted in Italy – long before Caravaggio, Saraceni, or Gherardo [delle notti]. And it is interesting to note that, in order to set this elaborate lighting scheme in motion, Antonio Campi altered the traditional iconography, linking together two episodes that legend had always kept apart: the visit of the Empress Faustina to the Saint, and the angelic visitation (whence the two kinds of light). But to return to the picture, I would emphasize the anti-plastic, anti-Renaissance function these two kinds of light assume. Emancipated from the human body, they invert its values, make it a hollow cipher, a logogryph, inaugurating the style of the "vanishing outline" for which Caravaggio will be unfairly criticized. The little torchlit page who struts ahead of the imperial couple, caught in the action of flinging his arms wide in surprise, seems to be entering an eclipse. His shadow spills black onto the contrasting light of his white sleeve; the light continues to illuminate a wisp of hair, a ruffle of lace collar, a stripe down the back of his garment. A round-headed little boy clutches at the prison grating, the better to see what is taking place. In addition to being an inspired touch of naturalism (for the way it turns what might have been

an "ornamental" episode of classicism into an essential component, a gauge of optical authenticity), the figure astonishes us with its beautifully exact observation of the shadow cast over his back, between his shoulders, where it bunches like the pushed-back hood of a cowl.

I would be the last person, of course, to deny how awkward, fussy, and pretentious most of this is. Not far from the Empress Faustina (who, in her contemporary costume, could pass for some *haute-bourgeoise* sitter to Moroni, painted in candlelight), the marshal, striking a classical pose in his antique garb, looks made of red-dyed papier-mâché. You would think you were witnessing some small-town religious pageant, lit on a shoestring budget by a talented designer forced to live and work in the sticks. Yet for all its shortcomings, the groping empirical ardor of the piece must still have come through, making an enormous impact on a mind as radical as the young Caravaggio's. For in all the work of the older Brescian painters, no composition, no lighting scheme so influenced him, nor did he put any other to better use, drawing on it twice, in fact: in the very early *Calling of Saint Matthew*, and the very late *Beheading of John the Baptist* at Malta.[53]

Antonio Campi's sudden conversion from Roman academicism was followed immediately by that of his brother Vincenzo. The initial impulse probably came from the elder Antonio, for while in 1567 Vincenzo's *Beheading of John the Baptist* in San Sigismondo already shows signs of a shift in style, his *Pietà* at Foppone is still thoroughly Romanizing in manner. Since few works can be attributed to Vincenzo with absolute certainty, and given that the remarkably animated figures of the prophets in the Cremona Duomo, dating from 1573,[54] are so singular as to elude classification, I would have to posit 1577 as the first year in which we can consider his style completely altered and genuinely proto-Caravaggesque. This is the year of *Saint Ursula and Her Companions*, painted for the church of the Magdalene in Cremona (with a protagonist as extravagantly "of the people" as Caravaggio's Magdalene), and of the Prado *Crucifixion* (which I have already cited as another clearly pre-

Pl. 53

Caravaggesque precedent). In both pieces, what alerts us to Merisi's imminent arrival is a certain force given to abrupt motions, a violence of bearing and action, in the head of Christ as much as in the body of the bald, armored warrior; the bravo wielding a hammer on the left is a rough sketch for the same figure in Caravaggio's *Crucifixion of Saint Peter*. Yet the two thieves in the background are curious amalgams of naturalism and a distinctly Northern brand of the Roman style: they suggest that the question of Vincenzo Campi – traditionally known as a painter of still lifes in

the manner of Aersten and his circle – is more complex than it is has hitherto been made out to be.[55]

As with Antonio, Vincenzo's change was due chiefly to his return to the most enduring elements in Lombard art; one proof lies in the similarity between his *Christ Being Nailed to the Cross* and an earlier work by an "ex-Giorgionesque" from nearby Lodi: one of Calisto Piazza's canvases in the church of the Incoronata in that town.

Vincenzo's *Saint Matthew* (on the fifth altar on the right in the church of San Francesco at Pavia) also reveals affinities with Savoldo. Malaspina attributed it to Bernardino [Campi] only out of confusion brought about by the surname; surely a picture as proto-Caravaggesque as this can belong only to one of the two "remodeled" Campis. More elements than just the Dürer-like treatment of the stained-glass window in the Prado canvas lead me to opt for Vincenzo.[56] Once again, you could swear you were looking at the work of a *follower* of Caravaggio. Yet, strangely enough, the raking light in the background, the realistically rendered, attentive saint, with his hand poised in the brightness, and the angel guiding his thoughts like some ironic, intimate attendant spirit all predate Caravaggio. Together with Antonio Campi's late works, these things of Vincenzo's serve as a rustic prelude to Caravaggio's rudimentary, yet altogether radical, aesthetic.

* * *

Imagine for a moment that, at this point in history, there had emerged no genius to soar miles above these restless but minor talents; or that, for one reason or another, knowledge of Caravaggio's mature achievements had never penetrated into Lombardy.[57] It is easy to believe that the innovations of the Campis themselves would not have failed to produce some sort of local results, not altogether unlike the Caravaggesque style. And something of the sort did actually occur. Luca Cattapane,[58] pupil of Vincenzo Campi, could easily be regarded as a very minor Caravaggio *manqué*. At first glance, his *Beheading of John the Baptist* (Cremona, formerly in San Donato, now in Santa Maria Maddalena) might well pass for competent work by one of the *Caravaggeschi:* the nocturnal lighting, the violent action, even a certain bravado in the artist's signing his name on the hilt of the executioner's sword. But who – and in Cremona, of all places! – could be "Caravaggesque" at the date inscribed on this painting, 1597? Certainly only an adept – as was altogether natural, given the geographical setting – of the experiments of Antonio and Vincenzo Campi.

It is significant, too, that Lanzi, chiefly with the above-mentioned painting in mind, wrote of Cattapane: "In the rest of his work, out of the wish to evolve a style of his own, or perhaps desiring to imitate Caravaggio, he painted more darkly and with less discrimination than the Campis." Lanzi was driven to this two-fold explanation – creationist and Caravaggesque – both out of ignorance of the chronology and by his having underrated the importance of the naturalistic revolt the Campi brothers had briefly waged around 1580. Ironically, of course, his comment now serves to point up the historicity of a "Campi-based" account of Caravaggio himself.

* * *

A name has been added recently to the roster of artists who figure in the history of Caravaggio's Milan years, thanks to Nicolas Pevsner's discovery of a document in that city identifying Simone Peterzano as the little revolutionary's first teacher.

This came to me as very welcome news; for, ever since I began investigating the curious chronicle of the Campis' rebellion many years ago, I suspected that Peterzano was in some way linked to those events. At the outset, I recall, I even debated whether to attribute various works to him or to Antonio Campi, including the *Assumption* in the Milanese church Santa Maria della Passione. I cannot remember whether I ever actually cited Peterzano among the "pre-Caravaggesques"; if I did, I can no longer locate the reference. Yet I can prove that I knew his work, and continued to ponder it, by the fact that quite early on, in 1917, I reattributed to him some frescoes in the Certosa di Garegnano [in Milan] then ascribed to Daniele Crespi, the painter of some works situated there, right next to his; that I discovered a large *Nativity* of his in Pavia's Santa Maria di Canepanova, incorrectly ascribed to Moncalvo; and that in 1920, on an extensive trip through Europe, I recognized him in the small *Deposition* the museum of Strasbourg had catalogued as a Torbido. I also had a strong suspicion that he was the true painter of the *Carthusian Monk* in the Cook Collection at Richmond, ascribed first to Zurbaràn, and then to Sofonisba Anguissola.

Who was this Peterzano?

Lomazzo[59] – who was, perhaps, as well-disposed to him as he was hostile to the Campis, and who refers to him repeatedly in the *Trattato, Tempio,* and the *Poesie* – portrays Peterzano as an artist well suited to the austerity of the counter-Reformation. His description of the *Assumption*

in Santa Maria di Brera makes it sound like the work of Muziano or Salmeggia – which would sharply contradict the artist's own insistence on signing himself "Titiani discipulus" (or "alumnus," according to Zani's variant reading), were it not for the fact that the paintings themselves reveal this insistence as nothing but a pose, a grand academic gesture, a pompous claim to noble descent.

As for the specifically "counter-Reformation" character of Peterzano's austerity, one could as easily trace the iconic simplicity of his composition back to Moretto's habitual asceticism; his way of describing form back to Savoldo, who was careful and precise, but without any artificial emphasis on *disegno;* his preference for high, and even whitened, hues, to Bergognone; or, for that matter, one could easily compare that favorite white tonality of his – certain cool, precise tonal effects, but a bit "coated," as though there were a film over the viewer's eye – to the tonality that will reappear, to matchless effect, in Caravaggio's very first works: the Uffizi *Bacchus,* the Borghese *Boy with a Basket of Fruit,* the Doria Pamphili *Magdalene,* etc.

There are, of course, links between Peterzano and the Milanese painters of the day, who knew and respected him. His Strasbourg *Deposition,*[60] a small work on copper (now ruinously faded), sets the three crosses in a deliberately archaizing perspective line, thereby relating it to contemporary compositions by Lomazzo, and establishing it as one of his first works (circa 1565). On the other hand, his figure of the dead Christ contains certain reminiscences of Savoldo, and the whole group of figures bespeaks an attempt to create a more "natural" version of Tintoretto's style by defining his shadows with greater precision. The figure of the Magdalene is handled with an abrupt but clear-cut foreshortening that anticipates Caravaggio's *Madonna del Riposo.*

Peterzano's large canvases in San Barnaba refer to Tintoretto's proto-Baroque manner of composition, much as Moretto refers to Roman prints. The parts, however, are not bound in rhythmic coherence, but are instead broken up and kept apart like fragments of some harshly burgeoning naturalism: the Venetian's whirlwind diminutions are condensed into brilliant illusionistic episodes: this is a particularly pre-Caravaggesque feature, recalling elements of Antonio Campi's *Saint Laurence* in the church of San Paolo.

As I have mentioned, the *Assumption* altarpiece in Santa Maria della Passione reveals a very close kinship between Peterzano and Antonio Campi, just as the former's *Nativity* in Santa Maria di Canepanova at Pavia closely resembles that by Antonio in Milan's San Maurizio: and

both in turn are quite clearly based on Savoldo. There are likewise traces of Moretto, Calisto, Lotto and Moroni in Peterzano's *Mystic Marriage of Saint Catherine* at Sant'Angelo, in his *Baptism of Christ* at San Carlo, in his *Annunciation* in the church of the Passione as well as in his altarpiece there (first chapel on the left) with the *Virgin, Child, Saint Catherine, and Two Female Saints*. Moreover, the painter's fondness for a neo-Quattrocentesque strictness is apparent in all these works.

The Entombment now in Milan's San Fedele (formerly in Santa Maria della Scala) shows Savoldo's influence even more clearly than the one in Strasbourg. Something of the "dead Christ" Savoldo had painted repeatedly in his youth is unquestionably present in the inspiration for this figure's severely foreshortened face, in the steely solidity of his torso. If the painting in San Fedele is in fact, as some maintain, a work dated 1591 (a date I personally have never managed to make out in scrutinizing the picture), then it is unlikely that Caravaggio knew it; yet it is equally hard to believe that his *Entombment* in the Vatican Pinacoteca is not partly derived from it. The weightiness, the beautiful verisimilitude of Christ's dangling arm, the Virgin's gesture, are practically identical in both paintings, despite important differences elsewhere in these two works, differences stemming above all from their creators' very different temperaments.

Finally, if I am correct in reattributing the Cook Collection's *Portrait of a Young Carthusian* to Peterzano (for its peculiar grayish-white tones, for the way the sleeves fold, and for the form of the hands, which are like those in the *Entombment*), then a Brescian interpretation of the most authentic aspects of Peterzano – or let us say the parallel between his path and Antonio Campi's, a path leading away from the then-prevalent Mannerism and towards the empirical naturalism of the older Lombard schools – will make more sense, clarifying too how Peterzano's example might have fostered Caravaggio's earliest artistic inclinations. If that poker-faced young Carthusian (really perhaps one of the novices at Garegnano) could just relax for a moment from the rigors of his counter-Reformation faith, he might better reveal himself for what he is: an older brother to the monks of Caravaggio and Zurbaràn.

* * *

Naturally, I have no intention of inflating these Milanese historical events beyond the bounds of historiographic propriety. Yet, whatever degree of importance one attaches to them, they show a certain coherence with the earlier and more fundamental events that I have presented here

as distinctly Lombard; and they were available, with all the force of cur-
rent events, for use by a young artist, drawn by nature to simplicity, who
despised complications, whose entire career was to bear witness to an aes-
thetic that was never less than elemental. All that remains to be pointed
out here is that, in the context of Milan's still-modest artistic achieve-
ments, the events we've been discussing were more than sufficient to set
brains whirling and tongues wagging, to arouse debate and to sharpen
people's wits.

There are proofs of this even in the work of artists normally opposed
to the artistic practices of the Campis. Ambrogio Figino,[61] for instance, in
his more representative paintings – *Saint Ambrose* in Milan's Castello
Sforzesco, or *Jupiter and Iris,* painted for the Emperor Rudolph and now
in the Museum at Pavia – would appear wholly possessed by the gelid
ferocity of the Michelangelesque, and almost neo-classical in the spareness
of his effects. Yet his Brera portrait of *Lucio Foppa* is of a much less impov-
erished simplicity, closer to the sort of classicism Salmeggia was able to
revive in his portraits; and his odd night scene of *The Agony in the Garden,*
painted in 1577 (the year of Antonio Campi's San Marco triptych) and
formerly in the Matszwansky Collection, shows clear signs of contact
with Antonio.[62]

Since Figino has always struck me as notable for his approach to
iconographic inventions, it is all the more rewarding to be able to dis-
cover in him an indisputable anticipation of a motif considered unique to
Caravaggio: that of the *Madonna with the Serpent.* As far as I know, few
historians have pointed out that Merisi's specific task in this work was to
create a subject around Saint Anne (patron saint of the *Palafrenieri,* the
Papal grooms, who commissioned it for their altar in Saint Peter's); so
that it is especially curious to see the well-established motif of Anne with
the Virgin and Child generate another one, the Madonna of the serpent,
which seems more closely connected with the Virgin of the *Immacolata.*
One might well be tempted to view the new subject as the peculiar inven-
tion of Caravaggio himself, were it not for the fact that Lomazzo, praising
Figino's meditative eclecticism, cites the example of "a canvas in which he
has depicted the Holy Virgin holding the Christ Child on her lap and
crushing the neck of an old serpent beneath her foot" (*Trattato,* II, 383).
In the eighteenth century this painting was moved from San Fedele to its
present site, in Sant'Antonio dei Teatini; and surprisingly, it has far more
in common with Caravaggio's picture than Lomazzo's description would
lead one to believe. What has always seemed (to me at least) the most
striking feature of Caravaggio's painting is the way the Child has placed

his foot over his mother's, as if to ratify her action. I long suspected that this idea was derived from some sculpture I couldn't quite identify: that placing of foot over foot, as though to express a bodily transfer of energy, seemed a motif that might well have appealed to Michelangelo, who, I thought, had perhaps touched on something similar in the Bruges Madonna or his fresco of *The Flood*. But it was not yet the same thing. Nonetheless, how plausible that it should be an epigone of Michelangelo's in Milan who applies an identical motif to the same subject matter: an artist, indeed, whom Caravaggio must have associated with during his apprenticeship. And the motif itself, as I have said, is too unusual for this to be a case of coincidence, much less of some then-fashionable topos. Knowing no other instance of it, I can only conclude that Figino used it first, and Caravaggio after him.

And Figino can best lead us into the study of his teacher Lomazzo. Lomazzo: a sort of daft white wizard, puttering about with metaphyscial systems and aestheticized astrology; whose books, quite representative of the late Mannerist climate in Lombardy, mingle its propensity for Quattrocentesque archaism with the intellectualism of Leonardesque classicism, bizarre symbolism, and even a wild enthusiasm for the cute technical tricks of Arcimboldi and Caterina Cantona.[63] What I mean to demonstrate here, however, is that up to now, only our ignorance of the Campis' innovations has kept us from discovering their presence in Lomazzo's writings: where they show up, predictably, in polemical form.

And even if Lomazzo's hostility to the Campis was due to material causes – competition, rivalry with these interlopers from Cremona and their band of mediocre disciples – this should not lead us to lose sight of the profounder aesthetic controversy they reflect.

It would be safe to assume that several of Lomazzo's theoretical passages on lighting – one of his major interests – allude to the Campis: at least, the one that complains of a willful crudeness in "many present-day painters, too well known for me to have to name them" (*Trattato*, I, pp. 388-89). A passage from the *Tempio* seems aimed at their experiments in lighting on the vault of San Paolo: "But to cast light laterally or obliquely would be merely to descend to the manner of certain contemporaries of ours, whose works are so disagreeable, robbing the viewer of brightness and appearing furious as well as confused."

But we gain a fuller sense of the outrage Antonio's startling experiments stirred among the painters of Milan when we come to Lomazzo's satirical poems. In his 1587 collection, not a single painter friend of the author's goes unsung (one of his sonnets is based on a painting by Peterzano,

Angelica and Medoro). Antonio Campi once again is never named outright, but how damning the implicit reference to him! The sonnet "Against a Modern Painter," atrocious but biting, can have no other target than the artist's Saint Catherine in *Prison:* "There are works by a certain puffy-eyed artist/ Who, the better to avoid the danger/ Of ordinary light, illumines them by fire-light./ Let them be praised by others as puffed up as himself./ Many such artists are listed triumphantly/ By Vasari:[64] one of these works is our artist's pallid *Passion of Saint Catherine,* and he is busy making/ Another like it for the King, a piece even more puffed up./ Yet their anatomy is much vaunted,/ As is their lifelike light, or rather firelight,/ And their fanciful compositions, too,/ Although their coloring is vague,/ As one might expect of a feeble talent/ Whose only real boldness lies in taking money for such work."

Since Lomazzo is obviously lampooning Antonio Campi's *Saint Catherine in Prison,* the most evidently pre-Caravaggesque of his works, what better proof is there that the Campis' subversion appeared to the Mannerists and Classicists of Milan as out-and-out rebellion against the whole of Renaissance theory – the same view that the academic cliques of Rome were soon to take of Caravaggio's revolution? And since Caravaggio happened to be a highly precocious apprentice during these controversies in Milan, it is entirely conceivable that he actively sided with the creators of works in which he must have sensed a correspondence with his personal inclinations, simple as they were, and free, in their simplicity, from any need for theoretical buttressing.

The description Mancini has left us of the adolescent Merisi during his first months in Rome should help us to imagine in what formidable bohemian squalor the apprentices of Milan were engulfed while the debate surrounding the Campis was at its height. Surely Caravaggio was already too much the incendiary to stay on the sidelines. One of Lomazzo's epigrams in dialect opens with a reference to "The most strenuous painter in all Milan,/ Campi's and Figino's apprentice,/ The devoted friend of Antonio of Bergamo/ And also of starving Andrea." This doggerel is almost moving in the way it inevitably conjures up an image of Caravaggio *avant la lettre.* The particular occasion for the squib is unknown, but it was probably a basic ideological clash between established painters, involving as well their partisan apprentices, who no doubt had to scrape a living wandering between the workshops of experimental painters and classicists while wrangling frightfully over these issues, between a hastily-gobbled crust of bread and another batch of plaster to be stirred for the latest fresco. At this point, leaving it to the chronicler Ripamonti to give us further details,

I shall end this local account of Milanese painting: painting which, years later, thanks to Caravaggio, would become part of the general history of Italian art.

* * *

If the course my investigations have taken is the right one, then a proper introduction to Caravaggio would begin with a survey of the artistic tradition of Lombardy, forgotten or misconstrued as it has been ever since the Renaissance cast a shadow over it.

The chain of the events I have presented here is, in essence, stronger than that which can be forged by hypothesizing any particular painter's indebtedness to the style of some specific predecessor. It reflects rather an enduring mode of vision and imagination, one that flew in the face of the entire Renaissance: as much opposed to the rhythmic formal classicism of Rome and Florence as to the chromatic formalism of Venice. It forms a historical continuum running from the intimate compositions of certain north Italian painters of the fourteenth century to the subtle study of light and atmosphere in Foppa and Bergognone; from the early *stile macchiato* and formal investigations of Moretto to the "values" of Lotto and Savoldo's first works, with their luminous surfaces; from the curious disenchantment of various mainland *Giorgionisti* to the Cremonese modification of the Roman style through color and illusionism; to the sudden stylistic conversions of Brescia's most probing and adventurous painters, Antonio and Vincenzo Campi; and finally, to the impact of their innovations on Peterzano and other painters in Milan towards the end of the fifteenth century.

There was, of course no hope that this Lombard art might be understood, so long as it was measured against the Renaissance yardstick; and strictly territorial or regional canons turn the history of any local painting into an endless suite of sealed chambers. What pitfalls lurk in local history! When I think of that Hungarian scholar who once decided to trace his history of Bolognese painting in a straight line running from Vitale to the Carraccis, or the scholar who cleverly managed to make Altichiero the ancestor of Paolo Veronese, I can only hope that I myself have avoided such dangers by limiting myself to the definition of just one abiding tendency in Lombard, tracing its irregular course from the hinterlands of the Veneto to Brescia, Cremona, and Milan. The point has never been to describe the history of a region. Had that been my purpose, I would have spoken of Zenale rather than Foppa, Luini rather than Bergognone, Romanino

rather than Moretto. Nor have I made any attempt to deny that this tendency also reflected, to some extent, the irresistible force of classicist ideals. On the contrary, I hope to have demonstrated that one of the signal qualities of the Lombard artists was precisely their capacity to accept the Renaissance as a given, to make room for it on the surface, the better to break free of it at the true core of their work. How reckless, then, to take their acceptance of it at face value, deducing from it a false critical standard! Comparison with Renaissance "models" inevitably condemns the Lombards to the limbo of "provincialism." And this is unjust: for there is a sense in which *all* artists are "provincial," in those parts of their work that they must execute half-heartedly. For Vasari, Titian was just such a "provincial" when it came to draughtsmanship; and if the term can be applied to Titian, just think where that leaves the painters of Brescia, who lacked an interest in even the most generally accepted standards of drawing! But how paltry, in any case, would be a criticism that stubbornly refused to see a compensation for Brescia's provincialism in its tendency to evolve – by slow, archaic degrees – towards a classicism all its own, one necessarily founded upon principles opposed to those of the Renaissance: upon a naturalism derived from light.

These Lombard painters never quite reached the goal they were striving towards, though; and that is, in fact, where their provincialism catches up with them. They remained bound to a certain affectionate empiricism, a penchant for details, whose ultimate intent either goes unspoken or shows up as an irregular metrical stress in their prosody. It is for this reason I have chosen to discuss them in a fragmentary manner, drawing attention to those elements which will be successfully brought together, for the very first time, in Caravaggio's style.

* * *

Yet Caravaggio suffered, and has continued to suffer, no less than his predecessors, from aberrant interpretation. Unfair as Baglione's and Bellori's charge of "mere naturalism" was, it did manage at least to account for one of the two sides of his style. It was certainly less misguided than modern readings that discuss him as a draughtsman, or a colorist, or a "sculptor in paint," or a Baroque artist, and so subject him yet again to some irrelevant classicizing criterion. It is quite another matter to speak of his luminism, the stylistic complement to his ineluctable naturalness.

Guided by the luministic achievements of his precursors – Lotto, for instance, whom Lomazzo (more authoritative here than Vasari, because he

is a Lombard) cites as a "master in rendering light"; or Savoldo, praised by the theoretician and painter Pino for his "great skill in describing darkness" – Caravaggio discovers the *form of shadows:* a style in which light, no longer subservient to the plastic definition of the bodies it falls upon, has the power to decide their very existence. For the first time, the fundamental principle underlying the artist's work is no longer one of the volume of the body, but rather one of substance; an element apart from, engulfing, man, no longer man's slave. Lomazzo, for all his classicism, ventured the following abstraction: "Light is a disembodied quality." In so doing, he in a sense anticipated by three centuries the maxim of his fellow Lombard, the sculptor Medardo Rosso: *"rien n'est matériel dans l'espace."* It is easy enough to see what a challenge this new style threw out to the bulwark erected by the wholly anthropocentric Renaissance, for which light was no more than man's characterless servant. For now light itself, and not man's conception of himself, was to become style's tool, its contrivance, its dramatic symbol. When it was some sudden shaft of light that made things real – form, *disegno,* decorum, and even magnificence of color inappropriate – things could not be anything but horribly natural. While the shadows are momentarily pierced by light, we see the event and nothing but the event: hence the inescapable naturalness I have just mentioned, its inevitable randomness, its banishment of selectivity. People and objects and settings co-exist, with no regard for any foreordained hierarchy of "dignities." Over the centuries, Caravaggio's precursors had already expressed this relentlessly egalitarian view of life, if less coherently than he in the changed climate of his time.

As against the grandiose, optimistic, but stop-gap solution of the classically inspired Baroque, Caravaggio's answer establishes its own bitterly true and abiding value by means of the firm, imperious accord it achieves between the physical and the metaphysical. But then, every authentic style contains (or has, at least, up through the beginning of the present century) a dialectic between naturalism and subjectivity of vision, in which supreme naturalness and supreme abstraction become interchangeable. The abrupt, abstract darkness of Caravaggio's chiaroscuro, which at first glance seems to express nothing more than a tragic, primordial cataclysm of light and shadow, suddenly discloses, as if by fateful accident, the most tangible, natural, *lived* events ever imagined or expressed.

This is at once the final outcome of the older Lombard order and the beginning of a new order: an event not so much Italian as European. The new art passes undistracted by the old Baroque giant, who sleeps an agitated, vaporous sleep; sure of the way, it emerges on the other side, where

it joins up with the great achievements of modernity.

The road may be tortuous, but it does lead all the way from the horse who is the true protagonist of *The Conversion of Saint Paul* to the *Umbrellas* that constitute the real subject of Renoir's famous picture. Or to put it in more stylistical, genealogical terms: when Rubens, to amuse himself, enters the Chiesa Nuova [in Rome] and copies Caravaggio's *Entombment*, he twists and distorts it in every possible way, as befits a Baroque Sisyphus. But three centuries later, when Cezanne copies the same work in order to learn from it, he reveals, with incredible insight, its quintessential, abstract, metaphysical aspect. There could be no better demonstration that there is indeed a shell of idealism enclosing the awesome naturalness of Caravaggio, the last of the "Lombards."[65]

150

NOTES

Roberto Longhi's notes appear without brackets. Notes within brackets are editorial notes.

1. [Federico Zuccari (1540/41-1609), originally from Sant'Angelo in Vado near Pesaro, Mannerist artist active in Rome. (Ed. note)]

2. [Lotto (1480-1556) was essentially a Venetian, but lived and worked at Bergamo in Lombardy between 1513 and 1525; he exerted a considerable influence on Lombard artists. Giovanni Gerolamo Savoldo (c. 1480-last documented 1548) was a Lombard from Brescia, but had extensive contacts with the Venetian *milieu*, worked in the city on occasion, and was influenced by Venetian painters including Giorgione and Titian. (Ed. note)]

3. [Antonio Campi (1523-1587), painter and scholar, member of an important artistic dynasty in his native Cremona. His work reveals a complex blend of influences ranging from Parmigianino and central Italian Mannerism to northern European art and Lombard "optical realism." (Ed. note)]

4. [Simone Peterzano (doc. 1573-1606), Bergamesque painter active in Milan. (Ed. note)]

5. [A pun: the word "campi" means "fields," and Caravaggio is the name of a town. (Ed. note)]

6. [Scipione Pulzone (c. 1550-1598), painter from Gaeta, to the South of Rome. (Ed. note)]

7. [Vincenzo Foppa (1427/30-1515/16),

painter from the region near Brescia, active in Pavia, Milan, Brescia, and elsewhere. A leading artistic personality in the Early Renaissance in Lombardy. For Longhi's analysis of his complex and ambiguous attitude towards the new "Renaissance" style, see the study "Carlo Braccesco," included in the present volume. (Ed. note)]

8. [Published in 1502, the *Calepino* was a reference book intended for students of Latin; it derived its peculiar title from the name of its Bergamesque author, Antonio, Count Calepi. For Lomazzo, see footnote 38 to Longhi's "Carlo Braccesco," included in the present volume. (Ed. note)]

9. [Originally published in English, J.A. Crowe and G.B. Cavalcaselle's *A New History of Painting in Italy* (London, 1864-1866) was the earliest survey to reflect a rigorously critical approach to problems of attribution. This monumental work was the joint effort of an English writer and one of the earliest among the great Italian connoisseurs. Working without the aid of photographs, armed only with his own notes and sketches and with a prodigious eye and memory, Giovan Battista Cavalcaselle studied pictures throughout Italy, and the conclusions set forth in the *New History* are essentially his. Cf. Donata Levi, *Cavalcaselle: il pioniere della conservazione dell'arte italiana,* Turin, 1988. (Ed. note)]

10. [For Venturi, see footnote 3 to Longhi's essay "Masolino and Masaccio," included in the present volume. (Ed. note)]

11. [Francesco Squarcione (1397-1468), Paduan painter. Although not much of his work survives, his studio was a locus of stylistic innovation, the impact of which

was felt throughout northeastern Italy; among the many important artists trained there, we may cite Andrea Mantegna and the Ferrarese Cosmè Tura, both of whom show the influence of his taste for Classical statuary and decorative motifs and of his "hard" drawing style. (Ed. note)]

12. [Tommaso Barasini (1326-1379), painter from Modena. (Ed. note)]

13. [Altichiero (doc. 1369-1384), painter from Zevio near Verona. (Ed. note)]

14. [The assassination of the 13th-century Dominican Inquisitor-General known as Saint Peter Martyr; he was stabbed to death along the road between Como and Milan. (Ed. Note)]

15. [Set in Lombardy, Alessandro Manzoni's novel *I Promessi Sposi* (1827, rev. ed. 1840) contains celebrated passages of landscape description. (Ed. note)]

16. [A term first used by Berenson in his *Florentine Painters of the Renaissance* (New York and London, 1896 and 1909). (Ed. note)]

17. [Bernardino Zenale (c. 1436-1526) and Bernardino Butinone (doc. 1484-1507), both painters from Treviglio near Bergamo. The celebrated altarpiece to which Longhi here refers, painted by the two artists in collaboration in 1485, is still to be seen in the church of San Martino at Treviglio. (Ed. note)]

18. [Bartolomeo Suardi (c. 1465-c. 1536), called Bramantino, Lombard painter and architect, active in Milan. (Ed. note)]

19. [Giovanni Martino Spanzotti (1450/56-ca. 1523), Piedmontese painter,

probably from Casale Monferrato near Alessandia. (Ed. note)]

20. This painter was long ago confused with Brea (Mary Logan, *Gazette des Beaux-Arts*, 1896), who, compared to him, is not much better than an idiot. That he was of Pavian origin is clear from many signs. Though it seems difficult to identify him with Bernardino Lanzani, many frescoes in Pavia ascribed to Lanzani (the stories of San Maiolo at San Salvatore, certain frescoes in San Teodoro) and to Pier Francesco Sacchi (those in the second bay of the right aisle of San Michele) are very close to his in character. And a number of the small panel paintings of the Franchetti collection in the Ca' d'Oro (figures of *Saints* and the *Martyrdom of Saint Philip the Apostle*) and the Contini collection (*Sermon of Saint Philip*), all belonging to one same altar, are certainly his. I shall soon give an account of them in an appropriate essay. [The essay was delayed until 1941, when I was finally able to identify the artist as the Milanese Carlo Brancesco.]

[Later identified by Longhi as Carlo Braccesco; see the eponymous essay included in the present volume. (Ed. note)]

21. [Ambrogio da Fossano (c. 14550-after 1522), called Bergognone, major painter of the Lombard Renaissance, originally from Lombardy or Piedmont. (Ed. note)]

22. [Originally from Fermigano near Raphael's home town of Urbino, in the region of the Marches, the painter and architect Donato Bramante (1444-1514) served the Dukes of Milan before going on to a brilliant architectural career in High Renaissance Rome, where he designed, among other things, the cele-

brated "Tempietto" at San Pietro in Montorio and drew up the original plan for the new Saint Peter's. (Ed. note)]

23. [Federico Borromeo (1564-1631), archbishop of Milan from 1595 and a member of the same famous noble family from which his predecessor in the office, the counter-Reformation Saint Charles Borromeo, had sprung; a bibliophile and art collector, in 1609 he founded the Biblioteca Ambrosiana, still one of Milan's principal cultural institutions. Federico figures as well in Manzoni's great historical novel *I Promessi Sposi* (see note 15 above). (Ed. note)]

24. [Alessandro Bonvicino (1498-1554), called Moretto da Brescia, the earliest of the trio of major painters to emerge from the Lombard center of Brescia in the 16th century; an outstanding portraitist and master of counter-Reformation religious imagery, whose delicate, silvery palette makes him a recognizable heir to the local tradition embodied in Bergognone. (Ed. note)]

25. [Longhi was the first to ascribe the still life in question (now in the Kress Collection, National Gallery, Washington) to Caravaggio; he defended the attribution tenaciously in an article in the magazine *Proporzioni* (1943) and again in his monograph *Il Caravaggio* (Milan, 1952). However, practically no other art historian has accepted Longhi's thesis; the work is generally given to an anonymous follower. (Ed. note)]

26. [Aelbert Cuyp (1620-1691), Dutch landscape painter. (Ed. note)]

27. [Towards the end of his life, the American connoisseur finally did publish

a revised edition: Bernard Berenson with Luisa Vertova, *Lotto*, Milan, 1955. (Ed. note)]

28. [More recent scholarship has tended to dispute Longhi's attribution of this predella to Lotto. See R. Pallucchini and G. Mariano Canova, *L'opera completa del Lotto*, Milan, 1975, p. 89. (Ed. note)]

29. [Ludovico Dolce (1508-1568), Venetian man of letters. The attack on Lotto's coloring is to be found in his *L'Aretino ovvero dialogo di pittura*, Venice, 1557. (Ed. note)]

30. The painting in the Siena Pinacoteca, borrowed (quite rightly) for the 1953 Lotto exhibition in Venice, is indisputably the original, despite the poor condition of the background.

Pl. 45

31. [Adam Elsheimer (1578-1610), painter and engraver from Frankfurt, worked in Rome from 1610. Carlo Saraceni (1579-1620), Venetian painter, active in Rome and in his native city. (Ed. note)]

32. [Orazio Borgianni (1578-1616), Roman painter. Practically at the outset of his career, Longhi devoted an important article to his work: "Orazio Borgianni" in the journal *L'Arte* (1914). (Ed. note)]

33. "Cose Bresciane del Cinquecento," *L'Arte*, 1917; "Precisioni nella Galleria Borghese: G.G. Savoldo," *Vita Artistica*, 1926, p. 71; "Due opere inedite di G.G. Savoldo," *Vita Artistica*, 1927, p. 72 [see, respectively, vols. I (*Scritti giovanili*, pp. 327-343) and II (*Saggi e Ricerche*, pp. 277-279 and 149-156) of the *Opere Complete*].

34. To this "Tuscan" period of Savoldo should also be added the two paintings of *Hagar and the Angel* and the *Benediction of Jacob* in the Rouen Museum, which are ascribed to Gerolamo da Santa Croce but bear the same initial as the Borghese *Venus*. L. I shall soon comment on these.

35. Let us correct a slight error on this account. The *Pastore (Shepherd)* discussed in that article does not come, as I had thought, from the Wemyss collection, but from a German collection (Anhalt-Dessau). And the exemplary Wemyss piece that is still at Gosford House in Edinburgh is only a derivation, as I was later able to ascertain *de visu*.

36. We remain certain of Mancini's authorship of this painting, despite the recent attempt to reinstate it in Caprioli's name (see G. Fiocco, in *Rivista del R. Istit. d'Arch. e St. d'Arte*," 1929, I).

[Piero di Cosimo (c. 1462-after 1515), Florentine painter whose highly personal work reflects (as Longhi suggests) a variety of disparate influences, beginning with that of his teacher Cosimo Rosselli, whom he assisted in frescoes in the Sistine Chapel. His style reflects an interest in artists as diverse as Filippo Lippi, Signorelli, Leonardo, and, unmistakably, the northern European manner imported into Florence with Hugo van der Goes's Portinari altarpiece (now in the Uffizi). Domenico Mancini was a minor Venetian follower of Giorgione. (Ed. note)]

37. [Callisto Piazza (c. 1500-1562), member of a family of painters from the town of Lodi in Lombardy. (Ed. note)]

38. [Giambattista Moroni (c. 1525-1578), painter from Bondo Petello di Albino near Bergamo. Regarded by Berenson as a rather prosaic craftsman, praised by Longhi as a representative of the unrhetorical attention to reality whch the Italian critic saw as one of Lombard art's most characteristic contributions to Italian art. See also R. Longhi, "Dal Moroni al Ceruti" in *Paragone* no. 41, May 1953, pp. 18-36 (an essay collected in the Longhi reader *Da Cimabue a Morandi*, ed. Gianfranco Contini, Milan, 1973.) (Ed. note)]

39. [More recent scholarship has held that the artist was actually born and raised in Milan or its outskirts, and that the town of Caravaggio, near Brescia, so far from being (as Longhi and everyone else believed) the artist's birthplace, was merely his father's place of origin. See Howard Hibbard. *Caravaggio*, New York, 1983, p.l. (Ed. note)]

40. The Campi name, that is, the name of not one over another of the three brothers but of the whole family, was left hanging by Kallab at the very moment when death cut short his important work on Caravaggio. I am not certain exactly how that citation would otherwise have been developed over the course of his study; I doubt, however, that it would have come out well for the Campis, since the critic had already planned for his inquiry into Caravaggio's precedents to look in the direction of Venice and Titian. I have noticed, in this regard, that Schlosser, who is better acquainted than anyone else with Kallab's intentions, when talking of Bernardino Campi in his *Kunstliteratur* (p. 352) calls him "Hauptvertreter dieser Schule an die ein Caravaggio Anknüpft." The source of the declaration seems to be Kallab's passage, but there is no need to cite it specifically, since in fact Bernardino Campi took no part in that local current

which, in a certain sense, prefigured the arrival of Caravaggio. And the fact that the revival of the two Campis remained still unknown, despite my repeated insistence, is clear from the passage in the 1928 *Handbuch der Kunstwiss* (Pevsner), where Giulio is said to be the head of the family, while his brothers, not to mention his cousin Bernardino, are considered his invariably inferior followers.

41. [Giulio Pippi (1492 or 1499-1546), called Giulio Romano, painter, architect, and engraver. One of Raphael's most important assistants in his native Rome, from 1524 he served the ducal family at Mantua, where he rebuilt the local cathedral and designed and frescoed the celebrated Palazzo Te. (Ed. note)]

42. [Author of the pioneering *Storia Pittorica della Italia* (1795-1796), upon which Stendhal was to rely heavily in his *Histoire de la Peinture en Italie*. (Ed. note)]

43. [Giovanni Antonio de' Sacchis (c. 1484-1539), called Pordenone after his home town in the Friuli. In the 1530s he created a sensation in Venice with his violently illusionistic foreshortenings, but almost nothing of his work there has come down to us. Frescoes by him still survive in two churches in Cremona. (Ed. note)]

44. This painting, brought to the Louvre during the Napoleonic era with the same attribution, to Bernardino Gatti (known as Il Sojaro), that had always been given it in Cremona (cf. Aglio, *Le pitture di Cremona*, 1794, p. 52, and Sacchi, *Not. pitt. crem*, 1872, p. 124), was later mistaken to be a work by Bernardino Campi because of the confusion of first names. Years ago — on the basis of its naturalistic traits — I suggested it be attributed

instead to Antonio Campi, and the suggestion was accepted in the new catalogue. Today I am in a position to right this error, which in any case was not entirely unuseful in leading to the truth. That the painting contained a number of foreshadowings of Caravaggio had already been noted by Rouchès in his volume on Caravaggio, though he didn't go into the reasons for the deduction.

45. Voss, *Ital. Zeichnungen d. Spätrenaissance*, Munich, 1928, plate 16.

46. [Frans Floris (1516-1570), Flemish painter from Antwerp. (Ed. note)]

47. [Marten van Heemskerck (1498-1574), Dutch painters. (Ed. note)]

48. See at least one engraving in Soresina-Vidoni's work on *La Pittura Cremonese*, Milan 1824.

49. The Hampton Court canvas strikes me as no more than a copy of the lost original, which can be much better seen in the splendid dark etching by Murphy.

50. Copy of no. 575 of the Innsbruck Museum.

51. Today in the Civic Museum of Cremona, to which I donated it in 1950.

52. [The *stile di macchia* is, literally, the "spotted" or "blotchy" style. In his *Life of Titian*, Vasari refers to the *maniera di macchia*, the "spotted manner" typical of the artist's late work. The term denotes a highly "painterly" approach, in which Tuscan-style *disegno* (draughtsmanship) and the smoothly applied colors of earlier painting make way for a flickering picture surface characterized by highly visible

brushwork, where strokes of different colors are often frankly juxtaposed. (Ed. note)]

53. After the Sant'Angelo painting we have no other reliable evidence of Antonio's last years. There used to be a *Circumcision*, now lost, at the church of San Marco in Milan, from the year 1586 — thus from before his death, which did not occur after 1591, as people continue to repeat even today (e.g., Pevsner in *Handb. d. Knstwiss.*, 1928), but in January of 1587, as can be gleaned from Grasselli's appendix (in the *Abbecedario del pitt. cremonesi*) and from Vincenzo Campi's own testimony (published by Sacchi, *op. cit.*, p. 250), in which Antonio is placed among the lists of the dead on April 8 of the same year.

54. We do not know the *Saint Francis* signed by Vincenzo in 1573, which used to be in the Church of Sant'Egidio at Mantova (Sacchi, *op. cit.*, p. 92).

55. We know of no still lifes that can be ascribed to him with certainty. The attribution of the two in the Brera Museum is not absolutely certain.

56. [Who in fact signed the painting in 1588. Vincenzo Campi (1536-1591), a Cremonese painter, was the brother of Antonio (see note 3, above). (Ed. note)]

57. [Caravaggio's career took him to Rome, southern Italy, Malta; but he never returned to his native Lombardy after his departure in 1591-1592. (Ed. note)]

58. [Cremonese painter, doc. 1575-1597. (Ed. note)]

59. [For Lomazzo, see note 38 to Longhi's "Carlo Braccesco," included in the pre-

sent volume. For Peterzano, see note 4, above. (Ed. note)]

60. I owe the photograph to the kindness of Sir Robert Witt. Another, more recent photograph by Bulloz shows the later abrasions, now irreparable. In the catalogue the painting was formerly attributed to Francesco Torbido, then later, and still today, ascribed generically to the Venetian School of the 16th century.

61. [Giovanni Ambrogio Figino (1548-1608), Milanese painter. (Ed. note)]

62. One should bear in mind that the same subject was treated in a nocturnal light by both Antonio Campi (Sacchi, op. cit., p. 57) and Peterzano, in two paintings cited by the old Milanese guides. They should still be among the paintings of the Archbishopric.

63. See the excellent characterization of Lomazzo's education in Schlosser's *Kunstliteratur*.

64. I believe [he] is alluding to Vasari's anecdotes (VI, 205-207) on the struggles endured by Bugiardini for the painting of the *Martyrdom of Saint Catherine* in Santa Maria Novella.

65. This article had already been written a few months earlier, when *Zeitschrift für bildende Kunst* (1928-29, 11-12) published the continuation of Dr. Pevsner's studies on Caravaggio, devoted to *Caravaggio's Lehrjahre*. The author endeavors to publicize and illustrate our much-repeated declarations of the importance of the Brescians, the Bergamasks, and the Campis as forerunners of Caravaggio. For this intelligent acceptance, we heartily thank him. We regret, on the other hand, that

perhaps an imperfect understanding of the "Lombard" import of our opinions (it would seem that P. is still unfamiliar with the 1917 essay on *Cose Bresciane del Cinquecento*) has led him to conclude in favor of the Venetians and "Giorgionism" — which would point to a Classicistic, Renaiassance (and thus, to our mind, unacceptable) interpretation of Caravaggio. One consequence of the missed distinction (fundamental to us) between "Venetians" and "Lombards" is Pevsner's attempt to insert Romanino, a pure Venetian, into the strictly "Lombard" group of Moretto, Moroni, Lotto, and Savoldo — an attempt we had already opposed in its day. Then, in a specific instance, this lack of distinction appears complicated by a mistaken attribution: P. indeed has failed to see that the *Saint Peter Martyr* in Alzano Maggiore, which he, since he thinks it is by Lotto, cites as a pre-Caravaggesque, is actually by Palma Vecchio — an attribution in which so expert a connoisseur as Adolfo Venturi also concurs (*Storia*, IX, 4, p.22). But let me make a few other observations prompted by P.'s article.

Page 278: Pevsner believes he has found confirmation of Federico Zuccari's assertion of the Giorgionism of the Caravaggio paintings in San Luigi dei Francesi (related by Baglione) in the tone of Zuccari's letter from Pavia, which was published by Ticozzi (*Lett. pitt.*, VII, 515) and, he claims, from 1603-04. The only problem is that, as we have already seen in note 16, that letter, and all the rest in that sheaf, are fabrications, probably made by Ticozzi himself. Pevsner, if he reread it, could not help but agree. Here, for example, we have the Campis being quoted in the full blush of life and prosperity, when in fact they were already dead as can be. And here we see G. Battista

Armenino arriving fresh in Lombardy, a fact that took place fifty years earlier!

Page 281: Lotto's *Presepio* (Nativity) in the Venice Galleria is, to our mind, but a 17th-century copy of the lost original. One should therefore proceed warily in imagining to what extent the original is embellished with traits that would appear to be marks of the time in which the copy was made [see also note to page 118].

Pages 284-286: Pevsner says that, except for the Milanese guides from the Seicento to the present, the brief mentions in the artistic dictionaries (Ticozzi, Nagler), and two modern citations, the printed sources are silent on Peterzano. The truth is otherwise. First of all, Ticozzi's source is the peerless Lanzi; and in Lanzi, the consideration of Peterzano, particularly the San Barnaba paintings, is anything but superficial. Lanzi, for his part, appeals to that same Lomazzo who, as we saw above, repeatedly (1584, 1587, 1590) cites the contemporary Simone Veneziano. Peterzano is mentioned in Gigli's *Pittura trionfante* in 1615, while Biffi (in *Pitture, sculture e ordini d'architettura*) assigns a 1593 date to Peterzano's *Assunta*, formerly in the Cappuccio church. In the late 18th century Zani provides all the variants of Peterzano's surname and his way of signing it.

For his part, Pevsner is now publishing some new documents on Peterzano, the most useful among them being the one that declares him to be from Bergamo, thus clarifying quite naturally (through Moroni) my Brescian and Lombard interpretation of the painter. Other documents among these fix the date of the large San Barnaba paintings at 1573, and that of the *Wedding of Saint Catherine* in the Sant'Angelo sacristy at 1579.

From the catalogue of works of Peterzano provided us by Pevsner, we

should remove the painting from the church of San Paolo, which is without question by Salmeggia, to whom the most dependable sources in fact attribute it, including the biographer of the Bergamasks, Count Tassi; while we should add the many paintings discussed here in the text.

Page 287: the Antonio Campi painting at Sant'Angelo is not a fresco, as P. believes, but a canvas; and it does not depict the *Liberation of Saint Catherine*, but, to be precise, *Saint Catherine Being Fed in Prison by Angels during a Visit by the Empress Faustina and Marshall Porfirius.*

Roberto Longhi's notes are translated by Stephen Sartarelli

Editorial notes David Tabbat

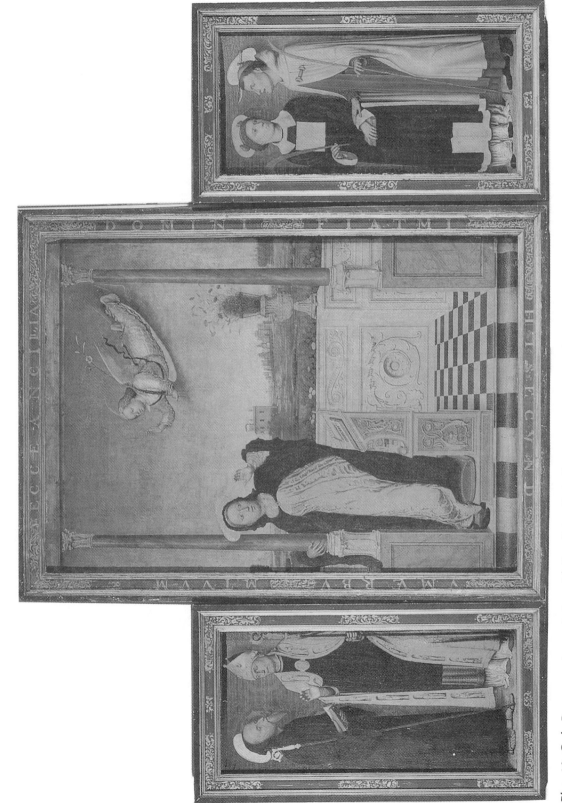

Plate 13: Carlo Braccesco, *Annunciation with Four Saints*, Paris, Louvre

Carlo Braccesco

Translated by David Tabbat

An art historian's memories are not only, as people tend to believe, memories of the work-table, of sparks going off spontaneously between photographs and documents, as if between two batteries; they are also — and to a far greater extent — memories of aimless journeys, fortuitous encounters, prolonged overtures addressed to stubbornly mute works, as afternoon light streams down from the skylights of museums, those deeply beloved landscapes of our own individual histories.

And were I to attempt to arrange my by-now-myriad memories in order of intensity, I think that I would always have to place at the head of the procession the eagerly awaited encounter, repeated many times thereafter, with the Master of the *Annunciation* in the Louvre Museum: number 1676.

It is one of the paintings I have known best and loved most for over thirty years, since I myself was twenty. When I met it for the first time, just after the war, it was, you must understand, an encounter prepared for by much useless puzzling over the photograph published by Alinari and by much meditation on the work's strange history. I knew that the picture had been bought from an oratory in Genoa in 1806 by Baron Denon,[1] and that for about eighty years, it had borne in the Louvre the name of Giusto d'Alemagna,[2] for practically no better reason than that a 1451 Genoese *Annunciation* of Giusto's was known: the painting's generically northern European traits, so common in Liguria, provided the reasoning for this attribution, however insufficient as a proof. The error was reinforced, and I remember how much irritation this caused me, by the assumption that the wings did not form a unit, stylistically speaking, with the central panel.[3] It saddened me that our great Cavalcaselle, in about 1875, had not corrected these twin errors in his *History of Flemish Painting*;[4] but I found it touching that, discussing the painting from memory, he described it as possessing a gold-leaf background, perhaps because he had been dazzled by the profusion of gold found, if truth be told, pretty much everywhere but the background. It also moved me that, in noting the delicate tonalities and the lightness of the shadows (and this in itself was already an appreciation), Cavalcaselle expressed in practically clinical terms his suspicion that the picture was unfinished, without first having wondered whether this were not, instead, the only sort of finish possible, given the temper of this singular artist.

I could find nothing else of interest in the things written around those years, save the passage dedicated to the work by Chaumelin in the *Histoire des peintres de toutes les écoles,* the curious Romantic-Positivist storehouse written under the supervision of Charles Blanc,[5] that delectable Flammarion

of art history.[6] There is no progress here in the historical and philological definition of the work, it is still spoken of as being by Giusto d'Alemagna; but there is an insistence upon the dominant impress of the Italian spirit, to the point of numbering Giusto among the Genoese. The most important aspect of this definition, however, is the unequivocal statement that the wings and the central part are the work of the same imagination and hand; the writer observes, among other things, that "Saint Stephen's blue damask has the same tonal value as the Virgin's mantle:" nothing more than an alert "studio" note, but to the point.

For the rest, one could sense that the attribution to Justus of Ravensburg was losing altitude from the fact that, around 1890, in his very well-informed history of German painting, Janitschek did not so much as mention the Louvre painting.

But the first explicit refutation of the reckless attribution came only in 1896, with Mrs. Logan-Berenson's well-known article in the *Gazette des Beaux Arts*.[7] The moment was ripe for arriving at the truth. Unfortunately, the youthful Anglo-American couple's recent touristic excitement,[8] provoked by their rediscovery of Ludovico Brea[9] along the Riviera, led them to the poor expedient of chalking up the Louvre *Annunciation* to him. Measured by the standard of this work, Brea is scarcely more than a peasant. Nor is it clear that the youthful traveler doesn't intend to cut this masterpiece down to size when she informs us that "it reveals no great mastery of form, nor any deep knowledge of anatomy, of light or shade; it stirs neither admiration for its author's genius nor curiosity about his intimate personality." In short, the aim seems to be to place this extremely cultivated work at the level of agreeable folk art, of amusing decoration: this is, in fact, the same sort of judgment which Berenson was to apply, a little later and with more justification, when he rated Defendente Ferrari,[10] that painter of Oriental lacquered work, as a mere artisan.

Surprisingly, even Frizzoni, reviewing the fine book on Foppa[11] by Mrs. ffoulkes and Monsignor Maiocchi, agreed in 1909 that this new wrong turning — partially redeemed though it may have been by a few good marginal observations regarding the work's links with the Quattrocento in Lombardy — was the right one. What is more, he failed to notice that the very volume under discussion weakened the new attribution with its acute observation that Liguria, around the turn of the century, was crawling with Lombard painters; the point being that it would have been useful to seek out our artist among them.

Nor was there lacking, at that time, one of those futile games imagined by documentary historians to constitute meat, value, and simplicity

in the demonstration of an attribution: I allude to the provincial attempt[12] to explain the Louvre painting as the work of Brea assisted, not by Giusto, but rather by Corrado d'Alemagna, another German expatriate active in Liguria at the end of the fifteenth century.

In truth, the attribution to Brea died in infancy, seeing that the Nice show of 1912, dedicated almost entirely to the greater glory of this honest local painter, did not even bother to borrow the Louvre painting. In those same years, perhaps on the basis of Labande's good and not-so-good observations (on the Virgin's movement, which cannot be by Brea, and on the ornamentation, in a style that strikes him — however improbably — as Florentine),[13] the old label was replaced in Paris with another one, more noncommittal, remaining to this day: "North Italian School, about 1500."[14]

It was Adolfo Venturi[15] who, shortly afterwards, clearly rejected the name of the painter from Nice and instead spoke to us, with admirable enthusiasm, of "an unknown Ligurian artist of exquisite gifts"; but to tell the truth (even if it means having to share a backstage memory with you), in those days in Rome, at the side of my alert and brilliant teacher, I myself had already taken on the role of *eminence grise* in promoting the fame of the great anonymous artist.

The interruption caused by the war didn't permit me to get to know the painter face to face until 1920; but from that first meeting in the Louvre, and after many hours spent interrogating him directly, I came to understand ever better his Lombard nationality, his transplantation to Liguria, and his links with that culture, Franco-Provençal or even Mediterranean, a culture in which Angelico's roses bloomed anew with Fouquet and Charonton, and even Piero[16] [della Francesca]'s sun gave off a touch of warmth. This is why, in my book on Piero, speaking of that admirable capacity to balance north and south, Flemish direct observation and Italian measurement, so characteristic of many painters in France and Spain in the last decades of the fifteenth century, I mention not only Bergognone's[17] distant backgrounds and Spanzotti's[18] scansion of light, but also the subtlety of the Master of the Louvre *Annunciation*.

As a result of the time spent with him, I was very well prepared to recognize other scattered bits and pieces belonging to him when luck brought them my way, "tossed here and there" like the Innominato's body [in Manzoni's *I Promessi Sposi*]. I met up with more than one of them, in fact, between 1920 and 1930, and I mentioned them fleetingly in a note to an essay of mine in 1928.[19] There the somewhat abstract concept of the Lombard-Mediterranean cultural complex made way for a mention of the reflections of the artist perceptible in the taste prevalent at Pavia at the

beginning of the Cinquecento, reflections so evident as to lead me to suppose that he was originally from that city and to insist upon the analogy, on an even higher plane, between his case and those of Foppa[20] and Bergognone. Like a sailor, I was good at making promises; and I promised that before long I would write a study devoted especially to him.

Why I have waited until today, which is to say another fifteen years, before doing so, can only be explained by the wandering course of our scholarly passions, ever ready to set sail for new destinations (an artist in every port), by my practically nonexistent awareness of the rapid passage of the years, and also by the hope (slow in being fulfilled) of being in a position at last to rescue the great Lombard painter from anonymity; I knew from experience how much harder it is to convince most people to believe, despite the evidence, that even great artists can lose their documents along the way than it is to get them to admire a new star for which one has found a name. But in response to the kind invitation of this Institute, what could I offer that might be more fitting than a brief presentation of the great anonymous Lombard? If my personal adventure with him has a sequel, it will, so to speak, come to light as I hold forth.

Pl. 13

Let us go back together, to the year nineteen-hundred and twenty, to the Louvre Museum, in front of the triptych hanging on the left, towards the far end of the first bay of that Grande Galerie which has taken on by now, in memory, the tranquillity of a broad roadway in the rain: the first notes, jotted down, I well remember, during the midday pause in a *crémerie* in the rue de Rivoli, are rather significant.

Apparition of gold and yellow-brown, azure and gray. The flesh-tones slightly dusky; almost a suspicion of mixed blood. On the brighter faces, slate-gray shadows. Saint Albert's Oriental slippers like black olives. Warm tones and cool tones (what does it matter?) that cannot be told apart. Gold, gold: but not flattened out by the light; instead, dazzling in the light, and burnt by the black feather of shadow. Feeling for gold. Cultivation of gold. Culture of Lombard gold (Monza, Treviglio, Lodi). Astute handling of form, such as would put many a Florentine to shame, yet not Florentine: confidential, intimate, not insolent and smug. The city in the torpid afternoon: an imaginary Pavia, a memory? And the angel, seemingly hammered out by some sculptor of the Charterhouse [of Pavia]. Violet as in Bergognone. The azures, on the other hand, are like a lake, pristine, as in Fouquet and

Charonton. As for the rest, even the Madonna: "rustic." The choice of the rose-trellis setting, as in an old Provençal lay: the carnations trembling in the sultry heat within the vase, which is — alas! — "Renaissance." Ironically so, however, as is the too-beautiful, impeccable fragment of acanthus-leaf decoration. Everything written and everything painted; large and minute. A miniaturist of genius. A great painter of small things. The most elevated dialogue between north and south, between van Eyck and Piero. The pinnacle of fifteenth-century Lombard painting.

Why not put them on public display, these old bits of the immediate impression? With all their ambitious manner, somewhere between Fromentin[21] and Baudelaire,[22] they are still irreplaceable, at least for me: and besides — one might as well admit it right now — that plunge into the first excitement will never again return.

Today we won't have time to do more than make a few general observations (of the sort taken for granted in a specialist's notes, always a bit cryptic), before getting down to particulars.[23]

On the whole, what stands out is the sovereign intelligence with which the two old formulae of the division into a triptych and of the gold-leaf background, both probably imposed by Ligurian taste, have been at once sublimated and eluded. The first of these formulae expresses itself through that calculated contrast (today less perceptible, because of the absence of the frame that always functioned, in those good old days, as a clear spatial introduction) between the four concierges murmuring in their lodges at the edges of the work, as if by the side of the road, and the showy opening of the loggia and landscape in the central panel. The second formula is manifest in the replacement of the old-fashioned gold background in the side panels with that sort of thin curtain drawn into a slight curve, a curtain woven into a red and gold brocatel on which the nearby saints cast a shadow, but recalling, because of the transverse notches of harsh light, a mat of woven broom, just now pulled down to keep out the glare; and, in the center, through the gold that swarms all over the place, a hint of the traditional background remains even in the dullish, powdery, ash-blond sky, against which, in fact, the real gold of the Virgin's halo stands out hardly at all.

Having thus demonstrated the overall unity of the various parts, it will be useful at this point to approach them one by one; starting, of course, with the principal subject, the *Annunciation*. The manner of eluding and at the same time sublimating the old abstract and symbolic requirements,

so much in evidence in many old Genoese art documents, for "fine gold" and "fine blue," should have led us to expect that the artist would have thought for himself about the difficulties of a subject that seems to run, for over-clever painters, along the razor's edge of a symbolism but a hairsbreadth away from the Freudian. Instead, here we find an image whose pointed irony is at first subdued, as if to say: you are asking me for luxuryclass annunciations, and I am going to show you what that leads to. Luxury is of this world, and so the gold won't be in heaven, but right here, in the clothing, on the lectern, on the capitals, and the more the better: proof of wealth, refinement, good taste.

So an elegant Lombard-style loggia stands on slender little columns of Loana stone and frames an open terrace where the white and pepper-red checkerboard of the pavement, in very precise perspective and yet seeming to levitate because of its contrasting colors, soon breaks off at the marble parapet with its impeccably carved decoration. "Renaissance" if you like, but a breath away from a mocking ornamental elegance. Those column bases, with thin golden plaques like brooches, and even more that large vegetable ornament (the parts that struck Labande as Florentine and which are instead, philologically speaking, Lombard, somewhere between the architect-sculptors Amadeo and Solari) seem to have been interpreted by a lyric poet of the Pléïade, by a du Bellay evoking the far-off, dusty calligraphy of Roman Italy, but darkening it, in the parts in shadow, with the ink of northern rains. All in all, this architecture rings as fragile and as hollow as a big piece of embossed jewelry, just like the pewter vase from which carnations curl into the air. And, when all is said and done, the crystalline norm of Italianate space, in a word, of perspective, gets snagged and unravels alarmingly freely against the thorny and saw-toothed outline of the Virgin's blue mantle, open over the tinsel robe written in shadows, like the metallic wings of a golden fly.

What becomes, in this figure, of Italian form, of Platonic *disegno*? The fact is that here it is a matter of modulation rather than of modeling: every earlier standard dissolves, the way pearls are said to dissolve in vinegar. How can we speak of anatomy with regard to those hands, which seem sucked up and consumed by the air, and which I wouldn't trade — especially not the one resting damp against the chilly colonnette — even for the studiously foreshortened hand in Leonardo's *Virgin of the Rocks?* An animistic anatomy, perhaps, seeping out from within, not arrogant and biological; biographical, if anything. Always an interior reflection, which seems to murmur and to be the impulse behind the "movement." And maybe this is why, in the present case, one almost wishes to indulge in old-

fashioned psychology; but it had better be subtle.

First of all, just who is this Lady of the Loggia? The "damsel" of the chivalric style, hinted at by French thirteenth-century miniaturists but found only by Simone [Martini]? Or nothing but a memory of her, already become a slightly coarse châtelaine of the Ligurian Riviera or perhaps the Côte d'Azur? Still rather a bluestocking but not, by this time, without a hint that her stockings are of good bourgeois wool. The book open on the golden lectern is, no doubt about it, the Book of Hours; but a bit lower down, on the shelf where the costly bindings make so fine a show, there are also, perhaps, the *Roman de la Rose* and the platinum-edged notebook for secret expenditures.

Or, to take a stab at an even more elementary question, that of whether this Lady of the Loggia be beautiful or plain, I have no idea who might be able to answer it. Who will ever know anything about that nearly albino, round and tiny face, or about the platinum-dyed hair parted in bandeaux beneath the old Byzantine *maforion*, the plucked eyebrows, rodent ears, skin drawn tight as an eggshell, with a hint of freckles and mites in the slightly oily tissue? And the secret of that shrewd and dreamy gaze, that mischievous shadow at the corners of the mouth, that air of the smug châtelaine, of the front-row churchgoer who would never, for anything in the world, allow herself to be caught unawares — can you explain it to me?

What's he coming buzzing around here for on his gilded perspective plate — this violet hornet, his tunic buffered by the wind, his shoulder-ribbon waving, his feet entangled in the last snippets of cloud, his garland reduced to just three flat little rosebuds and his plume brushing against the hot sky? Ah! A distraction at last, in this long string of afternoons, so wearisome that the very roses sleep, white and red, on the marble trellis, and the unchanging view trembles drowsily amidst the marshes and the brush: today once again, the washerwomen are going to wash the clothes in the Ticino; today as ever, one sees out there the meaningless spectacle of the already-old provincial town, with its covered bridge, its castle, and the Bramantesque cathedral of Nazareth-Pavia.

A captious reading, I don't deny it; but perhaps not so much so that it fails to convey a sketchy idea of the complex motivations at play in the anonymous painter's mind as he works at distilling from his over-used and much-abused subject matter this exquisite decoction, from which all trace of the dregs has vanished.

After which, going on to visit the saints in their boxes, one never tires of discovering how so much exposition and examination and variation of gestures and attributes can develop so harmoniously in those two little sec-

Pl. 55, 56

tions where, given the premises, it might have seemed that people could appear only as a quintessence of saints, sticks animated by holiness, Stradivari fiddles in their cases. And, above and beyond the action, what a weighing of values and tones: grays and tans, golds and reds, blacks and azures.

At the left, Saint Benedict like an old magpie, so black he's blue; the cowl sliding down his slate-gray pate, the staff forgotten in his arms when his hand flew to mark the place in the book. Next to him, Saint Augustine like a tonsured coin, his weight scarcely sufficient to bear that of his miter and solid gold cope, save only through sheer strength of nerve; his gloved hands test the small space alotted him. One gram more of gold would be too much, and it is perhaps for this reason that the painter, with such a disregard for the iconographic rules as only a notable lord of language can allow himself, has eliminated the nimbus, sign of holiness, from behind the miter.

At the right, spellbound as Donatello's Saint Leonard, here is Saint Stephen in an azure dalmatic embroidered in gold, with silver pebbles on his head and, beside him, Saint Albert[24] like the trunk of a young birch that has just been barked where those precious daggers struck home; while the slender reed, grown into a slender palm, answers Saint Benedict's staff.

But one can also get nearer to these sensitive trees, the better to examine the "seat of expression." The standard of measurement doesn't change, but one sees more clearly how Saint Benedict's head seems carved by a sculptor in a soft stone, in graphite; in Saint Augustine, the eyes of purest water, like the gems set into the miter and, at his throat, the light which seems to flash regularly at the urging of a hypertense pulse.

In Saints Stephen and Albert, one reads more intensely the lively twists and turns of the four hands suspended in mid-air like dried and veiny hanging plants, the straight drop of a smooth tunic and the slight crackle of gold-embroidered cuffs just barely able to support the tug of the stitching; and then the affable boldness in Stephen's face, apparent in the dentated eye-sockets, the firm curl of the hair, the compressed, nearly glued-shut lips; while from Saint Albert's half-closed mouth there seems to issue a weak, thin voice, through lips dry as a rotting hulk: "worn down with slight fever," as in the tale by Ungaretti.

Anatomy again? Yes, but freer and subtler than in Pollaiuolo, because its means are entirely different and practically evasive, having none of his organic demonism, but rather an affectionate sense of the body as just one more poor thing among so many others. Line? Yes, but one that passes like

Pl. 55

Pl. 56

hidden stitching among the fibers of a worn-out woven fabric. Tone? This too; but when it has to, it can reach the point of pure, resonantly intense color without losing its way: and then of course there's the whole inverse scale.

As for the overall impression, then: if one wishes to speak for a moment of "historical context" after so many allusions to all the cardinal points of the taste of the period, from Liguria to Lombardy to Flanders to France to the Tuscan Renaissance, it seems that practically nothing of the best in fifteenth-century European culture has escaped this great artist's notice or failed to please him; but in order to get our bearings, we should understand that he has quoted none of it, only expressed it, unrepeatably. His culture seems limitless, precisely because he is a person who, having developed in the midst of so much rich and contradictory history, uses it all up and makes it his own at the point of turning it into a work of art.

But was he really a "person"?

In 1925, when I ran into this panel[25] of the *Crucifixion of an Apostle* (who might be Philip or Andrew, I don't know which) on the walls of the Ca' d'Oro, for me it was a noteworthy indication; I felt that I was finally breaking out of that magical and mocking circle in which a unique work makes it easy for the critic to suspect that, while he thinks he's spotted a new and particular historical reality, a new "value," instead he is just groping blindly at parts of a body he already knows.

Pl. 57

I acquired an immediate certainty of a poetical identity with the Louvre triptych, without having to make (to use the esoteric language of finance) any down payment on it; it really cost me nothing; the proof was all the more credible because the panel, seemingly representative of the great anonymous artist in an earlier phase, already left him consisting of two intimately connected but historically distinct moments.

In telling here of the apostle's martyrdom, the painter divides the picture into zones with nearly archaic simplicity, while the free distribution of the figures within the two opposing groups recalls Foppa's freedom of treatment (ca. 1465) in the Sant' Eustorgio frescoes [in Milan]. Here as there, one finds the inexpressible red of Lombard bricks, striped and veined with deposits of lime, serving for the walls of Hieropolis or Patras, beyond which there opens, on this overcast day, a Ligurian sea-cove, below poor hillsides streaked with green. In the foreground, to each side of the crucified saint with his dry, elastic, nearly athletic body, the crowd is divided into the good and the bad, as in a passion play. On the left, still being egged on by white-robed false monks, are those who have ordered and carried out the martyrdom, wearing the world's rarest and liveliest

colors, all harmonized in the tonality of gold: red velvets, and gold; greens, and gold; blues, and gold; tans, and gold. On the right are the good, standing or kneeling or sitting on benches, all caught up in the same range of colors, but with the exceptional addition of the Asian wearing a cloak vividly striped in red and green-brown, and little golden boots, as in the subtlest Persian miniature.

I think that no one, looking more closely at these tyrants and henchmen, will have to make an effort to recognize a transposition of the same passionate and spirited race as in the Louvre painting, the same taste for *recherché* costumes and attributes, here even more farfetched: scimitars, Berber spears, broadswords, tasseled pikes; the same manner of brandishing them; the same pleasure in complicating the pictorial space by means of subtle, perfectly judged bits of gesture, so tiny and yet so peremptory that you feel like saying: these fellows are right, too.

But the believers on the other side are right as well, in their excitable, dessicated thinness, in their hands, exhausted and consumed by passing rays of light as in the Louvre Saint Augustine, in the ineffable modulation of the Persian jacket in the foreground. And nowhere else, save in our anonymous master, will you find such results obtained with gold: smooth, grainy, written and spoken gold, with all the virtues of tonal variation, yet with all the effectiveness of the old fourteenth-century symbolic splendor. If one but reflect that the painting must date from around the same years as the dazzling altarpiece by Butinone and Zenale at Treviglio, that in itself will be enough to show that here too we are in the presence of the preciously cultivated Lombard gold.

This same cultivation grows even stronger, tending towards the archaic, in the four Doctors of the Church in the same collection, which must therefore have once belonged, together with the predella, to a now-dismembered altarpiece. I mean that, placing them between the slender pilaster strips of a gleaming frame, the painter was able to pretend to be yet more of a traditionalist, even returning to the use of gold as a background for the figures. At first glance and seen from a distance, one almost thinks they are by a Sienese working in Avignon a hundred and sixty years earlier; such is the splendor of the varied sorts of gold and the antiquity of the abstract, almost Byzantine rose-motives impressed upon them. And yet the Saint Ambrose is as Lombard as an up-to-date Zenale, and, underneath the copes, in the delicate rocheting of the surplice, on the bases of the light feet, the form arises and oscillates as it does in the saints in the Louvre, while Saint Jerome in his eyeglasses, clad in a red like clotted blood, moves his two hands in that counterpoint we already know.

Meanwhile, my research kept adding other panels to the predella with the apostle: for example, the one which in around 1927 belonged to Baron von Hadeln and is now in the Kress Collection[26] in New York, and which is obviously mutilated, inasmuch as the gestures of the saint and of several spectators allude to a conclusion taking place outside the fragment. It may be either Saint Philip exorcising the pestilential dragon of Hierapolis or, more likely, Saint Andrew transforming the seven devils of Nicea into dogs. In that case, the woman on the right with the nimbus would be Maximilla, the Consul of Nicea's converted wife. Here too, the narrative gambit immediately reminds one of *Saint Peter Martyr Preaching,* painted by Foppa in Sant'Eustorgio, even in the simple carpentry of the pulpit and benches; and, as in the scene of the crucifixion of the saint, the red pepper of Lombard brickwork returns in the low wall, crumbling on top where the grass is growing, interrupted on the right to make room for a fragment of sloping, tree-covered hills beneath the overcast sky. The chromatic scale is always the same, with the indescribable series of colors crowned with written gold and tippling tinsel, with a whisper of shadow about the edges; the people are the same, too, especially these women in profile, fasting members of the Franciscan Third Order, mystic ardor practically splitting their mouths into a hare-lip, eyebrows leaping about like flies' feet. And yet, what melting sweetness in their unbound hair!

I encountered a third panel in 1929 at the Musée de Cluny,[27] where it bears our painter's almost magical number, 1676, which is, through sheer coincidence, the same as that of the triptych in the Louvre. It was amusing to see the painting displayed in that museum of "industrial" art, perhaps on account of the marvelous application of gold: but always modulated by a mind playing freely at the limit, even turning gold into a habit denoting superior acuteness in the wearer.

Here, if I am not mistaken, the scene is the regularly recurring miracle at Saint Andrew's tomb in Amalfi: the "manna" sweated by the saint, collected in a little basin on the altar and doled out to the faithful in spoonfuls, in accordance with the recipe. But the action takes place in a little Lombard Renaissance church, given that the structure of the triptych on the altar is Lombard, as is the little gilded door at the right, which has a tympanum and is divided in two by the slender pier. One breathes the air of a Charterhouse of the Po Valley in this interior, where the mild light streams from the little windows that frame a piece of sky and a bit of wan and liquid landscape, and where, at a signal from the tense, almost impatient priest, the devout kneel like thirsty goats, ready to nibble at the celestial food, which is really nothing but our painter's soaring wisdom.

Pl. 58

There: I've shown you all the anonymous Lombard's scant luggage, just as I found it in the cloakroom. I believe that no shadow of doubt can remain regarding the fact that these works are all by one hand, nor, I insist, regarding his exalted artistic stature; there is also the unutterable complexity of his taste, but that is a theme which would necessitate a discussion too long for an occasion such as this one.

Let us return to the point at which we declared, with no reservations, that the Louvre *Annunciation* is the high point of Lombard Quattrocento art, adding now that it is to be dated towards the end of the century; if we agree on this, we may also assume (as the rediscovered earlier works seem to suggest) that such greatness in maturity had its beginnings in a good initial training twenty or thirty years earlier. So we would find ourselves in Lombardy around 1460-70. Except that in those years, according to the opinion expressed by Toesca at the end of his splendid book published in 1912, "By then the Renaissance style was making inroads into Lombardy from every direction."[28] And if this is so, it would seem that there is no point in going on with the search, because in our painter's case there's no talking about any "Renaissance," at least not in the strict sense of the term. But I have attempted on several occasions to refute such an opinion: first of all,[29] by reconstructing the prevailing Lombard taste in the area between Milan and Pavia in the days of Bonifacio Bembo and Cristoforo Moretti; and also[30] by narrowly limiting the scope of the common assertion that definite traces of Renaissance "rationality" turn up even in the taste of Foppa and Bergognone.

The older taste, which was slow to die, the singular aesthetics which, as Dante puts it, "[*i*] *melanesi accampa*," is the triumph of an aristocratic, heraldic, totally secular and mad passion for luxury. "Here is show and triumph of pearl embroideries." They paint, even on a gold-leaf background, portraits of the dogs of the ducal pack: "the portrait of a dog named Bareta." The entire cosmos seems to want to bend and compress its way into the small gold space of a tarot card. In commissioning secular frescoes for the walls of castles, the main concern is that one should clearly see "that his Lordship eats off golden dishes." On those walls dukes and their families, sporting the sable masterpieces of their furriers, stroll or ride in a resplendent and absurd secular dream. At their feet, fields are magically transformed into the borders of tapestries; the woods of their distant feuds are silhouetted against a firmament that has, over time, been overrun and engraved like a horse's armor with the mathematical vicissitudes of their families' heraldic constellations; off there, beyond Alpine foothills brown as tooled leather and crowned with manors in gilded *pastille*, the sky,

scaly with white and near-black, creaks like the pewter settings for the stained-glass windows of the ducal oratory; every view and every act is shut in, blindfolded beneath the heavy, vacillating luxury of a private horizon.

These poetics, a trifle chastened but by no means outworn, still stand at the time of Galeazzo Maria [Visconti], as can be seen in his ducal chapel of 1472. Here, beneath the glided plaster decorations, there still oozes the sweet, soft line of the dying Gothic style that had bloomed anew so many times in Lombardy, from Michelino [da Besozzo] to Masolino to the Zavattari. But it would be too difficult to imagine whether our anonymous master grew up alongside Stefano de' Fedeli or Jacopino Vismara, or yet another among all these artists about whom we still know too little: just their names, or not even their names, as in the case of the painter who, judging by the few legible traces remaining under the "Elephant Portico" in the [Sforza] Castle [in Milan], seems far from ungifted. In short, I hear in our anonymous master, above and beyond that culture of gold, at a pitch of refinement which it remained for him to sublimate, some fundamental cadence learnt in those still-Gothic days: the way his figures branch out from the bottom to the top, almost as though they had springs; the intact blues and yellows; even the happy sweetness of Saint Stephen in the Louvre; all this finds a sort of spiritual prelude in these slightly curved silhouettes of little saints in the Poldi-Pozzoli Museum, which, since they come, as I have learned, from a church in Mantua,[31] might — who knows? — be the work of the then-dominant Lombard artist, the still-nebulous Michele da Pavia. In any case, they are similar to the culture of Bonifacio Bembo, as is shown by these two unpublished saints from the Hams collection; but perhaps they reveal an even higher quality of inspiration.

And another essential ingredient, a lucid Flemish attention to observed reality, could have been instilled in him here [in Milan] starting from the time of Zanetto Bugatto's return from the van der Weyden workshop in 1463. I am attracted to this hypothesis by an example showing saints extremely popular in Milan;[32] clearly the work of another very noble anonymous Lombard artist of those days, this picture seems to parallel closely the culture of our painter, precisely because of its northern European traits.

It should also be understood that, before he left, our artist must also have gotten to know the taste of Foppa in his full maturity and Bergognone as a youth. And because I realize that here the "Renaissance" is about to come back on stage, I can only say that, in my essay[33] on the subject, I have stated my case for the old Lombard precedents for the "direct painting"

which was to begin, over a century later, with the Lombard [Michelangelo] Merisi [da Caravaggio]. Perhaps some of you have read that essay. Venturi certainly did, and, to my inevitable satisfaction, in 1930 he revised along similar lines his entire view of Quattrocento Lombard painting.[34] There were others who did not care to read it. Certainly, if one allows oneself to be imposed upon, right at the outset of Foppa's career, by the triumphal arch and ancient medallions in the 1456 *Crucifixion,* then there is nothing more to be said, it is through that very archway that the Renaissance invades Lombardy; but if one chooses to notice that the arch is crooked and wobbly and that the medallions look as though they'd been modeled in wax in the open air, you can save yourself the price of admission, and you will understand better why the bad thief, for example, is steeped Pl. 37 in light and shadow as in a seventeenth-century painting and why the crossbar of his crucifix is turned into a blazing brand by its luminous foreshortening. In short, let us not confuse a Renaissance *depicted* in the painting with a Renaissance *expressed* in the painting; we shouldn't confuse them even in Mantegna, who is usually presented as Foppa's grave and lofty precursor but who instead — different though he may be from Foppa — does not look to me in the least like the Roman eagle that people say he is; more like an old hawk, trained to use his claws to scratch out on the falconer's stick certain signs evoking lost and ancient worlds.

There is no doubting the fundamental similarity of intentions between Foppa, Bergognone, and our great anonymous master; we have already taken notice of it by observing that all three sometimes depict the Renaissance, but do not express it; they like to take advantage of its triumphal appearance while eluding it at the core of their art, which is different and which in fact openly declares itself in favor, not of organized forms and of measurable space, but rather of things whose substance is light-air-color, and of space whose depth is intuited, felt out in a lovely empiricism.

Free of the rigid formalities of the Renaissance, the poetics that dictated the unforgettable background of the *Annunciation* to our master is indeed the same as the poetics which had already dictated to Foppa [in his frescoes at Sant' Eustorgio in Milan] the well-trodden path and the Manzonian lake of the *Assassination of Saint Peter Martyr* or the indoor-outdoor setting of the *Miracle of the Saint,* where what matters is not the Pl. 60 unmeasurable inexactitude of the perspective in the vault, but rather the light brushing the vault's underside and the tree trembling in the gray sky beyond the crenellated wail: a sensibility closer to Pieter de Hooch, two centuries later, than to a contemporary Florentine.

And it is still this same spirit which dictates to Bergognone, in flowing script, so many passages which, if they are not yet famous, are destined to become so. The barnyard behind the Bergamo *Madonna*, with chickens scratching between sunlight and shadow, and the light up above, applying ointment to the mouth of the belfry; the courtyard of the villa, open to the sunlight, with the oblique shadow showing the time of day, against the darkness of the Lodi *Annunciation*, with the swallows chirping their high notes on the ironwork in the archways, the shriek of the peacock cutting through the murmuring garden, and, beyond the low wall, in the mist, the Lombard village; the blood-and-violet sunset of the *Pietà* in the possession of Don Guido Cagnola — a passage so overflowing with feeling become painting, in those uncertain shapes of keeps, mountains, bell-towers, fraying in the last light, as to put us in mind of the most spontaneous and immediate things of our own Carrà.

Pl. 61

Pl. 62

Nor should we forget that, like our anonymous master, Foppa and Bergognone also continued to cultivate Lombard gold; in them, too, it is at times broken and modulated and inscribed with shadow by the brush, amidst the more broadly applied reds and whites, tans and blues. I'm thinking of Foppa's *Annunciation* in Casa Borromeo or Bergognone's *Saint Quirico* at Bergamo: a portentous harmony of gold and pale tobacco.

And yet it is true that, for these two famous Lombards, the Renaissance is an obstacle to be overcome and that sometimes, failing to make the hurdle, they get themselves disqualified. When this happens, it is due of course to their taste, which is not always at the highest level. Composition, prospective grid, and so forth, when present in their work, are provincial imitation; and then the over-strenuous form seems to collide with its own poorly-made packing-case. In these instances the Renaissance is still a sort of chemical precipitate, and a precipitate you notice, too — right there at the bottom of the glass.

But the decantation descends perfectly through our Master's filter. With him, there are no random fragments to be examined; rather, it is the whole which satisfies us, because every precedent, including the Renaissance, is freely refracted, like a gem in an ever-shifting, retractable, highly responsive setting: a setting that, when necessary, can accommodate irony.

So let us imagine that — after having been trained at the courts of Milan and Pavia around 1470 amidst the bayings of the last mastiffs and the songs of the last gentle Gothic gilders and draughtsmen from the time of Galeazzo Maria, after having understood all those matters we have been speaking of, and also, perhaps, after having observed the labors

of those [fifteenth-century Lombard] sculptors, such as the Mantegazza family and Amadeo, those who shattered many Platonic Renaissance crystals and sent the bits flying — our painter left too early to leave any sure traces in Milan and went to live more or less permanently in Liguria: that strange artistic region with which all his hitherto-discovered work is invincibly connected. What, then, is the Ligurian part?

.In Liguria he found himself in a position to benefit from the great artistic lesson, by then an old one, of Donato de' Bardi, the mysterious *Comes Papiensis* who was already dead by 1451 and to whom, contrary to current opinion, only one work may be attributed with certainty: the large *Crucifixion* in Savona.[35] On this work, which is a northern text, closer to van Eyck and Petrus Christus than to Masaccio, he will have meditated independently, just at the time that the youthful Brea was busily reducing it to a gilded catechism for Ligurian nunneries. He varied its typography in accordance with the ever-new Flemish contributions which reached the lords of Genoa by sea: first Dirck Bouts, then Gérard David, finally even Rembrandt. And to me it seems likely that whatever sounds, in our anonymous master, more Flemish, or more French and Provençal, by comparison with Foppa and Bergognone, must go back to Donato's exemplary text: if only because it perhaps stimulated him to travel in Provence to see the work of Simone [Martini] and Matteo da Viterbo, who could suggest to him new harmonies of gold and blue; and Charonton, who could yield him some drops of that diaphanous light, that extract of sunshine found, around 1450, in a Florence and an Umbria he had never seen. For our painter knew how to play with epochs, chisel away at centuries, interbreed cultures, and thus find a way to meet the traditional Ligurian taste halfway without sacrificing any of what was his own.

The Ligurians had grown to like "fine gold" and "fine blue" even before the time of Barnaba da Modena and Taddeo di Bartolo, who, around the middle of the fifteenth century, did not even look excessively old-fashioned. Of a true local artistic culture, there was not the slightest trace. So far as art went, Genoa was there for the taking. Every novelty was permitted, so long as it agreed to conceal itself under that gold and blue cloak. And it occurs to me that, had our anonymous artist been a Ligurian, he could scarcely have failed to set a higher tone in the region, and Liguria would not have had to turn to a mass of imported Lombards, or to Piedmontese who were not, with the exception of Spanzotti,[36] world-beaters when it came to painting. Galeotto Nebbia and Bartolomeo d'Amico da Castellanza Bormida were not, nor was Canavesio, nor Baudo

Pl. 63

from Novara, nor Manfredino da Castelnuovo Scrivia; Massone from Alessandria was not, either, and what was worse, he didn't care; having arrived in Liguria with a modest Paduan stock-in-trade of garlands, festoons, and shattered rocks, he too was forced, after a few good initial attempts, to gild away like everyone else, to apply brocade everywhere; and thus he walked backwards.[37]

So our brilliant anonymous master had to join the herd of fourth-rate Lombards and Piedmontese, of Pavians who were scarcely more than artisans, like Bertolino della Canonica, Francesco Ferrari, Francesco Grassi, and others of that ilk. It is true that one would like to imagine him as a new *comes papiensis,* a papal courtier, painting in summer for his own pleasure in his villa by the sea; but it is wiser to admit that he, too, was nothing more than an artist from abroad, hoping to get lucky.

There is nothing exceptional in such a fate, only something lamentable, given his stature. And yet, faced with the possibility, borne out by so many other instances, that so great a man may have been canceled out of the area's history, our bitterness yearns towards the hope that he was, at least to some extent, more highly regarded than the crowd of journeymen.

Now, to tell the truth, I can no longer keep secret from you that there does exist — and here we get to the last part of my personal adventure with him — a painter who has more than one claim to be the great anonymous master. He is a Milanese, still mentioned by Lomazzo[38] in the Cinquecento as being, along with Foppa and minor figures, a representative of the art of "properly showing forth" ["*del far ben vedere*"], which must mean rational measurement; and he is the same one who, by comparison with the mediocre others, dominates the Genoese documents between 1480 and 1501 (dates that match up well with our suppositions), receiving major commissions, to the point where he once even earns the title, not just of *pictor,* but of *artium doctor.* He is the same artist of whom the Genoese writer Soprani, working as late as the seventeenth century and basing his work on an earlier text, writes a biography: the only one (except for a reference to Giusto d'Alemagna) that he dedicates to a fifteenth-century master from outside the region, although there were so many of them in Genoa. The significance strikes us right away when we read praise of the "light of finest gold" in a Saint George on horseback, still visible on the façade of the Customs House until past the midpoint of the last century. Documents dated 1482 also prove that work to be by the master, and other documents from around those years give us the precious information that he was active as a painter on glass. This, too, makes us prick up our ears. Forgive me if I've been stringing you along, but it happens that

the artist's given name, and his family name even more so, sound almost unbelievable in the context of the history of fifteenth-century painting; they seem better suited to a *condottiero*, or at best to a gentleman dilettante. Who would have thought that one of the finest painters of the century could be named Carlo: Carlo Braccesco?[39]

And yet it is of him that the Genoese documents speak;[40] and it is he, in person, who signs himself *Carolus Mediolanensis* in the polyptych of 1478 in the sanctuary of Montegrazie,[41] seven kilometers north of Porto Maurizio, where, if the quality appears lower than in the Louvre's work, that is due not so much to the artist's being less mature, as to a restoration carried out perhaps a century after the picture was painted, dulling and imprisoning the more arcane subtleties. And yet the best-preserved passages do not fail to match up, better than in any other known picture, with the group I have linked, firmly I trust, with the supreme *Annunciation* in the Louvre.

As requested by the Ligurian traditionalists, the Montegrazie polyptych is still divided into disjunct areas in the Gothic manner, as in the days of Barnaba da Modena or Taddeo di Bartolo fully a century before. And the background to the whole thing is gold, tooled with little squares as in a contemporary Lombard tarot card. But getting closer to the painting, one immediately recognizes the Virgin, marred as she is by the restoration (which has stained her robe in particular), as the same type of woman, with platinum-dyed hair, egg-shell skin, fluttering eyelids, who will return, more thoroughly elaborated, in the lady in the Louvre; just as the familiar garland with the three little roses carved in relief already laughs on the forehead of these angels so full of pathos (who nonetheless hold firmly foreshortened lutes, still in good condition).

Pl. 64 At the left, Saints Luke and John are too soiled with repainting to allow easy reading; but on the adjacent pilaster strip, Saint Francis, emaciated temples throbbing, murmurs like the Carmelite in the Louvre. On the right, beneath Saint Nicolas's filthy cope, one can just make out a very subtle arabesque, perhaps in blue and gold, while at the garment's edges one may still see clearly the little imitation-embroidery figures, whose forms are those of Lombard Gothic in its final phase; as for the black, shiny, creaking Saint Anthony, he seems to be a parish priest who has just descended the mountain at Finale Ligure in overheated haste.

In the upper register, which is rather less damaged, Saint Sebastian is dressed like a modern page or squire according to a practice also followed by Spanzotti, the best among the Piedmontese; he stands beside the gentle Saint Catherine, who is pale as a white rose. On the other side, the fearless swordsman Saint Maurice carries, as you see, the same weapon as the

oriental warrior in the Franchetti predella. As for the Saint Claire — long, thin, and exhausted — she has lost no time in acquiring, as early as 1478, a clearly Bramentesque monstrance, practically before Bramante's own arrival on the scene. To go on with the catalogue: Saint Christopher is of the same thirsty, goat-like type as most of the onlookers in the predella we already know; and lastly, in the finials, the poorly preserved Annunciation is almost Provençal in type, while the Christ on the cross is a dry and elastic nude who strongly recalls the crucified Saint Andrew in the panel in Venice, and the figures of the mourners, with their burnished, fire-etched gold, are unmistakable, as is the panting Saint John, suffering in profile with his mouth closed.

Pl. 64

Even after so brief an examination, to me it seems highly plausible that this work of 1478 shows us the painter's early manner, although he is already well aware of the mixture of the northern and the homegrown that constitutes the taste of western Liguria; while the three related parts of the predella with the apostle will represent his work in the period between 1480 and 1490; and in the Louvre *Annunciation* he is at the height of his genius, in the last decade of the century. After that, the documents fall silent.

But let us even go so far as to suspend any definitive answer until after a careful cleaning (which, I am pleased to say, the artistic authorities of Genoa are already planning at my request);[42] it may allow the Montegrazie polyptych to reveal more and subtler qualities than have hitherto been visible. Regardless of the outcome, for me there can be no doubt: Carlo Braccesco, the only Lombard painter who, even after having emigrated, was important enough to transmit his own fame as far as the Milanese culture of the late Cinquecento; who, contrariwise, was the only foreign painter in Quattrocento Liguria to succeed in getting himself lastingly remembered by local writers as late as the seventeenth century; the artist who painted the Customs House Saint George in finest gold and — with what dazzling transparency we can only imagine — the stained glass of Saint Laurence's Cathedral, must be the creator of the greatest, most unforgettable masterpiece created in Genoa in the last years of the century: he must be the one to solve the riddle of the Louvre *Annunciation*.

By this roundabout but precise route, Carlo Braccesco of Milan, *eques auratus* or, if we prefer, the Gold King of the Lombard Quattrocento, makes his well-deserved entry and chooses his secure place in that already jam-packed empyrean which is the genius of Italian painting. Whether, in his case, that painting can be described as "Renaissance" — especially when addressing this distinguished group [of Renaissance scholars][43] — is, of course, an entirely different matter.

NOTES

Roberto Longhi's notes appear without brackets. Notes within brackets are editorial notes.

1. [Dominique Vivant Denon (1747-1825), France's Director-General of Museums under Napoleon I. (Ed. note)]

2. [Jos Atomann (documented 1445-1452), from Ravensburg in Germany, known in Italy as "Giusto d'Alemagna." His *Annunciation,* cited by Longhi, now hangs in the little museum of the church of Santa Maria di Castello in Genoa. (Ed. note)]

3. This first part of the work's 19th-century vagaries is from Villot's catalogue, Part II, 1860, p. 133. At the time the painting bore the number 258 and was engraved in Landon's *Musée,* tome 2, pl. 26. Measurements: center part, 1.56m x 1.07; the side panels, 0.98m x 0.48. In 1923, the catalogue drawn up by Demonts attributed the painting to the "École de Gênes." In 1926, Hautecour's catalogue cited the work under the new designation of "École de Ligurie" and specified its provenance as the private chapel of the Fregoso family in Genoa, perhaps based on the indications given by Denon. Ligurian historians, such as Alizeri, know nothing of this provenance.

4. *Storia della pittura fiamminga* ("History of Flemish Painting"), Ital. ed. 1899, p. 203.

[J.A. Crowe and G.B. Cavalcaselle, *Early Flemish Painting,* London, 1856. (Ed. note)]

5. *Histoire des peintres de toutes les écoles,* Paris, Laurens, no date: *École Gênoise,* appendix, p. 3.

6. [Camille Flammarion (1842-1925), French astronomer and popularizing writer whose books enjoyed a wide currency. (Ed. note)]

7. Mary Logan, in *Gazette des Beaux-Arts,* 1896, p. 194.

8. [Longhi's sardonic tone here must be understood in the context of his resentment of Bernard Berenson's entrenched position as the leading connoisseur of Italian painting. The inevitable rivalry between the two connoisseurs had turned acrimonious early, over the breakdown of plans to have the youthful Longhi translate Berenson's writings into Italian; and the hostilities reached such intensity that E.K. Waterhouse, reviewing Longhi's *Officina Ferrarese* in the Burlington Magazine (LXVIII, 1936, pp. 150-151), felt moved to write, "His two principal aims appear to be to establish as rigorous a chronology as possible, and to be as rude to Mr. Berenson as the large vocabulary of the Italian language allows." Cf. the correspondance collected in B. Berenson and R. Longhi, *Lettere e scartafacci 1912-1957,* Milano, 1993; also F. Bellini, "Una passione giovanile di Roberto Longhi: Bernard Berenson" in G. Previtali, ed., *L'arte di scrivere sull'arte,* Rome, 1982. (Ed. note)]

9. [Ludovico Brea or Louis Bréa (documented 1475-1522/23). One of a family of painters from Nice, all of whom worked prolifically in the territory between Nice and Genoa. (Ed. note)]

10. [Defendente Ferrari (documented 15 11-35), painter from Chiavasso in Piedmont. (Ed. note)]

11. C.J. ffoulkes and R. Maiocchi, *V. Foppa,* London, 1909, p. 259; and Frizzoni, in *L'Arte,* 1909, p. 259.

12. Bensa, *La peinture en Basse Provence,* etc., Nice, 1909, II, pp. 88-91.

13. Labande, "Les peintres niçois du XVe et XVI siècles," in *Gazette des Beaux-Arts,* 1912, p. 279.

14. The change of label actually occured at least as early as 1903, as becomes clear from the *Catalogue sommaire* of that year, in which the painting is in fact designated as "École du Nord de l'Italie" and bears the new number of 1676.

[The work is now labeled in the Louvre as being by Carlo Braccesco. (Ed. note)]

15. Venturi, *Storia dell'Arte,* VII, 4, 1915, p. 1091.

16. *Piero della Francesca,* 1927, p. 112 [now see vol. III of the *Opere Complete,* 1963].

17. [The Lombard (or Piedmontese-Lombard) master Bergognone's "empirical" spatial construction, and his capacity for typically Lombard naturalistic observation, are themes to which Longhi returns repeatedly in his writings. Cf. the passages devoted to Bergognone in the essay "Caravaggio and his Forerunners," included in the present volume. (Ed. note)]

18. [Giovanni Martino Spanzotti (1450156-ca. 1523), Piedmontese painter, probably from Casale Monferrato near Alessandia. (Ed. note)]

19. "Quesiti caravaggeschi, II: I precedenti," in *Pinacotheca,* 1928, p. 266, no. 1 [now see vol. IV of the *Opere Complete,* p. 141, included in this volume as "Caravaggio and His Forerunners."] Concerning the reflections of the great master in the Pavian culture of the first

decades of the Cinquecento, I cited then, as now, numerous frescoes in Pavia, such as the stories of San Majolo at San Salvatore, the Saint Anthony Abbot at San Teodoro, and the decorations in the second bay of the right aisle of San Michele — all works variously attributed to Lanzani and Sacchi. Today I can also add to this list the detached frescoes of events of the lives of Paul and Anthony, in the Civic Museum of Lodi. It is clear from such reflections that the master continued to have direct relations with his native region until the end.

20. [Vincenzo Foppa (ca. 1427130-1516), Brescian painter. In "Caravaggio and his Forerunners," Longhi discusses Foppa's capacity for paying superficial hommage to the new and fashionable forms of the Tuscan Renaissance, while in fact continuing to pursue artistic concerns more deeply rooted in the local Lombard tradition. (Ed. note)]

21. [Eugène Fromentin (1820-1876), French painter and critic. His literary style and close description of individual works, as exemplified in his book on Flemish and Dutch painting *Les maîtres d'autrefois,* had a profound impact on the young Longhi. Cf. G. Previtali, "Roberto Longhi, Profilo biografico," in G. Previtali, ed., *op. cit.,* p. 144. (Ed. note)]

22. [In his own day, the poet Charles Baudelaire was a well known art critic. His journalistic writings on art are collected in *Curiosités esthétiques* (1868); wrote the important book *L'art romantique* (1868). (Ed. note)]

23. There is no point insisting, in the text, on the work's particular thematic and stylistic links with the Lombard art of the last quarter of the fifteenth century. Here, in a

note, we may recall that the idea of placing the figures inside a small niche revetted in gold, to "naturalize," so to speak, the old effect of the gold background, is encountered more than once in Foppa. The motif of saints to the sides, placed in more restricted, enclosed spaces than in the principal composition, can be found in Butinone's predella at Treviglio. Also similar to the Butinone of those years is the harsh treatment of some of the modeling, while the difficult foreshortening of the angel is the same effect that Bergognone was seeking around '90. As for the exceptional representation of the angel Gabriel sliding down from above on a kind of *desco da parto*, and in a very boyish form at that, one may take this to be a kind of free fusing of the normal motif of the archangel and the unusual, even suspect, theme of the Christ Child who, pushed by God the Father, dives down from above in all the Annunciations in Lombard sculpture toward the end of the century — by the circles of Amadeo, Mantegazza, Cazzaniga, in the churches of Santa Maria delle Grazie and Sant'Eustorgio, in Palazzo Trivulzio, at Isola Bella, the Charterhouse of Pavia, etc. A likely explanation, then, is that, even formally speaking, the figure is related, as we have said, to the contemporary sculptors. There is no doubt, however, that this motif, invented in the past to indicate, in the subject matter, the whole Trinity (and in fact, appearing with them, as required, was also the Eternal Father and the dove), here has served only as a thematic cue for the aesthetic renovation of the motif of the Annunciation with two figures, freeing it, in a bold counterpoint, from the common frontal symmetry of the angel kneeling before the Virgin.

24. Usually this figure is indicated as Saint Angelo, but his attributes are those of the other Carmelite, Saint Albert.

25. All I can find worth citing on this painting (0.42m x 0.68) and the *Quattro Dottori* (together 0.44m x 0.70) that were originally joined to it is the passage by C. Gamba in an article on the Franchetti collection in *Bollettino d'Arte*, 1916, pp. 328-329, where he says that "some small panels with gold background, one of them depicting the martyrdom of St. Peter, the other four featuring Sainted Bishops in rich arabesqued robes, represent the Genoese art that precedes Lodovico Brea of Nice." Aside from the mistake about the subjects, which are the "Four Doctors" (not all bishops) and the *Martyrdom of Saint Andrew*, who according to the story is indeed tied, not nailed, to the cross, and aside from the statement about gold backgrounds, which is only true for the smaller panels, this definition is not far from the truth and is repeated in more generic form (Ligurian School of the 15th century) in the Ca'd'Oro catalogue (Fogolari-Nebbia-Moschini, 1929, pp. 86 and 89) with an attempt to set the subject right with a *Martyrdom of Saint Christopher*. Now, however, A.M. Brizio reminds me that this whole series of panels is cited in Berenson's indexes under the name of the Piedmontese painter Spanzotti, an understandable confusion since Spanzotti embodies in Piedmont, and in an almost equally elevated manner, a northern Lombard culture very similar to that of our painter.

26. The height of the Kress panel is 42 cm, like that of the Franchetti panel.

27. Here too the height is 42 cm, thus proving that it belongs to the same predella, or *banca*, as they used to call it in Liguria; the width of 0.51 m., that is, 18 cm less than that of the Venetian panel, leads one to believe that this panel, larger

in size, constituted the center, and that therefore the middle panel on top also depicted Saint Andrew. The catalogue of the Cluny Museum, 1881, p. 134, confusedly describes the unusual subject without making any attempt to define it hagiographically.

28. *Storia della pittura e della miniatura nella Lombardia*, etc., Milan, 1912, p. 579.

29. "I resti del polittico di Cristoforo Moretti in Sant'Aquilino; La restituzione di un trittico d'arte cremonese circa il 1460 (Bonifacio Bembo)," in *Pinacotheca*, 1928, pp. 75-87 [now in Volume IV of the *Opere Complete*, pp. 53-66].

30. "Quesiti caravaggeschi, II: I precedenti," in *Pinacotheca*, 1928, pp. 260-267 [now in volume IV of the *Opere Complete*, pp. 100-107; and included in this volume as "Caravaggio and His Forerunners"].

31. Prints of them can in fact be seen in D'Arco's book, *Delle Arti e degli Artefici di Mantova*, Mantua 1857, I, fig. 16, when they were still in the possession of Susani, who had saved them from the ruined church of San Silvestro. To D'Arco they seemed to be from the early Quattrocento; in fact they belong to the mid-century, or shortly thereafter, when the principal local artist was still Michele da Pavia. A similar stylistic moment is represented by Paolo da Brescia in 1458, in the well-known polyptych formerly in Sant'Albino at Mortara, now in the Galleria of Turin. Clearly, the connection with the Pavian artist remains purely hypothetical, since nothing can be inferred from the frescoes in the Chamber of Commerce in Mantua, which have been overly restored and were ascribed to him without any certainty.

32. These splendid remains of a polyptych, which until recently were, I am told, in a Milanese collection and are now on the market, raise another important question about Lombard painting in the Quattrocento. The quality is in fact the highest one can find in Lombardy, alongside Foppa, Bergognone and our painter; yet there is a more pronounced northern tendency here than in any of the others, so much so that it reminds one of the "technique" of the young Antonello [da Messina] in the Messina triptych. The brilliance of the red and the blue in Saint Lawrence is every bit the equal of Fouquet's. Perhaps another Lombard working in Liguria? We can only hope, in any case, that such a relic might never leave Milan, let alone Italy.

33. [Longhi is referring here to his essay "Quesiti caravaggeschi: i precedenti," translated in the present volume as "Caravaggio and his Forerunners." (Ed. note)]

34. In his volume on *La Pittura del Quattrocento nell'Alta Italia*, Pantheon ed., Bologna, 1930, the old reading of Foppa (*Storia dell'arte*, 1915) as a Renaissance painter is annulled. Before, Foppa "was developing the style of the Bembos and the Sant'Eustorgio frescoes" (which for Venturi were by an anonymous Lombard educated in Tuscany), "following the Tuscan concept of form much more than Mantegna's." Now, "Vincenzo Foppa, supreme representative of pre-Leonardesque Lombard art, displays from the start that tendency to luminous resolution of form that persists through the Cinquecento, especially in the masculine painting of Gian Girolamo Savoldo, and reaches the threshold of the Seicento with the hero of the new century, Michelangelo da Caravaggio. The color — foundation of

Venetian art — and constructive geometric design of the Tuscans are of secondary importance in the work of the Brescian artist, etc..." Unfortunately, the bibliography of this essential reversal of positions, which coincides with the reinstatement of the Portinari frescoes to Foppa and with their analysis according to another yardstick than the one used in 1915, is not given.

35. In the volume cited above, Venturi mentions as a major work of Donato de' Bardi the *Crucifix* of San Giuliano d'Albaro ascribed to him by Suida, an attribution also accepted by Toesca. In fact, however, between the signed *Crucifix* in Savona and the one in Albaro there is no parity of quality or plausible transition. Donato died before 1451, while the Albaro painting has a landscape that could not have existed anywhere in Italy before the years 1470-75. And already living in Genoa during those years was Giovanni Massone, a painter who elsewhere imitated the iconographical schemas of Donato.

[Donato de' Bardi (documented 1426-1450/51), painter from near Pavia in Lombardy, active largely in Liguria. Recent research by Federico Zeri and others has convincingly expanded the corpus of his work beyond the single picture Longhi credits him with. The Savona *Crucifixion* is signed "Donatus Comes Bardus Papiensis," indicating that his family had been ennobled by the Pope. For a summary of recent research, see the catalogue entry by Mauro Natale in *Arte in Lombardia tra Gotico e Rinascimento*, Milan, 1988, pp. 188-89. (Ed. note)]

36. For the close parallel between Spanzotti and our painter, see especially the wings with saints and patron formerly in the Istituto Rosminiano at Stresa, now in the Contini-Bonacossi collection in Florence, the Saint Sebastian in the Turin triptych, and the fresco of the *Christ Child Being Worshiped by the Four Doctors of the Church*, reinstated to him by A.M. Brizio, in the church of Saint Francis at Rivarolo Canavese.

37. Massone actually belonged to a line of painters active in Liguria since the early Quattrocento; there seems no doubt, however, that he was schooled in Lombardy or Padua around the middle of the century, in a "Squarcionesque" milieu. He then combined this education almost immediately with the late northern Gothic forms widespread in Provence and Catalonia and formerly visible in the earliest Giacomo Durandi and Canavesio. For an example of this style of the still young Massone, see the paintings in Pontremoli and Liverpool, and the somewhat later *Archangel Raphael with Tobias*, which went under the name of Benedetto Bembo at the Coray auction in Lucerne in 1930.

38. [Giovanni Paolo Lomazzo (1538-1600), precocious Milanese painter who, after losing his eyesight while still in his early thirties, devoted himself to writing about local art history and, especially, about artistic theory. His *L'Arte della Pittura* (1584) is an important source for the study of Mannerist thought. (Ed. note)]

39. The bibliography concerning Carlo Braccesco is given almost in its entirely in Baudi di Vesme's article "Un polittico di Carlo Braccesco a Montegrazie" in *Bollettino d'Arte*, 1913, pp. 9-12. Recapitulating its main points, the first question concerns the appearance of the appellation "del Mantegna" in Soprani, compared with Lomazzo's "Milanese." There is no doubt that they mean the same painter, because

the principal work cited by Soprani, the *Saint George* on the Palazzo delle Compere (later della Dogana), is the same that the 1482 documents assign to Carlo Milanese. Might the appelation have originated perhaps in one of those pompous declarations of lineage by the artist, who during his lifetime achieved an almost mythic level of fame? Such declarations were not uncommon in northern Italy, even on the part of artists who had not studied directly under Mantegna. One will recall, for example, the well-known painting by the Cremonese Antonio Corna, *Saint Julian Killing [His] Parents*, a very Ferrarese painting in appearance, a cross between Cossa and Baldassare d'Este, which nevertheless bears the writing: "hoc quod Manteneae didicit sub dogmate clari / Antonii Cornae dextera pinxit opus" ["this which he learned under the famous teaching of Mantegna/ was painted by the hand of Antonio Corna"]. Yet it seems to me unlikely that a consistent, personal artist such as Braccesco would attempt to inflate himself in that manner, for if he had, the appelation would not have failed to appear in some other documents of the period as well. A more likely explanation might be that the boast, in this case superfluous, arose from a later local tradition which, for similar reasons, may have wished that the city's most famous painter, while not from the city, had been at least a pupil of the "star" Mantegna. This second hypothesis would seem to be confirmed by Soprani's fantasy, especially in the later revision of his text by Ratti, which reads as follows: "Carlo del Mantegna, also Lombard, a painter widely esteemed as one who had been a disciple of Andrea Mantegna, and the similarity of his style to that of the master had caused him to inherit his surname" (Soprani-Ratti, *Vite dei pittori ecc. genovesi*, Genoa, 1768, I, 370).

The appellation was later interpreted differently by the Paduan and Mantuan critics of the late 18th century — that is, it was taken to mean that the painter had been not only a follower but actually a relative or even the son of Mantegna. Research on this matter, however, led to nothing, as one can see from the 1795 correspondence between Bettinelli and De Lazara, quoted by D'Arco (*op. cit.*, II, p. 225). Around the same time the very discerning Lanzi, while admitting that "it is rare to find things attributable with certainty to Carlo," fully seconded Soprani's other error as to the Doge who supposedly summoned Carlo to Genoa, and had the event take place in 1514, when the artist was already dead. Thus for Lanzi (1809 ed., IV, 9; V, 288), Carlo, having come to Genoa around 1515, looks a lot like the Pavian Cinquecento artist Pier Francesco Sacchi. In 1857 D'Arco, along the same lines, attempted to attribute to our artist, who had "moved to the Piedmont to work," the real Mantegna in the Turin Galleria, and to compare it with the works of the Paduan master's early followers in the chapel of Sant'Andrea in Mantua.

There are traces of this confusion of generations throughout 19th-century criticism. Even Alizeri, after having unearthed the 15th-century documents concerning the painter, attempted to relate a 1495 commission to the well-known Levanto *Saint George*, already a Cinquecento work, pompously ascribed to Andrea del Castagno and hauled off to Paris as such, during the Napoleonic era. Alizeri's attempt, repeated by Varni in 1870, was not entirely refuted by Suida in his 1906 monograph on Genoa, nor by Di Vesme, even though as early as 1890 Frizzoni (*Archivio Storico dell'Arte*, p. 126) had correctly reinstated the painting to the Pavian Pier Francesco Sacchi. (Along the same

lines, one had already tried to attribute to Carlo, the supposed Mantegnan, some grotesque and chiaroscuro decorations on Genoese palazzi, such as on palazzo Doria di Campetto, an opinion refuted by Alizeri; Suida carried on the endeavor by adding the equally late decorations of Via Orefici, while Carotti hung the same name on the vaguely Mantegnesque frescoes in the Verona Museum, in *Arch. St. d. Arte*, 1897, p. 262). Mario Bonzi (in *Raccoglitore Ligure*, 1933, no. 10) has recently turned his attentions again to the Levanto painting, rightly reconfirming the attribution to Sacchi and ruling out any possibility of relation with the "harsh, cubic, mediocre forms" of the Montegrazie polyptych. I am certain that the liberation, already under way, of Carlo da Milano's polyptych from its disfiguring restoration will allow the knowing connoisseur of Genoese art to revise his unfavorable assessment of this piece.

40. In order to provide in this essay all the essential information concerning the recorded information on Carlo Braccesco, we present here, in summary fashion, the contents of the documents unearthed by Alizeri (*Notizie dei professori del disegno in Liguria*, Genoa, 1870-80, II, 119-157, 372 ff, 393; III, 33, 456) and by Neri and partially summarized by Di Vesme. All later than the year indicated in the Montegrazie polyptych, which remains the first sign thus far known of Carlo da Milano's activity in Liguria, they span, with some interruption, the years from 1481 to 1501.

a) November 14, 1481 - September 29, 1482. — Commission and execution of the *Saint George* fresco on the Palazzo delle Compere in front of the house of Francesco Lomellino. The painter here is called "magister Carolus de Mediolano."

b) August 1482. — Ambrogio de' Fiori da Pavia, glassmaster, and master Carlo da Milano are commissioned for the four stained glass windows of the San Sebastiano chapel in the Genoa Cathedral.

c) April 9, 1483. — Master Carlo da Milano is commissioned to execute frescoes for the San Sebastiano chapel. They are to be as follows: on the outside of the entrance arch, the Annuciation; on underside of the arch, the twelve apostles; on the inside wall of the arch, the Four Doctors; in the vault, God the Father with three hierarchies of Angels; on the walls, the stories of Saint Sebastian. For colors, fine gold was demanded, "sufficienter et abundanter."

d) July 1484. — The painter undertakes to complete the above-mentioned frescoes.

e) September 4, 1484. — Master Carlo da Milano is commissioned for the *maestà* of the main altar of the church of Santa Maria degli Angeli in Promontorio, with an Assumption in the center. (In Liguria, *maestà* meant altarpiece, even one with many compartments.)

f) February 3, 1489. — Carlo da Milano takes on as apprentice a certain Pierino della Mirandola, introduced to him by the Pavian painter Francesco Ferrari.

g) May 27, 1490. — Master Carlo da Milano is commissioned to execute a *maestà* for the Carreghe altar in Santa Brigida, featuring Saint Francis and other Saints. (Document cited by Achille Neri in *Giornale St. e Lett. della Liguria*," 1903, p. 154.)

h) April 27, 1492(?). — Master Carlo da Milano agrees to paint a *maestà* for the main altar of Sant'Antonio di Belgandura (church not identified by Alizeri). It is to include: at the center, the Madonna and Child, and above, the Crucifix with Mary and John; to the right, Saint John the

Baptist, Saint Anthony and above, Saint Catherine; to the left, Saint Michael and Saint Bernard, and above, the Magdalen; in the gable ends [*puntine apicali*], three saints of his choice; in the predella, the twelve apostles. It is clear that this was to be a polyptych with roughly the same divisions as that of Montegrazie, thus very archaic for the year 1492 — an uncertain date, in fact, and chosen by Alizeri only because the document was mixed together among the notarial deeds of that year.

i) 1495. — Document concerning a *maestà*, with no further specification, ordered by the commune of Levanto.

j) 1496. — The Master rents a house from the painter Bartolommeo (Bertolino) da Pavia.

k) May 12, 1497. — Cristoforo della Torre agrees to paint or to have painted "per magistrum Carolum Braccescum de Mediolano" the outside and inside of the organ shutters [*ante d'organo*] in Genoa Cathedral. Inside, in color, figures of unspecified saints; outside, the Annunciation in green chiaroscuro.

l) November 18, 1500. — Master Carlo da Milano is to paint twelve medallions in the frieze on Antonio Lomellino's hearth. The decoration is entrusted to Giacomo Serfolio and Leonoro dall'Aquila. Of the former we still have the Madonna del Monte, a triptych copied closely from Massone; the latter seems to have been the same Serafino Leonori dell'Aquila who made a signed *Madonna* dated 1527, now in the museum of L'Aquila. This Madonna, according to Bindi (*Artisti abruzzesi*, 1883, p. 158), would appear to have come from Corsica, an artistic colony part Genoese, part Pisan; there are no other records of the artist in the Abruzzi.

m) March 6, 1501. — "Magister Carolus de Mediolano artium doctor et pictor" agrees to paint, for the patron Carlo da Chiavari, an altarpiece in the church of San Teodoro, with the Assumption in the center, Saint Blaise on the right, Saint Gothard on the left; in the upper gables, in the center, the Crucifix with Martha and Magdalen, on the sides Saints Theodore and Pantaleon; in the predella, the life of Christ. The model for the partitioning was the Lomellini altarpiece, executed for the same church by Giovanni Massone.

41. The Montegrazie polyptych was first studied by Di Vesme (op. cit.), who deciphered its signature and date and assisted in a restoration in 1911, which I assume was limited, however, to the simple task of reinforcement. Di Vesme seemed in fact not to notice that the dirt, accumulated during the 16th and 17th centuries, remained a stifling hindrance. The new restoration being carried out today under the leadership of A. Morassi will, I expect, obtain results which I am sorry I cannot thus far anticipate with other photographs and more reliable commentary, but which no doubt will alter the significance and internal history of this preliminary research.

42. [Cleaning confirmed Braccesco's authorship. The Superintendancy for Fine Arts has recently removed the polyptych from the Montegrazie parish church, where it had been on display for several years. (Ed. note)]

43. [The present paper was first delivered as a lecture before the (Italian) National Institute of Renaissance Studies at Milan's Castello Sforzesco in 1942. (Ed. note)]

Roberto Longhi's notes are translated by Stephen Sartarelli

Editorial notes David Tabbat

Black & White Plates

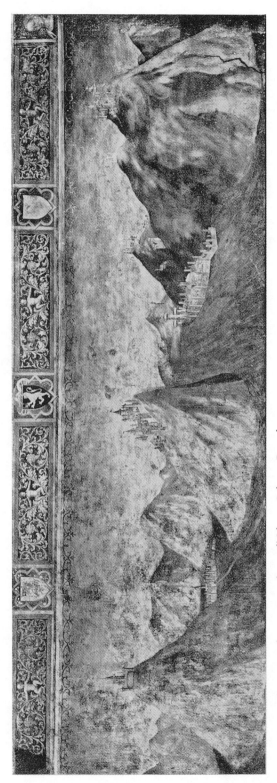

Plate 14: Masolino, *Landscape*, Castiglione d'Olona, Palazzo Branda

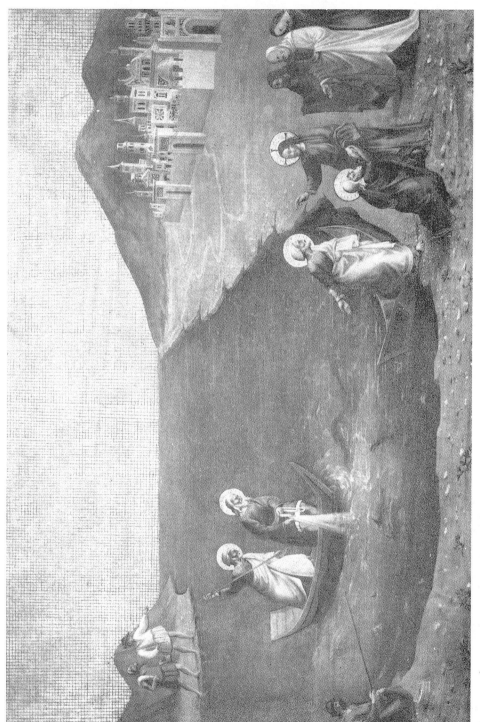

Plate 15: After Masolino, *The Calling of Peter and Andrew*, Florence, Matteini Coll.

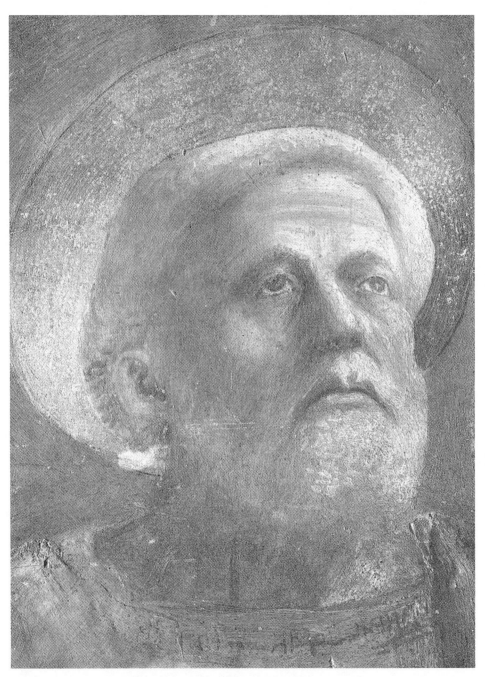

Plate 16: Masaccio, *Saint Peter,* Florence, Brancacci Chapel

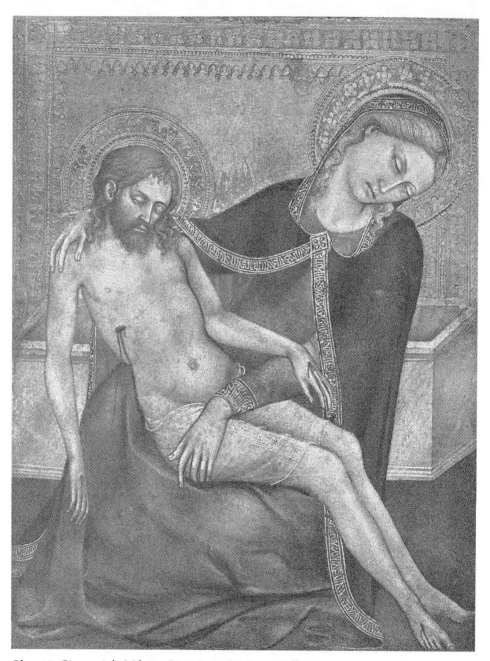

Plate 17: Giovanni da Milano, *Pietà,* Paris, Du Luart Collection

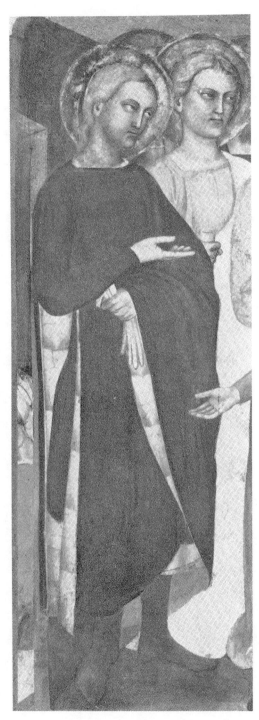

Plate 18: Giovanni da Milano, *Christ in the
House of Martha* (detail), Florence, Santa Croce

196

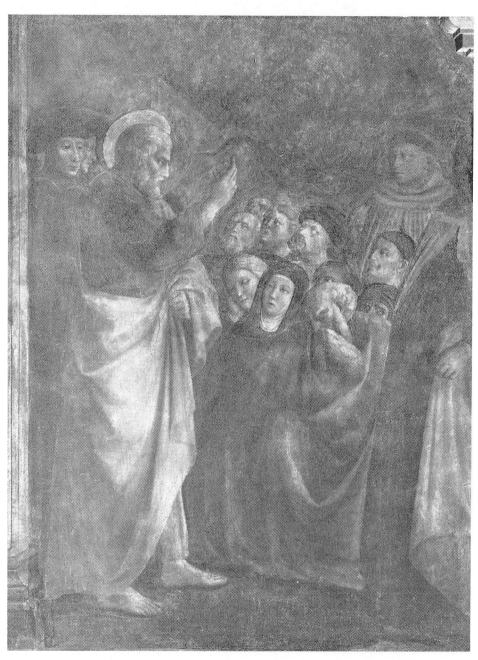

Plate 19: Masaccio and Masolino, *St. Peter Preaching,* Florence, Brancacci Chapel

Plate 20: Masaccio, *Buildings* (detail of plate 6), Florence, Brancacci Chapel

198

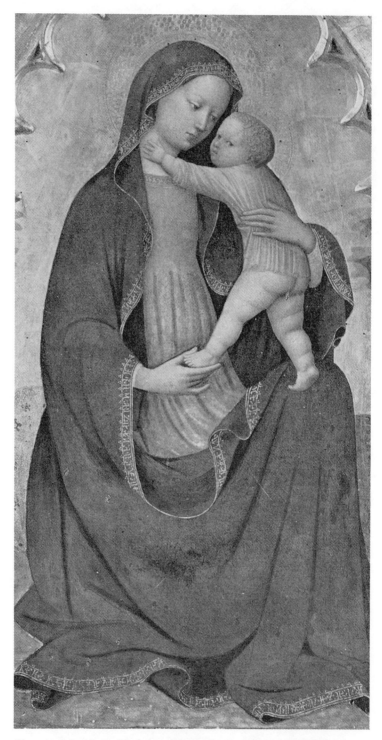

Plate 21: Masolino, *Madonna of Humility*, Bremen, Kunsthalle

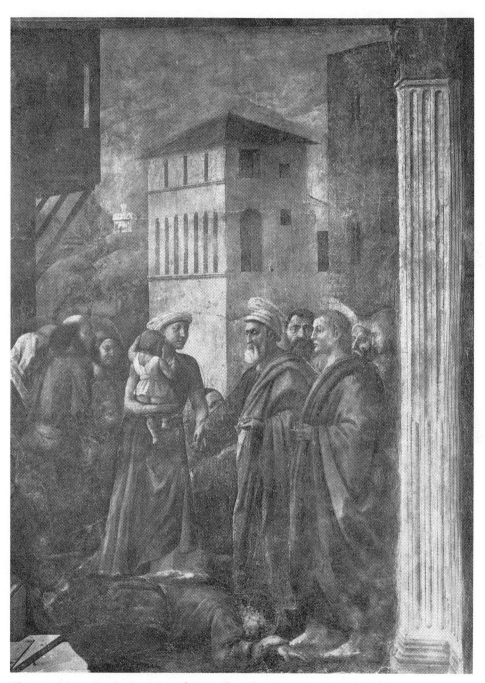

Plate 22: Masaccio, *St. Peter Distributing Alms,* Florence, Brancacci Chapel

Plate 23: Masaccio, *St. Peter Healing with the Fall of his Shadow*, (detail), Florence, Brancacci Chapel

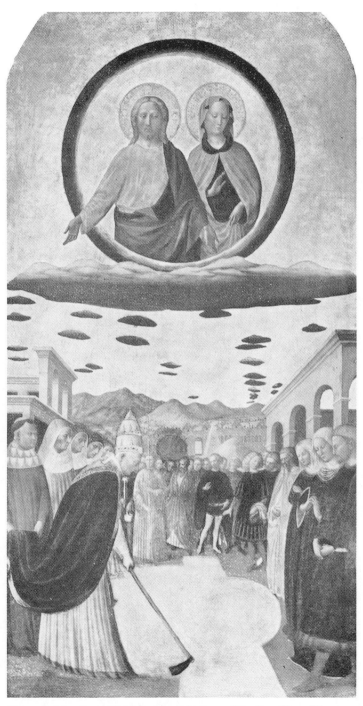

Plate 24: Masolino, *The Miracle of the Snow (The Founding of Santa Maria Maggiore),* Naples, Capodimonte

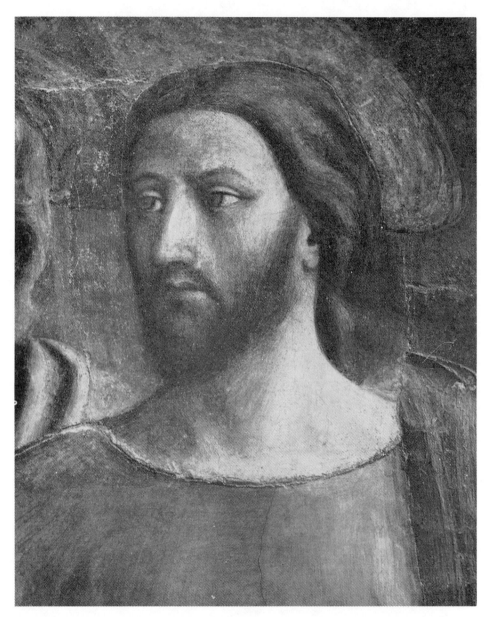

Plate 25: Masolino, Head of Christ (detail from *The Tribute Money*), Florence, Brancacci Chapel

Plate 26: Brunelleschi, *Christ Exorcising a Man Possessed by a Demon*, Paris, Louvre

204

Plate 27: Masaccio and Masolino, *Crucifixion*, Rome, San Clemente

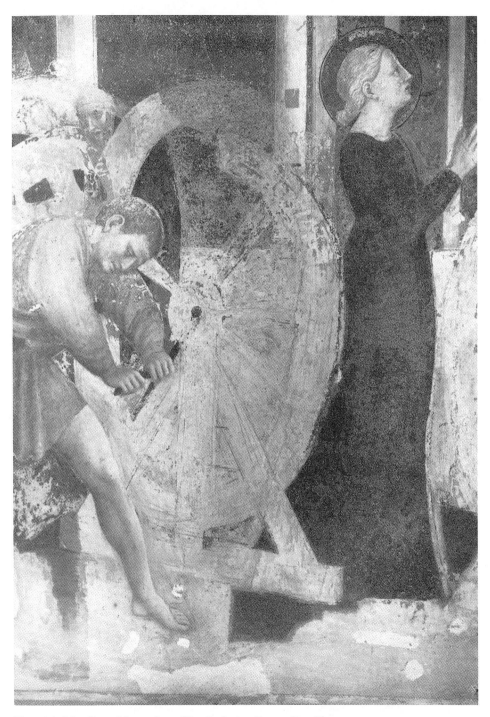

Plate 28: Masolino, *Martyrdom of St. Catherine,* Rome, San Clemente

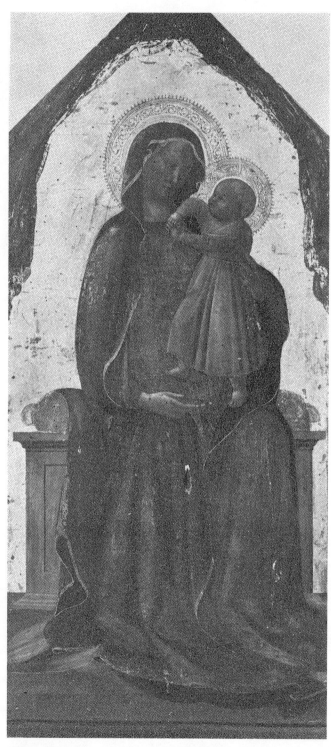

Plate 29: Masolino, *Madonna and Child,* Formerly Novoli,
Santa Maria

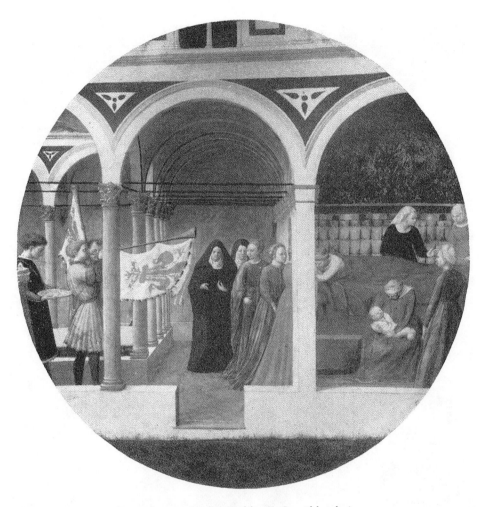

Plate 30: Masaccio, *Desco da parto*, Berlin (Dahlem), Gemäldegalerie

208

Plate 31: Masolino, *Feast of Herod*, Castiglione d'Olona, Baptistery

Plate 32: Masolino, *Madonna and Child with Angels*, Empoli, Santo Stefano

Plate 33: Masolino, *Madonna and Child with Angels,* Todi, San Fortunato

Plate 34: Fra Angelico (?), *Virgin and Child with Angels,* London, National Gallery

Plate 35: Fra Angelico, *The Agony in the Garden*, Forlì, Pinacoteca

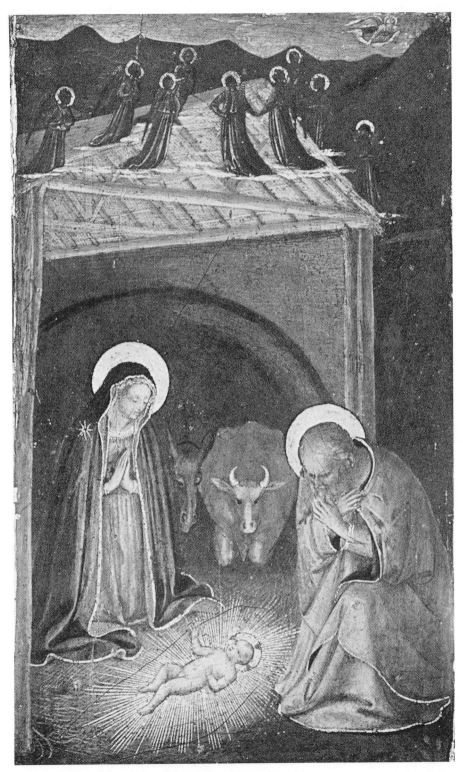

Plate 36: Fra Angelico, *Nativity*, Forlì, Pinacoteca

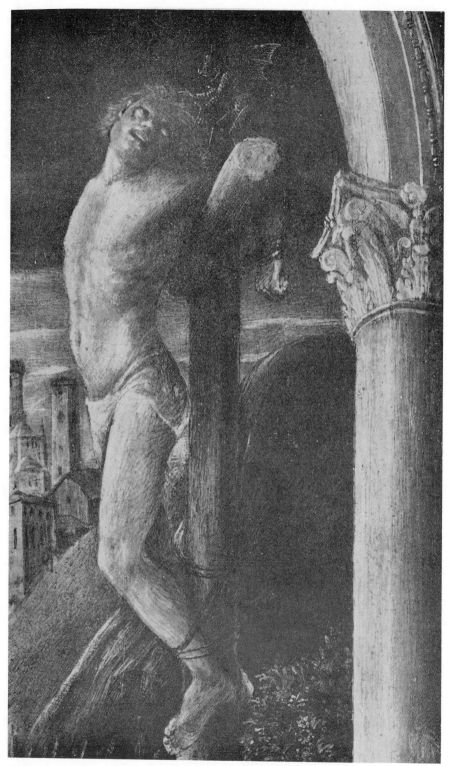

Plate 37: Vincenzo Foppa, *Crucifixion* (detail), Bergamo, Accademia Carrara

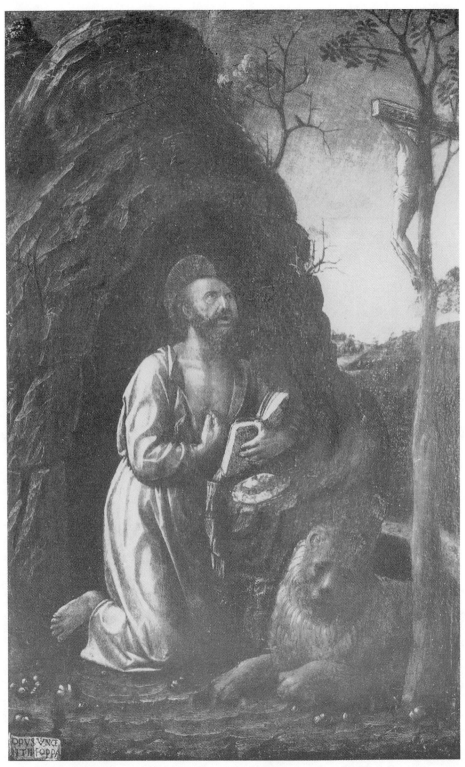

Plate 38: Vincenzo Foppa, *St. Jerome,* Bergamo, Accademia Carrara

216

Plate 39: Ambrogio Bergognone, detail from the *Circumcision*, Paris, Louvre

Plate 40: Ambrogio Bergognone, detail from *Madonna and Child Between Saints, Angels, and a Donor*, Milan, Pinacoteca Ambrosiana

Plate 41: Moretto da Brescia, detail from *The Drunkenness of Noah,* Turin, Bressi Fenaroli Collection

Plate 42: Moretto da Brescia, detail from *Elijah and the Angel*, Brescia, San Giovanni Evangelista

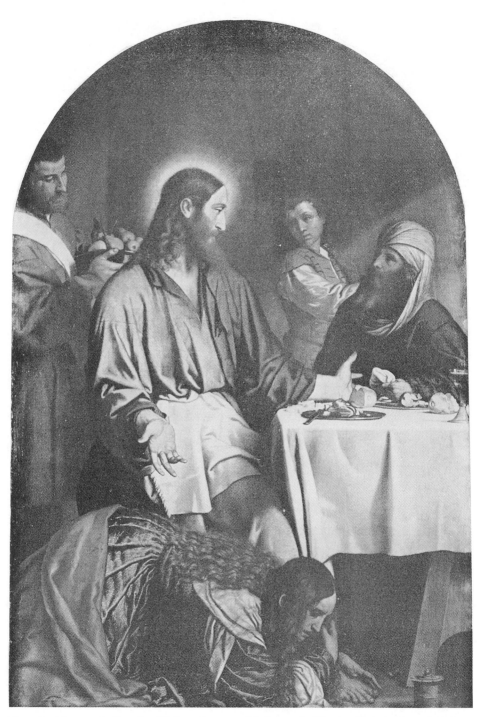

Plate 43: Moretto da Brescia, *Christ at Supper with Simon the Pharisee*, Brescia, Santa Maria Calchera

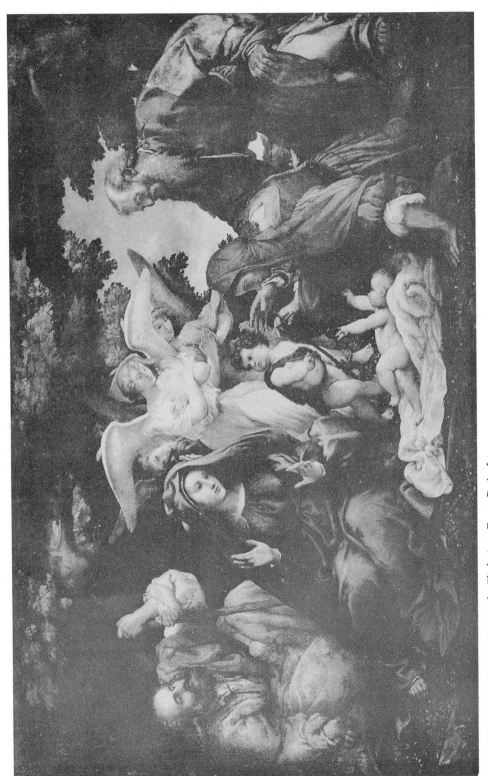

Plate 44: Lorenzo Lotto, *Rest on the Flight into Egypt*, Paris, Louvre

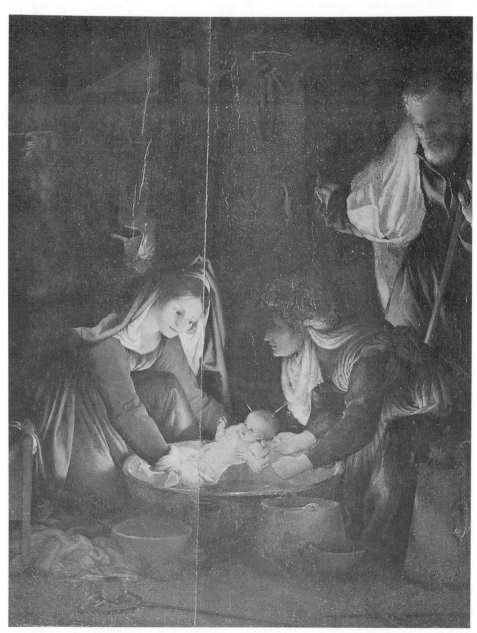

Plate 45: Lorenzo Lotto, *Nativity*, Siena, Pinacoteca

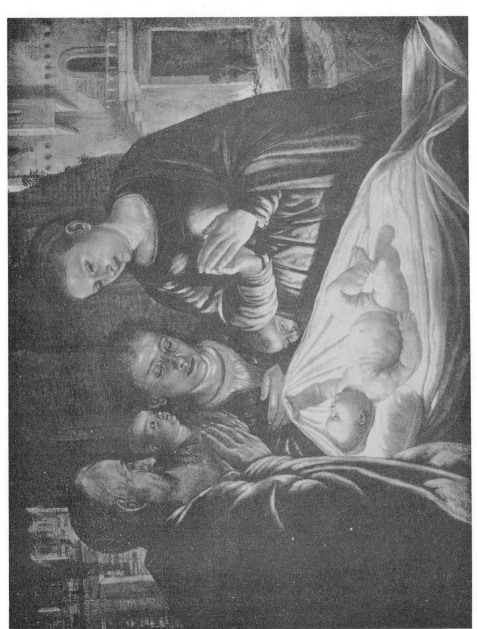

Plate 46: Savoldo, *Nativity,* Rome, Albertini Collection

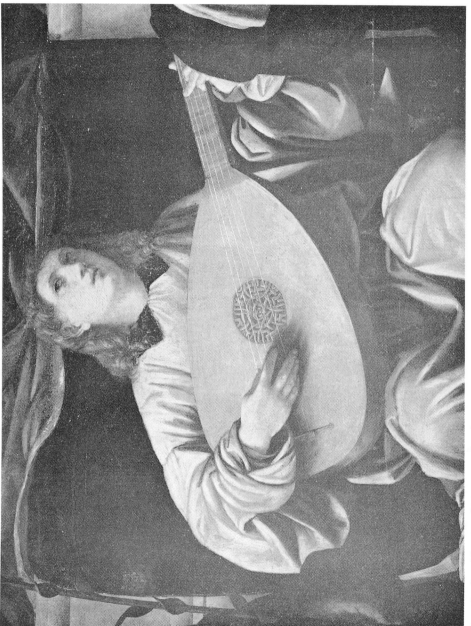

Plate 47: Savoldo, *Angel Musician* (detail), Treviso, San Niccolò

Plate 48: Caravaggio, *The Lute-Player*, St. Petersburg, Hermitage

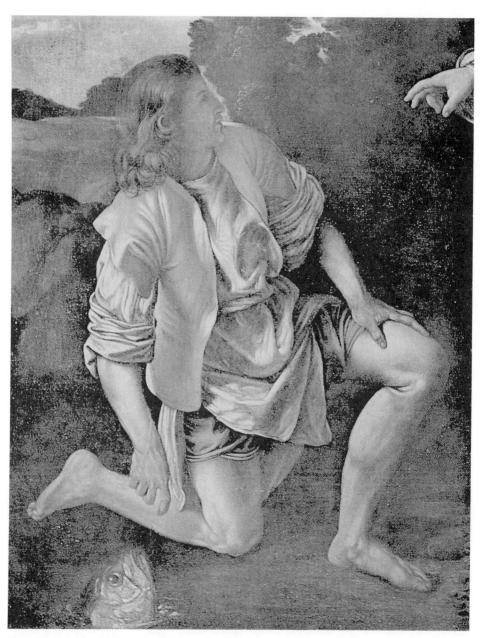

Plate 49: Savoldo, *Tobias and the Angel* (detail), Rome, Galleria Borghese

Plate 50: Antonio Campi, *St. Catherine in Prison*, Milan, Sant'Angelo

Plate 51: Antonio Campi, *Martyrdom of St. Lawrence,* Milan, San Paolo

Plate 52: Antonio Campi, *Martyrdom of St. John the Baptist*, Milan, San Paolo

230

Plate 53: Vincenzo Campi, *Christ Nailed to the Cross,* Madrid, Prado

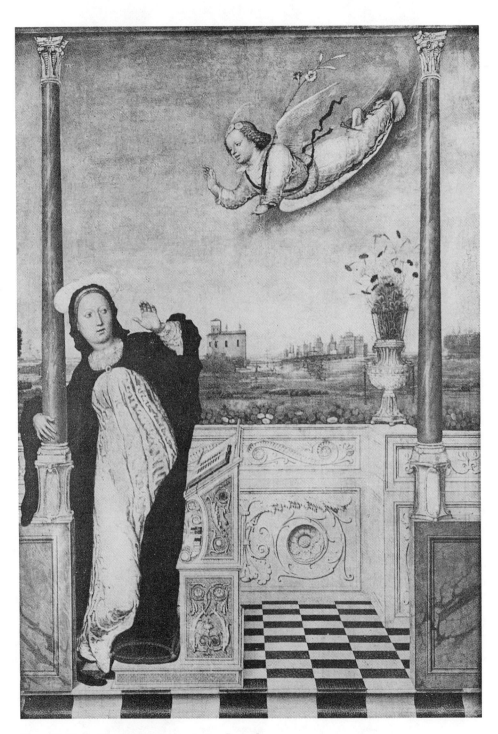

Plate 54: Carlo Braccesco, *Annunciation,* Paris, Louvre

Plate 55: Carlo Braccesco, *Saints Benedict and Augustine*, Paris, Louvre

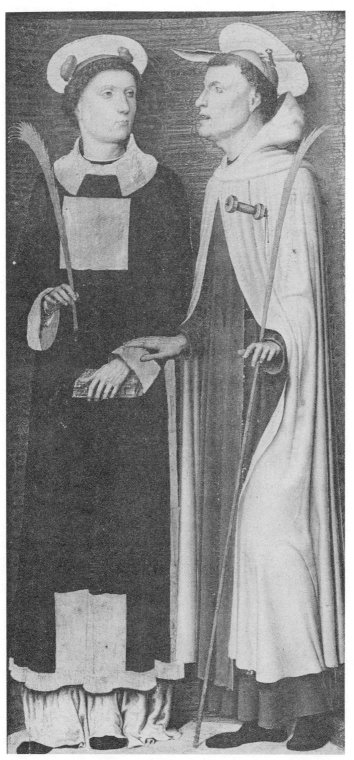

Plate 56: Carlo Braccesco, *Saints Stephen and Albert,* Paris, Louvre

234

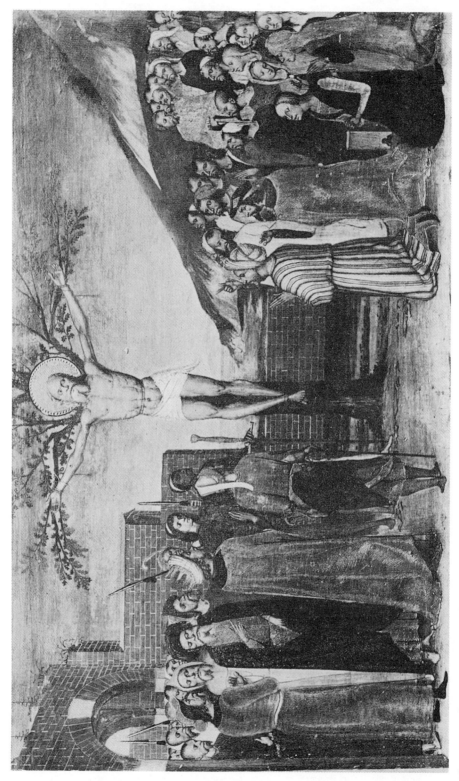

Plate 57: Carlo Braccesco, *Crucifixion of St. Andrew*, Venice, Galleria Franchetti

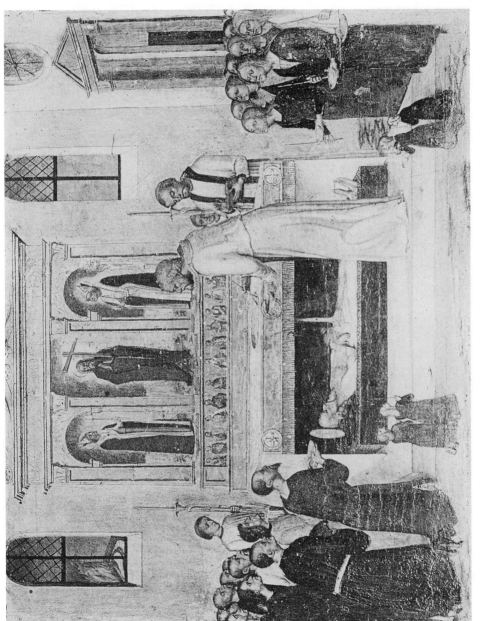

Plate 58: Carlo Braccesco, *The 'Manna' of St. Andrew*, Paris, Musée de Cluny

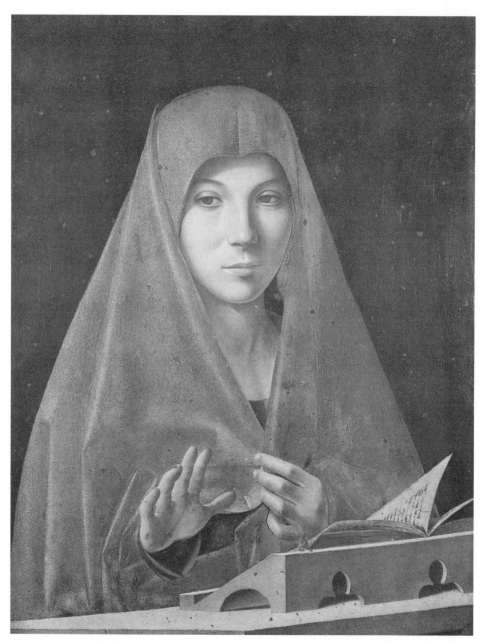

Plate 59: Antonello da Messina, *Annunciate Virgin*, Palermo, Museo Nazionale

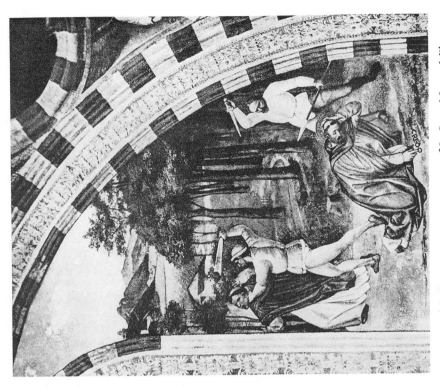

Plate 60b: Vincenzo Foppa, *Assasination of St. Peter Martyr*, Milan, Sant'Eustorgio

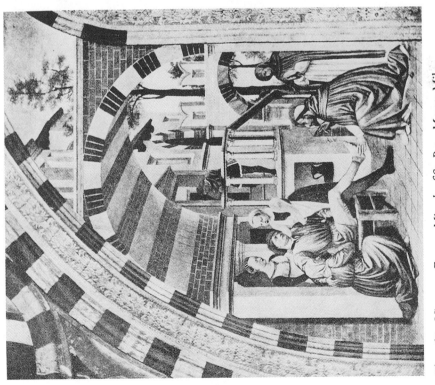

Plate 60a: Vincenzo Foppa, *Miracle of St. Peter Martyr*, Milan, Sant'Eustorgio

Plate 61: Ambrogio Bergognone, detail from the *Madonna,* Bergamo, Accademia Carrara

Plate 62: Ambrogio Berggonone, detail from the *Annunciation,* Lodi, Chiesa dell'Incoronata

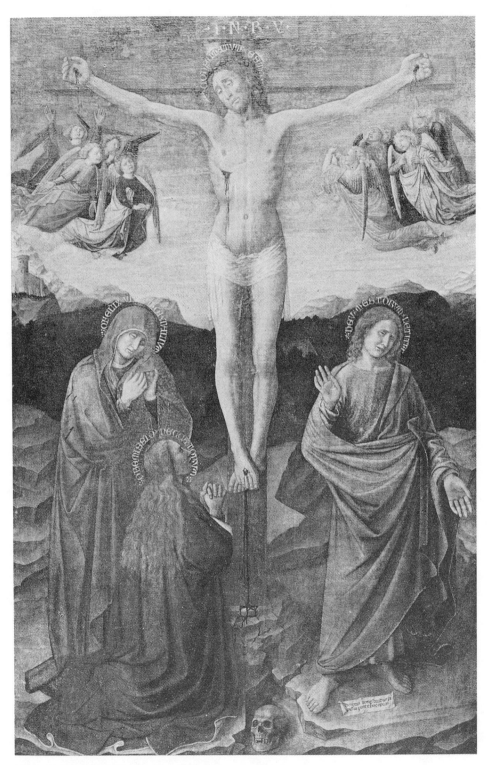

Plate 63: Donato de'Bardi, *Crucifixion,* Savona, Pinacoteca

240

Plate 64: Carlo Braccesco, *Montegrazie Polyptych,* Genoa, Soprintendenza

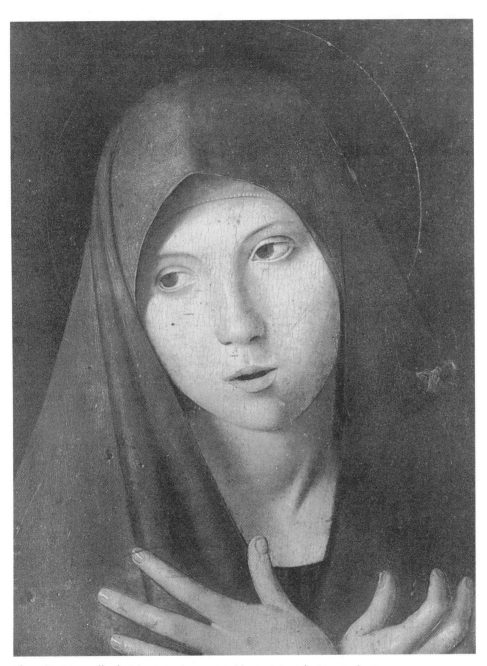

Plate 65: Antonello da Messina, *Annunciate Virgin,* Munich, Bayerische Staats-
gemäldesammlungen

Index of Names